The Four Winds Guide to
Indian Artifacts

Preston E . Miller and Carolyn Corey

Special photo Section "Is it Real....or is it an 'Artifake'"?

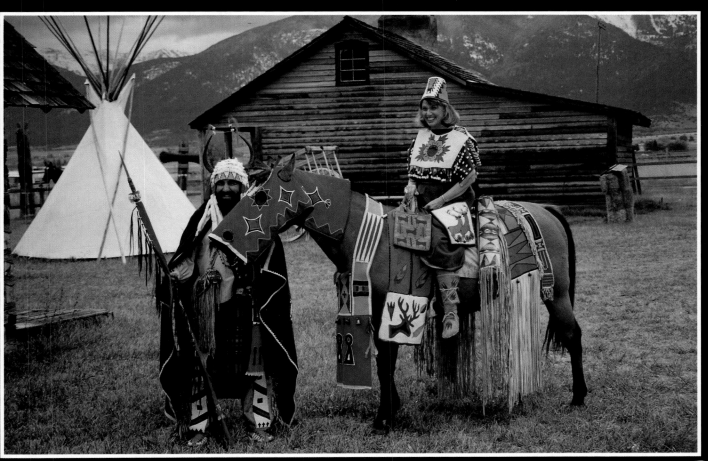

4880 Lower Valley Rd. Atglen, PA 19310 USA

D1224158

Layout by Laurie Ann

ISBN: 0-88740-995-4
Printed in China
1 2 3 4

Published by Schiffer Publishing Ltd.
4880 Lower Valley Road
Atglen, PA 19310
Phone: (610) 593-1777; Fax: (610) 593-2002
E-mail: Schifferbk@aol.com
Please write for a free catalog.
This book may be purchased from the publisher.
Please include $3.95 for shipping.

Please try your bookstore first.
We are interested in hearing from authors
with book ideas on related subjects.

All photographs by the authors

Contents

Introduction

How to use this book

The American Indian collectibles in this book were sold by Four Winds Indian Auction in St. Ignatius, Montana, over a ten year period in their absentee mail/phone/fax auctions. Included are genuine Indian-made items of both new and old vintage. Stone artifacts, photographs, trade beads, frontier and military related items; replicas made by both Indian and non-Indian crafts people will be featured in the companion volume to this work, *The Four Winds Guide to Indian Trade Goods, Replicas & Stone Relics*. The full range of items in each category, with *descriptions, dates, price estimates* and *prices realized*, will provide useful information to both sellers and collectors.

The *title* of each item is named using terminology that is most accepted by experienced collectors. This is followed by a *date* approximating the year in which the item was made. Without certified provenance, it is difficult to be completely accurate when assigning dates to Indian material based solely on appearance, so that a date of "c. 1870" assumes that an item could be made ten years earlier or later.

Information on **provenance**, when available, *is italicized*, following the date.

The **descriptions** contain pertinent construction details; such as a detailed list of bead colors and materials used, as well as the size and condition of the item. All are very important factors in determining the value of an item. For instance, certain bead colors can help verify the age (*see Bead Glossary*); usually the older a piece is, the more it is worth. Also, the use of thread or sinew, brain tan or commercial hide (see Chapter 8, "Trade Ornaments and Materials used on Indian Artifacts.") and whether or not the item is in good sound condition can be very important when assigning values. Many books fail to take these things into account when establishing an item's value. It is important to realize that a pair of moccasins with half the beads missing is worth considerably less that a pair with little or no damage. The same applies to torn rugs, damaged baskets, broken pottery or stone artifacts; often the damaged item can be worth less than half the value of a similar but intact one. Sometimes an item will be so undesirable that you might have difficulty finding a buyer. The exception could be when an item has a provenance or rarity that makes it one-of-a-kind. For instance, a stiff torn moccasin that has provenance proving that it was picked up at the Battle of Wounded Knee or a damaged but very rare early incised buffalo hide parfleche would continue to fetch a high price.

Finally, we list the price for which each item sold in our auctions preceded by the estimate range. Example: "Est. 400-800 **SOLD $250(88)**" The dollar amount following the word **SOLD** is the amount for which the item was sold and the numbers in parenthesis indicate the year that it sold. This is an accurate method for assigning values to artifacts. At auction, the highest price realized is determined by the bidders. It means that at least two people had similar ideas as to the value of an item. Also, it can be assumed that because participants in any one auction are limited, there must be other buyers outside the auction realm who will pay as much or more. **The estimate range reflects the** current (1997) market value as determined by our personal opinion guided by many years of experience (Preston has been selling, buying and collecting Indian artifacts for over 40 years). Sometimes the range can seem quite broad; for instance, "Est. 400-800" might leave you a little doubtful as to the real value. As the seller, you can always ask $800 and come down, but you can never ask $400 and go up when a customer is ready to buy. This principle works vice versa for the buyer. If you can buy or sell an item within our suggested estimate range, you can feel secure that your transaction was financially acceptable. **There are so many variables to every situation that it would be impossible to assign one price value to each artifact.**

It is important to note that if an item sold for a certain amount in 1988 it should have appreciated with time. Since there is no scale that can be assigned to evaluate the appreciation that accrued with time, you will have to use your personal judgement. Because some items appreciate slowly, not at all, or even depreciate this can only be determined by knowledge of the current trends in the marketplace.

Any omissions are due to information that was not available or could not be verified. For example, we have included some noteworthy items that did not sell at auction for which our estimates serve as a value guide.

Reasons for Collecting

Beginning in the 1970s, the collecting of Indian artifacts reached new levels of popularity, perhaps encouraged by the fact that several major antique and art auction houses began selling collections of old Indian-made items to high paying buyers. Prior to these auctions, Indian-made relics seemed to be viewed as merely craft work having little or no art value. Because of this new status, many old and here-to-fore unknown treasures were gradually unearthed from old family trunks, attics, and museum storage areas to be placed into the collectors' market. Today, there are many people collecting Indian artifacts, and the number continues to grow. The reasons for collecting include investment potential, historical value, art and craft appreciation, home and business decoration, and personal adornment.

Investment potential

Many collectors make an expenditure with the hope that their acquisitions will some day be worth more money. It is common to meet collectors who purchased a rug, basket, or beadwork item twenty or thirty years ago and report just having sold it for five or ten times their original purchase cost (for example, in chapter 1, a Sioux dress top which was purchased for $200 in 1962 sold for $7000 in 1994). Usually, it seems the best quality and most rare artifacts sell for increasingly higher prices. Mediocre and poor quality items can reach a peak and even go down in value. Education and reliable advice are the best deterrents against making a poor investment.

Historical value

Quality and rarity alone do not always determine the price of an item. Unlike coins, stamps and guns, Indian relics are most always one of a kind. No two pieces are exactly alike and some collectors will pay exorbitant prices to have the one they want. Perhaps they have a photo of great grandfather and a famous Indian holding an item. This creates a sentimental attachment for which only they can determine the value. For others it might be that in all their years of collecting, they have never seen another like this one for sale. After all, if a collector has the cash and knows only one example exists and he must have it, only he knows what he will be willing to pay. But remember, this kind of demand cannot be predicted. For example, the price realized for a war shirt being worn by famous Sioux chief Sitting Bull in an old photo does not determine the value of all similar war shirts.

Art and craft appreciation

Some collectors will make a purchase because they appreciate the work that went into the making of a basket, stone axe or beautifully beaded pair of moccasins. Not everyone will see each item the same way. Past experience and especially whether or not you have tried the work yourself will enhance your appreciation of the finished product. If you have ever tried sewing beads with sinew, or gathered materials and woven a basket, you will most certainly have developed an appreciation of the skills required to make these items. Combine this with the cultural insights and artistic abilities required and you will develop an expanded realization of an item's value.

Home and business decorating

Nothing matches the beauty of Indian baskets, Navajo rugs, old beadwork, etc. tastefully displayed in a beautiful log home with a stone fireplace. Multiply this to include adobe haciendas, historical and modern houses, offices, restaurants, etc. and you can soon see the value Indian artifacts have to architects and interior decorators. The value can only be determined by the need, space and finances available. And all the while you are enjoying their enrichment to your surroundings their investment potential is probably going up.

The authors in their Victorian living room in 1990, with some of their collection.

Personal adornment

Many collectors have experienced the fun of wearing a beautiful piece of southwest silver jewelry, a beaded or quilled buckskin jacket, or perhaps decorating their favorite Appaloosa with Indian horse gear. Re-enactors, buckskinners, movie personalities, cowboys, Indians and others are among the increasing numbers of people who wear and use their collectibles. It is among these people that the collecting of replica artifacts has become understood and popular.

The visual beauty and construction of a Sioux fully beaded vest, or an expertly painted Crow rawhide parfleche will provide many years of wonderful appreciation to its owner. One will never tire of looking at it and anticipating new discoveries about its design, construction and history. For most collectors, this is the real reason for collecting. The pleasures experienced from collecting are many and varied. Each person will develop their own unique and interesting reasons.

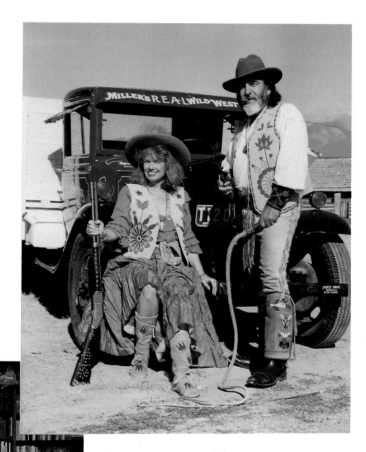

The authors are wearing matching fully-beaded vests. Carolyn's was made c. 1890 and belonged to a Kootenai Chief named Koostata. Preston's vest is new and was made for him by Cecile Lumpry, a Salish Indian. Also, notice the 1876 Winchester which is decorated with brass tacks. He purchased the rifle many years ago for $150 at Shoup's Grove Flea Market near Lancaster, Penna. The "Wild West Show" truck is a 1932 Chevrolet.

5

Bead Glossary

Terms and abbreviations used in descriptions of GLASS BEADS in this book:

BEAD SIZES (refer to color bead chart)

"Seed" beads are the smallest beads varying from Czech 10° (largest) to 22°. Czech 12°-13° and Italian 4° (see bead chart) were the most commonly found sizes on pre-20th century pieces.

"Pony" -or more correctly called a "pound" bead- is a large seed bead (Czech size 5° or "I"- see largest beads on the bead chart- to Czech 9°) which usually pre-dates the use of smaller seed beads on Plains and Plateau items *See also pony and Crow beads in the Trade Beads chapter in the companion volume.*

"Crow" beads are larger still and have a large hole for stringing on necklaces or thong decorations on objects and clothing. "Old style" size approximately 7 mm. to 9 mm. (see chapter 8, page 188).

BEAD STYLES

"Basket" beads are cylinders cut from longer tubes manufactured since mid-1800s (not currently being made to our knowledge.) Very versatile use in sewing and stringing. Usually transparent, "lined" (with interior color), or satin (a gleaming satin-like finish).

"cuts" or cut beads- are multi-faceted beads resulting in a sparkling effect. The best are still being made in Czechoslovakia in size 13° only, transparent and opaque. 19th century pieces frequently have "Czech" cuts in **t.** (transparent), **gr.** (greasy), and in even smaller sizes (even 20° and less!).

"Tile" bead is an opaque molded cylinder bead with straight sides. Primarily used strung in loop necklaces and thong decorations as early as mid-19th c.

"tri-cuts" are a 3-cut faceted bead, larger than a **cut** (see above) often used on Indian items made after the turn of this century to the present. Usually pearl (**lustre**) or iris (multi-color metallic), lined (see below), also transparent and opaque.

BEAD COLORS

*No adjective with bead color refers to **opaque** or a solid-color bead; ie. red bead*

"C. pink" or Chey. pink abbreviation for Crow or Cheyenne pink. Both refer to the same old-time bead color, a dusty muted pink popularly used by those tribes in 19th century and earlier.

"gr." or "greasy"-translucent (**transl.**) or cloudy (semi-transparent). Many old beads were made this way; and many are now being re-made in Europe today. Gives an old piece (or modern reproduction) a richly varying beadwork texture.

"Pony trader blue" or Trader blue- Rich "greasy" medium blue in many color variations (darker than greasy blue and lighter than cobalt). This color was popular on the Plains in the early-19th c. in a "pony" bead size along with white, black and rose white heart. Also "Bodmer blue", an intense greasy blue named for Karl Bodmer, 1830s painter of Plains Indian subjects.

t. or **trans.** abbreviation for transparent or clear (see-through)

white lined, w. heart, or **w. center** all mean the same, referring to the color of the interior of a bead. Outer color usually red, sometimes brick, pink, orange, green, yellow or bright blue in modern reproductions. Can be any size of bead. A very old style of seed bead was a *highly* desirable rose or rose-red, no longer being made (*Exception: blocky Crow bead now made in India*).

Also see White hearts, in Trade Bead chapter in the companion volume, and Bead Detection, in "Artifake" Section of Chapter 8.

BEADWORK STYLES

Flat or applique Used to cover large areas with solid beading; sewn straight or in curved rows. Overall appearance is flat. Used by many tribes, ie; Blackfeet, Plateau, and Cree.

Lazy-stitch Multiple (5-12) beads strung and sewn down to create humped or raised rows; often used to cover large areas. Principally used by the Sioux, Cheyenne, Arapaho and Ute; a modification used by the Crow.

Embossed or raised Beads sewn in a crowded arched stitch for a 3-D effect as found on Iroquois and other Eastern tribes beadwork.

Peyote or gourd A netting technique usually used to cover solid objects ie; fan handles, key chains, ball-point pens, etc. Common to contemporary Indian beadwork items.

References

For further information on tribal styles and how-to techniques, see:

Miller, Preston, *Four Winds Indian Beadwork Book*, St. Ignatius, Mont., 1971

Whiteford, Andrew H. *North American Indian Arts*, New York, Golden Press, 1970. Concise visual and factual guide to quick identification of material culture objects.

Abbreviations and Definitions

For definitions of other materials used in making Indian artifacts such as buckskin hides (brain-tanned and commercial) and trade wool (white selvedge) *see Chap. 8, "Trade Ornaments and Materials Used on Indian Artifacts," p. 192-193.*

SPECIAL TRIBAL DESIGNATIONS and terms used in this book:

Intermontane refers to a geometric decorative style shared by Plateau, Crow and some Basin tribes (spanning a large geographic area).

See Conn, Richard, *A Persistent Vision*, Seattle, University of Washington, 1986, 128-131.

Blackfoot or Blackfeet- In modern times, Indians of the Blackfoot Confederacy refer to themselves as **Blackfoot** from Canada; and **Blackfeet** from United States. We use this designation in the book.

See Hungry Wolf, Adolph and Beverly, *Indian Tribes of the Northern Rockies*, Summertown, Good Medicine Books, 1989, 2-4.

GENERAL CARD "W"

SIZES				
14/0	3	732	STRIPED BEADS	
5/0	Snow white (4)	616		
13/0	28	18 1/2	CSS 1 R	
4/0	523	507	6599	
12/0	824	18	6697	
3/0	828	102	6721	
11/0	828 1/2	63	CSS 2	
2/0	11	64	6631	
10/0	13	735	205	
0	801	103	6687	
9/0	806	27 1/2	6657	
c	807	27	06671	
8/0	807 1/2	20	06679	
7/0	808	20 N	06686	
d	812 1/2	31		
e	813	30 1/2		
f	810	30		
g	811	464		
h	803	448		
i	805	49		
l	38	695		
COLOURS	6	Black (40)		
Cristalux	7			
Cristalux extra	678			
2	523			
41	22			

SLIGHT DEVIATIONS FROM COLOURS AND SIZES TO BE TOLERATED

Card #1, Edition 1962 from Societa Veneziana Conterie, Italy in 1970. This card displays both Italian sizes (0° to 5°) and Czech sizes (7° to 14°). Notice that bead colors are identified by numbers. 19th century bead cards also use numbers for identification of colors. Notice the many shades of blue, green and red. #28 is greasy yellow; #810 and #811 are white lined reds.

Abbreviations used in this book
Listed alphabetically

See also bead definitions for bead color abbreviations

alt. = alternating
apx. = approximately
avg. = average
bkgrd. = background
c. = circa
C. pink or Crow pink (see Bead Glossary)
comm. = commercial
cond. = condition
Czech. = Czechoslovakia
D. = deep (depth)
diam. = diameter
diff. = different
dk. = dark
ea. = each
Ex. = example
exc. = excellent
excl. = excluding
Fdn. = Foundation
gr. = greasy
H. = high (height)
incl. = including

L. = length
lt. = light
Ital. = Italian
mocs = moccasins
nat. = natural
No. or N. = North
nr. = near
pred. = predominantly
pr. = pair
prob. = probably
prov. = provenance
pt. = point
Res. = Indian Reservation or Reserve(Canada)
So. or S. = South
t. = transparent
transl. = translucent
turq. = turquoise
VG = very good
W. = width
yrs. = years

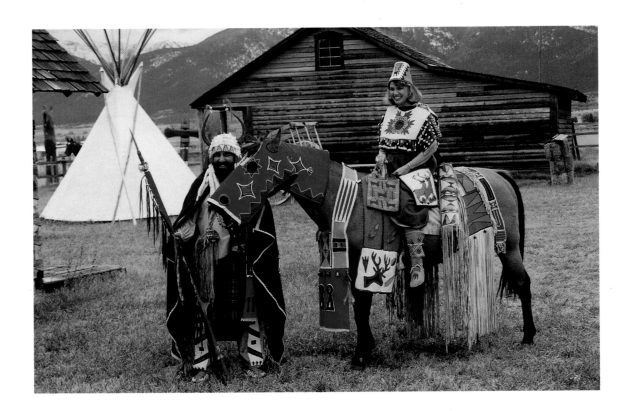

Fun at Four Winds The authors and the horse are wearing a mixture of old and new items. Carolyn's dress, cape and bags are old. Preston is wearing a fine old pair of Blackfeet leggings and a replica buffalo horn headdress. The horse mask and martingale are new; the parfleche cylinder, saddle bag and saddle blanket are old.

I. Clothing and Accessories

War shirts, Jackets and Pants

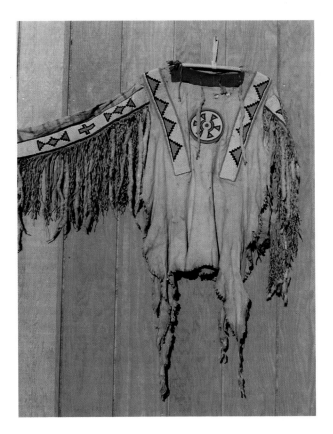

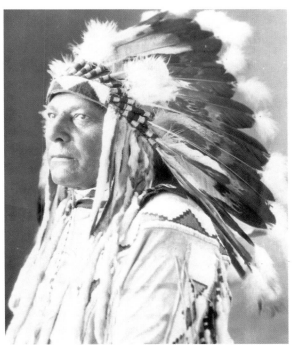

BLACKFEET WAR SHIRT c.1870
Included is photo of George Star, Blackfeet Indian from Browning, Montana wearing shirt in 1927. Shoulder and arm strips are applique beaded with sinew in gr. yellow, cobalt, gr. blue and white lined rose on white bkgrd. Beaded rosette on front and back with ermine skin drops and fringed sleeves. Red trade cloth around neck opening. Made from mountain sheep hides. Est. $12,000-25,000 **SOLD $9750(85)**

CANADIAN BLACKFOOT SHIRT and PANTS c.1930
White buckskin with long fringe. Matching beaded strips on pants and shirt are white with gr. red, corn yellow, and lt. blue triangular motifs. Dk. green wool bib bound with purple felt has beaded star in center. Large man's size. Est. 2000-3000 **SOLD $2250(92)**

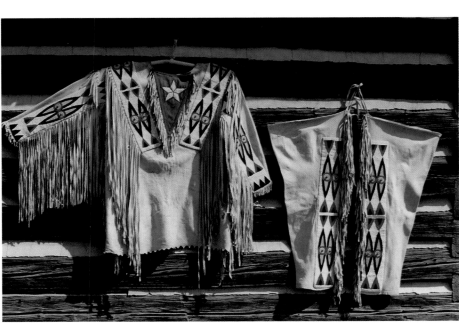

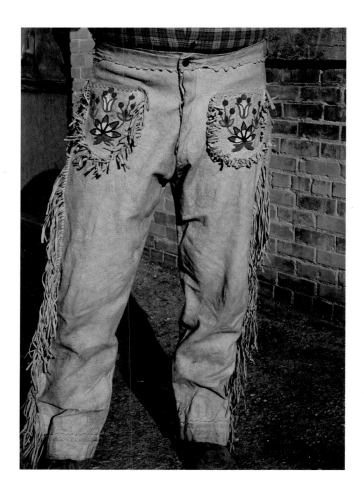

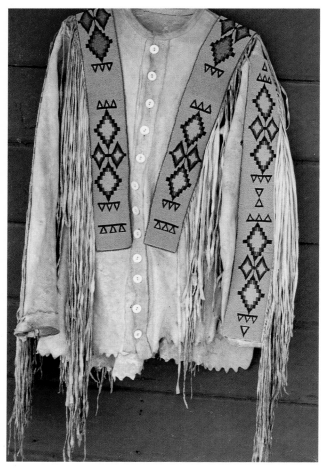

BLACKFOOT WAR SHIRT c.1900
White buckskin with 18" L. fringe and buttoned front. Wide (3.25")
strips in lt. blue bkgrd. and traditional designs in gr. yellow, dk blue, green
and red. Exc. cond. Est. $2500-5000 **SOLD $3900(88)**
BLACKFOOT BUCKSKIN PANTS c.1900 (Collected with preceding shirt.)
White buckskin with side fringes and floral beaded pockets both front
and back. Exc. cond. Large size. Est. 600-900 **SOLD $400(88)**

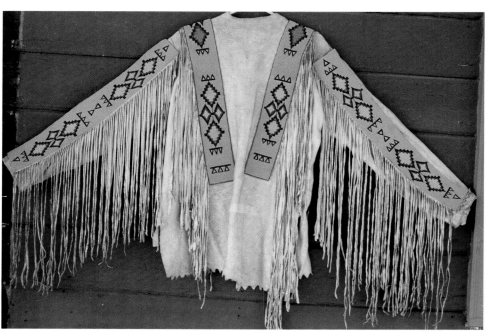

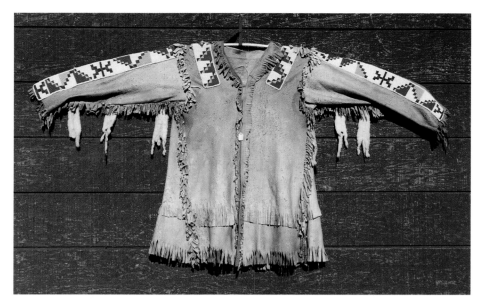

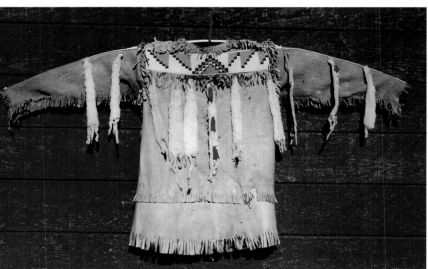

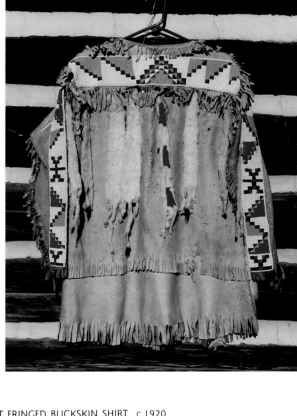

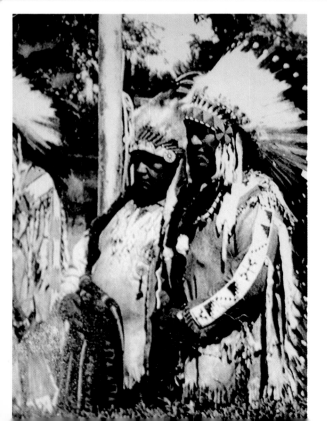

BLACKFEET FRINGED BUCKSKIN SHIRT c.1920
This is a wearable example of an early 20th century documented war shirt.
Includes a dated laser photo (Oct. 1932) of an Indian wearing this very
shirt. Body is lightly smoked deer hide (almost white) with lots of fringe,
12 full ermine skins (6 across back- 3 on each sleeve) and applique
beaded strips on sleeves, shoulders and across the back. Dramatic back
has wide (3.38") horizontal beaded strip in white with gr. red, trans.
cobalt, and lt. turquoise Classic triangular patterns in flat stitch. Central
ermine has 3 red satin ribbons. Sleeve strips are full-length. Shoulder and
sleeve fringe have red and blue trans. basket bead ornamentation.
Beadwork in exc. intact cond. Old metal hook and eye front fasteners.
Overall exc. patina. Exc. cond. 32"L-40" chest. Est. 1900-3000 **SOLD
$2250(95)**

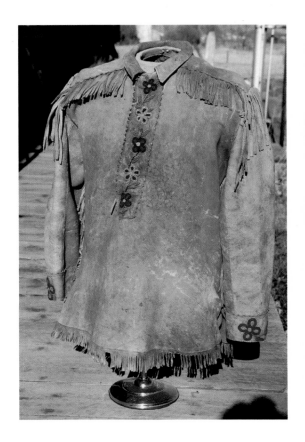
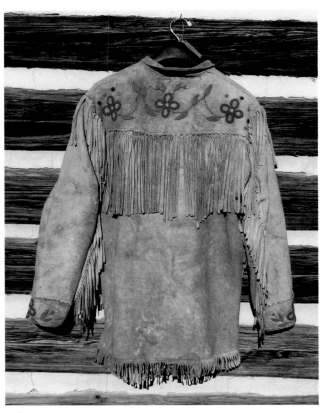

CANADIAN CREE MOOSE HIDE BEADED SHIRT c.1920
Back yoke, cuffs and front placket beaded in trans. rose, trans. cobalt,
Sioux green, clear, gr. yellow and Crow pink floral motifs. Thong tied front
opening. 6" fringe at armholes. 8" fringe across back yoke. Beadwork
completely intact. Good wearable cond. Size L to XL. 48" chest. Est. 400-
800 **SOLD $500(95)**

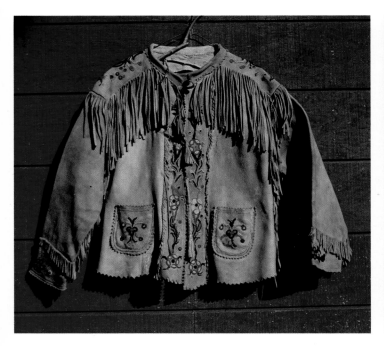
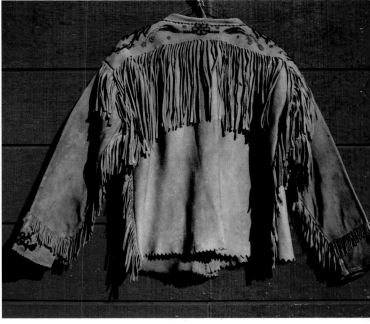

CREE MOOSE HIDE BEADED JACKET c. 1870 Beaded floral motif on pockets, lapel, yoke and cuffs in subtle pastels:Cheyenne pink, clear
rose, white heart rose, lt. blue, trans. dk. cobalt,etc. All sinew sewn. Scalloped "pinked" roll collar, hem and pocket edges. Leather
tassel tie front. Man's size. Exc. patina and cond. Est. 800-1500 **SOLD $750(90)**

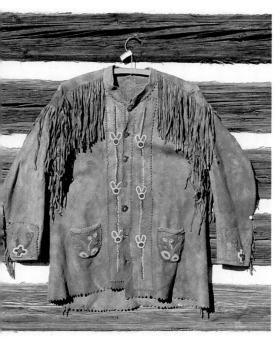
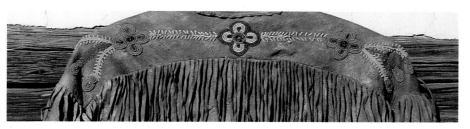
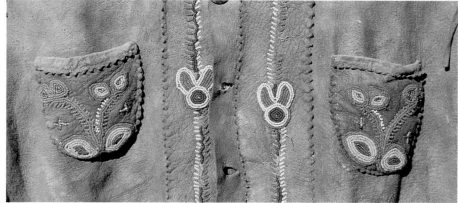

CREE INDIAN SCOUT JACKET c.1870
Early abstract floral patterns connected by barbed stems that are red
white heart, C. pink, lt. blue, t. rose, porcelain white and gr. blue. Floral
and leaf motifs in additional colors of periwinkle, gr. green. Robin's egg
blue, dk. cobalt, pale green, t. green, gr. pumpkin, brass and silver
metallic facets. Beadwork is on back yoke, pockets, cuffs and both front
lapels all have "pinked" edging. Supple wearable smoked moose hide.
Nice dark patina of age. 31" L-40" chest, sleeve 19.5"-8" L back fringe.
Est. 950-1500 **SOLD $950(96)**

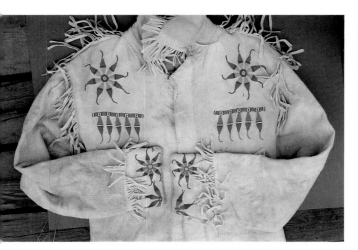
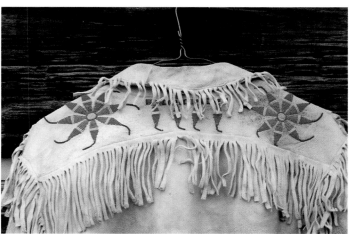

ASSINIBOINE BEADED SHIRT *Collected from Ft. Belknap Res., Montana c.
1920.* White Indian-tanned buckskin with beadwork on cuffs,pockets and
shoulders. Beadwork is blue, red, white, black, and yellow. Man's size.
Exc. cond Est. 900-1250 **SOLD $750(87)**

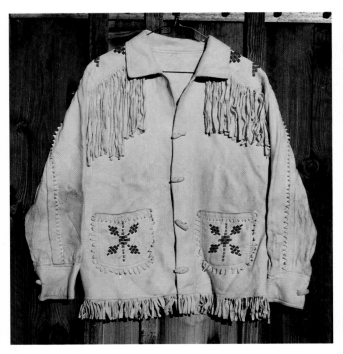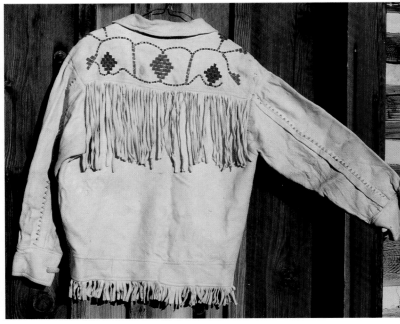

BLACKFEET BEADED BRAIN-TAN JACKET c.1940
Supple leather fringed and "pinked". Beadwork on back yoke and
pockets in geometric designs: med. blue, t. red tri-cut, t. turq.
tri-cuts. Rolled leather buttons. A few beads missing on pockets;
otherwise, exc. cond. 26"L. Medium size. Est.275/400 **SOLD $275(92)**

Dresses

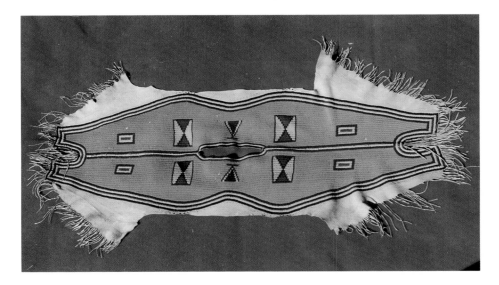

EARLY SIOUX FULLY-BEADED DRESS YOKE c.1860
*Purchased from Mr. Luongo of Plume Trading Co. at his store/museum in
Monroe, NY. 30 years ago.*
RARE. The square geometric designs and striped border are indicative of
this 1860's style. It appears that this top once had a dress body attached
to it. The lacing holes indicate that the dress was carefully un-stitched
which is not unusual, as these heavy tops were often used separately
over a cloth or buckskin dress, making it easier to put off and on. Sinew-
sewn and lazy-stitched in seed beads: Lt. blue bkgrd. with gr. yellow, rose
white heart, trans. cobalt and trans. bottle green rectangular and
triangular motifs. Surrounding concentric border: trans. cobalt, gr. yellow,
bottle green, Cheyenne pink, t. cobalt. Buckskin is pliable and in
wearable cond. Exc. original cond. 54" total With 46" at shoulder. 3"
buckskin fringe along sleeve. Est. 8,000-15,000 **SOLD $7000(94)**

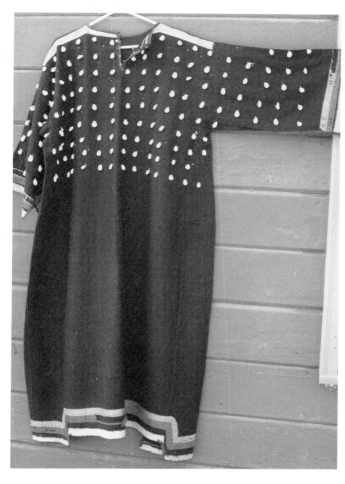

SIOUX TRADE WOOL DRESS c.1870
L. D. Bax Collection. Yellow monie cowrie shell decorated yoke front and back on navy blue undyed selvedge wool. Red and green silk ribbon trim on sleeve and bottom; purple silk binding on split sleeves, neck, and gusset. Some deterioration of silk ribbon (as expected) otherwise exc. cond. Shows no fading. Large size-54" L. X 48" chest. Est. 2000/3000

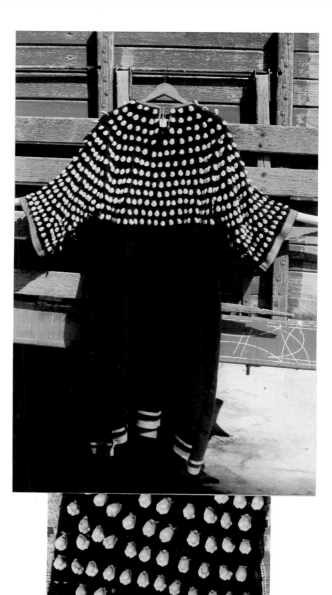

CHEYENNE TRADE WOOL DRESS c.1870
Large yellow monie shell decorated front and back yoke and sleeves. White selvedge navy wool with silver metallic fringe, wide rose and narrow lt. blue silk ribbon at hem. Gold muslin binding at neck and gusset corner. Entirely hand-sewn. Very elegant with rich, muted tones. Exc. cond. Front slightly faded with partial deterioration of silk ribbon. Special note: atypical diagonal weave wool rarely seen on undyed selvedge trade cloth makes this a very unusual piece. 47" L. X 44" chest-flared skirt to 72". Est. 1800/2500 **SOLD $2000(90)**

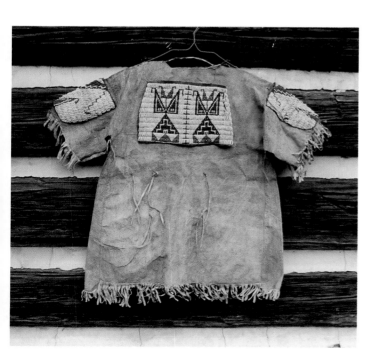

SIOUX CHILD'S DRESS With BEADED PANEL c.1880
Re-cycled panels are probably from woman's legging tops. Front panel: white with rose white heart, med. green, blue, cobalt, and gr. yellow. Two panels on sleeves: white with green, red, periwinkle and brass facets. Buckskin body is fringed at sleeves and hem with thong trim. All beadwork intact-leather stiff but stable. 23"L X 14" chest. Est. 400-800 **SOLD $475(95)**

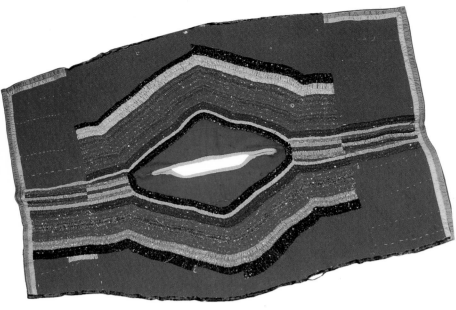

BLACKFEET WOOL BEADED DRESS YOKE c.1890
A Classic Blackfeet style. Tri-cut beaded lanes in red, silver, metallic green,
dk. blue iris, cobalt, cranberry, clear gold, gold iris and opalescent clear.
Size 13° seed bead lanes are pale yellow and lt. blue. Cloth is old-time
red-orange twill weave wool with deep green inset at collar. Gold and
olive silk ribbon trim. Plaid blue and white calico lining with floral print
patchwork. Appears to have been worn but never completed. 36" W X
20"L. Est. 400-700 **SOLD $425(93)**

FLATHEAD GIRL'S
BUCKSKIN DRESS c.1920
*Belonged to Ellen Big Sam,
Arlee, Montana.* Indian-
tanned hide. Both sides
have sequin-trimmed
sleeves;basket bead
trimmed thongs. Fringed
all-around bottom. 32"
chest-35" L. Est.100-150
SOLD $90(93)

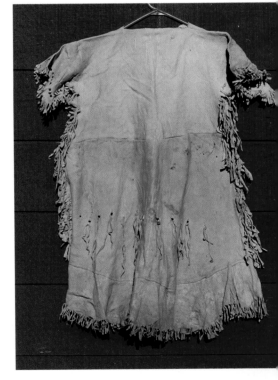

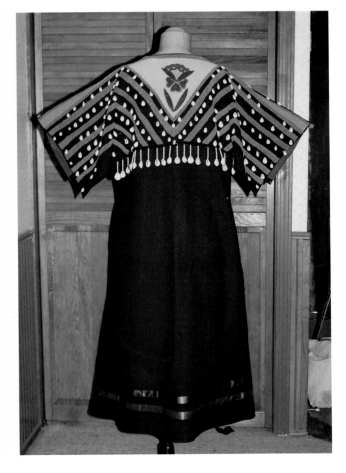

NEZ PERCE WOOL DRESS c.1890
*Sold many years ago in a trading post on the Coeur d'Alene
Reservation nr. Moscow, Idaho.* Triangular beaded yoke has typical
stylized flower on back and leaves only on front Cut-beaded
flower characteristic of late 19th century in choice pastel bead colors:
soft green, t. rose, cobalt, clear gold and gr.yellow with bkgrd. of irregular
pale blue Italian 4°. Stripes on bodice in alternating pink and pumpkin
(also Ital. 4°). Yellow monie cowries and porcelain white bead dangles on
bodice. Body is navy wool with 2 rows of rayon satin ribbon (soft green
and deep rose) nr. hem. Neck bound with calico and ties with leather
thongs strung with multi-colors of tube beads. 48" L X 43" bust. Est.
2000/5000

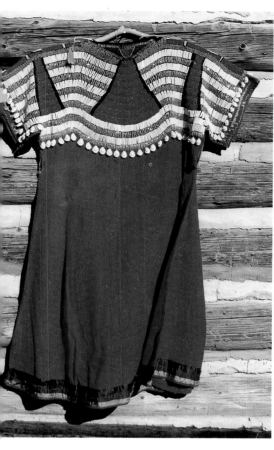

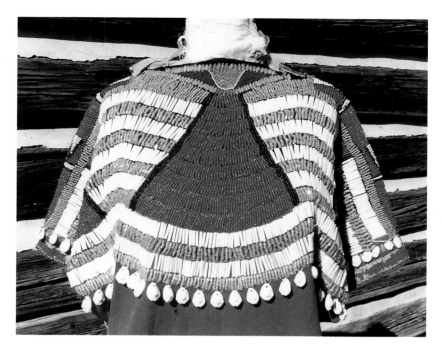

CAYUSE WOOL DRESS c.1890
Magenta trade wool. Fully-beaded top with red white center and green pony beads; white bugle and pumpkin basket beads. Neck area embellished with Czech glass "corncob" Mardi Gras beads in yellow, green and blue. Very early configuration emulating "tail" (at neck) in clear yellow, lt. blue and cobalt beads. Large cowries hang from bodice bottom. Silk ribbon in 3 tiers at hem in dk. and lt. green, and deep purple. Center row embellished with 1/4" brass spots. Sleeve hem has 2 tiers of silk ribbon in lt. green and orange with 1/4" brass spots. Shoulder strips are red white center, pink and cobalt pony beads. Est. 2000-3500 **SOLD $1800(90)**

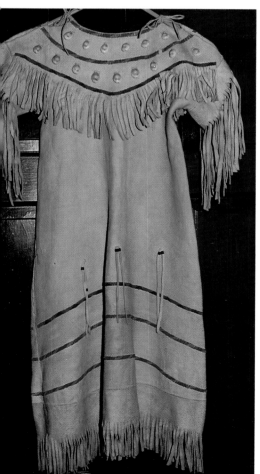

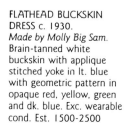

CROW GIRL'S BUCKSKIN DRESS c.1930
Purchased in Hardin, Montana. White Indian-tanned buckskin with large yellow monie cowries on yoke; beadwork stripes in med. and dk. blue, and orange. 37" L. Est.225-400 **SOLD $275 (93)**

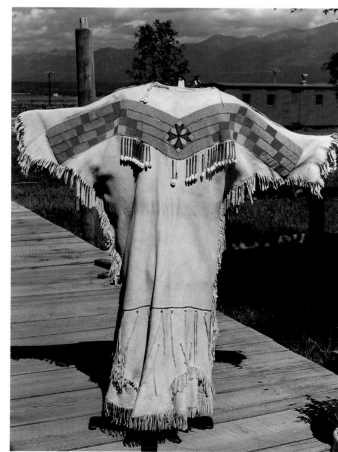

FLATHEAD BUCKSKIN DRESS c. 1930.
Made by Molly Big Sam. Brain-tanned white buckskin with applique stitched yoke in lt. blue with geometric pattern in opaque red, yellow, green and dk. blue. Exc. wearable cond. Est. 1500-2500

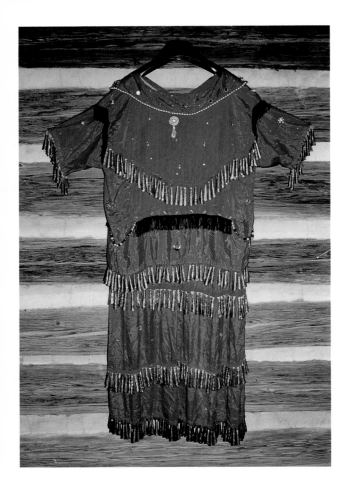

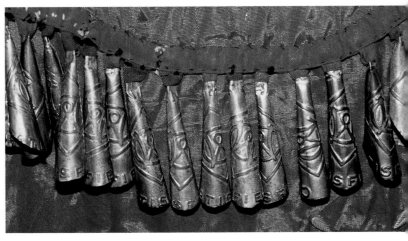

ORIGINAL RAYON JINGLE DRESS c.1920
Probably Chippewa-Cree. Recently on display at Montana Historical Society in Helena. Red-violet rayon satin with black rayon fringe (2"). Profusely decorated with 4 rows of 2" embossed tobacco tin jinglers (see detail) which are also all-around bottom and sleeve hem. Red muslin strips support rows interspersed with rhinestones, pearls, and other costume jewels of the period. 41"L-42" chest, Exc. cond.
Est. 500-800

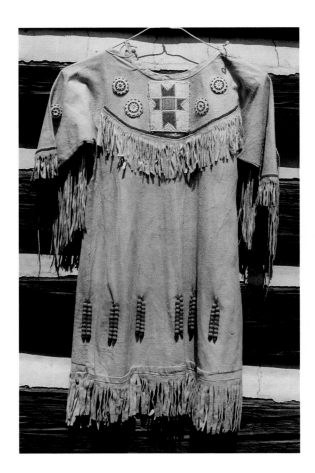

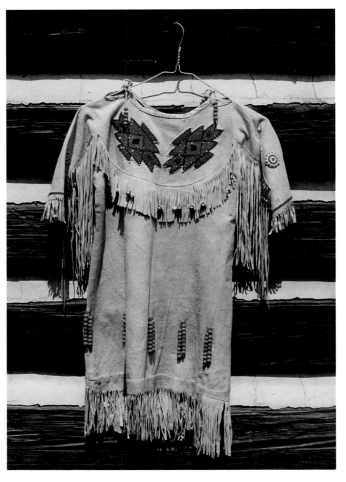

CROW LITTLE GIRL'S DRESS of brain-tan buckskin. c.1940
Different beaded design each yoke front and back (1) red and blue tri-cuts (2) opaque white and blue panel plus 6 rosettes. Narrow red and dk. blue seed beaded trim on sleeves and 1 yoke. 12 red and blue Crow bead dangles on skirt-4 on neck closures. 29" L. Exc. cond. Est. 250-400
SOLD $175(87)

Vests

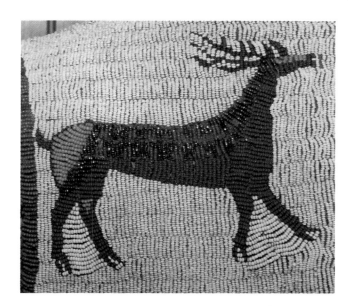

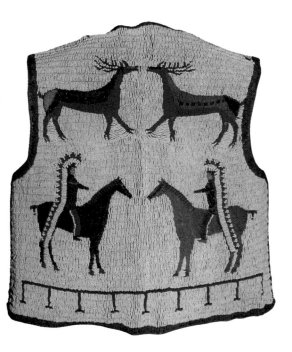

CLASSIC SIOUX PICTOGRAPHIC FULLY-BEADED VEST c.1870
Montana private collection Collected between 1885-1898.(documented). Lazy-stitched and sinew-sewn. White bkgrd (size 12 beads). Front panels (not shown) have facing horse and rider; 1 horse is white lined rose, the other is dk. blue. Riders and war bonnets in white lined rose, white and blue,t. dk. green, gr. yellow, lt. blue, white lined rose, white, and faceted metal beads. Back: 2 elk plus 2 horse and riders wearing trailer war bonnets. Bead colors: One horse is all brass facets with dk. blue mane. The other is Sioux green with dk. blue mane. Riders and elk similar colors as front. Border: White lined rose with geometric pattern in apple green and dk. blue. Lining:maroon print calico.
Exc. cond. 24" X 19". Est. 8000-15,000 **SOLD $8000(92)**

SIOUX FULLY-BEADED CHILD'S VEST c.1880 or earlier.
Sinew-sewn lazy-stitched with white bkgrd. in characteristic geometric patterns incl. "pitch fork" motifs-rose white heart, Sioux green, faceted brass, and periwinkle. Border is cobalt with pumpkin triangles. Lining is early 2-color brown floral calico. Exc. patina and cond. 17.5"L X 14" With Est. 2000-3500 **SOLD $2500(96)**

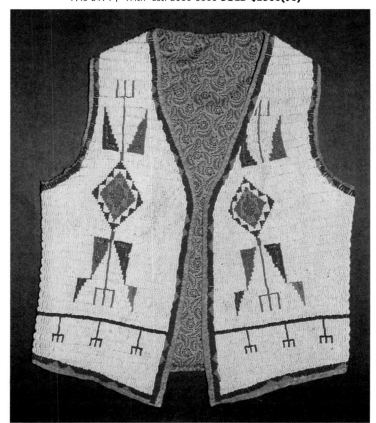

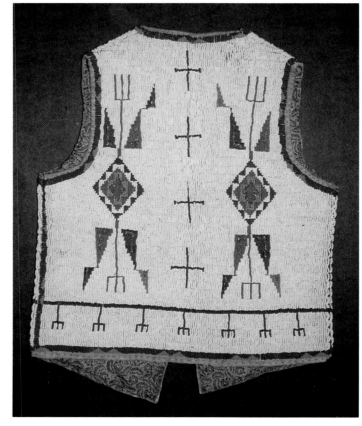

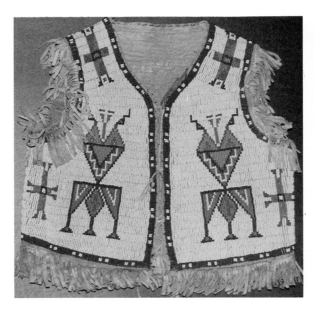
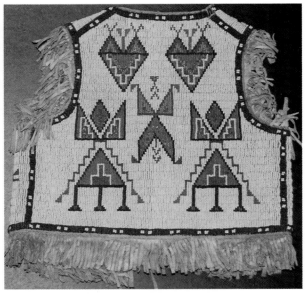

SIOUX FULLY-BEADED CHILD'S VEST c.1880
Lazy-stitched and sinew-sewn on buckslin. White background with
classic designs in periwinkle, apple green, cobalt, rose white heart and
brass facets. Border: cobalt with tiny white square motif. 2"L buckskin
fringed armholes and hem. Buckskin ties. Good patina of age. Perfect
cond. 13"L including fringe. Est. 2500-4000 **SOLD $3500(97)**

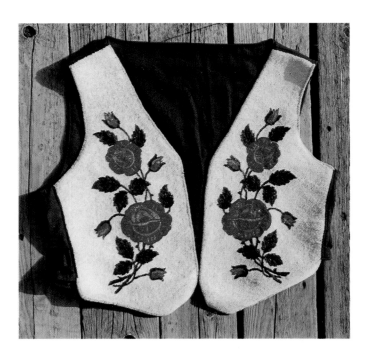
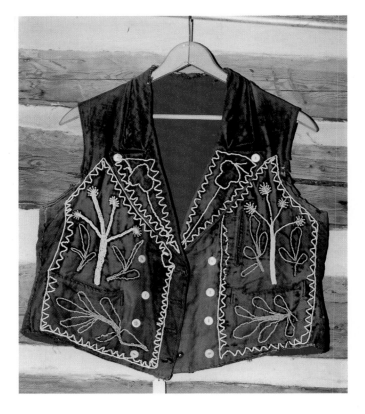

FLATHEAD FULLY-BEADED VEST c.1910
All cuts and tri-cuts. 13° white cut bead bkgrd. with pale blue cut
rolled edge. Tri-cut size 12° roses and buds: t. red, pale t. yellow, pale t.
orange, and t. pink. Leaves and stems: t. lt. green and t. forest green.
Front panels have original calico plaid lining. Back is new addition of
denim (double layered) with tie belt. All in exc. cond. NO beads missing.
20.5" L 9.25" W. front panels. Fits 42" chest. Est. 900-1500 **SOLD
$950(97)**

EARLY PLATEAU VELVET BEADED VEST c.1870
Early stylized designs in white and lt. blue. Front is worn and faded green
velvet (bright green under the collar); back is gabardine. Mother of pearl
buttons. Red wool lining. Obvious store bought vest with Indian
conversions. 42" chest. 22"L. Est. 250-450 **SOLD $210(93)**

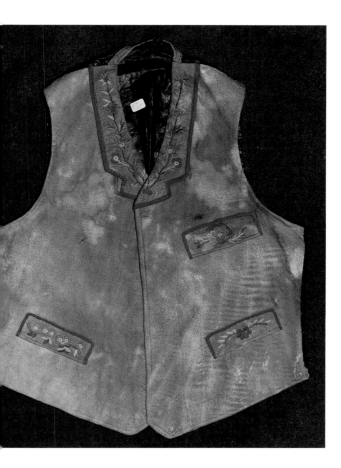

CANADIAN METIS SILK-EMBROIDERED VEST c. 1870
Smoked buckskin with floral motif on flaps and notched collar that are bound with narrow red silk ribbon. Back is black polished cotton with buckled strap. Expertly tailored. Good cond. 20"L X 36" chest. Est. 300-500 **SOLD $200(93)**

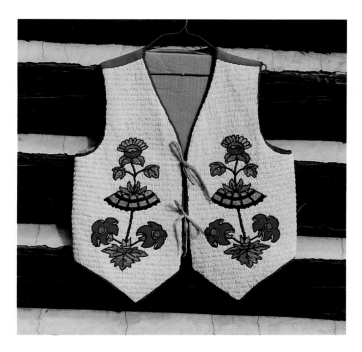

PLATEAU FULLY-BEADED VEST Contemp. Lazy-stitched bkgrd. is white with flowers in tri-cut beads of pink, black, yellow, orange, red and green. Back is made of smoked buckskin lined with rust colored silk and bound with maroon ribbon. 40" chest X 22"L. Exc cond. Est. 960-1200 **SOLD $960(96)**

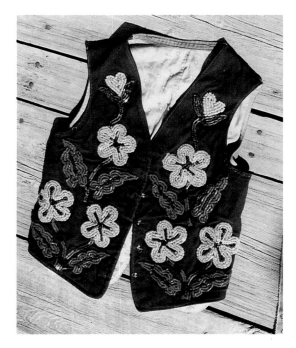

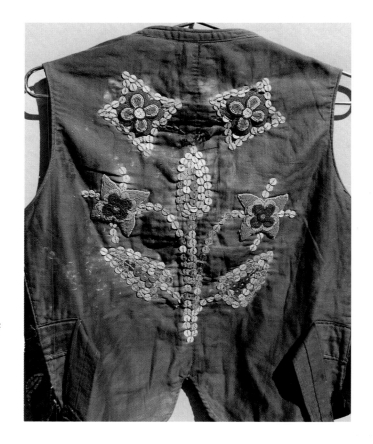

PLATEAU PARTIALLY-BEADED TRADE CLOTH VEST c.1900
Very unusual piece. Navy wool front in all basket bead stylized floral motif: t. orange, satin pink, cobalt, t. emerald and t. dk. green. Back is faded purple chintz with large metal sequin design (some brass; most are silver with remnants of green). The 4 floral sections are tiny cut beads(some as small as size 18) over heavy wool (raised 3-d look). Red white heart, t. rose. Chey. pink, lt. blue,etc. Lining 2 different color calicos which suggests that it is hand-made and not the usual store bought vest. 33" chest. Apx. 19"L. Est. 600-950 **SOLD $650(96)**

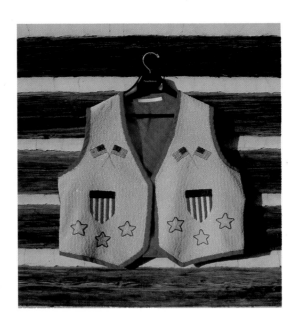

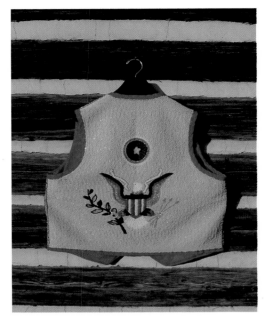

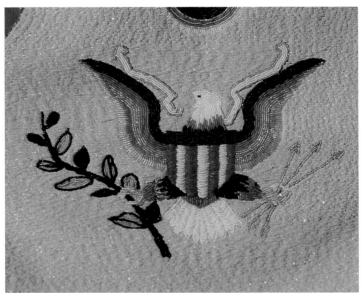

CHIPPEWA FULLY-BEADED VEST Contemp.
Made by Sue Shegonee, Chippewa from Wisc. Lt.blue Japanese cut bead
bkgrd. (apx. size 11 and 12) in patriotic designs. FRONT: crossed flags in
t.red, cobalt and pearl white with stars in t. yellow with cobalt outline.
BACK: elaborate eagle holding olive branch and arrows with snake in t.
golds, browns, and t. greens. (See detail). Lined and bound in red satin.
17.5" across shoulders. 51" chest. 26" length. Est. 1500-1850 **SOLD**
$1500(96)

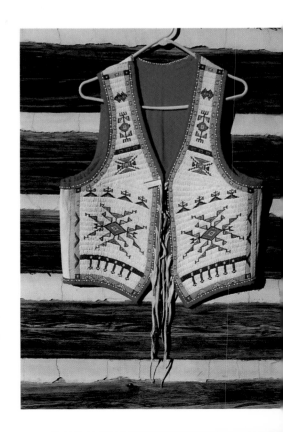

SIOUX FULLY-BEADED VEST Contemp. *Made by Douglas Fast Horse from So.
Dak.* Apx. size 10 beads. Lazy-stitched in classic Sioux geometric
patterns. White with lt. blue border, t. cobalt, red, t. red, t.yellow, yellow
and Sioux green. Cream-tone commercial leather back lined in red felt
forming binding on front. Buckskin ties. 23"L x 42" chest. Exc. cond. Est.
750-950 **SOLD $1100(96)**

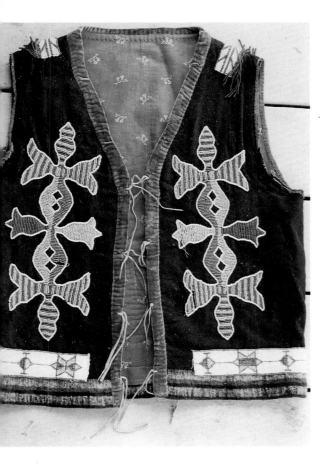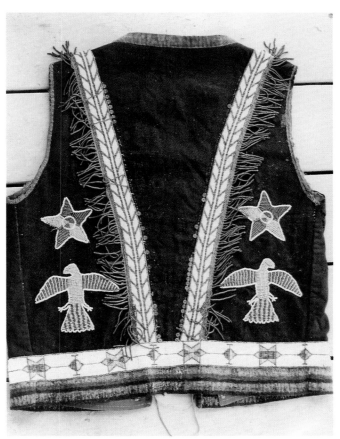

PRAIRIE PARTIALLY-BEADED TRADE WOOL VEST c.1890
Possibly Ponca with Santee Sioux influence. Early mohair rainbow selvedge navy cloth. Characteristic Prairie bi-lateral symmetrical abstract curvilinear motifs in t. rose, gr. yellow, gr. blue, gr. green, and pale blue all outlined in single line of white. (Star form and striped fill-in are Santee style.) Loom-woven strips along hem and diagonally placed on back;bordered on back with brass sequins and metallic fringe. Rose and white calico lined. Neck and front bound with gold silk velvet. Front buckskin tie thongs. Armhole binding is raveled;some brass sequins missing. Exc. cond. Est. 2000-5000

See Johnson, Mike "Part 2. Floral Beadwork in North America", *American Indian Crafts and Culture*, Vol. 7 #9, Tulsa, Nov. 1973: 3-5.

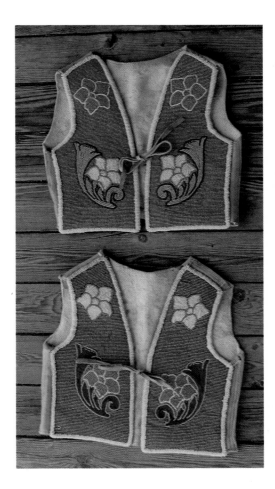

KOOTENAI CHILDREN'S VESTS c.1980
Fully-beaded applique-stitched fronts;blue bkgrd. with pink and rose floral design (Each slightly different). Made for twin 2 yr. old boys. Est. 250-475
SOLD$175(86)

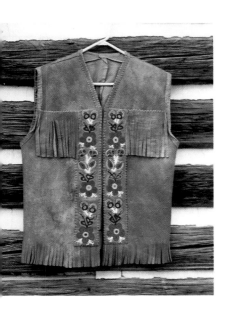

CANADIAN CREE FLORAL BEADED MOOSE HIDE VEST
Purchased from Cree Indians c. 1970. Beaded panels are old style Cree flower designs in many colors of seed beads: Red, lt. blue, trans. dk. blue, orange, yellow, lt. green, trans. dk. green, white, etc. Cloth lined. Large size (40-44) Exc. cond. Est. 350-700
SOLD $450(95)

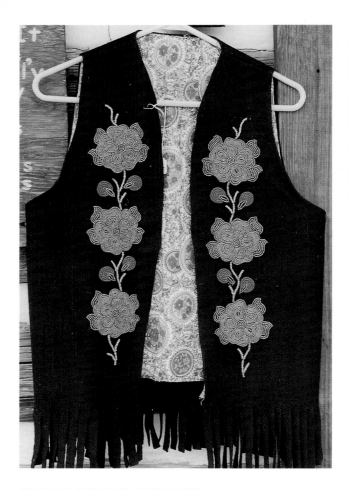

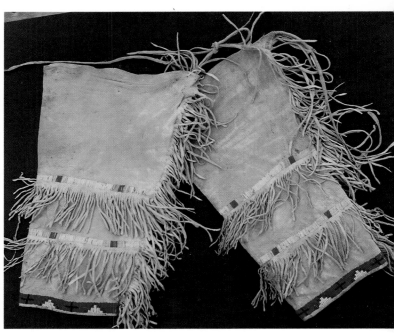

SIOUX WOMAN'S PARTIALLY-QUILLED BUCKSKIN LEGGINGS c.1875
Unusual. Two (1/2" W) strips of simple band sewn quills in pale green
with red and yellow stripes. Bottom hem has 5/8" lazy-stitch beadwork
strip in trans. red bkgrd. with white and dk. gr. blue cross and mountain
motifs. Buckskin fringes on sides (6"L) and below quill work (3"L). 15"L.
Insect damage to 25% quills on 1 side. Est. 875-1,200 **SOLD $925 (94)**

CANADIAN CREE FLORAL BEADED VEST c.1970
Heavy felt navy wool with silver-lined pink, green, clear, and opaque red
on front only. Calico-lined. 38" chest;27" L incl. 4" fringe. Never worn.
Exc. cond. Est. 150/200 **SOLD $150(94)**

Leggings

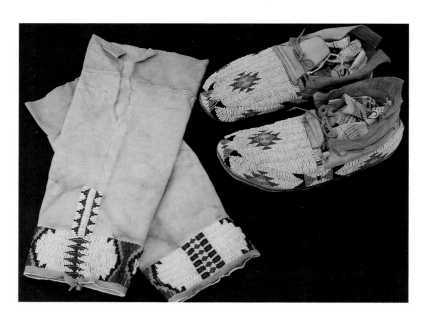

Left to right: CHEYENNE WOMAN'S BEADED
LEGGINGS c.1890
All sinew-sewn on heavy supple buckskin. All
beads are intact. Lazy-stitched white bkgrd. with
trans. red-orange, forest green, trans. yellow, cobalt,
lt. blue and clear in 6 lanes plus 3 vertical lanes
above band. Expertly sewn together with very tiny
stitches. White edge-beaded at bottom. Originally
12" H. Extension in commercial hide (matches
Indian tan) with thread sewn changes size to 14.5".
Est. 350-650 **SOLD $400 (94)**

CHEYENNE WOMAN'S FULLY-BEADED MOCCASINS
c.1915
White lustre (pearl) bead bkgrd. lazy-stitched with
red, periwinkle, black and yellow geometric motifs
on toe and bordering sole. Made of comm. leather
that looks just like brain-tan. Welted soles; heavy
latigo soles. A few white beads missing on heel of 1
from wear. Show use but VG cond. Probably worn
with preceding leggings. 10"L. Est. 400-750 **SOLD
$385 (94)**

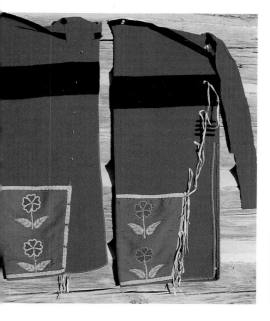
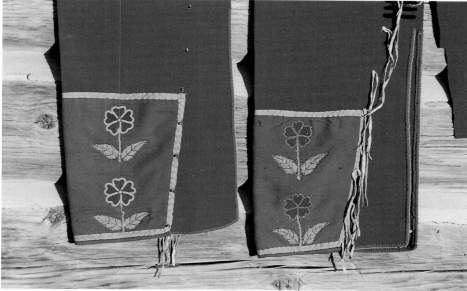

CROW PANEL BLANKET LEGGINGS c.1900
Red 4 point (Pendleton?) blanket with black stripe. Green wool flannel panels decorated with beautiful cut stylized flowers-similar design each side with diff. colors. *I side*; rose white heart, t. yellow, pale periwinkle and turquoise with pink-lined tri-cuts; *Side 2*: Same colors with addition of yellow cuts. Buckskin side thongs with hollow brass beads. Black silk ribbon bound top. Same green wool bound bottom and sides with periwinkle edge-beading all sides and hem. A few tiny moth holes green wool-2" edge-beadwork missing; otherwise, exc. cond. Nice patina. 35.5" X 13.75" W. Est. 750-1200 **SOLD $750(96)**

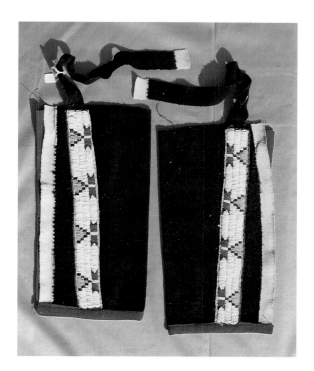

SIOUX CHILD'S TRADE CLOTH LEGGINGS c.1890
3 lane lazy-stitch beaded strips: white bkgrd. with gr. yellow, t. cobalt and gr. red geometric motifs. Edge-beaded in alt. cobalt and gr. red. Navy wool with white selvedge (saved list) bound with red wool on back and hem. Selvedge-ties. 14" H. X 7" W. Exc. cond. Est. 450-650 **SOLD $475(97)**

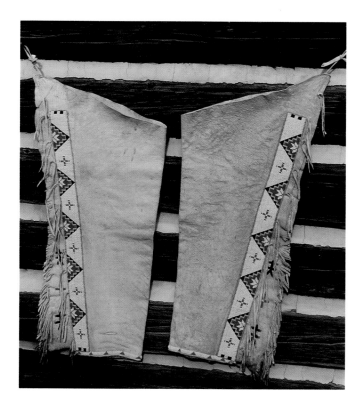

SIOUX BEADED BUCKSKIN MEN'S LEGGINGS c.1930s
Heavy hide probably elk. Lightly smoked. Sinew-sewn lazy-stitched in white ground with Classic triangle and alternating cross designs in trans. cobalt, yellow, turquoise and red. Side flaps have double dragonfly designs in cobalt and red with red cross. Bottom hemmed with single lane white with red triangles all around. Strips are 29"L X 2.5"W. Bottom 9" + 5" fringed flaps. 35"L. Fine wearable cond. Est. 875-1500 **SOLD $1100(95)**

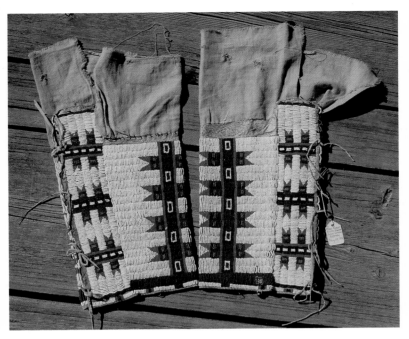

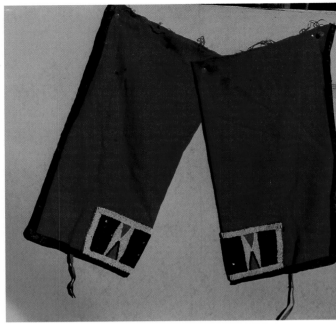

SIOUX WOMEN'S LEGGINGS c.1890
Pine Ridge, So. Dak. Traded from Paul Dyke in 1971. Lazy-stitched and sinew-sewn. White bkgrd. with gr. green, red, cobalt and turquoise Classic geometric design elements. Canvas-top. Leather thong ties. Beadwork all intact. Good cond. 12" H. X 7" W. Est.1750-2500 **SOLD $1200(93)**

SALISH TRADEWOOL CHILD'S LEGGINGS c. 1920
Belonged to Molly Big Sam, Flathead Res. Red twill w/purple silk ribbon binding. Panels are black velvet w/metallic sequin trim & beadwork pred. white w/red & blue triangles. Has a few stains & tears. Buckskin ties. 17" x 9". Est. 95/200(96) **SOLD $70(96)**

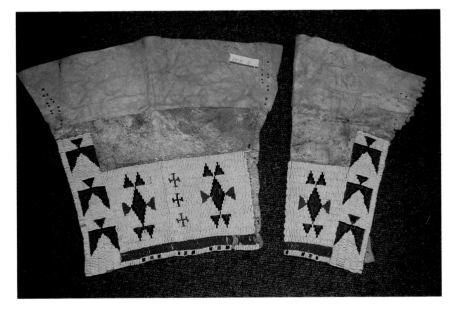

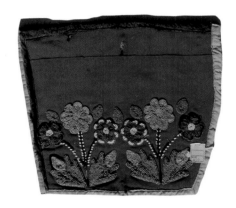

PLATEAU WOMEN'S LEGGING c.1890
Possibly Nez Perce. Floral beaded on red trade cloth with blue and yellow ribbon binding. Partially-beaded in t. lt. green, lt. blue, opaque lt. green, buckskin, t. brown, gr. yellow, cobalt blue, and white. A few loose beads. 11" X 12". Est. 150-250 **SOLD $175(95)**

SIOUX FULLY-BEADED WOMEN'S LEGGINGS c. 1870
White bkgrd. with rose white heart, t. cobalt, rich med. yellow-green and tiny brass facets in Classic diamond and triangle motifs. One solid row nr. bottom of yellow-green beads. Lazy-stitch and sinew-sewn. Exc. patina-supple buckskin. Very few beads missing. Exc. cond. 13"H. X 9.75" X 15.5". Est. 750-1500 **SOLD $950 (95)**

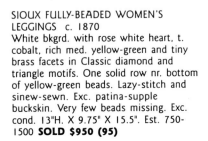

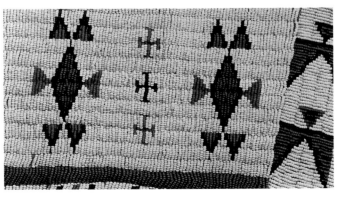

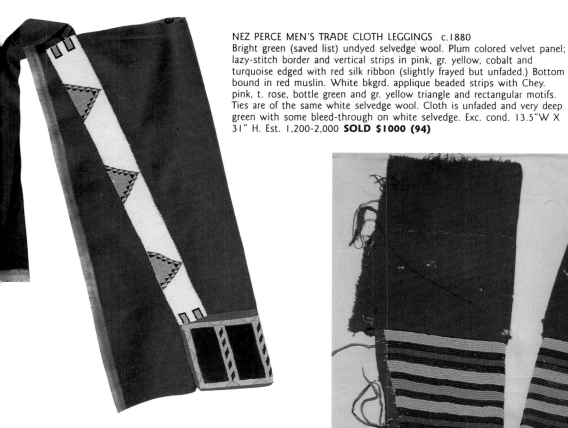

NEZ PERCE MEN'S TRADE CLOTH LEGGINGS c.1880
Bright green (saved list) undyed selvedge wool. Plum colored velvet panel; lazy-stitch border and vertical strips in pink, gr. yellow, cobalt and turquoise edged with red silk ribbon (slightly frayed but unfaded.) Bottom bound in red muslin. White bkgrd. applique beaded strips with Chey. pink, t. rose, bottle green and gr. yellow triangle and rectangular motifs. Ties are of the same white selvedge wool. Cloth is unfaded and very deep green with some bleed-through on white selvedge. Exc. cond. 13.5"W X 31" H. Est. 1,200-2,000 **SOLD $1000 (94)**

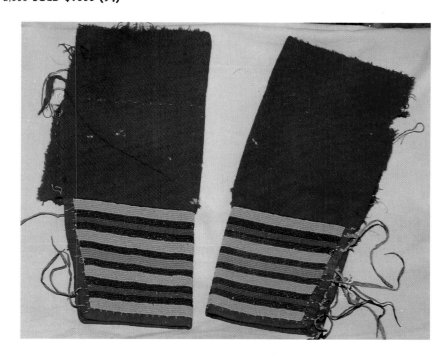

NEZ PERCE MEN'S BEADED PANEL BLANKET LEGGINGS c.1910
Belonged to the daughter of Jackson Sundown. Red wool with black stripe bound with purple rayon all-around. Panel is lt. blue, apple green cuts, trans purple cuts, and gr. yellow. Shows wear. VG shape. 28"L X 16 W with ties. Est. 300/500 **SOLD $250(90)**

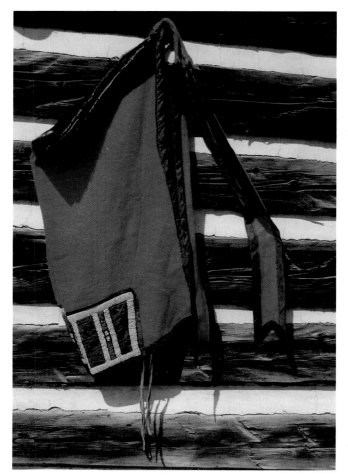

BLACKFEET WOMEN'S LEGGINGS c.1880
Striped beaded panels are lt. blue, cobalt, red white heart and apple green. Red twill wool trade cloth tops. Canvas backed. Numerous tiny moth holes-otherwise; exc. cond. Buckskin side ties. 13.5" X 12". Est.350/675 **SOLD $350(92)**

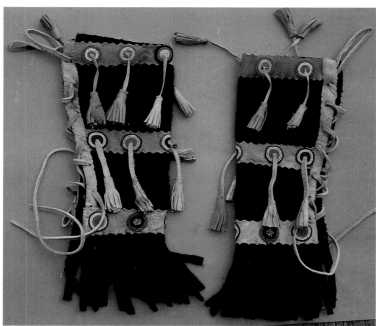

NO. ATHABASCAN BLUE DUFFLE LEGGINGS c.1975
Smoked moose hide bands with colorful beaded rosettes. The top 2 rows have 5" moose hide tassel dangles. Very heavy wool fringed on bottom. Moose hide lacing on sides. 17"L incl. fringe. Est. 150-300 **SOLD $150(95)**

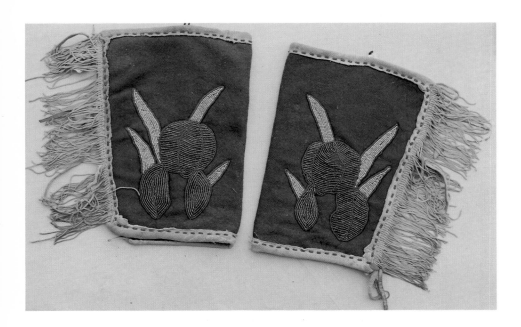

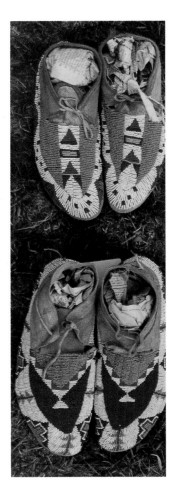

YAKIMA PARTIALLY-BEADED WOOL LEGGINGS c.1960
Bright Kelly green wool felt with iris floral motif in amethyst, trans. orange outlined with green tri-cut leaves. Buckskin bound and sewn with red trans. beads. Yellow chainette fringe both sides. Blue calico lined. Attractive color combo. Exc. cond. 11" H. Est. 150-300 **SOLD $150(95)**

Footware

Moccasins

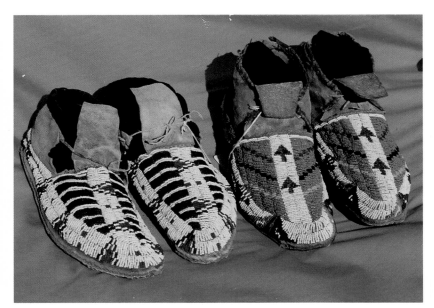

Top to bottom: SIOUX FULLY-BEADED MOCCASINS c. 1890
Pred. white with lt. blue, gr. yellow, white lined rose, Sioux green and dk. blue beads. Cuffs are bound with red cotton cloth. Rawhide soles. Apx. 9.5"L. Exc. cond. Est. 1000-1800 **SOLD $1000(94)**
SIMILAR. White bkgrd. with dk. opaque blue, white lined rose, and Sioux green beads. 10.5"L. Ex c. cond. Est. 1200-2000 **SOLD $1200(94)**

SIOUX FULLY-BEADED MOCCASINS c.1870
Lazy-stitched and sinew-sewn. White bkgrd. with dk. blue, white lined rose, brass facets, apple green, gr.blue, t. rose, and gr. sky blue. Cuff is bound with maroon printed calico. Rawhide soles. Beaded tongue has alt. white and white lined rose stripes trimmed with tin cones and red feather fluffs (missing cones on 1). 11.5" L. Exc. cond. Est. 800/1500 **SOLD $1100(92)**

Left to right: SIOUX FULLY-BEADED MOCCASINS c.1880
Pred. white with t. amethyst rectangular blocks and step-triangles also in t. red and t. lt. green. Unusual color combination. Sinew-sewn. Black silk velvet binding (worn) on cuffs. Heavy rawhide soles show wear and age. 1/2" white beads missing on heel back; otherwise, all beads intact. Good patina. VG cond. 10.75" L. Est. 1000-1500 **SOLD $1450(95)**
SIOUX FULLY-BEADED MOCCASINS c.1890
Sioux green with white, transl. Pony trader blue, t. cobalt, gr. yellow, black, t. yellow. Central white strip has t. blue and brass facets arrow motif. Sinew-sewn. Cuff bound with blue and white calico print. Good dark patina. Rawhide soles show use. 1" seam open on heel back. VG cond. 10" L. Est. 1500-2000 **SOLD $1150(95)**

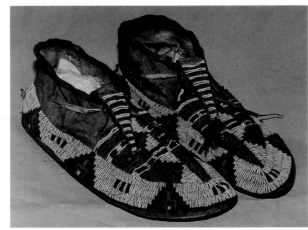

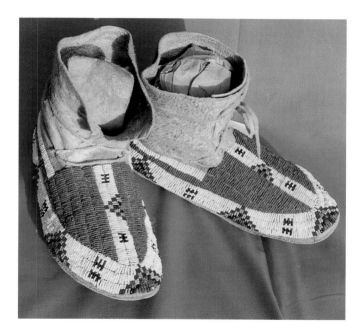

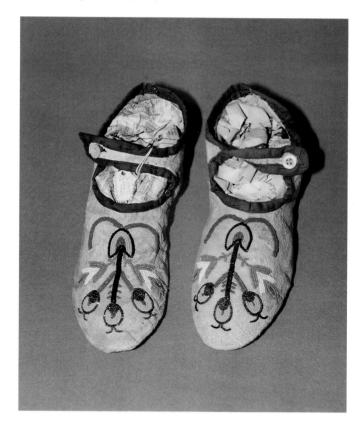

SIOUX FULLY-BEADED MOCCASINS c.1870
Lazy-stitched and sinew-sewn. White bkgrd. with dk. blue, white lined rose, brass facets, apple green, gr.blue, t. rose, and gr. sky blue. Cuff is bound with maroon printed calico. Rawhide soles. Beaded tongue has alt. white and white lined rose stripes trimmed with tin cones and red feather fluffs (missing cones on 1). 11.5" L. Exc. cond. Est. 800/1500 **SOLD $1100(92)**

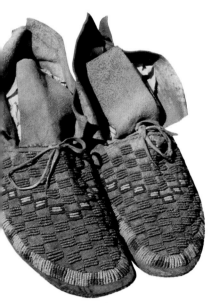

SIOUX PARTIALLY BEADED SLIPPER STYLE MOCCASINS c.1875
Buffalo rawhide soles. Delicate floral pattern (abstract) in pastel hues: periwinkle, gr. blue, gr. yellow, and red white heart. Cuts: amethyst, rose white heart, and tiny size 16° bottle green. Fashioned like ballet slippers with purple muslin bound ankle straps with pearl buttons. Although labelled "Sioux" variations of this triple floral design are more often found on Blackfeet and Cree mocassins. Show age but no wear. Pristine cond. 9"L. Est. 500-800 **SOLD $425(94)**

SIOUX PARTIALLY-BEADED MOCCASINS c.1890. "Checkerboard" design in Sioux (periwinkle)blue, milky white and white center red. Lazy-stitch border in pred. milky white along sole and heel seam. 10.5" L Est. 500-800 **SOLD $350(88)**

Left to right: SIOUX FULLY-BEADED MINIATURE MOCCASINS c.1890 *RARE* Periwinkle, cobalt, red and Sioux green checkerboard pattern. Tiny size 3"L. Accession # penned on sole. Exc. patina and condition. Est. 250-450 **SOLD $275(97)**
ARAPAHO FULLY-BEADED MINIATURE MOCCASINS c.1880 *RARE*. Pred. t. pale rose and cobalt with lime green and garnet. Orange muslin cuff trim. Distinctive shape. Nice patina. Exc. cond. 3.75"L. Est. 250-500 **SOLD $275(97)**

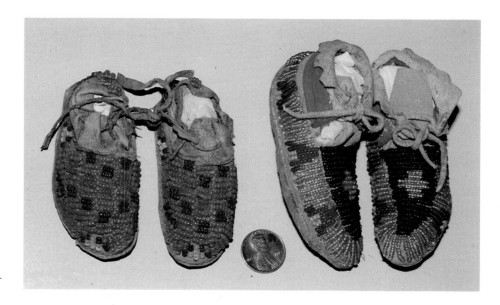

TRIBAL STYLE IDENTIFYING CHEYENNE-ARAPAHO MOCCASINS:

Characteristic high split cuff with sloping profile; single vertical lane on back seam and understated elegance of colors and design elements.

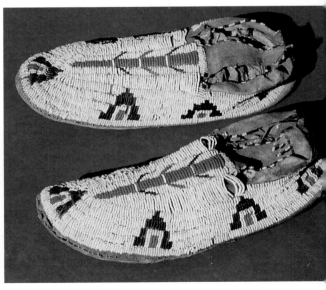

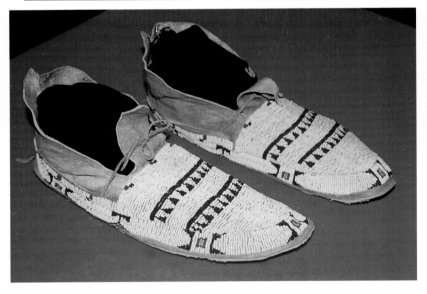

CHEYENNE FULLY-BEADED MOCCASINS
c.1870
Lazy-stitched and sinew-sewn. Pred. white with rose white heart and dk. cobalt in triangle and central tapering stripe. Tongues edge-beaded in alt. white and gr. green. Beadwork intact. Stiff-not flexible. Rawhide soles stiff but intact. 10"L. Est. 800-1250 **SOLD $1100(96)**

CHEYENNE-ARAPAHO FULLY-BEADED MOCCASINS c.1870
Pred. white with dk. blue double stripe and tiny triangles across toe. Border has rose white heart outlines, gr. yellow rectangles and rose white heart elements along upper border. Lazy-stitched and sinew-sewn. Light overall exc. patina and cond. Rawhide soles show light use. Unusually large size-11.5"L. Est. 1800-2500 **SOLD $2000(95)**

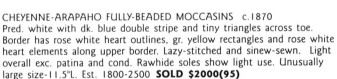

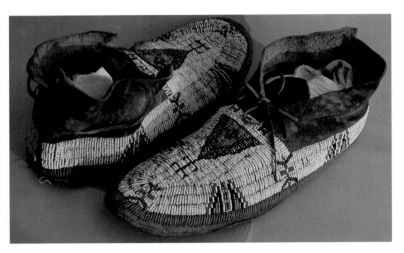

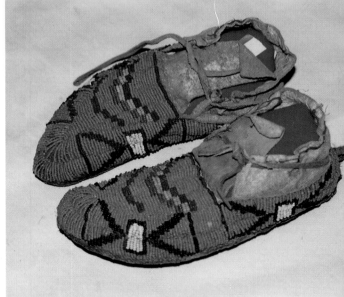

CHEYENNE-ARAPAHO FULLY-BEADED MOCCASINS c.1880
Sinew-sewn. Lazy-stitched white bkgrd. with transl. robin's egg blue, Cheyenne pink, white heart red, black, cobalt and silver metallic facets on smoked brain tan. Partial hair-on rawhide soles. Exc. cond. 11" L. Est. 650/975 **SOLD $850(92)**

ARAPAHO(?) FULLY-BEADED CHILD'S MOCCASINS c.1880
Gr. green (Arapaho green) lazy-stitch bkgrd. with step chevron in rose white heart, gr. yellow, and cobalt. Hour glass motifs along sides are white and deep cobalt. Interesting construction: toes curve inward. Rawhide soles appear to be buffalo. 1 sole has 3 holes from wear. VG cond. Sinew-sewn. 6.5" L. Est. 650-975 **SOLD $610(95)**

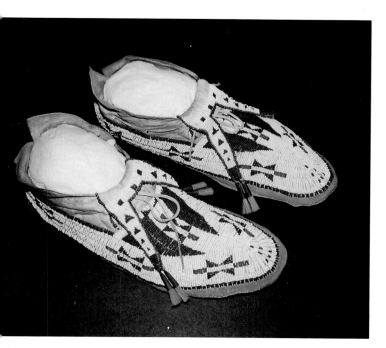

CHEYENNE FULLY-BEADED MOCCASINS c.1915
Classic style and beadwork designs. Sinew-sewn and lazy-stitched. Pred.
white with typical geometric motifs in red, and t. blue. Split tongue same
colors; edge-beaded with tin cone and yellow horsehair appendages. 1/2"
buckskin space between the sole and the beadwork is yellow-ochre, also
tongue edges. Rawhide soles and upper buckskin show patina of age.
Exc. cond. 11.5"L. Est. 1000-1500 **SOLD $1150(96)**

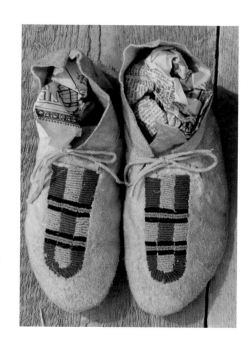

CHEYENNE PARTIALLY-BEADED MOCCASINS. c. 1890
Sinew sewn with rawhide soles. Old-time design in gr. yellow, white lined
rose, lt. blue, black and t. med. blue. Apx. 8"L. Exc. cond. Est. 400-800
SOLD $450(94)

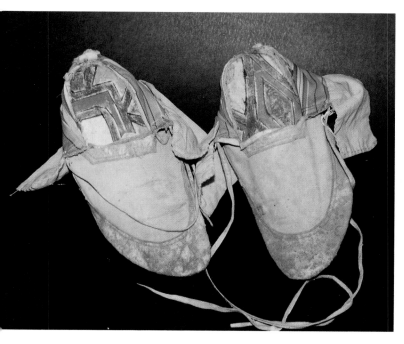

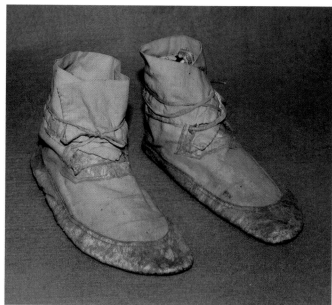

CHEYENNE BUCKSKIN and MUSLIN MOCCASINS c.1890
Unadorned uppers are machine sewn buckskin border onto muslin uppers and
cuffs; striped calico lining. (Usually this style is fully-beaded with cloth
hidden). Buckskin tie thongs. Rawhide soles reveal fancy painted
parfleches interior. Exc. cond. Est. 150-500 **SOLD $182(97)**

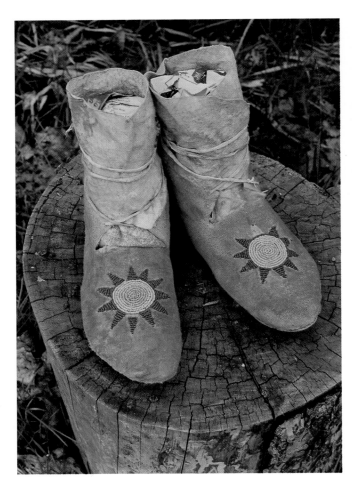

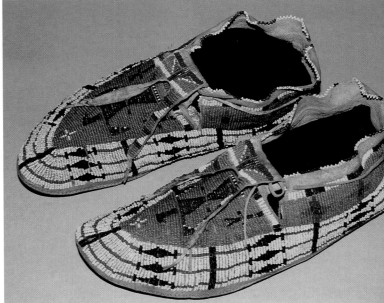

CHEYENNE RED-OCHRE ANKLE WRAP MOCCASINS c.1870 Partially beaded rosette in Chey. pink and Sioux green. Rawhide soles are painted parfleche on inside. Exc. shape. Est. 400-750 **SOLD $475(93)**

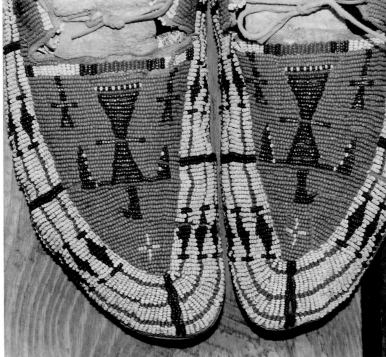

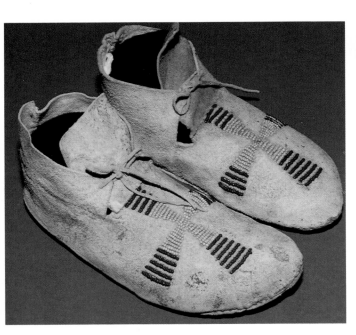

CHEYENNE(?) FULLY-BEADED MOCCASINS c.1880 RARE. Unusually lavish. Traditional large thunderbird pictographic motifs prominently displayed on vamp in silver and brass faceted beads with rose white heart, deep t. cobalt, and apple green bkgrd. with morning star motifs around fully-beaded cuffs. Triple band of rose white hearts with dk. cobalt and metallic diamonds on white bkgrd. Forked tongue fully-beaded same colors. Remnants of red quill wrap on tongue (tin cones missing). Show wear. Rawhide soles. A few edge-beads and scattered beads missing; otherwise, exc. unrestored cond. 10.5"L. Est. 2000-4500 **SOLD $2900(96)**

CROW CHILD'S PARTIALLY-BEADED MOCCASINS c.1880 Large cross motif has Crow pink center with alternating stripes in cobalt and gr. yellow. Sinew-sewn. Good patina. Rawhide soles. 7.75" L. Est. 350-600 **SOLD $376(94)**

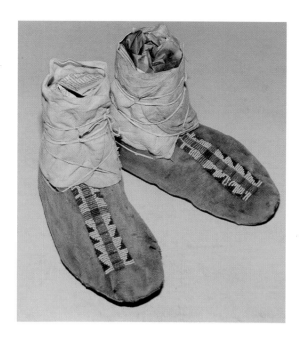

CROW PARTIALLY-BEADED MOCCASINS
c.1890
Rectangular panel beaded in beautiful pastel tones-pale blue, rose white heart, pale pink, t. gold and t. green. Muslin ankle wraps. Sinew-sewn. Rawhide soles. 9.25"L X 7.5"H. Est.350/650 **SOLD $275(91)**

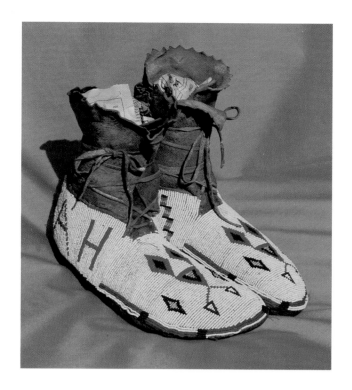

KUTENAI FULLY-BEADED ANKLE WRAP MOCCASINS c. 1890
Striking design: White bkgrd. with red white heart, Chey. pink, t. dk. cobalt and gr. yellow diamond and triangular elements. Entirely applique (flat) stitched. T. red and white lines alternating border. Side has letters "A.H" on outside in red white hearts; inside has step-rectangles in 3 colors. Very dk smoked hide. Soft-soles show light use. I small hole nr. heel from wear. Est. 900-1800 **SOLD $950(95)**

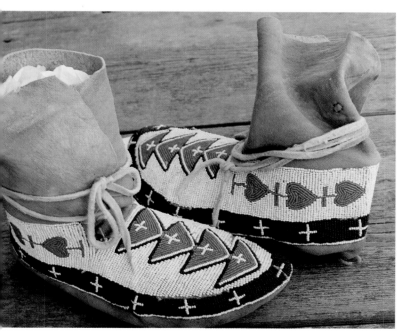

KUTENAI (?) FULLY-BEADED ANKLE WRAP MOCCASINS c.1900
Applique-stitched white bkgrd. with lined rose and black designs. Apx. 9.5"L. Exc. Cond. Est. 1200-2000 **SOLD $1500(95)**

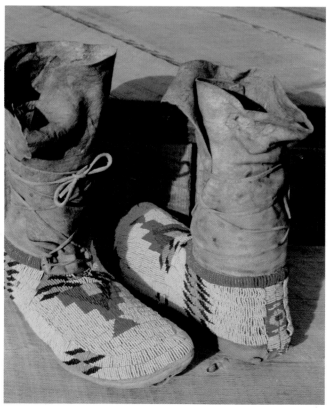

KUTENAI (?) FULLY-BEADED MOCCASINS with high ankle wraps. *The colors of red and orange indicate a 20th c. origin (See Bead Glossary).* Lazy-stitched with lt. blue bkgrd. and geometric design in gr. red, t. green, gr. yellow and orange cut beads. Est.600-1000 **SOLD $600(94)**

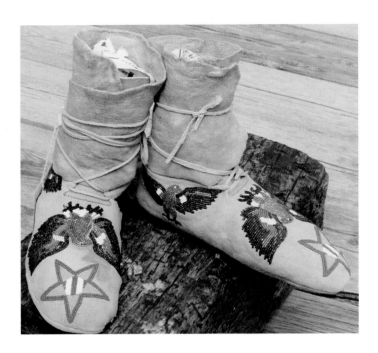

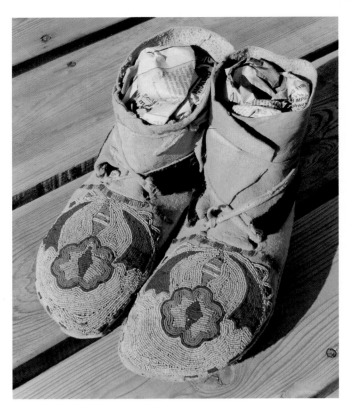

NEZ PERCE PARTIALLY-BEADED MOCCASINS c.1910
Belonged to daughter of Jackson Sundown, famous rodeo bronco rider. Eagle motif in gold and iris tri-cuts;star in orange,yellow and white. 8.5" H. X 10" L. Est. 250/350 **SOLD $250 (90)**

PLATEAU BUCKSKIN ANKLE WRAP MOCCASINS c.1900.
Fully-beaded toe design. Early abstract floral motif-lt. blue bkgrd. in contour beaded pattern with lt. green, t. red, navy blue and Cheyenne pink size 13° cut beads. Dk. blue trade wool cuffs. Apx. 9.5"L. Exc. cond. Est. 800-1200 **SOLD $900(93)**

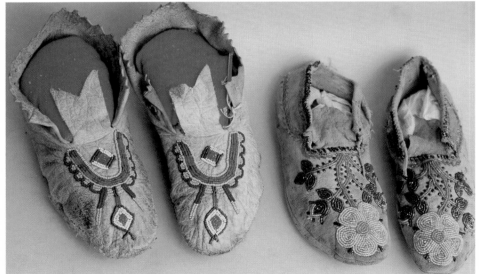

FLATHEAD PLAIN ANKLE WRAP MOCCASINS c.1910
Belonged to famous Louie Ninepipe, one of the last full-blood Flatheads living on the Res, who was born in the Bitterroots. Obtained at his give-away in 1975. RARE DOCUMENTED PAIR.* These are a pr. of "everyday" mocs. Exc. cond. 10.5"L 7.5"H Est. 300-500 **SOLD $375(97)**
*For complete biography and 2 photos of Louie, see Hungry Wolf, Adolph and Beverly, *Indian Tribes of the Northern Rockies* Summertown, Good Medicine Books, 1989:113-115.

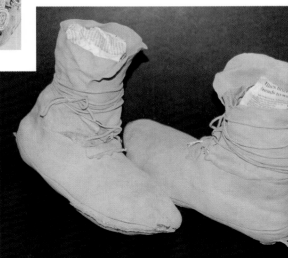

Left to right: BLACKFOOT PARTIALLY-BEADED MOCCASINS c.1900
Classic U-shaped design with 3 prongs said to represent the 3 divisions of the Blackfoot Confederacy; exclusive to the Blackfoot tribes*. Multi-colored beadwork in: cobalt, gr. blue, gr. yellow, red white heart, etc. Pinked cuffs. Heavy hide possibly elk. Soft soles show wear. Good cond. 10"L. Est. 435-650 **SOLD $375(95)**
*Hungry Wolf, Adolf and Beverly, *Blackfoot Craft worker's Book*, Skookumchuck, Good Medicine, (1977):7.
PLATEAU FLORAL BEADED MOCCASINS c.1920
Appliqued tri-cuts in pale pink wild rose and two color green leaf pattern; cuffs bordered in bronze iris, clear and soft orange. Half the beads missing on the cuff but only a few are missing on toe. Worn holes on cuff backs and patina of use. 9"L. Est. 190-250 **SOLD $225(95)**

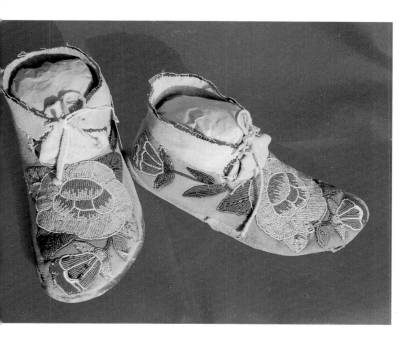

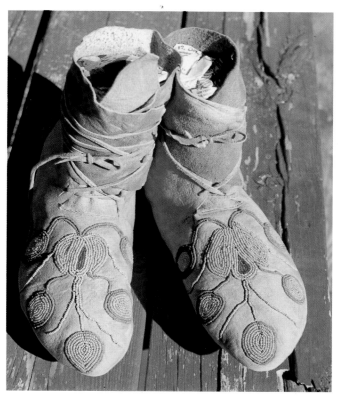

NEZ PERCE FLORAL BEADED MOCCASINS c.1875
Lovely 3-flower motif completely covers top and sides. **All cut beads**
in pale pink crystal, pink, gr. blue, rose, t. gold outlined in pale blue.
Several shades of green cuts for leaves. Cuffs are edge-beaded in green and
red tri-cuts. Soles are well-worn through on right foot. A few beads
missing here and there; otherwise, good cond. 9.5"L. Est. 800-1,200
SOLD $950(94)

SO. PLAINS WOMAN'S MOCCASIN BOOTS c. 1880. COMANCHE ?
Yellow ochre buckskin with red ochre on button flap. German Silver
domed buttons. Sinew-sewn. Hard-soles. Pred. white lazy-stitched design
with tiny cuts in white lined rose, gr. yellow, lt. blue and cobalt design
motif. Metallic bead edging. Rawhide soles are 10" L. and narrow-apx. 23"
H. Est. 1200-2000 **SOLD $1300(87)**

FLATHEAD PARTIALLY-BEADED MOCCA-
SINS c.1890
Lovely shades of pink, lt. blue, apple
green and t. rose in a typical Flathead
stylized floral pattern. Soft-sole. Buckskin
is supple. Exc. cond. Apx. 10"L. Est.275/
395 **SOLD $325(91)**

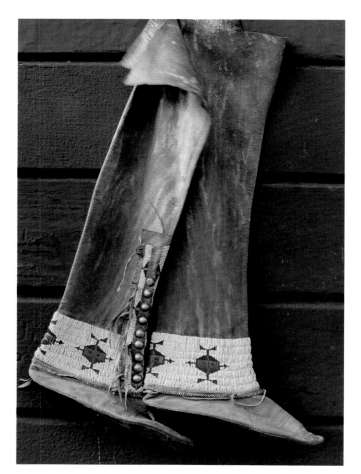

SO. PLAINS GIRL'S
MOCCASIN BOOTS
c.1890
Prob. Comanche.
Lightly red ochre
overall with dk. red
ochre button flaps. 7
stamped silver
buttons each side are
3/4" diam. Flaps are
narrowly bordered
with white, t. cobalt,
red white heart, t.
grey-green, and
turquoise triangle and
line patterns which
continues around
ankle and down heel
in back. Rawhide
soles with welting.
Superb cond. 7.5" L.
19" H. Est. 1,875-
2,500 **SOLD
$1500(94)**

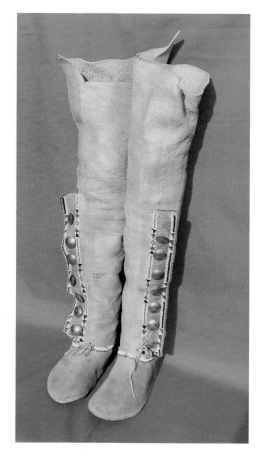

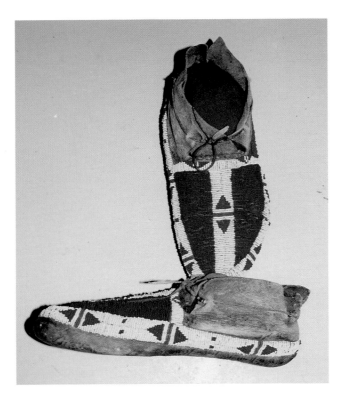

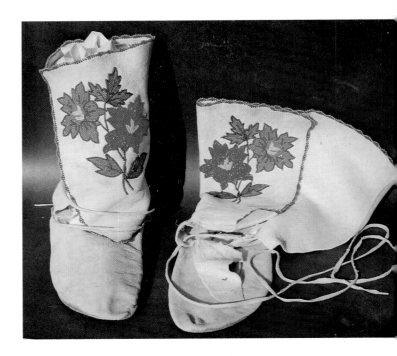

EARLY UTE FULLY-BEADED MOCCASINS c. 1860
RARE. These are an outstanding example of the Classic and hard to find Ute moccasin. Dk. cobalt, white, rose white heart geometric designs. Sinew-sewn on buffalo hide. The buffalo rawhide soles have been shaped so that the sides are turned up, much like Apache mocs, for use in desert terrain. (See side view). This is an identifying characteristic of Ute mocs. Fine cond. Exc. patina. 10"L. Est. 1800-3500 **SOLD $1700(97)**

CROW WOMAN'S HIGH-TOP MOCCASINS c.1950
Purchased from Lammer's in Hardin, Mont. All cut beads in typical Crow diagonal beadwork flowers in red, orange, and 2 shades of t. green. White buckskin edge-beaded in orange and red. Rawhide soles. Shows wear but good cond. 9"L. 9" H. top. Est. 200-350 **SOLD $125(94)**

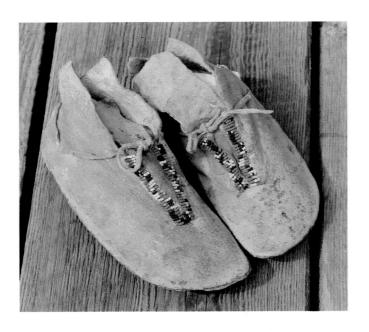

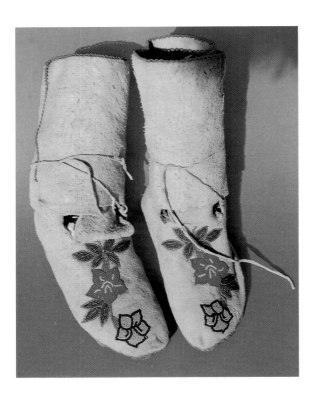

EARLY APACHE (OR UTE) CHILD'S PARTIALLY-BEADED MOCCASINS
c.1860
Sole shape and beadwork suggest Ute. Yellow-ochre buckskin with red ochre v-shape outlined with gr. green, white, black and gr. yellow erratic bead pattern in 2 lanes. Rawhide soles. Good patina and exc. shape. 7"L. Est. 500-800 **SOLD $450(95)**

CROW WOMAN'S PARTIALLY BEADED HIGH TOP MOCCASINS
c. 1960's
Typical lily floral design in all cut beads: Orange, yellow, red and blue flowers. Leaves are t. gold and t. green. Periwinkle edge-beaded top and sides. Hard latigo soles. VG cond. Show slight wear. 6" H., 8.25"L. Est. 175-250 **SOLD $200(95)**

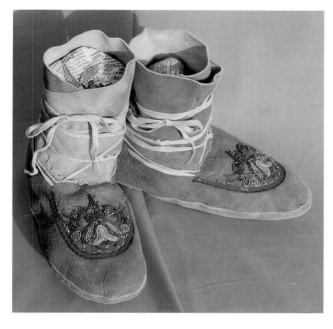

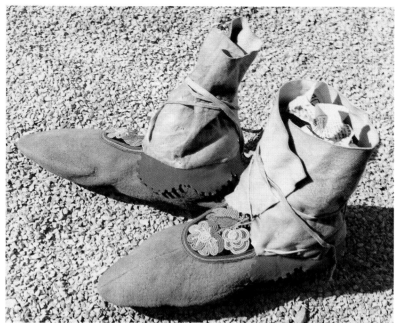

CREE MEN'S PARTIALLY-BEADED ANKLE-WRAP MOCCASINS c.1890
Unusual tri-cut stylized floral pattern in brass facets, red white heart, lime green and varied metallic beads ie;silver, blue etc. Vamp-shape outline in 3 narrow bands (1/4") of wool braid: purple, red and green. Smoked moose hide. Soft-sole. Never worn. 11"L. Exc. cond. Est. 250-500 **SOLD $326(94)**

OJIBWA ANKLE-WRAP MOCCASINS c.1900
Smoked moose with black velvet floral-beaded vamp outlined with 5 rows wrapped horsehair. Red wool cuffs in detailed cut pattern. Caribou ankle-wraps. Never worn. Pristine. Exc. cond. 10" L. Est.500-800 **SOLD $150(88)**

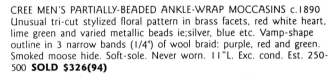

CHIPPEWA PARTIALLY-BEADED MOCCASINS c.1920
Pucker toe with separate vamp bordered in yellow-green and black. Cuff bordered with same colors. Abstract floral yellow-green, black and red outlined with white. Some beads missing from vamp outline only;otherwise intact. Very dark patina of use. 9.75" L. Est. 50-95 **SOLD $95(95)**

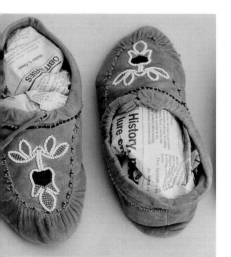

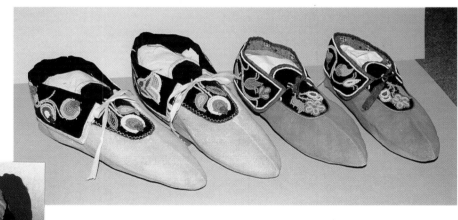

Left to right: CHIPPEWA PARTIALLY-BEADED MOCCASINS c.1900
Beautiful stylized pastel floral motifs on black velvet vamp and cuffs. Bound with pink silk ribbon. Soles show no wear. Slight deterioration on a few spots of silk ribbon; otherwise, perfect cond. 9.5"L. Est. 250-400 **SOLD $250(96)**
CHIPPEWA PARTIALLY-BEADED MOCCASINS c.1890
Stylized floral patterns in subtle pastels on black velvet cuffs and vamp. Blue rayon ribbon edged and calico lined. Silk embroidered vamp edges. Pristine cond. 9.25" L. Est. 313-495 **SOLD $350(96)**

CHIPPEWA PARTIALLY-BEADED MOCCASINS c. 1920
Black velvet vamp and cuffs partially beaded in typical floral design in t. green tri-cuts, Sioux green, t. red, pearl and orange. Red rayon ribbon bound cuffs, vamp and ties. Welted moose hide soft-sole. Slight wear soles and ribbon edges. Exc. cond. 10"L. Est. 125-195 **SOLD $160(96)**

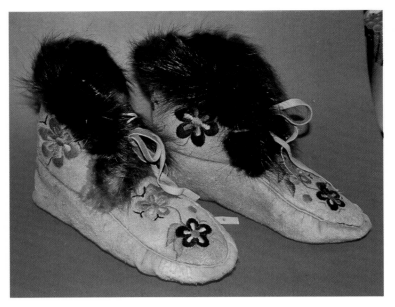

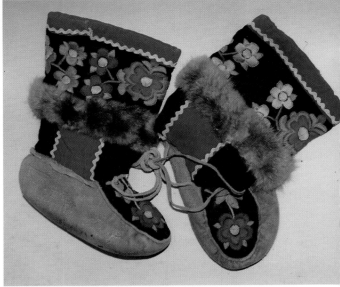

CANADIAN CREE MOOSE HIDE MOCCASINS c.1930
Made by Marie Carter, Metis from Onion Lake Reserve in Saskatchewan. Floral thread embroidery in dk. and lt. blue, red, purple and green. Long beaver fur trim around ankle cuffs. Fine cond. Wearable. 10" L X 7.5" H. Est. 175-400 **SOLD $195(95)**

CANADIAN CREE WOMAN'S FLORAL EMBROIDERED MUKLUKS c.1940
Brightly colored cotton crewel work on black wool and red velvet trimmed moose hide moccasins. White rick-rack trim. Beaver fur trim. Green stain (paint) on left vamp and hide. Stitching loose on right heel. 9.5"L; 12"H. Est.150-250 **SOLD $150(92)**

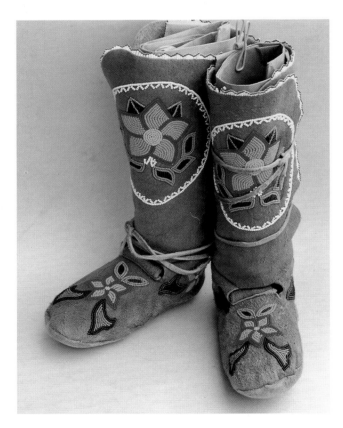

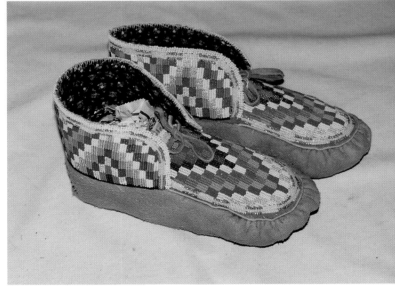

CANADIAN CREE MAN'S MOCCASINS Contemp.
Fully-beaded vamp and cuff flat beaded design in checkerboard chevron in many colors incl., white, salmon, pink, dk. red, etc. Smoked brain-tan moose hide with soft sole and puckered vamp. Cuff is floral calico lined. 11"L X 4"W X 5"H. Est. 200-350

ROCKY BOY-CREE WOMAN'S MOOSE HIDE HIGH-TOPS Contemp.
Partially beaded colorful flowers in yellow-orange, yellow and t. red with 6 shades of green leaves with white circular pattern on tops. Fancy edge-beaded top and sides in white and t. red. Slight wear on soft soles. 10"L X 13.5" H. Exc. cond. Est. 275-400 **SOLD $350(95)**

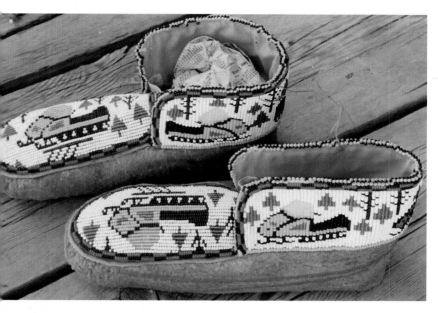

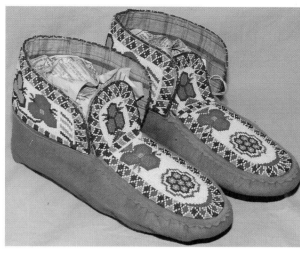

METIS MOOSE HIDE BEADED MOCCASINS c.1950
From Canoe Lake, Saskatchewan, made by Philomene Bouvier. Fully-beaded vamp and cuffs:white bkgrd. with green trees and yellow,brown and black snowmobile design. (This model is now obsolete) Polished cotton lined. I piece soft-sole construction. 9.5"L Exc. cond. Est. 300/600 **SOLD $260(89)**

CANADIAN CREE MOOSE HIDE MOCCA-SINS Contemp.
Fully-beaded vamp, cuffs and tongue; bead size 10° white bkgrd. with colorful blue and red-orange floral pattern. Geometric multi-color border. All beaded portions calico lined. I-piece soft-sole construc-tion. Est.200-350 **SOLD $200(92)**
Contemporary Canadian beadwork is commonly done in a large seed bead size 10°, whereas most contemporary Plateau and Plains beadwork is done in a bead no larger than size 11°. Also see Bead Glossary.

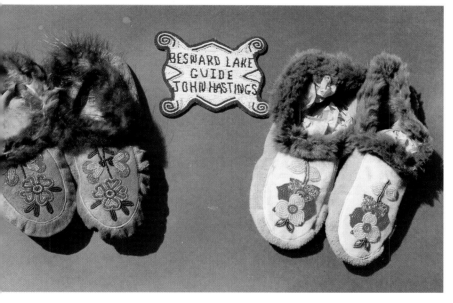

Left to Right: CREE PARTIALLY-BEADED MOOSE HIDE MOCCASINS With BEAVER CUFFS c.1950
Vamp t. rose, pink, red and 2 shades green in characteristic Cree floral pattern.and size 10° beads. A few worn places on fur; otherwise, VG cond. 11"L. Est. 80-175 **SOLD $100(94)**
SIMILAR. c.1950
White wool vamp has shades of trans. pink, green and red in floral pattern. Appear to be unused. Exc. cond. 11". Est. 80-175 **SOLD $100(94)**

LEFT TO RIGHT: The following items are all made of plain (unadorned) buckskin sewn with black thread c. 1890:
CHIPPEWA MITTENS Good cond. 10"L X 4.5" at wrist. Est. 60-110 **SOLD $60(94)**
CHIPPEWA PLAIN BUCKSKIN MOCCA-SINS Heavy elk or moose hide. Vamp outlined with red yarn. Heavily soiled soles. 10.75"L. Est. 60-125 **SOLD $100(94)**
CHIPPEWA ANKLE-WRAP SMOKED MOOSE HIDE MOCCASINS Vamp welted with turquoise wool. Wrap is edge pinked all sides. 9.75"L. 7"H. wrap. Est. 70-150 **SOLD $70(94)**

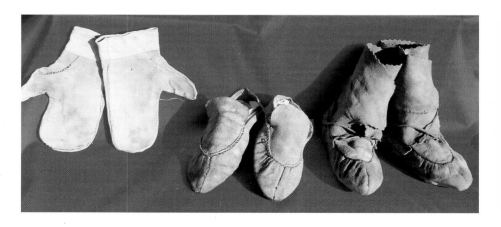

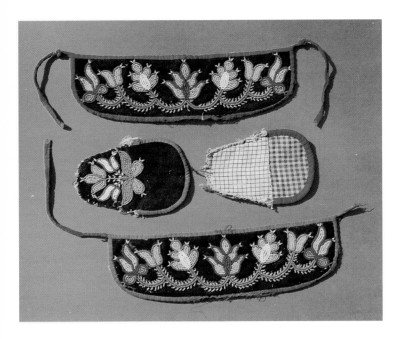

SET OF 4 ATHABASCAN MOCCASIN WOOL UPPERS and CUFFS c.1890
Multi-colored beadwork on navy wool bound with red muslin. Checkered gingham backed. Old stylized floral with gr. blue and white connecting stems. Some of the binding worn through; otherwise exc. cond. Cuffs 10" X 3". Vamps 5" X 3.5". Est. 200-350 **SOLD $210(94)**

See Bead Glossary for definition of **embossed beadwork** *on the following 5 Iroquois moccasins:*

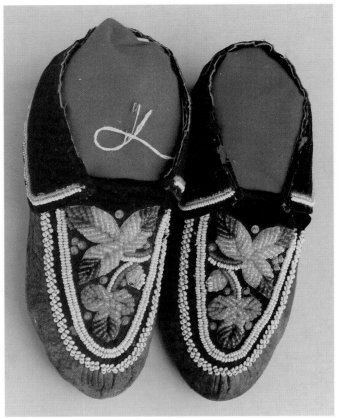

IROQUOIS PARTIALLY-BEADED MOCCASINS c.1870
Black velvet vamps have embossed pony beadwork edged with white ponies. Black velvet cuffs have white and clear pony bead trim. Soft-sole. A few beads missing otherwise good shape. Shows wear. Cuffs 2.5" 10"L. Est.450-575 **SOLD $475(93)**

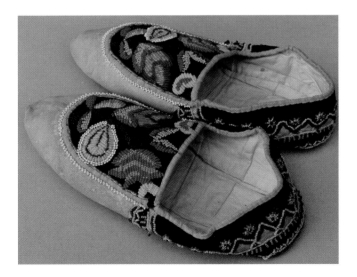

SENECA PARTIALLY-BEADED MOCCASINS c.1840
Black velvet embossed beaded vamps in asymmetric floral;partially-beaded cuffs. Pink silk ribbon bound. Muslin lined. Supple and soft leather;soft sole. Early bead colors. Pristine cond. 9". Est.500-800 **SOLD $550(92)**

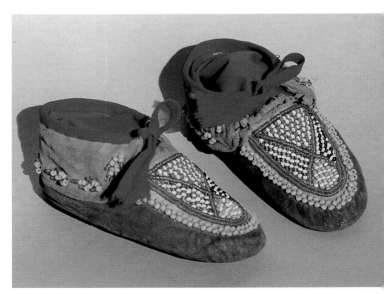

IROQUOIS CHILD'S PARTIALLY-BEADED MOCCASINS c.1870 Smoked moose hide. Gold velvet cuffs (worn nap) and vamp have early style geometric designs in pastel pony beads. Red wool Fox braid binding + ties. All muslin lined. Show minor wear on soles. VG cond. 6.5"L. Est. 180-275 **SOLD $125(96)**

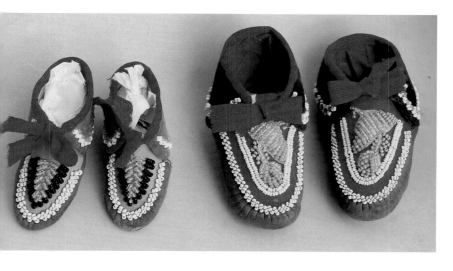

Left to right: IROQUOIS BABY MOCCASINS c.1870
Pink (faded red) cotton vamp embossed beading in t. cobalt and t. ponies outlined in white ponies. Velvet cuff bordered with white and t. ponies bound with red wool Fox braid. Completely muslin lined. Never used. Exc. cond. 4"L. Est. 175-250 **SOLD $225(95)**

IROQUOIS CHILD'S MOCCASINS c.1870
Red cotton vamp outlined in white pony beads with typical embossed motif:robin's egg blue, Cheyenne pink and mustard ponies. Purple velvet cuffs bordered in red wool Fox braid. Completely lined. Intact and original cond. 5.75"L. Est. 180-275 **SOLD $185(95)**

ESKIMO SEALSKIN MUKLUKS c.1860
Geometric applique at top. Apx. 17"H. X 10.5" L. Exc. cond. Est.175/250 **SOLD $125(91)**

Mukluks

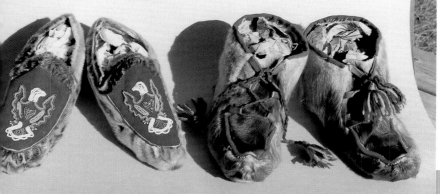

Left to right: TLINGIT SEALSKIN MOCCASINS c.1920
Heavy red wool vamp partially beaded with characteristic eagle motif:gr. yellow, periwinkle, white, lt. green and metallic facets.A few gr. yellow beads missing on 1 moccasin only. Exc. cond., never worn. 10"L. Est. 300-450

SEALSKIN MUKLUKS c.1900?
Heavy leather tabs with braided multi-color wool yarn with tassels. Red wool welted vamp;green wool bound top. Shows wear. Exc. cond. 9.5"L. Est. 125-240 **SOLD $125(97)**

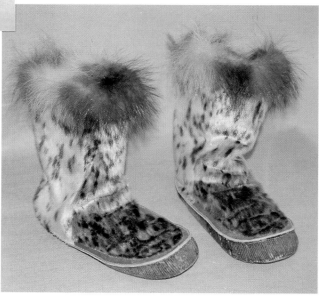

ESKIMO SEALSKIN MUKLUKS Contemp.
Beaver fur cuffs. Back of 1 cuff has 4" of sparse fur; otherwise exc. cond. 12.5"L 12"H. Est. 50-95 **SOLD $35(97)**

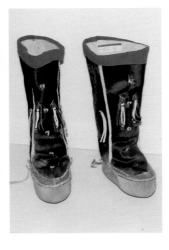

ESKIMO CHILD'S SEALSKIN MUKLUKS
Contemp.
Red cotton cuffs. 2.5" red and white bead loop dangles with fringed sealskin. Never worn-pristine cond. 5.5"L.10"H. Est. 75-150

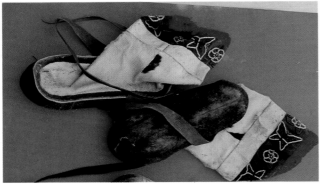

ESKIMO PARTIALLY BEADED SEALSKIN MUKLUKS c. 1930
Moose hide tops beaded in lustre beads in alt. butterfly and floral designs. Wide red felt binding. Wide leather ties. Wearable. Scattered moth holes; otherwise, good cond. 9.88" soles. Est. 85-175 **SOLD $100(95)**

Handgear

Gloves and Gauntlets

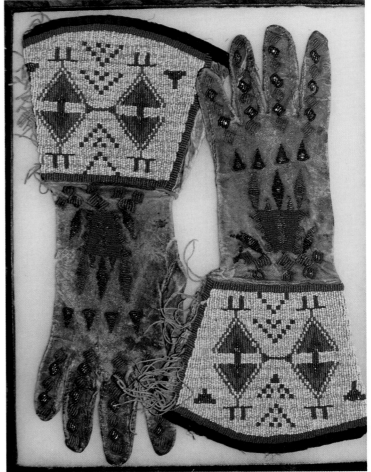

SIOUX BUCKSKIN GLOVES c. 1870.
This is the earliest style of beaded glove and sometimes shows up in collections belonging to U.S. Cavalry soldiers serving at Western forts. Also popular in the early days of the Wild West Shows. Partially beaded with fully-beaded cuffs. Sinew-sewn and lazy-stitched. White bkgrd. with exceptional bead colors: white lined rose/red, Sioux green, t. dk. green, trans. gold, med. blue and metallic facets. Considerable age patina. Exc. cond. Est. 1500-2500 **SOLD $800(91)**

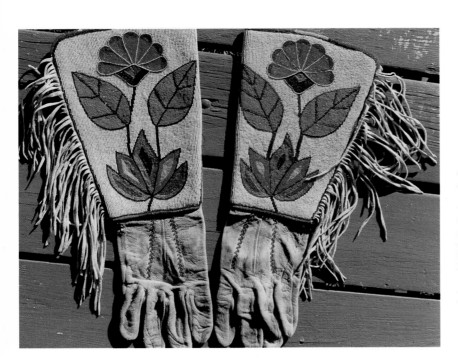

CROW FULLY-BEADED MAN'S GLOVES
c.1880
Pale blue bkgrd. with cut bead stylized floral design in apple green, red white heart, cobalt, pink, t. dk. green, tr. lt. green; t. yellow on cuffs. rose white heart cuts on glove portion. Calico lined. 5" buckskin fringe. 18" L. Beaded panels-10" X 7". Exc. cond. Est. 650/1000 **SOLD $675(90)**
NOTE: *Beaded panels are usually longer on Crow fully-beaded gloves than Plateau style.*

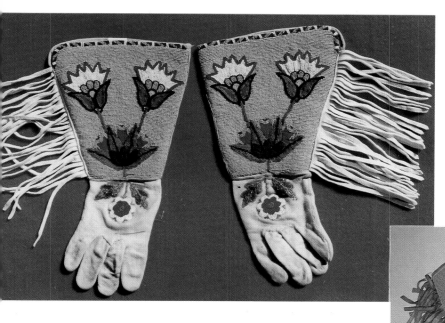

PLATEAU FULLY-BEADED GLOVES c.1880-1900
Cuffs have lt. blue bkgrd. with stylized flowers in white, t. red, Crow pink, and gr. yellow. Leaves are cobalt cuts, pale t. grey-green, and turquoise with t. rose stems. Partially beaded glove has very small white, t. red, clear and amethyst flower. White buckskin gloves have 6" fringe. 15" total L. cuff panel 8.5"L X 8". Exc. cond. Est. 600-1200 **SOLD $1000(94)**

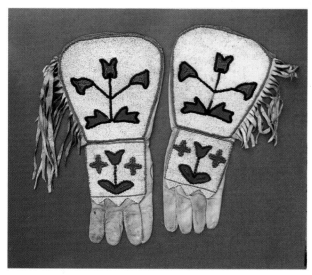

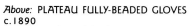
Above: PLATEAU FULLY-BEADED GLOVES c.1890
Lt. blue applique bkgrd. with bilaterally symmetrical stylized floral pattern in: t. rose, gr. yellow, pumpkin, apple green and white outlines and stems in med. blue. Richly smoked buckskin. Welted seams. Fringed. Exceptional pair. Exc. cond. Man's medium size. 17" L X 8" hem. Est. 1250-2000 **SOLD $1600(96)**

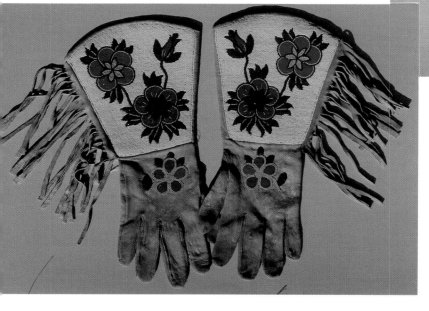

PLATEAU BUCKSKIN GLOVES c.1940
Fully beaded cuffs in floral motif; white bkgrd. with lt. blue and t. cut beads in red, orange and dk. blue. *Clue to age here is the colors of the beads.* See Bead Glossary. Exc. cond. Est. 400-800

CANADIAN BLACKFOOT FULLY-BEADED GLOVES c.1915
Irregular Italian seed beads are applique-stitched with thread. Hand-sewn white Indian-tanned buckskin and lined with old red calico. Unusual to find with the hand part beaded. Large size. 3 small spots where a few beads are missing; otherwise in exc. cond. Nice patina. 16" L X 7.5" W. Est. 800-1600 **SOLD $1000 (95)**

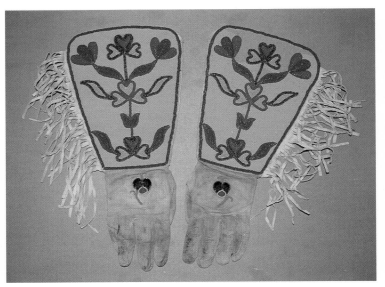

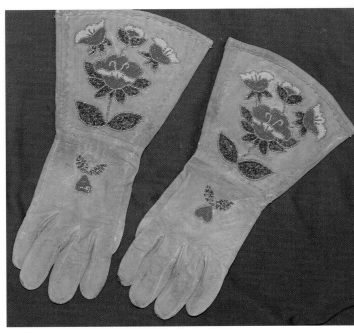

BLACKFEET FULLY-BEADED GLOVES c. 1915
Robin's egg blue Italian 4° applique beaded bkgrd. Stylized bilaterally symmetrical contoured floral pattern in gr. red, gr. green, t. cobalt and Chey. pink bordered in t. cobalt. Small stylized flowers on glove in dk. cobalt, lt. green, t. pumpkin, pink and red. Fringed buckskin. Palms are dark from use. cuff. Nice patina. Exc cond. Small size. 15.5"L. X 7.25" W. Est. 750-1000 **SOLD $650(96)**

PLATEAU BUCKSKIN BEADED GLOVES c.1930
Made by Adelaid Michelle of the Pend d'Oreille tribe (Flathead Res.). Partially beaded in floral designs in gr.yellow, white center red-orange, gr.green and metallic tri-cuts. Lined with an old sugar sack labelled *"Missoula, Montana"*. Shows wear on palm side. Large Man's size; 15" L. Est. 200/ 350 **SOLD $150(89)**

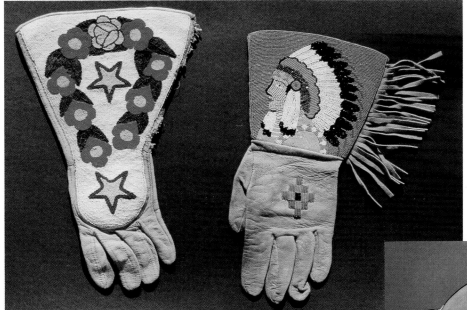

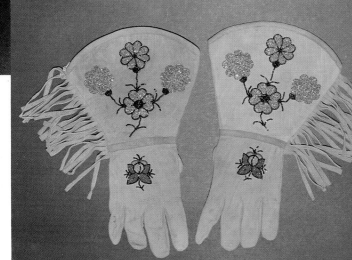

FLATHEAD BUCKSKIN BEADED GLOVES c.1915
Charming iridescent all tri-cut beaded floral pattern in purple, red, pink and blue outlined in black. 4" L. fringe. Flat-felt seams. 2-color calico lined. Man's size. Good construction. Exc. shape. Est. 225-325. **SOLD $175(91)**

Left to right: BLACKFOOT (BLOOD) FULLY-BEADED GLOVES c.1900?
Unusually large beaded panels (12" X 9" width at cuff) applique stitched in colorful star and flower pattern. Bottle green, gr. yellow, t. red, cobalt and red-orange on white bkgrd. Buckskin with cotton lining. Inside seam torn apx. 2" with 2 (1") holes in leather only. Beadwork in exc. shape. Woman's size. Est. 1500-2250 **SOLD $1600(97)**
PLATEAU PICTORIAL FULLY-BEADED GLOVES c. 1930
Indian head with war bonnet contoured in C. pink, white red and tri-cuts: black, yellow, and forest green. Periwinkle bkgrd. Step diamond on glove is gr. green, black and orange. Orange chintz-lined cuffs. Buckskin side fringe. Palms soiled from use. Exc. cond. Large man's size. Est. 435-950 **SOLD $650(97)**

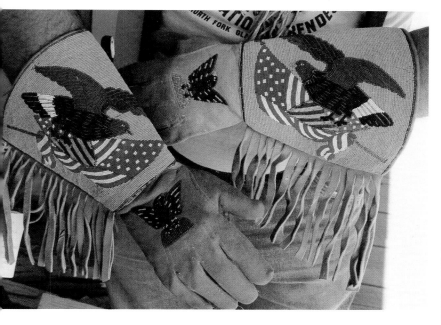

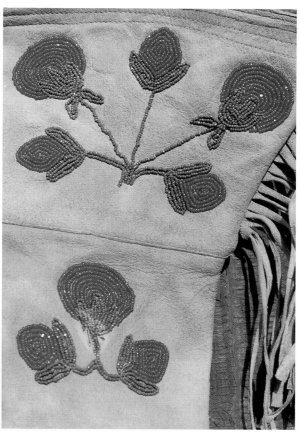

NEZ PERCE BUCKSKIN GLOVES c. 1930
Belonged to Adeline Adams, the daughter of Jackson Sundown, the world champion Nez Perce bronco rider. Fully-beaded cuffs in patriotic eagle and flag pattern. Lt. blue bkgrd. with cuts, tri-cuts and metallic beads in realistic design. Large man's size. Exc. shape. Est. 1200-2000 **SOLD $1500(94)**

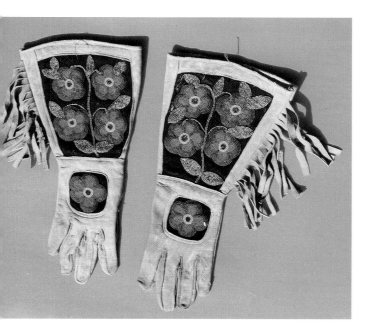

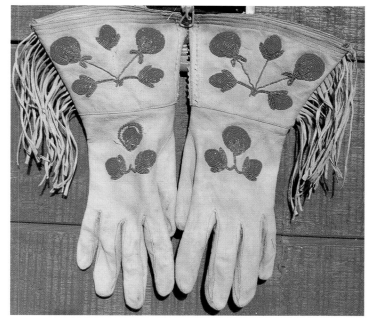

UMATILLA PARTIALLY-BEADED BUCKSKIN GLOVES c.1920
Floral pattern on black wool insets in t. rose, pumpkin, silver-lined clear and gr. yellow. Palm side of gloves are machine quilted. Completely lined with red cotton. Show age but not wear. 17"L X 8"W. cuffs. Fringes 4". Est. 250-475 **SOLD $325(94)**

FLATHEAD PARTIALLY-BEADED GLOVES c.1900
Documented gift from Chief Paul Charlo in 1915. Exquisite cut beadwork in rose white hearts and apple green in typical early Flathead circular floral motif. Lightly smoked buckskin still supple and wearable. A few beads missing; otherwise, exc. cond. Medium to large size. 13" L +5.5" fringe. Est.250/300 **SOLD $175(91)**

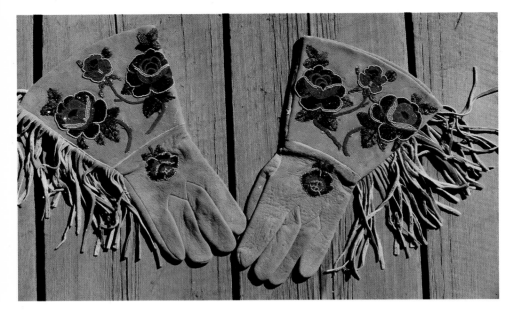

SHOSHONE PARTIALLY-BEADED GLOVES
c.1960
Traditional Shoshone rose designs on yellow-tone smoked buckskin. *(Characteristic hide color and smoked 1 side only typical of Shoshone hides).* All cut beads in red and rose with 3 tones of green for leaves. Exc. cond. Large size. Est. 250-400 **SOLD $350(95)**

KUTENAI MAN'S BUCKSKIN GLOVES
Contemp.
Top quality smoked brain-tan hide. Abstract floral beadwork on cuffs in pearl, dk. blue, and pale blue with 2 shades of green for leaves. Cotton-lined cuffs. Medium size. Brand-new. 13" L. 3.5" fringe. Est. 85/125 **SOLD $125(92)**

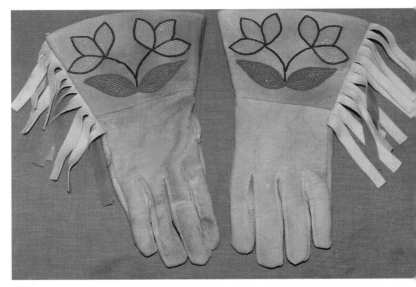

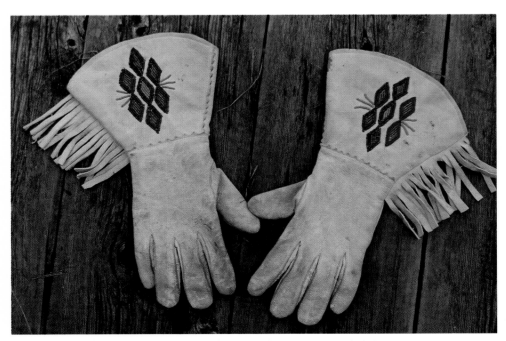

KUTENAI BUCKSKIN GLOVES c.1935
Beaded diamond motif on cuffs are dk. blue, t. aqua and red tri-cuts with lt. green. Some beads replaced. Lined with pink cotton. Small size. Shows use. Good cond. Est. 75-95 **SOLD $65(90)**

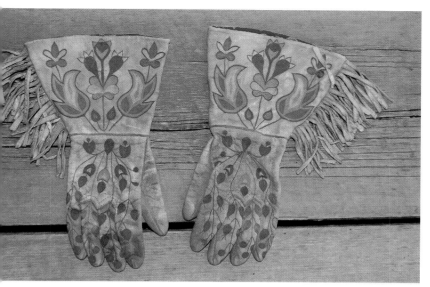

PLATEAU SILK EMBROIDERED BUCKSKIN
GLOVES c. 1880
Lavender, pumpkin, chartreuse, bright
rose, etc. stylized symmetrical all-over
pattern. Welted seams. Red paisley calico
lined. Shows patina of use; embroidery in
perfect cond. 12" L. Side fringe 3"L. Est.
850-1000 **SOLD $800(95)**

CREE-METIS SILK EMBROIDERED GLOVES
c.1890
Profuse floral design-unfaded bright
colors. Pink cotton quilting lined. Fur trim
completely insect eaten; also, upon close
exam, some silk embroidery threads
disintegrated. Leather very supple-shows
no use. Light patina. Woman's size
medium. 13"L. Est. 200-400 **SOLD
$335(96)**

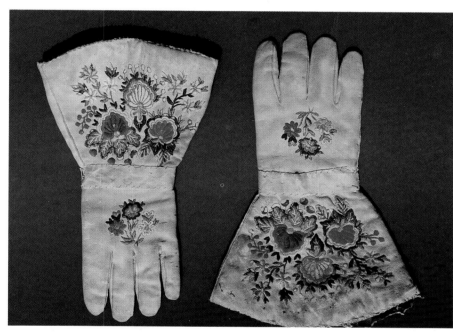

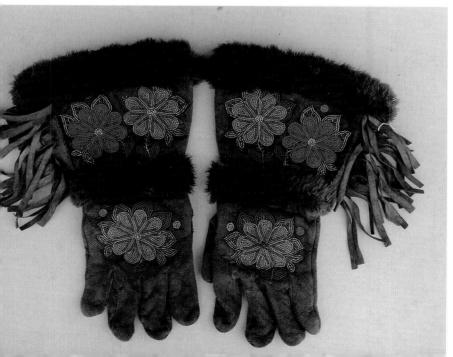

CANADIAN CREE PARTIALLY BEADED
MOOSE HIDE GLOVES c.1930
Dark smoked hide with beaver fur trim.
Beadwork is typical floral design in white
lined pink and salmon, t. forest green and
t. yellow-green. Shows wear. 15"L X 9"W.
Est.195-275 **SOLD $195(93)**

Mittens

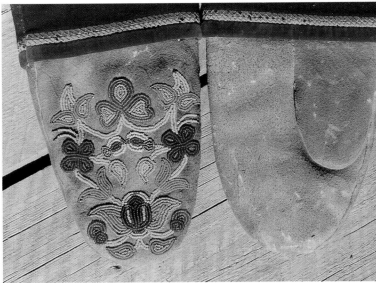

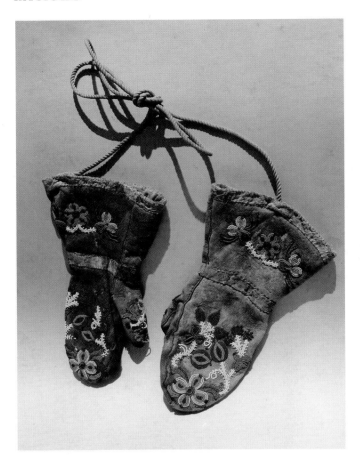

ATHABASCAN PARTIALLY-BEADED BUCKSKIN MITTENS c.1880
Bead colors:rose white heart, gr. robin's egg blue, c. pink, 3 shades of green, and lots of brass facets entwined by white stems. White wool lined. Heavy cotton cording connects the two. Rawhide around wrist and cuffs; remnants of beaver fur eaten by moths. Shows considerable wear-both thumbs worn through and 1 of the palms. Fair cond. 12.5"L X 7" at cuffs. Est. 450-650 **SOLD $475(94)**

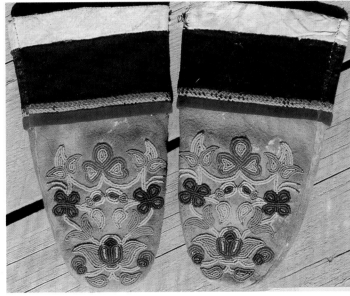

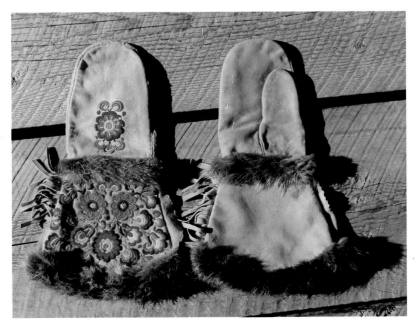

ATHABASCAN MOOSE HIDE BEADED MITTENS c.1870
Symmetrical stylized floral pattern has characteristic silver and gold-colored metallic beads as accents with gr.yellow, pumpkin, t. rose, periwinkle, pink, dk. gr. blue, and t.salmon. Navy wool cloth cuffs (yellow and blue selvedge) are burgundy velvet bound with embroidered braid. Completely lined with navy wool. Exc. cond. 11" L. Est.350/500 **SOLD $345(92)**

CANADIAN-CREE "NORWAY HOUSE" MITTENS c.1890
Metis silk embroidered floral patterns on very fine soft buckskin mittens. Colors: reds, pinks, purples, blues, greens oranges and yellow. Welted seams. Beaver trim at wrist seam and hem. Exc. cond. overall. 2.5" fringe. 14"L X 5" wrist. Est.500-750 **SOLD $700(95)**

Cuffs

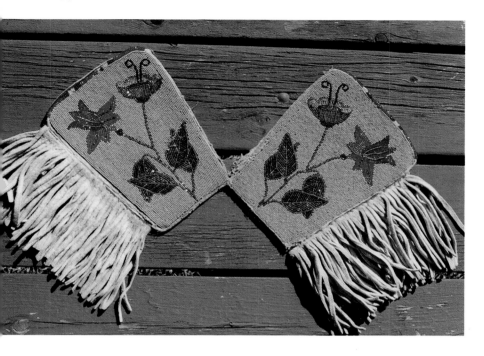

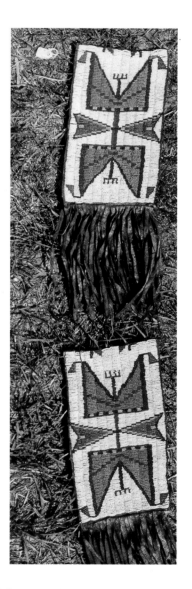

FLATHEAD (Salish) FULLY-BEADED CUFFS c.1900
Won by A.M. Schneider in a poker game from one of Chas. Allard's cowboys during the 1906 buffalo round-up. Lt. blue bkgrd. with tri-cut floral pattern in red, t. yellow, t. green, t. orange, iris, etc. Bead edging in red, white, and blue. Dk. blue muslin lining. A few beads missing on each glove. Good cond. 5" buckskin fringe. 8 X 6" W. Est.350/475 **SOLD $265(91)**

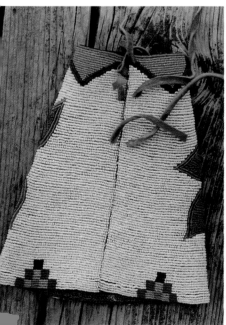

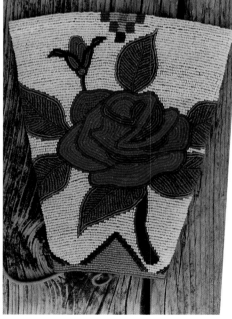

SIOUX FULLY-BEADED CUFFS
Classic Sioux geometric design with white bkgrd. and striking colors: periwinkle, apple green, cobalt, rose white heart, and gr. yellow on buckskin. All sinew-sewn. These appear to have originally been tab ends from a saddle blanket. 5" X 9" each with 6.5" fringe. Est. 425-575 **SOLD $450(91)**

FLATHEAD FULLY-BEADED CUFFS c.1920
Completely beaded front and back in size 13° beads on canvas. White bkgrd. with red and t. rose realistic rose motif with opaque and t. green and cobalt leaves. Geometric border designs in lt. blue, cranberry, cobalt and mustard. Exc. cond. Apx. 8" W X 12" L. Est. 300-600 **SOLD $600(95)**

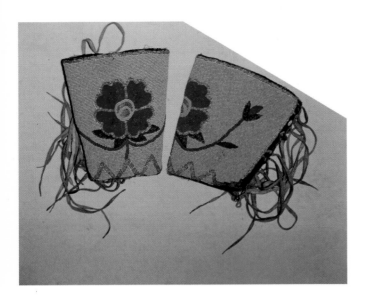

NEZ PERCE FULLY-BEADED CUFFS c.1880
Lt. turquoise applique (flat) stitch bkgrd. with stylized flowers and buds
in trans. shades of red, rose and yellow with gr. yellow, pumpkin stem and
t. forest green leaves. T. yellow zig-zag design border. 2-color calico lined.
Good patina shows light use. A few beads missing at wrist only. Exc.
cond. Apx. 13"L side fringe. Est. 375-575 **SOLD $675(95)**

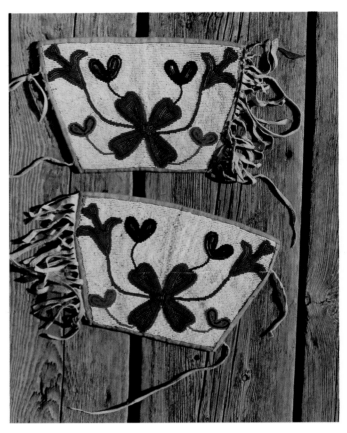

CREE(?) FULLY-BEADED CUFFS c.1910
Stylized floral applique beadwork. White bkgrd. with cobalt, t. red, red
white heart, t. green and t. gold. Exc. cond. Buckskin fringes apx. 4".
9.75"W X 6.25" W. Est. 295-495 **SOLD $250(95)**

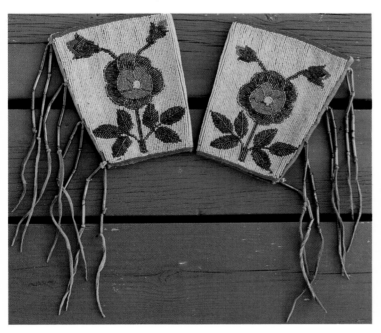

CANADIAN BLACKFOOT FULLY-BEADED CUFFS c.1910
White satin bead bkgrd. with red, t. red, amethyst and gr. yellow tri-cut
flowers;leaves are green tri-cuts with amethyst outlines and stems.
Backed with royal blue cotton. Ties are buckskin thongs with t. metallic
green bugles. 12" X 7.25" with 9" dangles. Est. 300/400 **SOLD $200(90)**

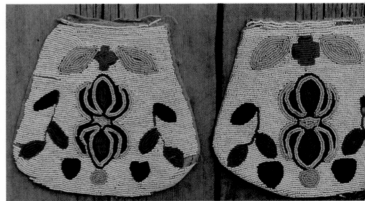

FLATHEAD (Salish) FULLY-BEADED CUFFS c.1900
White bkgrd. with cranberry, gr. yellow, t. green, pink, lt. blue stylized
floral motifs. Sewn on canvas. A few beads missing. Shows age. 6.5" X
6.5". Est. 95/150 **SOLD $95(90)**

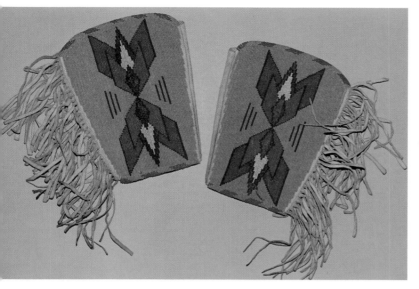

BLACKFEET FULLY-BEADED CUFFS c.1940
Lt. blue bkgrd. with red, t. red, cobalt and t. turquoise geometric chevron designs. Rayon-lined. 5" buckskin fringe. 9"L X 7"W. Est.325/400 **SOLD $325(91)**

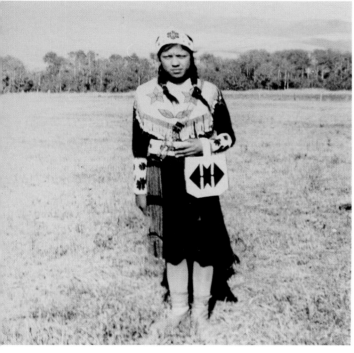

FLATHEAD (Salish) FULLY-BEADED CUFFS c.1920
All cut beads; white bkgrd. with stylized floral pattern in reds, gr. yellow and 2 colors of green; black stems and leaves. Alternating stripe rolled beaded border (both sides). Leather thong ties. White cotton back shows use. Exc. cond. 10.25" X 5.75". Est. 325-450 **SOLD $325(96)**

FLATHEAD FULLY-BEADED CUFFS c.1890
Incl. photo of Flathead girl wearing cuffs with her outfit. c.1915.All cut beads. Size 13° and14° appliqued in straight lines (unusual) and expertly done. White bkgrd. with 3 flower bilaterally symmetrical motif in t. garnet red, t. brown, t. yellow-green, t. pale green t. bottle green and cobalt. Border: Chey. pink, gr. blue and white. Brass beads along front cuff edge and on 2 thong dangles. Green ribbon binding and 2 color calico lining (both show wear). Open: 7.5" at wrist 11.5" Widest pt. 7.25"L. Beadwork exc. cond. Est. 450-950 **SOLD $600(97)**

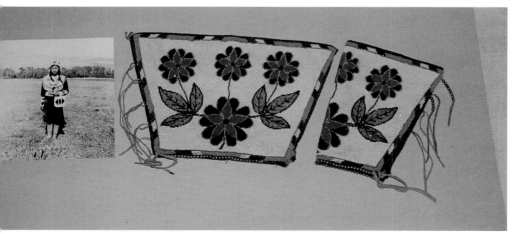

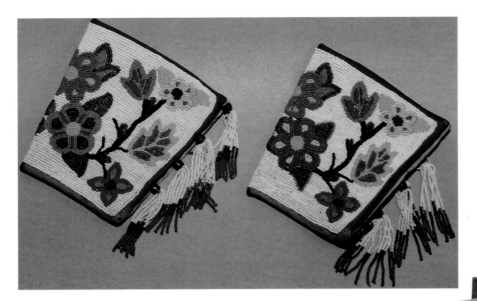

GREAT LAKES FULLY-BEADED CUFFS
c.1940
Made as part of an outfit for a marching band in LaCrosse, Wisc. Size 10° white bkgrd. floral design in multi-bright colors including red bugles. 4 tassels of bead fringe hang 3" on the side. Metal zipper closure. Rayon binding. 6"W X 5.5", folded. Est.225/350 **SOLD $215(92)**

Belts

CROW FULLY-BEADED PANEL BELT
c.1890
Heavy strap leather belt. Pale blue with three 8" cut beaded panels in unusual floral motif: red white heart, pale blue, lt. and dk. green, t. cobalt, and white. Some beads missing. 2" X 45". Est. 300-400 **SOLD $250(90)**

CROW PANEL BELT c. 1880
Highly desirable old colors: Crow pink, lt. periwinkle, rose white heart, apple green, cobalt and white outline. 1.5"W. Sinew-sewn and completely intact. Very heavy harness leather 1/4" thick. Buckskin ties fit 34-36" waist. Est.700-950 **SOLD $800(96)**

BLACKFEET FULLY-BEADED TACK BELT
c.1900
Lt. turquoise with geometric panels in cut beads: beautiful rich cobalt, gr. red and t. emerald green. Diagonal border edged in periwinkle. Applique flat stitch on very heavy harness leather. Exc. cond. A few beads missing from border edge. Good patina. 2.5"W X 36"L. Est. 375-500 **SOLD $400(95)**

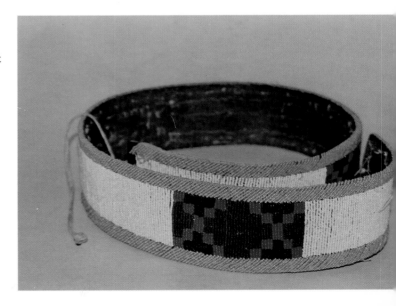

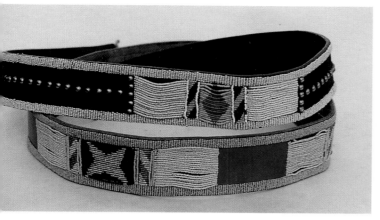

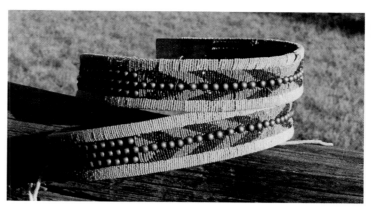

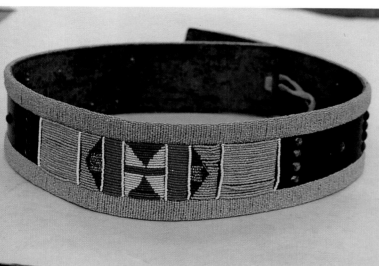

NEZ PERCE WOMAN'S PANEL BELT. c. 1900.
Brass tacks and tiny cut beads sewn to heavy harness leather. Cuts are size 16°; edged in pale blue. Panels are pink and t. grey-green. Sinew-sewn. (Indian owner did some thread-sewn repair work on one end) Exc. cond. A wearable piece. 1.5 X 37" L. Est. 350-450 **SOLD $185(88)**

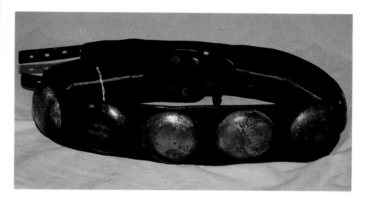

NEZ PERCE PANEL BELTS c.1880. Each is in near perfect cond. **All cut beads.**
TOP TO BOTTOM: c.1870. Chalk blue edging and panels. 3 repeated panels are gr. yellow, rose white heart, Crow pink, cobalt, and periwinkle cut bead designs. Heavy harness leather with tacked panels. A few tacks missing;only 1 tiny row of edge beadwork missing. Sinew and thread sewn. Incredibly good cond. Fits 36" waist. 37.25" X1.75"W. Est. 600-900 **SOLD $650(96)**
c.1915-30 **All cut beads.** Lt. periwinkle edges and panels. 3 panel design in metallic, t. cobalt, gr. green, mustard, Crow pink. Red-brown latigo leather. No beads missing due to method of construction:most beads are sewn with wire. Very unusual. 36"L X 2"W. Est. 400-600 **SOLD $350(96)**
Turquoise horizontal panel and edge-beadwork. 3 repeated panels in t. rose, Crow pink, chalk blue, gr. blue, red with heart, med. blue and white. Sinew and thread sewn. **RARE square shank brass tacks on harness leather.** A few horizontal bead rows missing. Exc. cond. 2.88" X 36"L. Fits 34" waist. Est. 750-1200 **SOLD $750(96)**

CHEYENNE GERMAN SILVER CONCHA BELT c.1870
Heavily patinated conchos (2.5" diam.). Copper riveted strap buckle closures. 2.75" heavy harness leather. 37"-39" waist. Est. 550/800 **SOLD $550(92)**

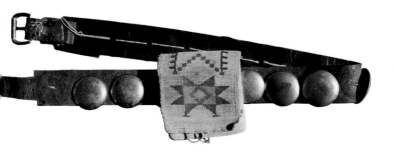

PLATEAU GERMAN SILVER CONCHA BELT With CORN HUSK POUCH c.1880
RARE. Pouch is original to the belt, 16 (1.88") domed conchos on heavy brown harness leather. Folding belt pouch has 3 diff. designs panels: 8 pt. star in purple, green, yellow, pink and red on outside slightly faded and worn. Inside has diamonds and arrow motif. Good overall patina. Fits 36" to 38" waist-2" wide. Est. 1250-1700 **SOLD $1000(95)**

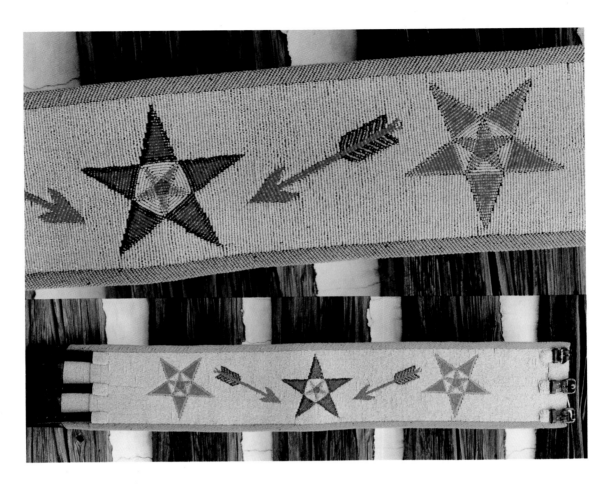

FLATHEAD FULLY-BEADED WIDE BELT c.1915
Lt. periwinkle with tri-cut design motifs of star and arrow in dk. red, rose w. lined, dk. green, pink and t. cranberry. Apple green rolled beaded edge. Heavy harness leather. Pristine cond., probably never worn. **Unusually wide** 5.75" X 37" L. Est. 800-1100 **SOLD $800(96)**

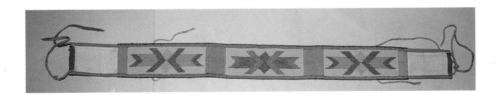

BLOOD (CANADIAN BLACKFOOT) FULLY-BEADED POW-WOW BELT
Contemp.
Three panels are pale blue with colorful geometrics in red, orange, green, t.blue and Chey. pink. Rolled edge and between panels is t. turquoise. Heavy canvas with cotton bindings. Buckskin ties. 13.75 W x 30" beadwork plus 5" each side. 40' total L. Est. 280-375 **SOLD $250(96)**

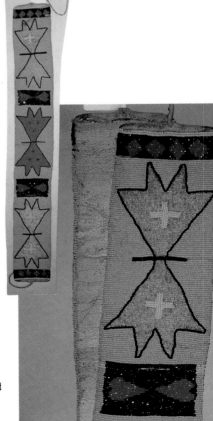

FLATHEAD (SALISH) FULLY-BEADED BELT
c.1930
Typical geometric shapes on lt. blue bkgrd. Colors: periwinkle, t. topaz, metallic brass with tri-cuts in orange, cobalt and copper iris. Canvas with rolled beaded edges. 4.5"W X 32"L with buckskin ends and ties. Est. 188-300 **SOLD $300(96)**

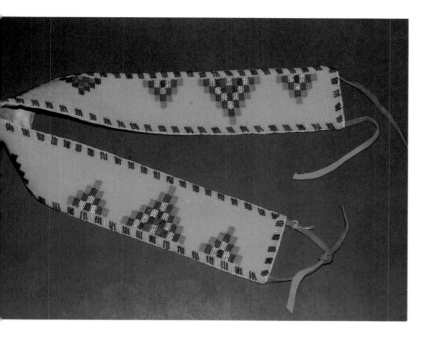

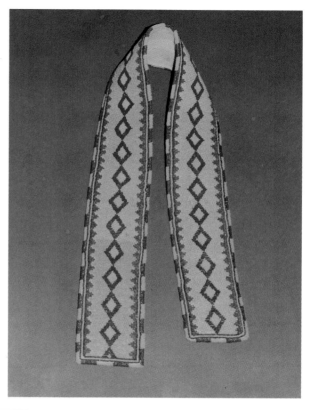

CANADIAN CREE FULLY-BEADED BELT Contemp.
From Onion Lake Reserve, Sask. Appliqued on canvas-size 10° beads. Yellow bkgrd. with triangular step patterns in green, t. silver, orange, lt.and med. blue. 3.25"W X 30"L. Buckskin ties. Est. 100-250 **SOLD $150(95)**

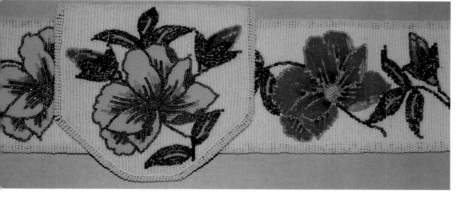

CANADIAN CREE FULLY BEADED BELT Contemp.
From Onion Lake Reserve, Sask. Lt. blue bkgrd. with designs in brown, yellow, orange and dk.blue. Buckskin lined with 4 tie thongs. Applique stitched and in mint cond. 4 X 42"L. Est. 250-450 **SOLD $275(96)**

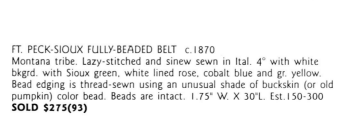

SO. CHEYENNE FULLY BEADED BELT Contemp.
Applique stitched with white bkgrd. Flowers: 1) Tri-cut lt. blue outline with yellow flower and orange center. 2) T. lt. gold outline with red, maroon and brick flower. Silver lined forest green leaves and stems. Beaded on canvas. 4"W x 45"L. Exc. cond.Est. 500-650 **SOLD $400(96)**

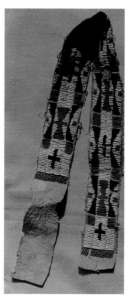

FT. PECK-SIOUX FULLY-BEADED BELT c.1870
Montana tribe. Lazy-stitched and sinew sewn in Ital. 4° with white bkgrd. with Sioux green, white lined rose, cobalt blue and gr. yellow. Bead edging is thread-sewn using an unusual shade of buckskin (or old pumpkin) color bead. Beads are intact. 1.75" W. X 30"L. Est.150-300 **SOLD $275(93)**

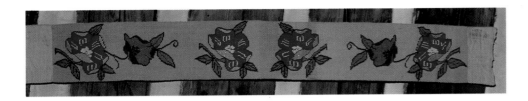

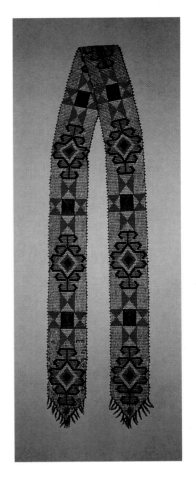

CROW FULLY-BEADED WOMAN'S BELT c.1950
12° pale blue bkgrd. with characteristic Crow flowers in orange, cut Crow pink, periwinkle, cobalt, white and apple and t. green leaves. Heavy canvas. 4.5"W X 30.5" beadwork +5" plain canvas. Est.300-500 **SOLD $350(93)**

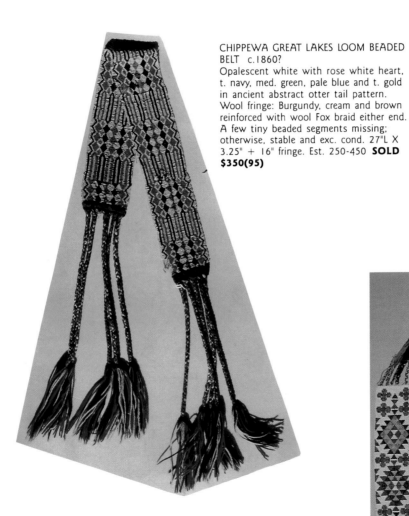

CHIPPEWA GREAT LAKES LOOM BEADED BELT c.1860?
Opalescent white with rose white heart, t. navy, med. green, pale blue and t. gold in ancient abstract otter tail pattern. Wool fringe: Burgundy, cream and brown reinforced with wool Fox braid either end. A few tiny beaded segments missing; otherwise, stable and exc. cond. 27"L X 3.25" + 16" fringe. Est. 250-450 **SOLD $350(95)**

NO. CALIF. LOOM-BEADED BELT c.1900
Pitt River Clear bead bkgrd. with t. red, t. green, c. pink, dk. and lt. blue designs. Exc. cond. Est. 100-195 **SOLD $125(96)**
NOTE: See below left description

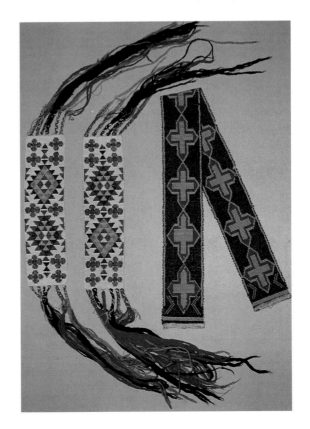

LEFT TO RIGHT: CHIPPEWA LOOM-BEADED GARTERS c.1890
White bkgrd. in all transparent design: forest green, red, cobalt, rose and gold with opaque lt. blue. Braided wool fringe is blue-grey, dk. brown and red. Apx. 12"L. Beadwork: 10.5" X 2.75". Est. 400-500 **SOLD $300(96)**
NO. CALIFORNIA LOOM-BEADED BELT c.1890
Pitt River.* Repeating cross pattern in t. forest green bkgrd. with t. rose and gr. yellow edged in gr. blue. A few scattered spots of beads missing, overall VG cond. 2.88" X 32"L. Est. 94-195 **SOLD $150(96)**
NOTE: Pitt River belts are identified by the edge beads that are held fast with crossed threads.

Accessories

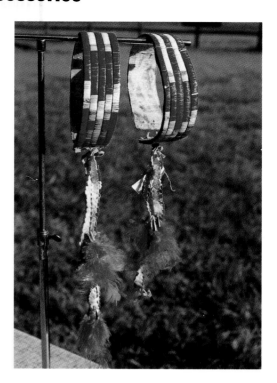

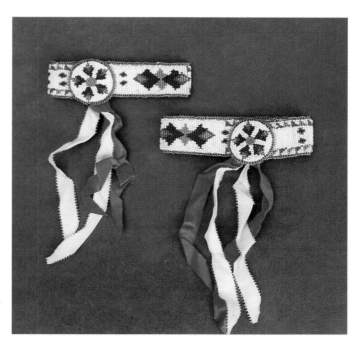

CHIPPEWA LOOM BEADED SASH c.1890
White bkgrd. with elaborate pattern in t. rose, black, gr. yellow, emerald green and lt. turquoise. Braided yarn drops with tassel ends are gold, purple, cobalt green and white. A few beads missing; otherwise, VG cond. 3.5" X 33"L. 17" tassels. Est. 275-500 **SOLD 325(95)**

SIOUX FULLY-QUILLED ARMBANDS c.1910
Red with white, purple, yellow and turquoise wrapped quill work. Colorful edge-beaded buckskin drops with pink feather fluffs. A few quills missing here and there; otherwise, VG wearable cond. 5 slats wide: 1.5" X 13" circumference. Est. 315-395 **SOLD $375(95)**

FLATHEAD FULLY-BEADED BELT and POUCH c.1940
This Pow Wow dance piece was used until recently by the great-grandson of Jackson Sundown. Belt has t. turquoise bkgrd. with red, black, dk. blue and yellow geometric pattern. Red bugle bead edging. Lt. blue muslin backed. Pouch is lt. blue with red crescent moon; white and brown horse. 4.75" X 5.25". Belt is 3.5" W. Fits 35-36" waist. Est.350/600 **SOLD $300(92)**

CAYUSE FULLY-BEADED ARMBANDS c.1915
White bkgrd. with red, t. cobalt, pumpkin, periwinkle geometric design. T. rose edge-beaded rosettes and band. Calico lined. Red and white rayon streamers. Est.175-250 **SOLD $150(93)**

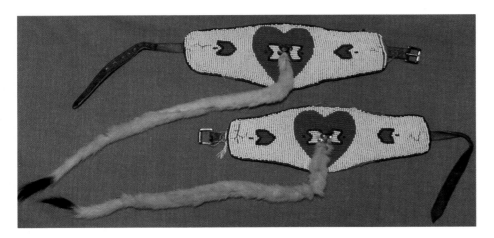

NEZ PERCE-FLATHEAD BEADED ARMBANDS c.1930
Belonged to Pat Adams, grandson of Jackson Sundown. These were part of his dance outfit. Size 10° beads-white bkgrd; white red heart and chevron design cobalt outlined and edged. Cased ermine drops hang 13"-fastened with celluloid sequins. Green and white checkered calico lined. Some beads missing on edge and bkgrd. Beaded portion 8.5" X 3";16"L leather straps. Est. 95/175 **SOLD $70(92)**

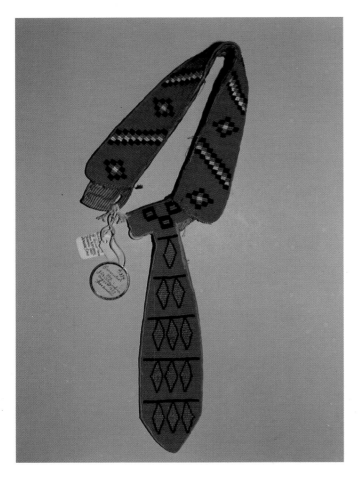

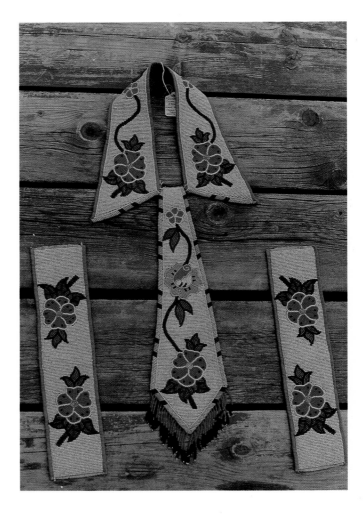

KUTENAI MAN'S DANCE SET c. 1935
Made by Sarah Saloway of Elmo, Mont. Necktie and collar with matching armbands fully-beaded: lt. blue bkgrd. with flowers: gr. yellow, t. red, and pumpkin outlined with Crow pink-dk. blue stem and lt. and dk. green leaves. Exc. cond. Est. 250/400 **SOLD $300(89)**

GROS VENTRE BEADED COLLAR and NECKTIE
Collected on the Ft. Belknap Res. in Mont. with documentation that it belonged to Joe Assiniboine in 1927. Fully-beaded applique (thread-sewn) predominantly white lined red geometric designs in lt. blue, white and black. Striped pillow ticking lined. A few beads missing; otherwise, good cond. Est. 400-600 **SOLD $300(92)**

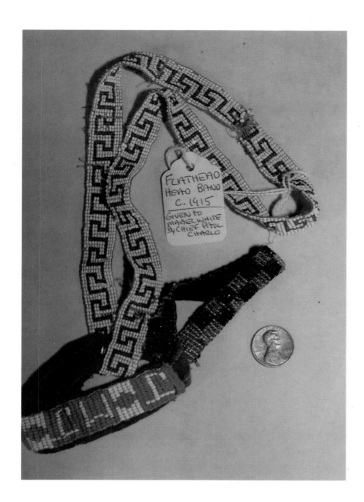

FLATHEAD LOOM-BEADED HEADBAND and 2 WRISTBANDS c.1915
Originally given to Mabel White by Chief Paul Charlo. White bkgrd. with t.
brown fret-design. Wristbands mounted on cloth. One is red and
white;other is clear and cut bronze. About 5 rows of beads loose or
missing. Headband is 1/2" W X 22". Est.40-60 **SOLD $40(93)**

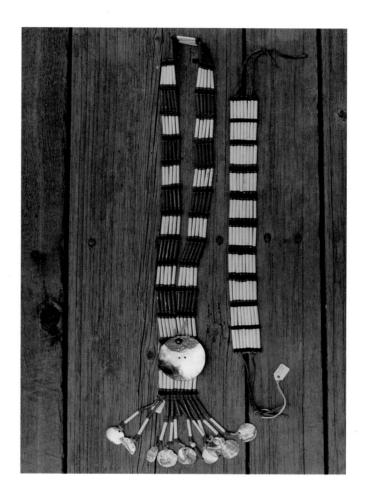

Left to right: BLACKFEET WOMAN'S NECKLACE c.1910
Alternating chalk-white and deep red 1" tube beads (5 beads wide) with
periwinkle and dk. red large pony beads with latigo leather spacers. One
(2.5") blue-green abalone disc, 7 shell disc dangles and 2 serrated abalone
discs on bottom. Hangs 24". Est.400-475
SOLD $400(93)
BLACKFEET CHOKER NECKLACE c.1890
8 milk-white tube beads wide; front 4 panels have small brass beads,
surrounding 2 have red white heart beads and latigo leather spacers.
Natural greenish patina on brass beads. VG cond. 1.5" W X 14.25"L + tie
thongs. Est.215-350 **SOLD $250(93)**

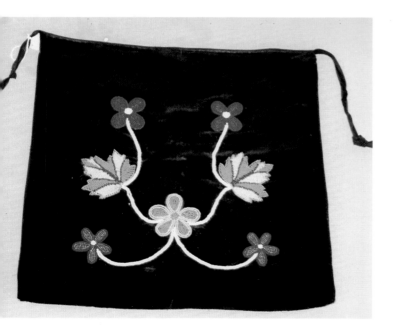

WOODLANDS BLACK VELVETEEN DANCE APRON Contemp.
Size 10° beaded design in floral motif: multi-colors. Black muslin tape tie;
lined with black satin. 16" sq. Good cond. Est.110/150

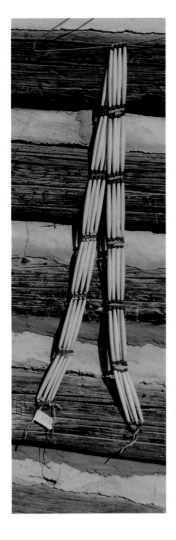

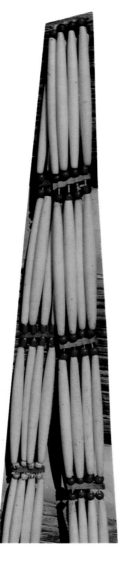

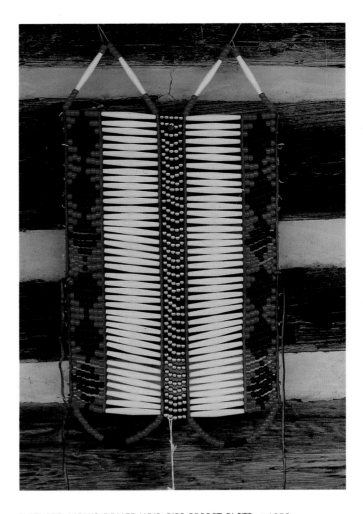

FLATHEAD MAN'S DANCE HAIR PIPE BREAST PLATE c.1975
Worn and made by Steve Small Salmon of Pend d'Oreille tribe. Red and black plastic Crow beads with 3" plastic hair pipes. Brass beads in center. 17" X 11". Est. 125-175 **SOLD $125(90)**

FLATHEAD (Salish) MAN'S HAIR PIPE BANDOLIER c.1890
Eckley Collection from Ronan, Montana. Bone hair pipes are 4.5"L. Exceptional early trade bead separators are wire-wound rose white hearts; striped round and 8 barrel-shaped rose white heart. Heavy leather spacers. Smooth natural patina of age. Strung on buckskin. Hangs 30"L. Est. 400-800 **SOLD $700(96)**

NEZ PERCE MAN'S DANCE BREAST PLATE c.1950
Made of old-time celluloid 4" hair pipes, brass beads and black tile beads. Pink conch shell in center with feather drops. 15"W X 23"L. Est. 100-200 **SOLD $125(92)**

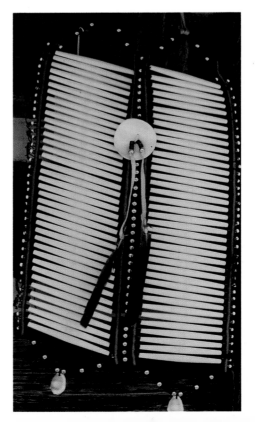

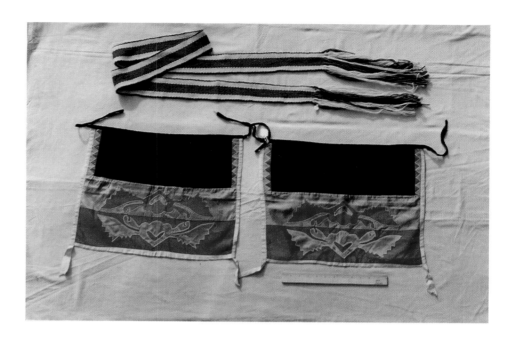

SO. PLAINS RIBBON WORK APRONS c.1950
Red and lavender rayon double image reverse colors. Machine sewn with yellow thread overcast stitch. Yellow rayon ribbon bound on 3 sides. Upper part navy wool. Backed with black cotton. Ties and top bound with black cotton. 1 apron lightly stained. 19"W X 15"L + 4" ribbon dangles. Est. 150-250 set

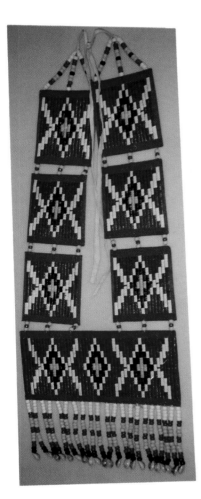

SIOUX FULLY-QUILLED BREAST PLATE
Contemp.
4.25" quill wrapped slats are mounted on 6 red cotton backed square sections in red with white, purple and yellow diamond motifs. Connected by yellow and red Crow beads on top and bottom. Lower dangles are Crow beads same colors plus cobalt and white with olivella shells. 12.25" W at bottom panel. Hangs 36" L. Unused exc cond. Est. 500-800 **SOLD $550(96)**

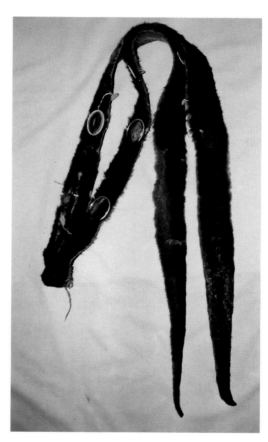

FLATHEAD OTTER FUR BANDOLIER c.1910
with 6 mirror ornamentation. *This piece belonged to the late Jerome Vanderburg and was made by his wife Agnes.* Wear and patina of the otter appears to be much older than the mirrors. 51"L. Est. 200-350 **SOLD $200(95)**

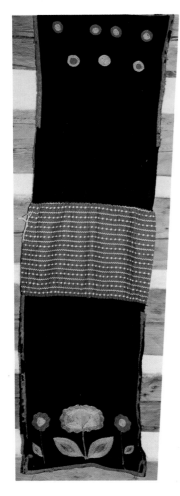

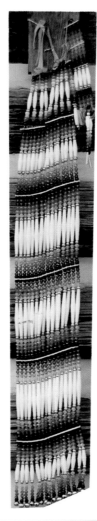

BLACKFEET WOMAN'S DANCE BREAST-
PLATE and MATCHING CHOKER c.1980
3" and 1.5" hair pipes with trans. facets in
yellow, orange, red. Brass beads and black
and brown Crow beads. Hangs 40" X 6".
Choker is 16". Est. 95-125 set **SOLD**
$95(90)

Head gear

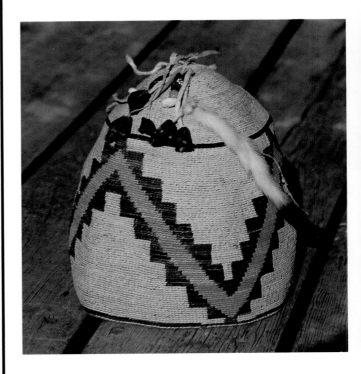

PLATEAU (NEZ PERCE?) WOOL FLORAL
EMBROIDERED BREECHCLOTH c.1910
Black wool panels front and back with
central blue and white calico panel. Front
has chain-stitch silk thread in pink, soft
gold, and pale green. Back has circular
designs. Bound with red silk ribbon
partially disintegrated. Backing blue
calico. 12"W X 44"L. Est. 110-195 **SOLD**
$110(93)

NEZ PERCE CORN HUSK BASKETRY HAT
(FEZ) c. 1890
RARE. All corn husk: soft orange
chevron design bordered with black step
pattern. Double black lines along rim and
top border. Top ornaments dangling from
buckskin thongs: 5 deer dew claws,
Venetian fancy bead, wire-wound Crow
bead, monie cowrie shell and ermine tail.
8" H. X 8" diam. Unusually fine piece in
perfect cond. Est. 1500-2250 **SOLD**
$1500(95)

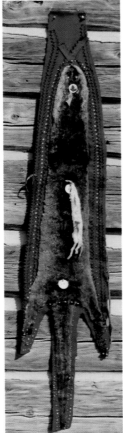

BLACKFOOT OTTER DANCE DROP
c.1880
Red wool blanket with fine dk. green
pinked wool overlay. Full otter hide
bordered with 1/4" brass spots (some
domed-others flat). 10 brass hawk bells
across tail and around legs. (Some missing
with only loop left.) Embellishment on
otter: 3 (1.5") conch shells, central one is
on white weasel with red hackle feathers.
Center back has remnants of leather
thong fasteners and pr. of blue muslin
ties either side on bottom half. Exc. cond.
63.5"L X 11" W. Est. 563-800 **SOLD**
$560(96)

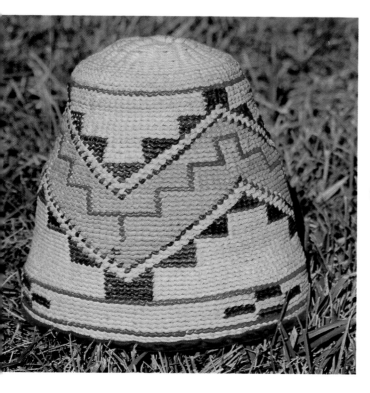

YAKIMA ALL CORN HUSK BASKETRY HAT Contemp.
Attractive yellow, muted red, muted black chevron design. White hop string top. Red velvet lined. Exc. cond. 7"H. 7.5" diam Est. 800-1200

*See Bead Glossary for definition of **embossed beadwork** on the following 5 Iroquois hats*

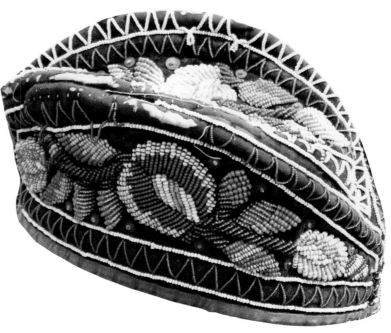

IROQUOIS GLENGARY BEADED HAT c. 1880.
Black velvet with red velvet ribbon binding. Embossed floral panels with brass sequin trim. "Zigzag" beaded outline in need of some repair-all else is intact. 11" L. Est. 300-450 **SOLD $250(88)**

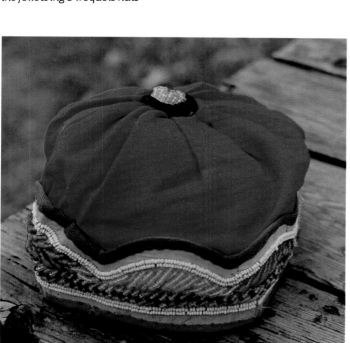

IROQUOIS GUS-TO-WEH (MAN'S CAP) c.1860
Red twill wool crown with all-around embossed beadwork and trimmed with wool braid. Lined with polished cotton. A few moth holes, otherwise exc. cond. 8" diam. Est. 200-375 **SOLD $175(89)**

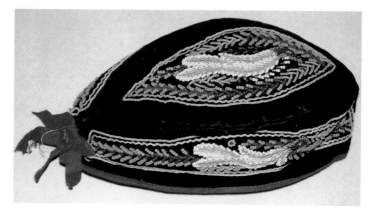

IROQUOIS GLENGARY BEADED HAT c.1860
Highly desirable bird motif on top and both sides. Black velvet. Bird: clear and white beads with t. rose and C. pink head and tail surrounded by tendrils in gr. blue, gr. yellow, pumpkin, lt. blue, Crow pink and t. rose. Bordered by narrow white rick-rack and opal. white seed beads. Embossed beadwork is mixture of pony and seed beads. Red cotton binding and back bow. Muslin lined. 12"L X 6" top X 4" H. Exc. cond. Est. 560-900 **SOLD $550(95)**

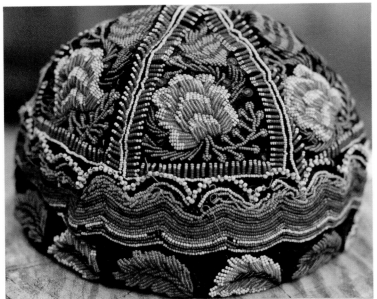

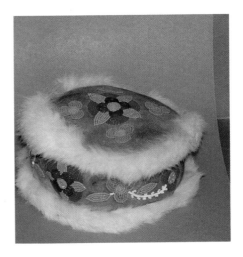

CREE BEADED MOOSE HIDE HAT
purchased in New York state in the 1940s.
Typical stylized floral beadwork in lt. blue, pearl, t. red, lt. green and orange with white stems. Smoked hide with white fur trim. Plaid calico lined. Like-new cond. 7" diam. X 4" H. Est. 110-175 **SOLD $135(96)**

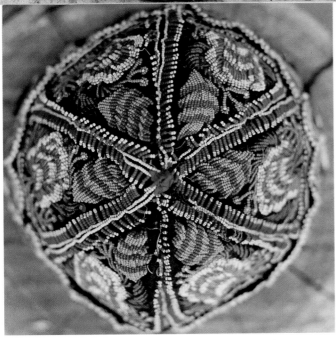

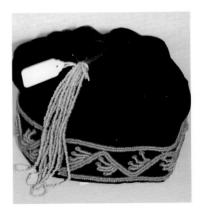

IROQUOIS BLACK VELVET SMOKING CAP
c.1880
Gathered at top with velvet covered button. T. gold ponies with brass sequin beaded border. Opalescent blue pony beaded loop dangles hang 6" from top button. Purple chintz lining. Good cond. 7" diam. Est. 150-250 **SOLD $75(92)**

IROQUOIS BEADED SMOKING HAT c.1840
Elaborate embossed beadwork in a myriad of rich pastel tones apx. size 13°beads (and smaller) on black velvet. 6 identical floral beaded sections bordered with gr.blue and white. Lower portion has border of 9 rainbow hues;rim has alternating white and pumpkin leaf design with gr. blue and gr. green stems. Red silk ribbons on top. Superb item in good cond. Apx. 8" diam. Est.500-800 **SOLD $450(92)**

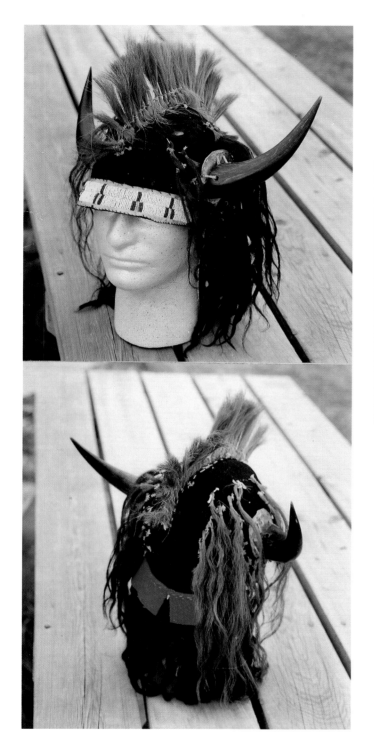

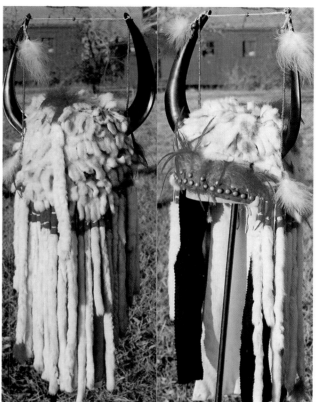

BLACKFEET SPLIT BUFFALO HORN BONNET c.1940
Collected on the Blackfeet Res. near Browning. Mont. Horns mounted to a felt hat crown with a tacked leather brow band surrounded by red hackle feathers. Fine red wool back drop lined with plain muslin and 2 strips of navy wool dangling on each side. The top of the hat is covered with fringed ermine strips. The sides and back have ermine tubes wrapped with red wool at tops. 12" thongs with clear turquoise beads are attached to the tip of each horn and terminated with red and white fluffs. A well-made headdress reminiscent of the old-style made long ago among the Blackfeet tribes. 30" L. Est.800/1500 **SOLD $875(92)**

SIOUX BUFFALO HORN BONNET c.1940
From Pine Ridge Res. So. Dak. Brow band has 2 lane lazy-stitch in white with pony trader blue, gr. yellow and pale blue. Top has yellow dyed horsehair 4" L. tied and sewn into upright position. Each side has dyed horsehair attachments: 1) dk. blue 2) green. Back of neck has lower panel of long black buffalo hair painted green on back and trimmed with red wool. 2 horns attached with circles of rawhide. Base is old felt hat. Est. 500-900 **SOLD $750(95)**

SIOUX QUILLED BUFFALO TAIL HAIR ORNAMENT Contemp.
Pred. red quill wrapped slats with rawhide back (2" X 5") and old trade mirror. 2 white quill-wrapped dangles with red horsehair tin cone dangles. Apx. 26" total L. **SOLD $185(87)**

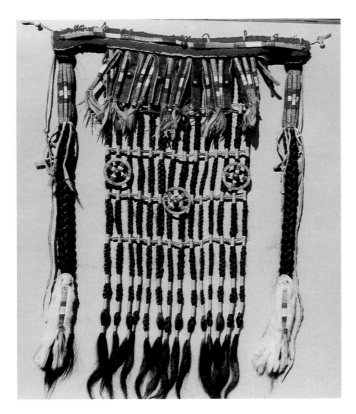

SIOUX HAIR DROP HEAD DRESS c.1940-50
Purchased by an Indian man in 1966 who wore it on the Pow Wow circuit for the next 20 years. Buckskin covered rawhide band has red white heart lanes either side of quill wrapped strip in gold, red and white. Two hair braids either side with quilled slats, ermine and tin cone trim. Central horsehair braids wrapped with yellow thread and lined with four rows of pony beads (clear, yellow, gold and lt.blue.) Three quill wheels attached with brass buttons. 3" fringe below band is hair-on buffalo hide with quilled slats and hackle feathers. Some beads are loose on band, but none are missing. Brow band back shows wear. VG cond. 14"W beaded band. 22"L. Est. 350-600 **SOLD $375(96)**

BLACKFEET DANCE ROACH Contemp.
Made by Tyrone White Grass of Browning, Mont. Yarn base white with orange and multi. Peach-colored dyed deer hair 3"L. Porcupine hair 7"L front and 4"L back. Est.350-450 **SOLD $375(91)**

PORCUPINE and DEER HAIR DANCE ROACHES c.1980
Each has yarn base with red dyed deer hair on outside.
Top to Bottom: CHIPPEWA-CREE *Rocky Boy Res.*, Mont. Rust yarn base. 6"L porky hair. Base is 13"L. Est. 175-350 **SOLD $100(90)**
BLACKFEET. Green, burgundy, and red yarn base. Porky hair 6" L-base is 13"L. Est. 175/350 **SOLD $150(90)**

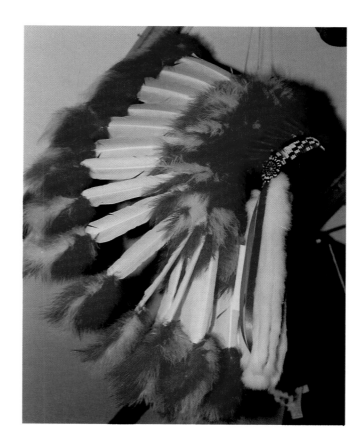

PORCUPINE HEADDRESS OLD-TIME DEER HAIR BASE Contemp.
Old-style roach worn on the back of the head. Red deer hair with orange deer hair base 6.5". 8" porky hair in front. Exc. cond. Est.275-450 **SOLD $300(93)**

OKLAHOMA INDIAN-MADE FEATHER BONNET
Pony beaded band is white, red and gold with side beaded rosettes. White turkey feathers heavily trimmed with red, orange and yellow fluffs. White rabbit strips; red and yellow ribbon drops 18"L. New. 16" across, 32"L. Est. 275-400 **$200(91)**

Decorated Blankets and Hides

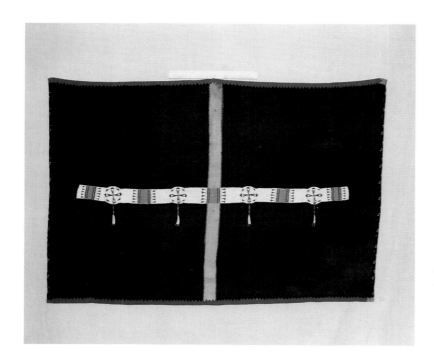

SIOUX CHILD'S "SKUNK" BLANKET With BEADED STRIP c.1880
Extremely rare. This piece is a delicate and exact duplicate of the adult size ones so prized by collectors. Blue wool trade cloth with white selvedge sewn together in middle which resembles a skunk's white stripe! The sinew-sewn lazy-stitched. Strip is 2.5" X 36.5" with 4 rosettes. Bkgrd. is white with dk. blue, white center rose, med. blue and gr.yellow. Each rosette has a 4.5" dangle of seed beads and dentalia shells. Blanket is bound on vertical edges with 2 color print black calico. Long edges are bound with red trade wool with white selvedges cut in sawtooth pattern. 31" X 45". Est.3500/5000 **SOLD $4000(93)**

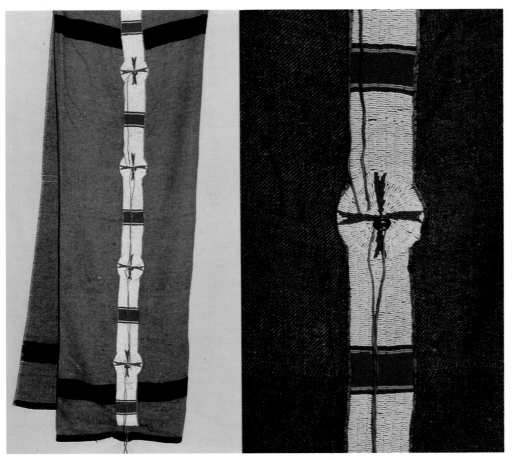

CLASSIC SIOUX BEADED STRIP ON OLD
BLANKET c. 1865
White bkgrd. and white center rose and
cobalt rosettes; cobalt and gr. yellow
block design. Brass hawk bells and
thongs at rosette centers. Brown twill
blanket has dk.brown wide and 1 narrow
stripe at hem. (Actually 2 blankets hand-
stitched together years ago with baseball
stitch.) Overall patina shows age. Exc.
cond. Strip is 58"L. X 2.75"W. Rosettes
are 3.75" diam. Blanket measures 64"W X
66"L. Est. 2500/4000 **SOLD $2200(92)**

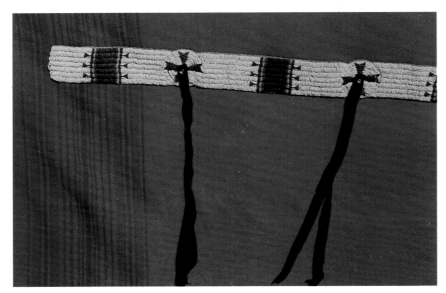

SIOUX BEADED STRIP ON STRIPED RED
BLANKET c.1880
7 rows lazy-stitch white bkgrd. with
cobalt and white center rose cross on
rosettes; cobalt, Sioux green, gr. yellow,
white center rose geometric design.
Sinew-sewn. Wool blanket has faded rose
silk binding and is original to the strip.
Navy grosgrain ribbon streamers on
rosettes added later. Strip- 3" X 56.5".
Blanket-71" X 66". Exc. cond. Est. 2000/
3000 **SOLD $2000(90)**

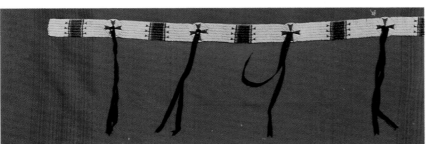

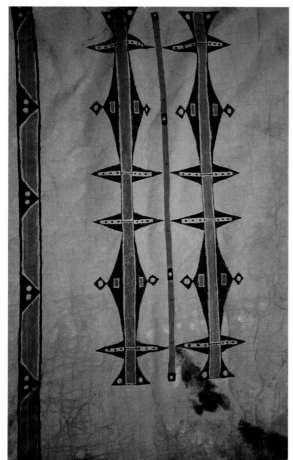

CROW TRADE CLOTH PEYOTE BLANKET c.1910
*Purchased many years ago on the Crow Reservation at Lammers in Hardin,
Mont.* 4 band navy wool rainbow selvedge joined in the center with red
wool 8-band selvedge. Sides bound with 3 layers of silk ribbon (yellow,
green, and red outer). One neat little repair patch in navy, otherwise mint
cond. 3.25 yds. X 14"W. Est.350/400 **SOLD $295(91)**

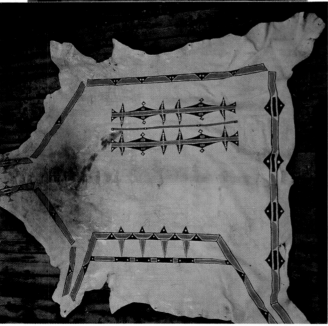

NEZ PERCE PAINTED BUFFALO ROBE c.1900
From Kooskia, Idaho. Wearing robe. Vermillion and black box and border
design. Stitch marks where a quilled strip used to be. Huckleberry and
smoke stains nr. neck. Supple. Several tears sewn with sinew. I round
buckskin patch. 7'2"L X 6'2"W. Est. 1950-2500 **SOLD $2000(96)**

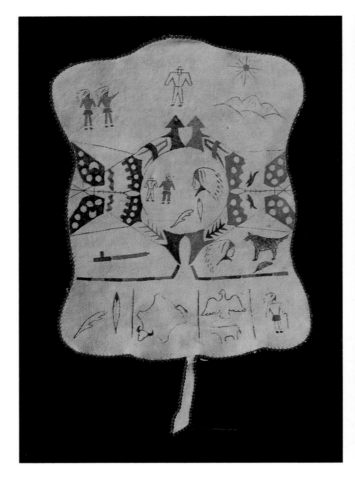

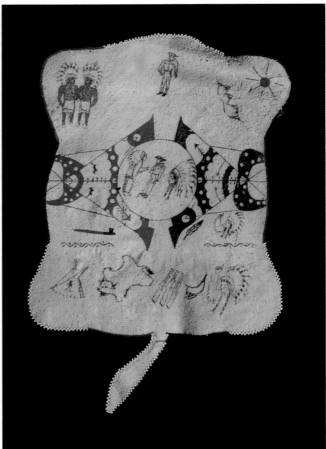

BLACKFEET PAINTED BUCKSKIN RECORD OF ADOPTION CEREMONY
c.1930-1940
Picture writing probably by Dan Bull Plume to commemorate the naming and adoption of a white man into the Blackfeet tribe. Across the top of each are Indians greeting the white man from the East (symbolized by the sun rising over the mountains). Next, they are inside the lodge for the naming ceremony. Below that is the pipe and name given to the adoptee and the bottom row illustrates the names of the Indians attending the ceremony. Red and blue painting. Adoptee is Chief Wolf Plume. Bottom row shows Eagle Calf, Bull Robe, Old Man. Red beaded edge. Exc. cond. 9.5" X 15"L. Est. 75-195 **SOLD $200(94)**

SIMILAR. Adoptee is Chief Eagle Feather. Alternating red, white and blue beaded edging. 9.5" X 15". Exc. cond. Est. 75-195 **SOLD $200(94)**

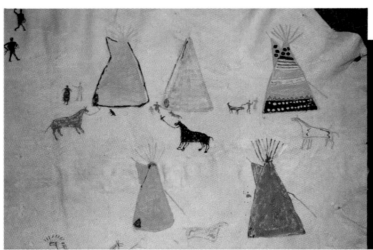

BLACKFEET PAINTED ELK ROBE c.1920
By Bull Plume from Ace Powell Coll. and O'Neil Jones Coll. Painted images depict battles and tipi camp scenes. Apx. 4.5' X 3'. Est. 600-1200 **SOLD $650(96)**

Dance Outfits and Related Paraphernalia

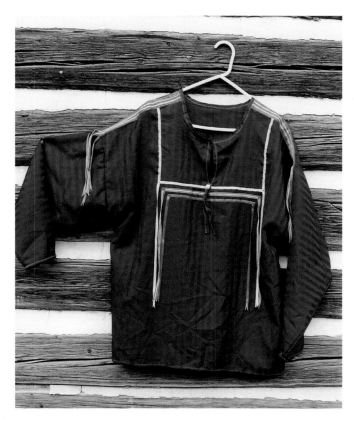

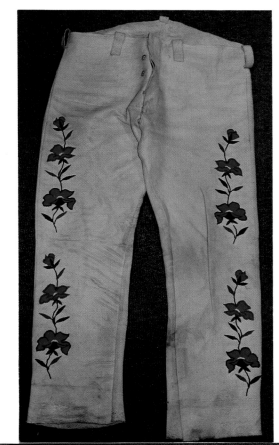

WINNEBAGO DARK BLUE RIBBON SHIRT c.1950
Yellow, orange and rainbow-colored ribbons stitched with orange thread. Appears to be rayon. 50" chest, 21" sleeves, 30"L. Est. 63-80 **SOLD $50(95)**

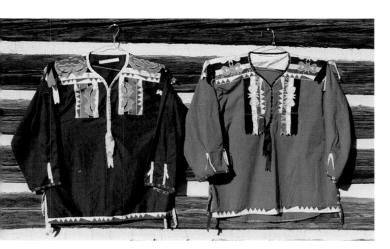

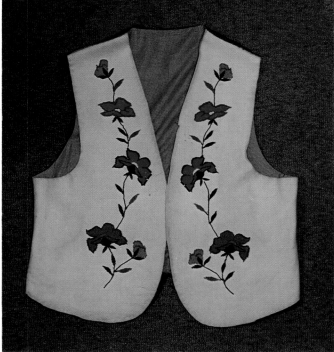

WINNEBAGO RIBBON SHIRTS Contemp. Old time applique ribbon work across shoulder yoke, front and bottom hem. Ribbon bound neck and sleeves. Never worn. Exc. cond. Each has 50" chest, 24" sleeves.
LEFT TO RIGHT: A) Navy blue with purple, med.blue, red and white. Yellow ribbon binding at neck and sides. Red binding at bottom and sleeves. Est. 75-125 **SOLD $75(96)**
B) Teal blue with black, red and yellow. Black ribbon neck binding; red on sleeve and side slits. Est. 75-125 **SOLD $85(96)**

CROW MAN'S PARADE SUIT c.1960s
Vest front, pants pockets and front partially beaded in characteristic Crow diagonal floral beadwork in red, periwinkle, orange, greens and dk. brown. White brain-tan deer hide. Vest cotton lined with rayon back. Large size. Shows some wear; otherwise, VG shape. Est. 500-750 **SOLD $400(90)**

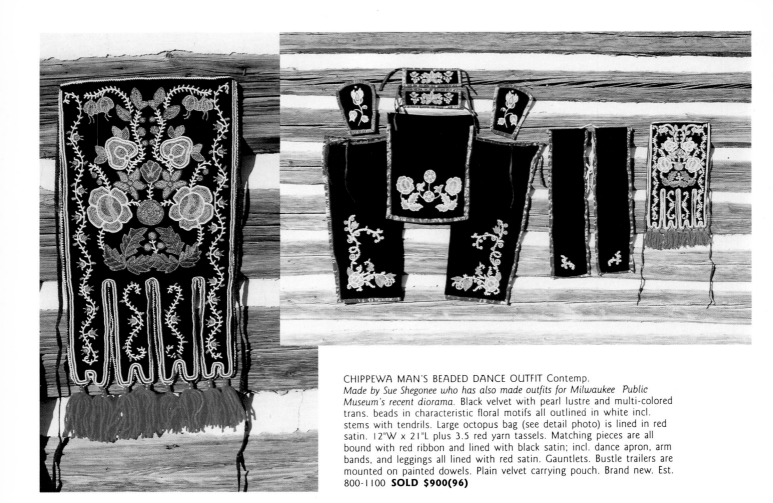

CHIPPEWA MAN'S BEADED DANCE OUTFIT Contemp.
Made by Sue Shegonee who has also made outfits for Milwaukee Public Museum's recent diorama. Black velvet with pearl lustre and multi-colored trans. beads in characteristic floral motifs all outlined in white incl. stems with tendrils. Large octopus bag (see detail photo) is lined in red satin. 12"W x 21"L plus 3.5 red yarn tassels. Matching pieces are all bound with red ribbon and lined with black satin; incl. dance apron, arm bands, and leggings all lined with red satin. Gauntlets. Bustle trailers are mounted on painted dowels. Plain velvet carrying pouch. Brand new. Est. 800-1100 **SOLD $900(96)**

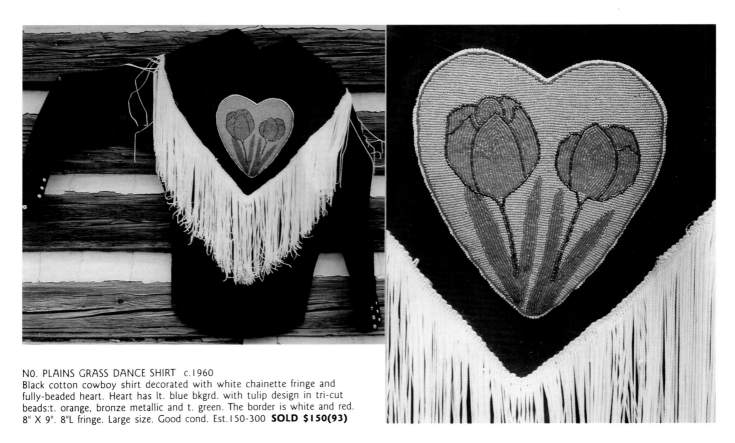

NO. PLAINS GRASS DANCE SHIRT c.1960
Black cotton cowboy shirt decorated with white chainette fringe and fully-beaded heart. Heart has lt. blue bkgrd. with tulip design in tri-cut beads:t. orange, bronze metallic and t. green. The border is white and red. 8" X 9". 8"L fringe. Large size. Good cond. Est.150-300 **SOLD $150(93)**

BLACKFEET FULLY-BEADED DANCE SUIT c.1950
Made by Cecile Horn of Browning Mont. for her brother-in-law Joe Horn. Pearl white bkgrd., all pieces in matching floral patterns: Flowers are orange, t. red, yellow and black with green leaves on burgundy stems. Lt. blue border with dk. Breech clout has fully-beaded panel of flowers and Joe Horn's name in dk. blue. Beaded cape, collar, breech clout and tie all fringed with red 5"L. chainette. Each side of beaded headband has circular rosettes of white horsehair with 2" beaded rosette in center with rooster feathers, blue triangles. Beaded on canvas in size 13°. All lined with blue cotton. Heart shaped belt drops, belt, cuffs, arm bands. Set includes 2 well-used angora anklets and pair of large chrome dance bells. Exc. wearable cond. Est.2500-3000 **SOLD $1850(93)**

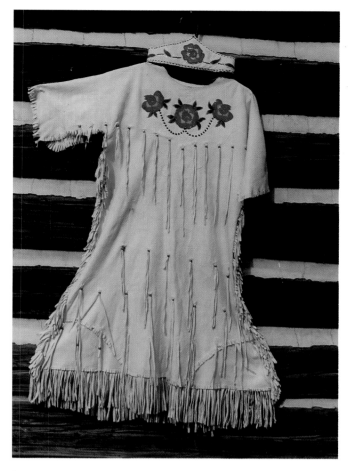

KUTENAI GIRL'S BUCKSKIN DRESS & MATCHING CROWN Contemp. Soft white brain-tan fringed hide with beaded roses in red and yellow tri-cuts on front and back yoke and on Princess crown. Long thong decoration. 37" bust X 41"L. Est. 650-1000 **SOLD $650(93)**

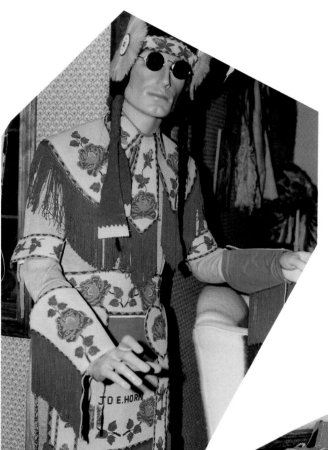

CHIPPEWA-CREE LITTLE GIRL'S DANCE OUTFIT Contemporary.
Rocky Boy Res., Mont. Red velvet dress trimmed with cowries and velvet ribbon (chest 24"-20"L.). Smoked moose hide moccasins with fully-beaded toe 5" L. Fully-beaded crown, belt (20"X 3") and leggings with matching beadwork design in pred. turquoise with white, red, orange, and t. yellow. Est. 300-450 **SOLD $250(88)**

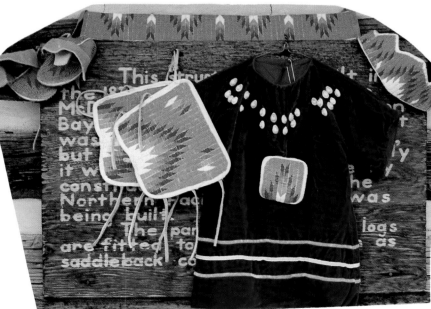

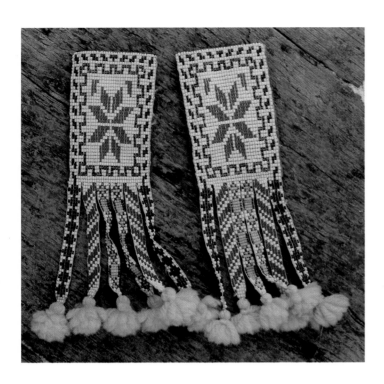

LOOM-BEADED SHOULDER EPAULETS c.1940
White background with orange, t. gold, t. navy blue, red, pink and silver metallic facets. White wool tassels. Exc. condition. 2" X 7". Est.75-150
SOLD $80(93)

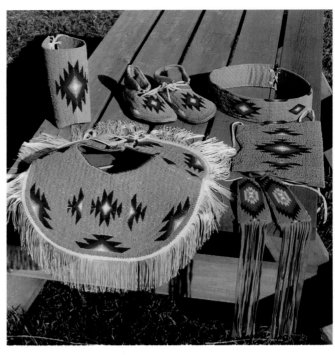

ROCKY BOY WOMAN'S FULLY-BEADED DANCE OUTFIT c.1992
Chippewa-Cree, Mont. Lt. blue seed beaded background (lazy-stitch) in cobalt, brown, yellow, orange, red and white geometric modern Powwow design. All lined with lt. blue cotton. Includes fringed cape, leggings, moccasins, belt and hair wraps. Moose hide moccasins are 10.5"L. Never worn. Est.1250-1750 **SOLD $900(93)**

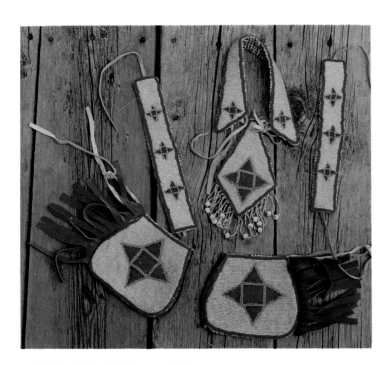

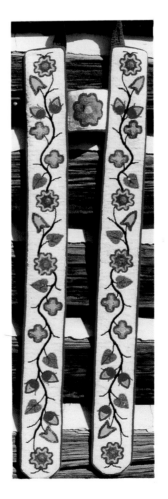

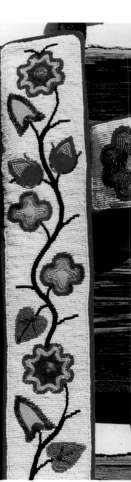

FLATHEAD BOY'S BEADED DANCE SET 1977
Made by Cecile Lumprey. Gleaming yellow tri-cut bkgrd with red tri-cut borders and design motif; lt. blue outline. Calico backed. Never worn. Collar (13") and tie, cuffs, and arm bands. Est. 75/95 **SOLD $75(90)**

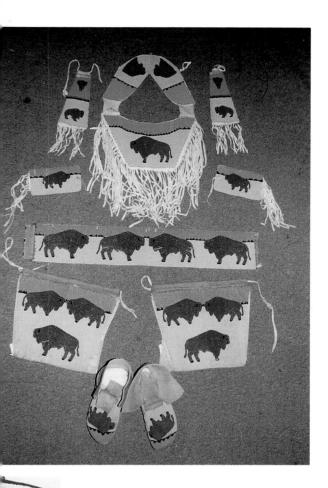

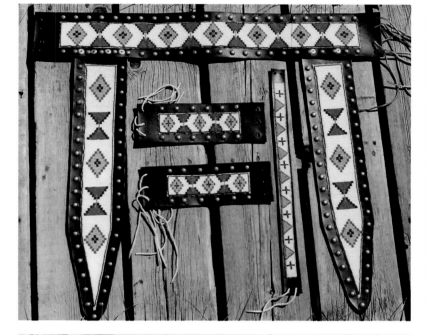

CANADIAN BLOOD (BLACKFOOT)
POWWOW DANCE SET Contemp.
Buffalo motif. Applique stitched pale green
and lt. sky blue with black geometrics.
Buffalo are 2 shades of brown with black.
Zippered leggings and fringed cuffs with
29"L x 5"W. belt. Cape is fringed and calico
lined. 9"L moose hide mocs have patched
and torn soles. Shows lot of use. Fair cond.
Est. 625-750 **SOLD $675(96)**

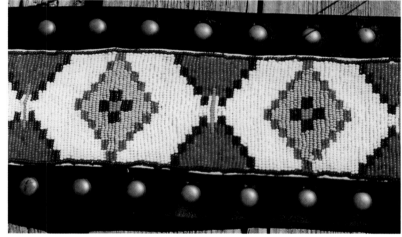

BLACKFOOT-STYLE FULLY-BEADED MEN'S DANCE SET Contemp.
Flathead-made applique(flat) beadwork in white, gr. blue, dk. blue,
Cheyenne pink and pumpkin. (See detail photo). Sewn on canvas. Step-
triangle and diamond pattern. Mounted on heavy dk. brown leather. Brass
spots decoration. Incl. belt: 35", side tabs, cuffs and hat band. Exc. cond.
Est. 750-900 **SOLD $600(94)**

FT. BERTHOLD-SIOUX GRASS DANCE
HARNESS c.1930
2 fully-beaded strips (4" X 41"L)
connected with beaded square. White
bkgrd. stylized floral in bright colors with
red wool binding. Exc. wearable cond. Est.
750-950 **SOLD $750(94)**

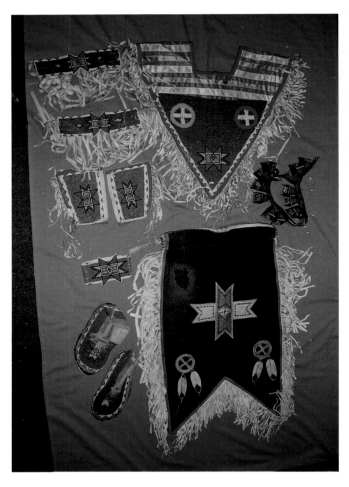

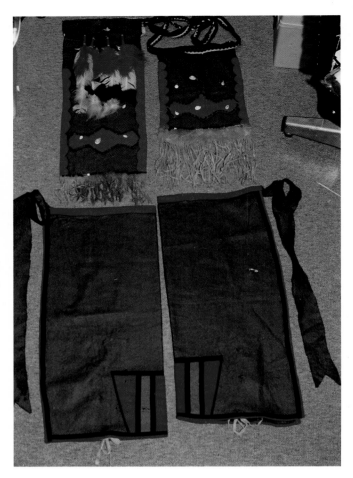

FLATHEAD INDIAN DANCE OUTFIT c.1940
Belonged to the family of John Peter Paul, War Dance Chief. Green felt leggings, dance apron, and bustle trimmed with red felt and gold basket beads, cowrie shells, and smoked brain-tan fringe. Leggings have red muslin binding with silk ribbon trim; red and turquoise felt panels with silk ribbon binding. Est.50/75 **SOLD $50(90)**

BLACKFEET POWWOW DANCE OUTFIT Contemp.
Made by Debbie Paul of Browning Mont. and worn by her Champion Dancer husband Phillip. Fully-beaded with buckskin fringes(dance apron is grey wool partially beaded). Matching cape with sewn ribbons at shoulder, cuffs, 10.5"L dance "mocs"(canvas with rubber soles)show heavy use with missing beads, fringed leg bands, arm band and old dance bells (with heavy clapper). Beadwork is applique stitched-unusual grey background with yellow orange, black and white. Well-used. Fair to poor cond. Est. 300-450 **SOLD $300(95)**

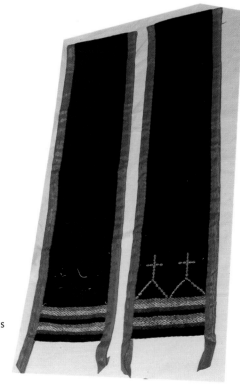

BLACK WOOL RAINBOW SELVEDGE BUSTLE DROPS c.1950
Bound with red rayon grosgrain. 1 panel has 1/4" brass sequins in cross and triangle design; other panel is missing sequins. Blue calico lined. Never worn. Hangs 32"L X 6.75"W. Est. 50-100 **SOLD $50(93)**

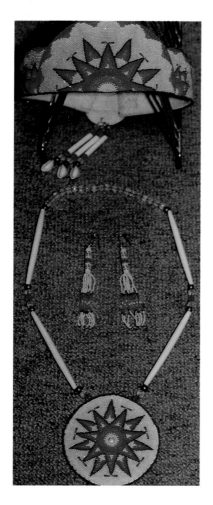

FULLY-BEADED PRINCESS CROWN and
MATCHING MEDALLION NECKLACE
c.1985
Transl. white bkgrd. with burgundy,
orange, cobalt and yellow. All in cuts.
Necklace on bone hair pipes with brass
and yellow and orange facet beads.
Peyote-beaded earrings. Est. 240/275
SOLD $200(90)

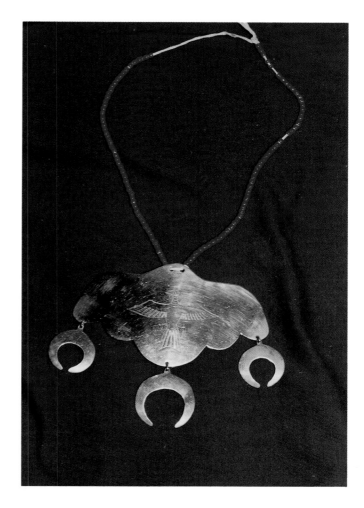

CHEYENNE GERMAN SILVER PECTORAL NECKLACE c. 1984
Strung with center red Crow beads on leather thong. Stamped "DD" on
back. Hangs 18". Ornament is 8" X 6". Est.75/95 **SOLD $75(89)**

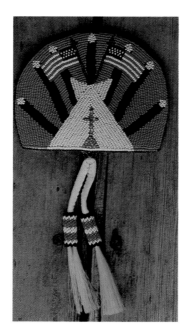

NATIVE AMERICAN CHURCH PIN Fully-beaded symbolic beadwork with
blue background; horsehair dangles with cut beaded peyote stitch trim.
4.5"w X 3.5'" H. + 4" dangles. Est. 60-85 **SOLD $45(88)**

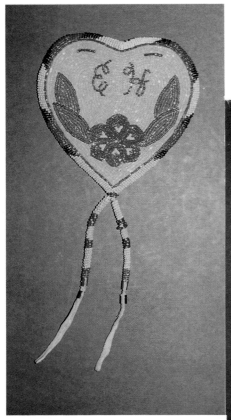

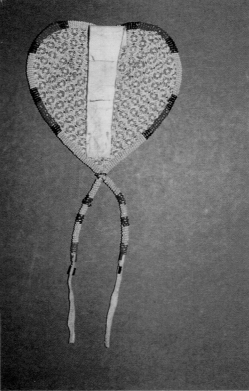

CROW BEADED HEART-SHAPED BELT
ORNAMENT Contemp.
Fully-beaded with yellow tri-cut bkgrd.
and red tri-cuts with t. green cuts edged
in lt. blue, green and red cuts. Bead-
wrapped thong dangles. Calico-backed.
(See back view) 5" X 10" L. Est.110/150
SOLD $100(91)

2 SETS OF DANCE (sleigh) BELLS c.1930
1) matched set grooved chrome-plated brass bells 1.13" diam. with rivet
attachments. 1" W. heavy stamped dyed belt leather. 13"L each. 2)
unmatched 7 (1.13") brass riveted bells on 14" belt leather and double
canvas straps and 3/4" brass bells. Est. 50-95 **SOLD $125(96)**

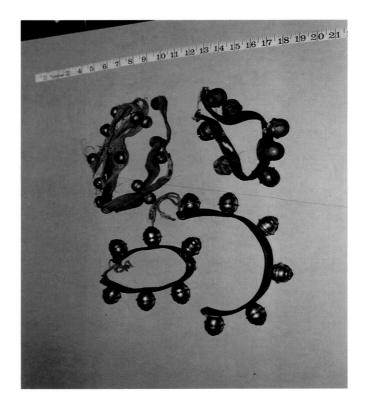

II. Containers, Pouches and Bags

QUILLED and BEADED PIPE BAGS

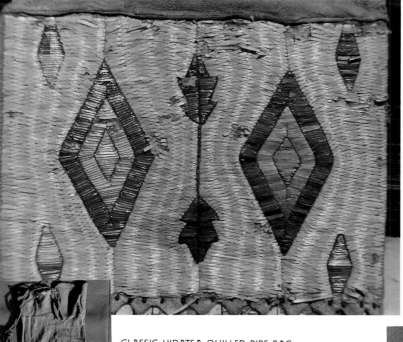

CLASSIC HIDATSA QUILLED PIPE BAG
c.1870.
Each side is fully quilled with very fine porcupine quills (apx 27 /inch). Sinew-stitched panels are 5" X 6.75". Side 1: simple band technique with the yellow bkgrd. in horizontal rows and the 2 large purple, pink and green hexagons in vertical rows. Side 2 is very unique with a contour quilled yellow bkgrd. as part of the design. The bkgrd. has countoured vertical rows of 2 quill diamond technique around the design elements, creating a beautiful textured effect. The designs are 2 large diamonds, 4 feathers and 2 leaf patterns connected by a stem. The quill wrapped rawhide slats are orange with purple, pink and green rectangles and 3 small purple and white crosses. 7"L. X 6.5"W. Buckskin is supple and shows good patina. Sewn quill work has scattering of insect damage and slats are 98% intact. VG cond. Unfaded. 38"L. including fringe. Est. 3500-5000 **SOLD $3050(95)**
See Gilman, Carolyn and Schneider, Mary L., *The Way to Independence*, St. Paul, Minn. Historical Society, 1987: Cover and p. 49.

SiOUX(?) FULLY-QUILLED PIPE BAG With QUILLED SLATS c.1870
RARE. Unusual 3 sinew thread simple band sewn-quilled technique in narrow (5/32") parallel rows. (46 rows). Primarily red with central rectangle in purple and yellow both sides. Each side has same 6 very unusual design elements above and below rectangle. Vertical 1" quill work strip on each side embellished with 4 pairs of tin cones with red feather fluffs. The top has rolled beaded edging in trans. red, periwinkle and cobalt. The large quilled slat panel is on painted parfleche rawhide. One side has heavy braided cord and rolled mustard-colored muslin hanging from top plus 9" dangles with remnants of red quill wrapping and 5 prs. of red fluff/tin cones on bottom. This side of bag has heavy insect damage to the quill work under the dangles in the design elements only. Buckskin is supple and in good cond. Sewn quilled panels apx. 8" X 7.5 W. Slat panels 7.25" X 6.5" L. Buckskin fringes hang 10". 33" Total L. Est. 4500-6000 **SOLD $4000(94)**

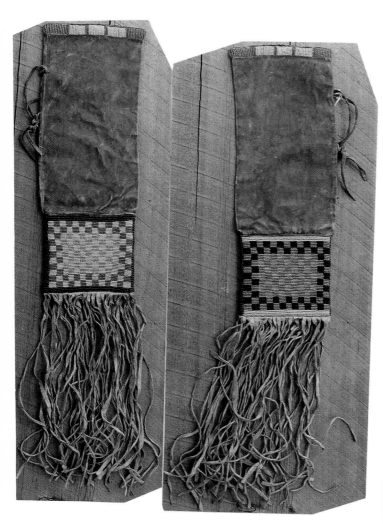

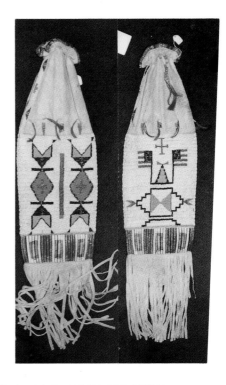

SIOUX PIPE BAG With AMERICAN FLAG DESIGN c.1890
Sinew-sewn and lazy-stitched beadwork. Flag motif, tin cones with red horsehair dangles and quilled panels add to the value of this bag. Bead colors are gr. yellow, white lined red, apple green, metallic silver facets and cobalt blue on white bkgrd. Flag pattern and exc. cond. determine the value of this piece. Est. 2500-3500

BLACKFEET PIPE BAG c.1870
Unusual checkerboard design in different colors each side. I) Apple green, black, pink and gr. yellow; 2) rose white heart, gr. yellow, chalk blue and trans. green. Buckskin fringes and bag are red-ochred. 26" L X 5" W. Good patina. Est. 1500/2500 **SOLD $675(90)**

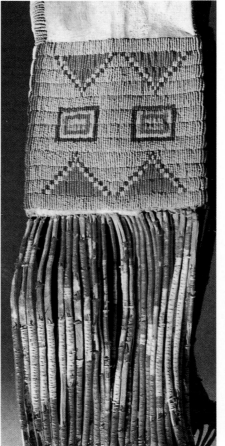
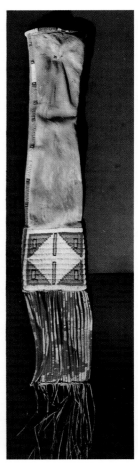

EARLY SIOUX PIPE BAG With QUILLED SLATS c.1860
Beaded panels are sinew-sewn and lazy-stitched; each side different. I) White bkgrd. with pale gr. green, rose white heart, gr. yellow, and cobalt geometric motifs. 2) Periwinkle with Classic early concentric squares and triangular motifs in rose white heart, and gr. yellow outlined in cobalt. Supple buckskin is yellow ochred with excellent patina. Quilled buffalo rawhide slats are 8" L. X 5.5" W. in red, purple, yellow and pale green. Not a single bead is missing or restored. Apx. 50% of the quills are missing. Bottom buckskin fringe shows remnants of dk. blue and dk. green paint; about 50% fringe is missing. 46" L. X 5.75" W. Est. 3000-4000 **SOLD $2750(94)**

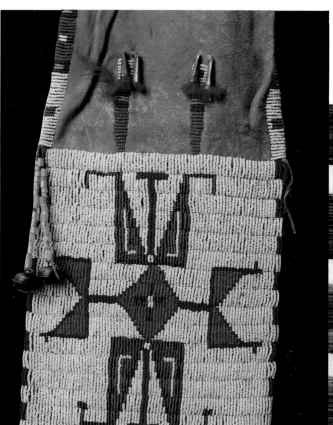

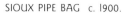

SIOUX PIPE BAG c. 1900.
Sinew-sewn panels are lazy-stitched in white bkgrd with designs in gr. yellow, Sioux green, white center rose, dk. and med. blue, and metallic beads. Quilled panel has red, green and purple designs. Tin cones trim with red feather fluffs, pink basket bead dangles and brass hawk bells. Apx. 42" L. Beaded panel 7" X 8"H. Slats 6+" W X 5+"H. Est. 1800-2500(96)

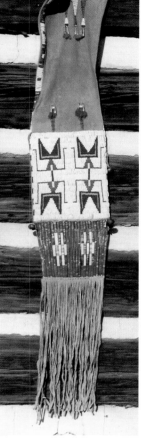

SIOUX PIPE BAG With QUILLED SLATS
c.1890
Lazy-stitched beaded panels (7.5" X 7.5") . White bkgrd. with dk. blue, corn yellow, Sioux green, gr. blue, red-orange and metallic seed beads. Sinew-sewn. Different design each side. Quilled slats (7.5" W X 5") are made out of painted parfleche and quill-wrapped in pred. red. with white and purple designs. Edge-beaded in alt. red, white, and blue. Bottom buckskin fringes are 13" L. 39" total L. Est. 1100/1500 **SOLD $1000(89)**

EARLY PIPE BAG c.1860
Rare. Possibly Ute. Lazy-stitched panel both sides in apple green, trans. green and chalk blue with black. Sides have addition of gr. yellow;top also has additions of brass facets. Quill work slat panel has red, purple and white designs. 5" bead-wrapped drop with horsehair in tin cones. (Not shown). Exc. cond. 28" X 4.75" W. 6" L. buckskin fringe. Est. 2250/4000 **SOLD $2250(92)**

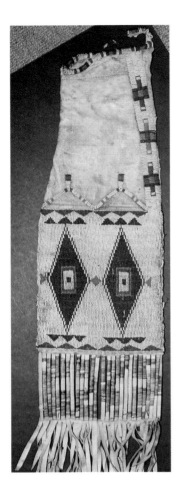

SIOUX PIPE BAG With QUILLED SLATS
c.1870
Beadwork bkgrd. is white lazy-stitch with cobalt, rose white heart, turquoise, and t. lt. green. Quilled panel is pred. red with white and purple crosses. Rolled beaded edging on top. Apx. 1.5" square top corner torn, but no beadwork missing. Fringe partially missing. Fair cond. 33" total L. X 7.75". Est.900/1800 **SOLD $900(91)**

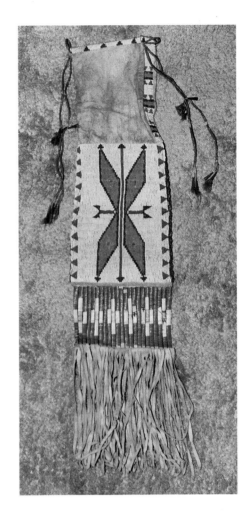

SIOUX PIPE BAG c.1880
Large atypical beaded panel same both sides: double chevron motif. Beadwork is sinew-sewn in gr. blue, dk. cobalt, white lined red, t. gold, etc. Red quill-wrapped thongs have tin cone with red horse hair dangles. Quill-wrapped slats pred. red, have only a few damaged quills. Exc. cond. Apx. 34" L. Est. 2000-3000
SOLD $1050(88)

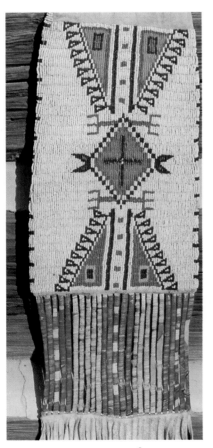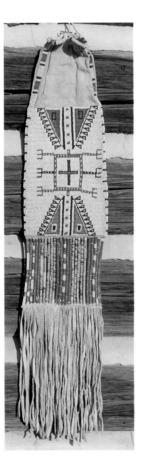

FORT PECK SIOUX PIPE BAG With QUILLED SLATS c.1880
Belonged to the consignor's Sioux grandmother and was acquired by her at Poplar, Mont. on the Fort Peck Reservation. Lazy-stitched and sinew-sewn beadwork on both sides. Unusually intricate design motifs:white bkgrd. Italian 4 ° with central diamond in gr. robin's egg blue;lower triangles in periwinkle with gr. yellow; upper ones in trans. gold outlined in white lined rose and dk. opaque blue. Cross, etc. in faceted brass beads both sides. 2nd side lower triangles are Sioux green,upper ones are periwinkle with same colors as 1st side. Rolled beaded top and vertical beaded stripes. Quilled panel (6" X 6.5") is made from an old painted parfleche. Colors: red, med. blue, orange and white in interesting stripe design. Quills over 90% intact. Buckskin fringe is 11"L. Overall L. is 34" X 7" W. Beaded panel 7" X 11"H. Hide is still soft and supple. Est.2500- 3500
SOLD $3250(93)

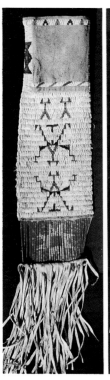
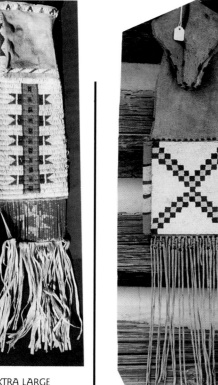
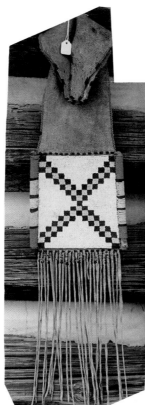
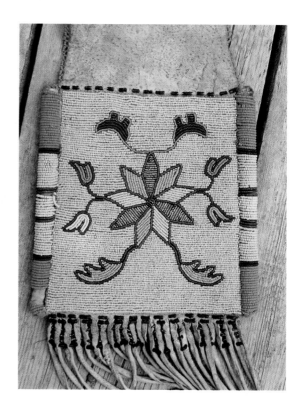

SIOUX PIPE BAG With EXTRA LARGE BEADED PANELS c.1885
Lazy-stitched sinew-sewn beadwork both sides. Beautiful visual piece. Each side has white bkgrd. with very different designs. 1) Apple green central vertical rectangle with small internal squares and outside rectangle and triangular pattern in cobalt, rose white heart and metallic cut brass beads. A bold and striking design. 2) Same colors with "spidery" geometric pattern. Beaded panels are (tall) 12" X 7.5" W. Upper part of buckskin is partially beaded in vertical and horizontal bands of same colors. Quilled slat panel is red with white 8 pt. star and orange square in center. Slats are made from painted parfleche as revealed by missing quill work on apx. 4 slats. Panel is 4" X 7" W. Overall cond. is VG. Fringe hangs 11". Total L. is 35". Est. 2500-3500 **SOLD $2500(94)**

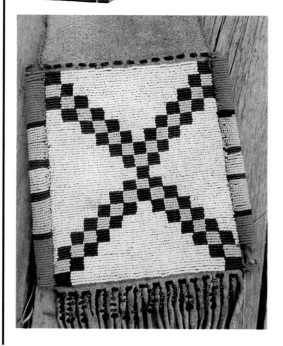
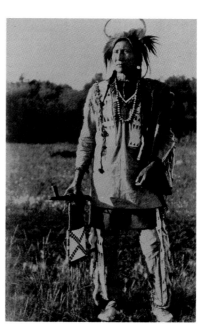

BLACKFOOT PIPE BAG c.1890
Applique stitched using both sinew and thread. One side has an abstract symmetrical floral pattern with lt. blue bkgrd.; the other side has a geometric step pattern with white bkgrd. There is an interesting insertion of metallic glass faceted beads added to the bottom buckskin fringes where it attaches to the bag. An unusual feature is 2 wooden muslin-covered and bead-wrapped sticks on either side of the beaded panels. This was done either as a visual addition or to stiffen the panels. Pipe bags constructed using this technique are scarce and therefore, more valuable.
When this bag was sold in '89 we did not know of the existence of a photo of a Canadian Blackfoot man holding this pipe bag (see photo). This discovery has added significantly to its value for the present owner. Est. 4000-6000(96) **SOLD $1800(89)**

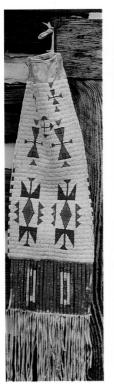
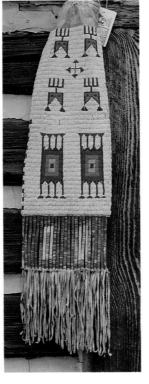
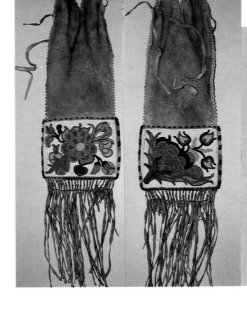
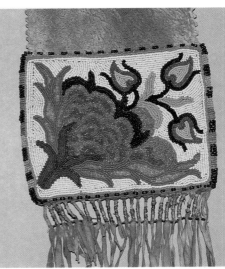

SIOUX PIPE BAG With EXTRA LARGE BEADED PANELS c.1915
Beadwork is sinew-sewn and lazy-stitched. Exceptional design. Due to the fact that the red beads are opaque, and not white-lined, we would date the bag after the turn-of-the-century and possibly as late as 1930 (*See Bead Glossary*). Quilled slats have very few quills missing, same with beadwork. Very visually attractive and in exc. cond. which enhances it's value to collectors. Est. 2000-3500 **SOLD $2500(94)**

CREE PIPE BAG c.1880
Profuse floral patterns (different each side) in lovely pastel shades: t. rose, t.pink, t.gold and white heart rose. Opaque: olive green, med. and dk. gr. blue, c. pink and black. "Pinked" smoked moose hide. Rolled beaded edge same colors. Bottom buckskin fringe quill-wrapped in sections of orange, purple, green and red separated at the bottom by a row of cobalt seed beads. Panels: 6" X 5" H. Apx. 28"L X 6.5". Est. 1800-2500 **SOLD $1850(96)**

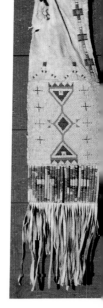

SIOUX PIPE BAG With QUILLED SLATS c.1870
Beadwork bkgrd. is white lazy-stitch with cobalt, rose white heart, turquoise, and t. lt. green. Quilled panel is pred. red with white and purple crosses. Rolled beaded edging on top. Apx. 1.5" square top corner torn, but no beadwork missing. Fringe partially missing. Fair cond. 33" total L. X 7.75". Est.900/1800 **SOLD $900(91)**

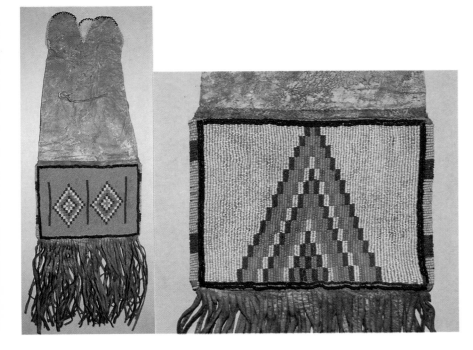
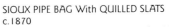
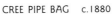

BLACKFOOT PIPE BAG c.1880
Different applique panel each side. 1) Pred. white and porcelain (mixed) bkgrd. with Classic step triangle motif: cobalt, lt. blue, gr. yellow and apple green. Border is double line black. 2) Lt. blue bkgrd. with double diamond separated with 3 cobalt stripes. Border is navy blue. Panels are 7" W. X 5". Rolled beaded sides in chalk blue and cobalt. Characteristic 4 tab top edge-beaded in alternating lt. blue and deep blue-black and green mix. Hide shows traces of red and yellow ochre. Good patina. Fine cond. Total L 25"-bottom fringe 7"L. Est. 1800-2500 **SOLD $1800(96)**

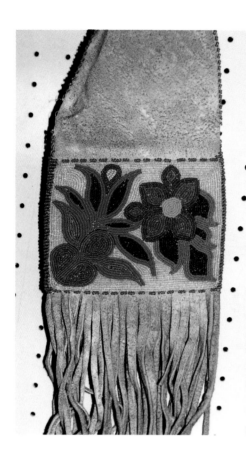
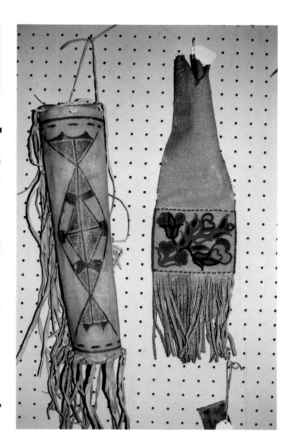

CREE PIPE BAG c.1880
Characteristic profuse floral pattern different each side. Trans.beaded bkgrd. with 3 shades and sizes of rose white heart; 4 shades trans. and gr. blue; trans. rose, pumpkin, brick and black. Rolled edge and edge-beaded sides and top all in beautiful rich shade of rose white heart. Smoked moose hide-dark patina from use. A few scattered inches of edge-beading missing or loose-panel beadwork completely intact. Exc. cond. Est. 1800-2500 **SOLD $1800(96)**

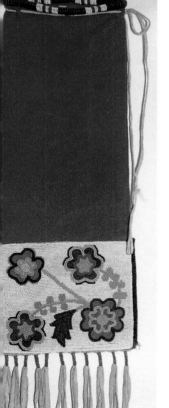
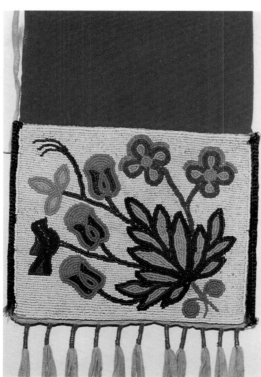

CREE RED TRADE CLOTH FULLY-BEADED PIPE BAG c.1870 RARE. Beaded panels in diff. floral patterns. Each side has typical pastel stylized flowers and leaf motif; 1 side has cobalt bird motif within flowers. Red quill-wrapped buckskin fringe. Expertly restored with old red wool (original wool same but had disintegrated), rolled bead edge and quill work restoration. Otherwise original with all beads intact. 19" X7" bag. 7" X 6" panels. 35" total L. Exc. restored cond. Est. 1250-1750 **SOLD $1000(97)**

Large Bags

BANDOLIER BAGS

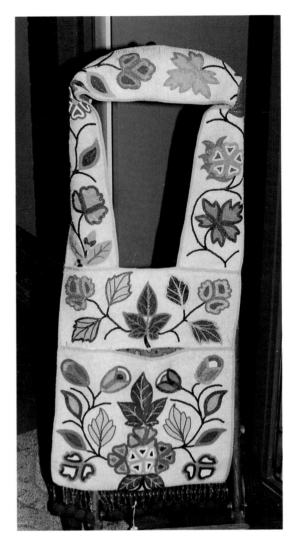

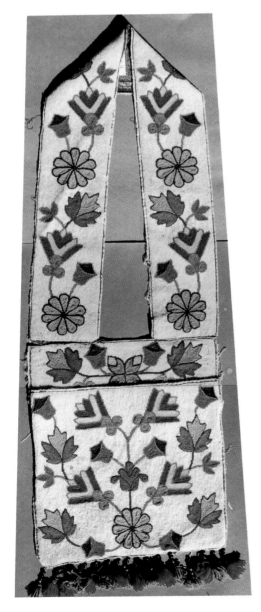

GREAT LAKES FULLY-BEADED BANDOLIER BAG c.1890
The flower patterns are flowing and realistic which is typical of Chippewa beadwork. This is a large bandolier with classic old color beads and designs. The square bag portion has bilaterally symmetrical floral designs and the shoulder straps have asymmetrical designs. Pristine cond. Est. 2500-3500 **SOLD $2000(94)**

GREAT LAKES FULLY-BEADED BANDOLIER BAG c.1890
Characteristic of the Southern region, see reference above. Completely fully-beaded in bilaterally symmetrical abstract floral pattern. Flat stitched in t. rose, c. pink, periwinkle, cobalt, gr. yellow, amethyst, brick, t.red, and apple green. Tassels are alternating faded blue and red wool yarn strung with cranberry faceted beads. Thin fragments of red silk binding (apx. 98% disintegrated). Backed with blue and white calico. All beadwork intact. 13.5"W pouch. Straps 5" W. Hangs 42" L. Est. 1800-3000 **SOLD $1800(96)**

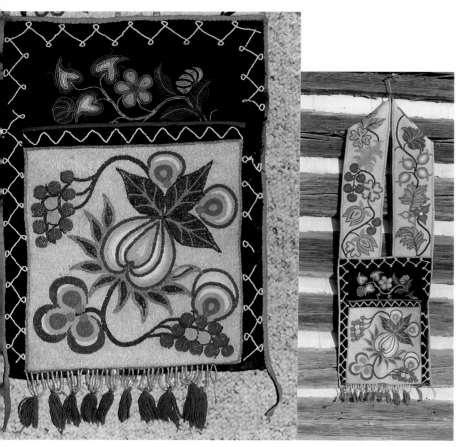

CHIPPEWA FULLY-BEADED BANDOLIER
BAG c.1880
*Belonged to the owner's Sioux grandmother
who acquired it at Poplar, Mont. on the Fort
Peck Res. These bags were popular on both
the Ft. Peck and the Ft. Belknap Res. from
1890 to 1920. There are early photos of
young girls in buckskin dresses with
bandoliers around their necks, which were
examples of trading and gift giving that took
place between tribes.* This piece has many
old bead colors applique stitched into floral
designs. (Note asymmetry of design
elements both on bottom panel as well as
straps.) The bottom section is bound with
faded blue and red military braid. The
bottom panel is bordered with black velvet
and a white beaded border motif. Bottom
fringed with blue wool tassels and t. basket
beads. Shoulder band bound with red
polished cotton. Bkgrd. bead is clear.
Among the myriad of rich bead colors;t.
rose, white lined rose, Chey. pink, gr. yellow
and multiple shades of blue and green. This
bag is in close to perfect cond. 2 bottom
tassels with basket beads are missing. 45" L.
X 13"W. The band is 6" W.; beaded panel
11" X 12". Est.1500-3000 **SOLD
$1650(93)**

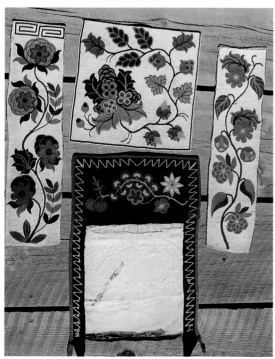

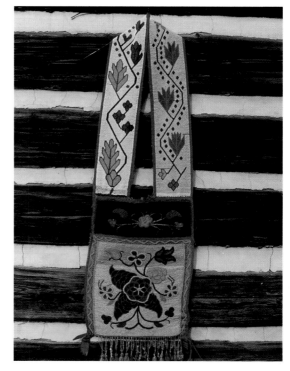

CHIPPEWA FULLY-BEADED BANDOLIER PIECES (4) c.1870
For some unknown reason, this bandolier was dismantled and
never put back together. White bkgrd. with trans. pink, cut rose
white hearts, gr. yellow, pumpkin, trans. gold, gr. dk. blue,
periwinkle, dk. green trans., gr. green, cobalt, apple green, etc.
Unusual double fret pattern at 1 end. Velvet back has porcelain
white zig-zag beaded pattern and burgundy braid binding. Exc.
cond. Straps 5.5" X 23". Pouch 13" sq. 13.5"W X 20"L. Est.800/
1200 **SOLD $825(91)**

GREAT LAKES BANDOLIER BAG c.1890
Probably Chippewa. The shoulder strap is loom-beaded in 2
different stylized leaf motifs while the bottom panel is applique
stitched in curvilinear realistic floral pattern. It is unusual to
see both loom and applique beadwork combined in one
bandolier. The central panel is partially beaded with symmetrical
floral design. Entirely bound with red braid. Multi-colored wool
tassel fringe strung with basket beads.
Est. 1000-2000 **SOLD $450(87)**

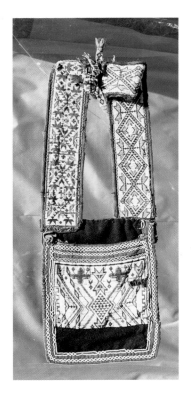

GREAT LAKES LOOM-BEADED BANDOLIER BAG c.1870
Possibly Chippewa. White bkgrd. with C. pink, bright gr. blue, cobalt, trans. rose, and gr. yellow geometric motifs in size 13-16° (very tiny) beads. 5 loomed tabs at top with wool tassels. Applique beaded trim around pouch in "otter tail" and diamond patterns in white and gr. yellow. Panels backed with red and wool trade cloth. Red is saved list (white selvedge) seen on strap underneath. Bound with wool twill red binding and gold military braid. Considerable repair work and re-arranging done long ago including; bottom 1/3 of beaded panel missing and replaced with navy wool. Straps also modified. Pouch 9.25"W. 28" L. Intact but fair cond. Est. 900-1500 **SOLD $1000(94)**

SADDLE BAGS

CHEYENNE QUILLED SADDLE BAG c.1890
Pink with purple and yellow sewn (simple band technique)
quilled lines on buckskin. Seed-beaded side panels in Cheyenne pink, cobalt, white and red design with 16 pairs of tin cones with yellow horsehair. Exc. and original cond. 12.5" W X 9" H. X 2" deep. Est. 900-1600(96) **SOLD $475(87)**

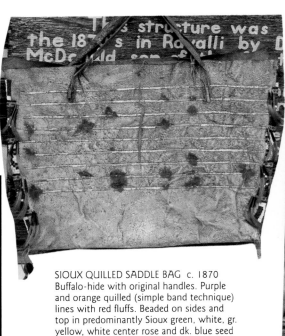

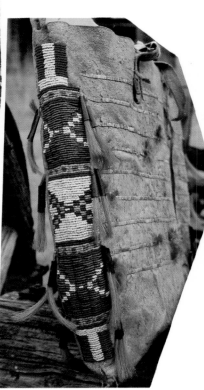

SIOUX QUILLED SADDLE BAG c. 1870
Buffalo-hide with original handles. Purple and orange quilled (simple band technique) lines with red fluffs. Beaded on sides and top in predominantly Sioux green, white, gr. yellow, white center rose and dk. blue seed beads. Tin cone trimmed with yellow horsehair on top and sides and 4 multi-colored yarn tassels on thongs. 15" H. X 21" W. Exc. cond. Est. 1200-2000(96) **SOLD $800(89)**

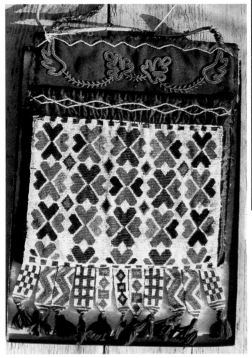

GREAT LAKES LOOM-BEADED BAG c. 1860.
Lovely colors of intense gr. blue, t. rose, cobalt and black on white bkgrd with loom-beaded appendages; each with purple yarn tassel. Brown wool backing with black muslin and black twill tape. Bead-wrapped rope handle. Panel is 10" X 8". 16" total L. X 11". Est. 800-1500 **SOLD $575(88)**

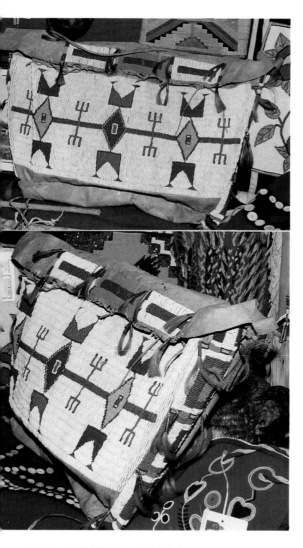

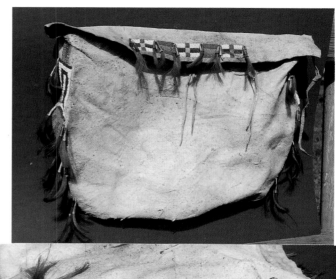

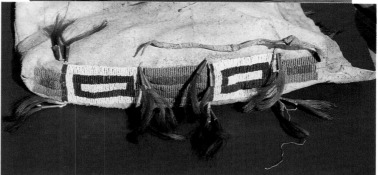

SIOUX PARTIALLY-BEADED SADDLE BAG c.1880
Appears to be buffalo with beaded panels on flap (1.25") and sides (2.5") in rose white heart, cobalt, white, Sioux green and gr. yellow. Sinew-sewn. All intact. Rust-color horsehair protrudes from tin cones above flaps and on either side of the beaded panels-only 2 missing. Exc. cond. Supple and sturdy. 21" W. X 15" H. Est. 600-1200 **SOLD $950(96)**

SIOUX FULLY-BEADED SADDLE BAG
c.1880
Lazy-stitched and sinew-sewn in Classic Sioux design motifs; predominantly white with cobalt, gr. yellow, white lined rose, Sioux green and lt. blue seed beads. Numerous tin cones with yellow horsehair protrusions embellish the beaded flap and side panels. This is an exceptionally large and beautiful piece in superb cond. Est. 4000-6000 **SOLD $5500(92)**

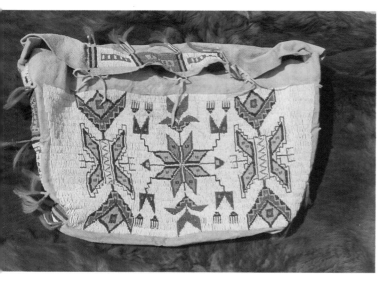

FORT PECK SIOUX FULLY-BEADED SADDLE BAG c.1880
Belonged to the owner's Sioux grandmother who acquired it at Poplar, Mont. on the Fort Peck Res. Rare documented example of unique beadwork designs and colors being used on this reservation during late 19th century. Lazy-stitched and sinew-sewn beadwork in Italian 4°. White bkgrd. with intricate baroque designs in pastels: Chey. pink, trans. rose, gr. yellow, gr. blue, 3 greens; t. emerald, rich med. green and Sioux green; periwinkle and metallic silver facets outlined with t. dk. cobalt. Strip on flap and sides in same colors. Orange horsehair in 35 (1") tin cones along sides and flap. Heavy elk or buffalo hide. Completely sinew-sewn. Original cond. 16" H. X 22" W. Front panel 21" W. X 10.5"H. Est. 3000-5000 **SOLD $3750(93)**

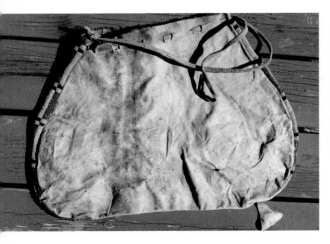

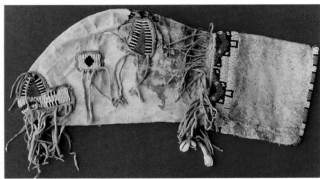

SIOUX CALF HEAD MEDICINE BAG c.1870
RARE. Sinew-sewn and beaded buckskin pieces at ears, eyes, mouth, and nose in white, pumpkin, cobalt and deep rose white heart edged in lt. blue. Head shows remnants of white and brown hair. Rolled beaded edge in alternating lt. blue, white and dk. blue. Thongs at neck strung with old cowries, buffalo tooth, rose white heart and aqua Crow beads. Exc. cond. 16"L X 6.75" w. Est. 3000-5000

RARE ARAPAHOE MEDICINE BAG c.1850
Unusual configuration is identifiable as a sacred bag which held medicine paraphernalia. Made of heavy buffalo including drawstring and one triangular appendage on side-bottom. Sides seed-beaded with 3 lazy-stitch rows in alt. stripes of yellow, and gr. blue with pink and black checkerboard pattern in between. Some gr. blue beads have disintegrated but sinew thread remains. Top is edge-beaded. Patina shows considerable age but piece is still very sturdy. 21"W X 15"H. Est.2000/3500 **SOLD $1200(91)**
*See Kroeber, Alfred L. *The Arapaho* Lincoln, Univ. of Nebr.,1983:38 and 209.

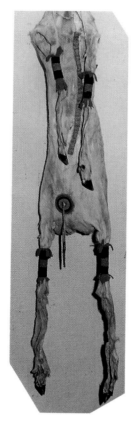

ASSINIBOINE-SIOUX TOBACCO BAG c.1870
Collected in 1880 by Howard M. Cosier, part-owner of a mercantile store on the Fort Peck Res. in Poplar, Mont. Made from the skin of a newborn antelope. The skin has been peeled from the body and tanned with hair and hoofs still intact. Each leg is trimmed with fringed red trade cloth and bead wrapped with white lined rose and cobalt blue seed beads. A beaded rosette and buckskin thong with tin cones are attached to the abdomen. The opening is at the neck. Nice patina and exc. supple cond. Est. 2000-3000

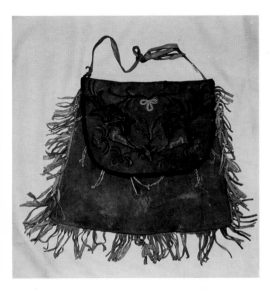

ATHABASCAN MOOSE HIDE BEADED SHOULDER BAG c.1870 Floral beadwork on flap is dk. blue, green, t. purple, t. rose, t. green, tr. blue and metal facets. Sinew and thread-sewn. Blue cloth binding. Moose hide shoulder strap. Exc. cond. 18" X 14.5". Est. 475-800 **SOLD $500(96)**

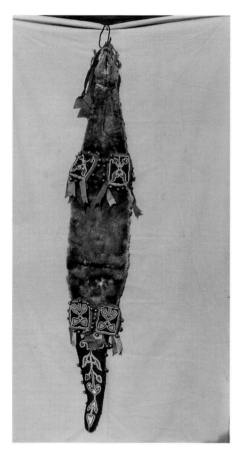

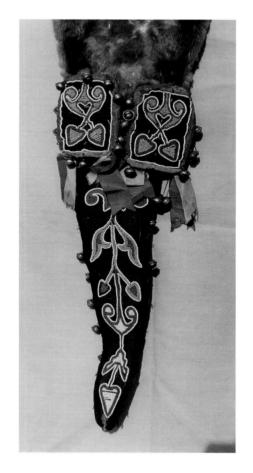

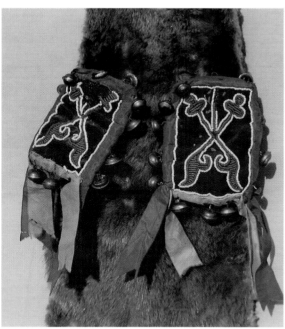

WINNEBAGO OTTER HIDE MEDICINE BAG c.1870

RARE. This imposing otter bag was used to hold sacred medicines associated with the rite of the Great Midewiwin Society. Stylized floral beadwork on black wool panels are bound with green silk ribbon and the tail panel is bound with black velvet. Size 5° beads: white outline with gr. yellow, Cheyenne pink, gr. green, white lined red, periwinkle blue, gr. blue and lots of flat brass hawk bells. Red and green silk ribbons tied to the nose of the otter. Sacks of herbs and a bamboo whistle are inside. The bone skull of the otter is still in the head. A few beads missing on 2 front feet panels and some hawk bells missing. Exc. cond. 52" L. Est.2500-3500
SOLD $2750(93)

FLAT BAGS

All bags are applique (flat) stitched unless otherwise noted.
See Bead Glossary for more information.

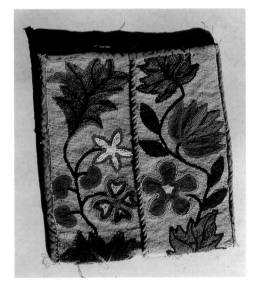

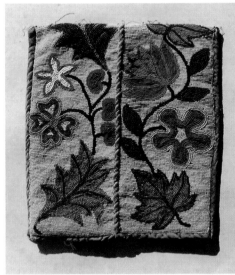

CHIPPEWA FULLY-BEADED (BOTH SIDES) FLAT BAG c.1890
Interesting example of Indian ingenuity-made from a bandolier strap before 1900. Bkgrd.: opalescent white; leaves: trans. lt. green, forest green and Sioux green, Stem:dk. brown Flowers: rose white heart, C. pink, pumpkin, gr. blue, periwinkle, brick, trans. gold. Bound with worn green velvet. Chintz pattern lining. Tapestry braid down center. Exc. cond. 11.5" X 10.25"W. Est. 500-900 **SOLD $600(94)**

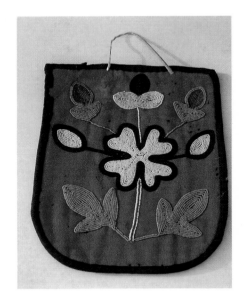

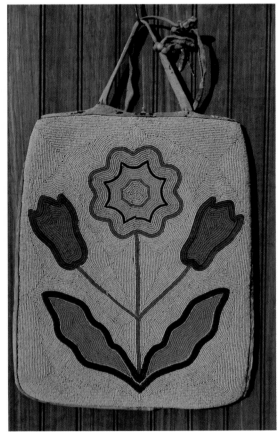

NEZ PERCE LARGE CONTOUR-BEADED FLAT BAG c.1870
Early floral-style design: lt. blue bkgrd. with t. rose, pumpkin, rose white heart, gr. green, periwinkle, gr. yellow, t. green, and t. navy. All buckskin back, handle, and binding. Navy and white calico lined. Exc. shape. 10" X 12". Est. 1200-2000

PLATEAU PARTIALLY-BEADED TRADE WOOL BAG c.1860
Rare. This contour beaded bag has symmetrical abstract floral design on red twill cloth characteristic of early Plateau style. Porcelain white, gr. robin's egg blue, t. rose and black. Black wool binding and grey flannel backed. Wool has tiny moth holes with a few larger ones expertly repaired. Good cond. 11" X 9.25" W. Est. 600-950(96) **SOLD $400(94)**

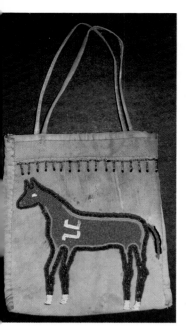
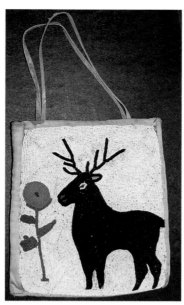

UMATILLA CONTOUR BEADED ELK MOTIF FLAT BAG c.1870
RARE. **High value due to figural subject matter and uniqueness.** White bkgrd. with dk. cobalt elk figure, stylized sunflower is pumpkin, rose white heart. Opposite side partially-beaded with concentric outline (spirit line) horse in periwinkle, gr. yellow, Sioux green outlined with rose white heart; white horse track motifs. Dk. red calico lined. Muslin bound. Exc. shape. 9"L. X 8" W. Est. 1800-3000 SOLD $2300(97)

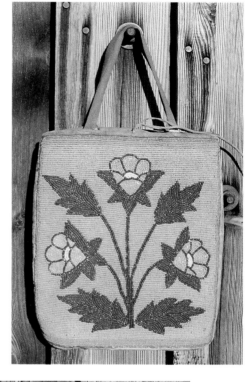

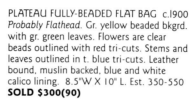

PLATEAU FULLY-BEADED FLAT BAG c.1900
Probably Flathead. Gr. yellow beaded bkgrd. with gr. green leaves. Flowers are clear beads outlined with red tri-cuts. Stems and leaves outlined in t. blue tri-cuts. Leather bound, muslin backed, blue and white calico lining. 8.5"W X 10" L. Est. 350-550 SOLD $300(90)

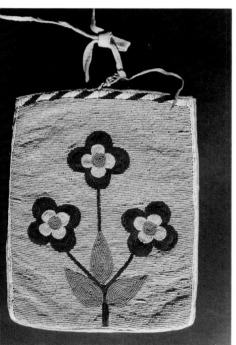

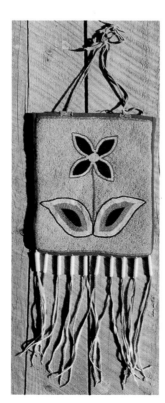

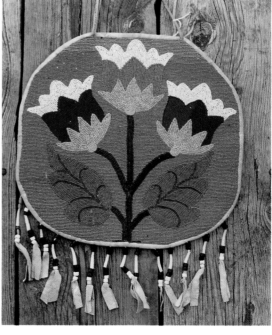

EARLY PLATEAU FULLY-BEADED FLAT BAG c.1875
Cheyenne pink bkgrd. with pale blue border and diagonal cobalt stripes at top. Stylized flowers are trans. cobalt, gr. yellow and Sioux green centers and leaves. Stems are cobalt. Buckskin backed. Green plaid calico lined. Buckskin handles. Exc. patina. 9" X 12". Est. 800-1,500 SOLD $900(96)

PLATEAU FULLY-BEADED FLAT BAG c.1890
Possibly Cayuse. Pink bkgrd. stylized floral design in black, t. yellow, opalescent white, t. pink and red white heart. Gingham lined. Bound with red wool. Pendleton blanket backed. 10 white tube beads on buckskin thongs form bottom fringe, 8.5"L. 10.5" X 8.75" W. Exc. cond. Est.400-600 SOLD $300(91)

NEZ PERCE FULLY-BEADED FLAT BAG c. 1910.
Bkgrd. is lt. blue with dk. blue, green, white and old mustard. Bird is brown cut beads. Buckskin back and fringe. Lining is an interesting floral calico. 10" W. X 12". Est. 450-700 SOLD $395(87)

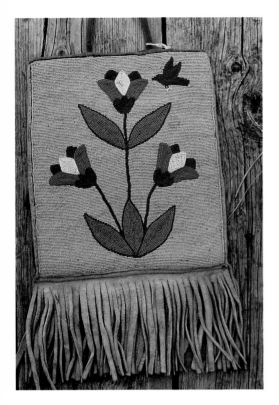

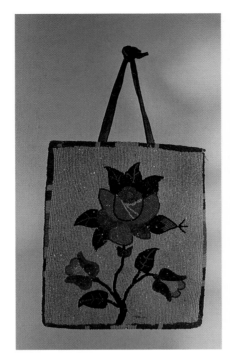

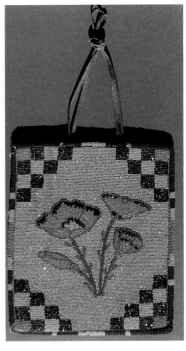

NEZ PERCE FULLY-BEADED FLAT BAG c. 1910.
Bkgrd. is lt. blue with dk. blue, green, white and old mustard. Bird is brown cut beads. Buckskin back and fringe. Lining is an interesting floral calico. 10" W. X 12". Est. 450-700 **SOLD $395(87)**

UMATILLA FULLY-BEADED FLAT BAG c.1900
Owned by Irene Crawford of Pendleton, Ore. Beaded both sides in outstanding floral designs. All size 13° cut beads. Poppies have lt. blue bkgrd. with t. red, t. green, gr. yellow checker board in corners; roses have pink bkgrd. Rolled edge-beaded in gr. yellow, royal blue and periwinkle. 7" W. X 8.5". Est. 450/850 **SOLD $450(93)**

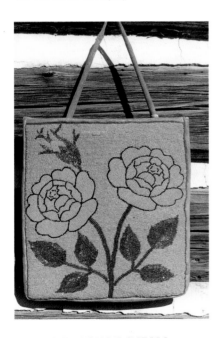

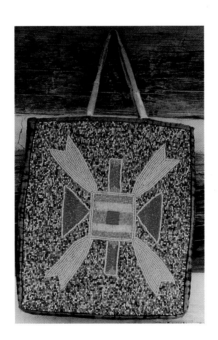

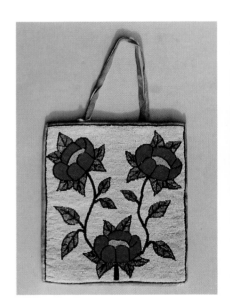

FLATHEAD FULLY-BEADED FLAT BAG c.1920
Purchased directly from Cecile Vanderburg on the Flathead Res. A large and fine example of this style of woman's bag. Pumpkin-colored flowers outlined in iris tri-cuts on lt. blue bkgrd. with green tri-cut leaves and t. brown stems. Border and leaf veins in red white hearts. 12.5" L. X 11" W. Est.475/600 **SOLD $450(95)**

FLATHEAD FULLY-BEADED FLAT BAG c.1920
Bkgrd. is tri-cut multi-color with corn yellow and red tri-cut motif with gold, clear and pink tri-cuts. Dk. green worn velvet binding. Magenta wool back with interesting single white beaded stripe (not shown). 9"W X 11"L. Est. 200/300 **SOLD $200(93)**

LARGE FLATHEAD FULLY-BEADED FLAT BAG c.1920
White bkgrd. with 3 flower symmetrical pattern. Flowers are t. red, corn yellow outlined in black iris tri-cuts; t. lt. green leaves outlined with forest green tri-cuts and gr. green stems. Bound and backed with smoked buckskin. Buckskin handles. Polka-dot calico lining. Exc. cond. Apx. 10" W X 12" H. Est. 375/450 **SOLD $375(94)**

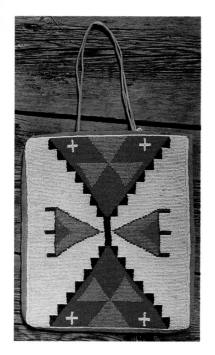

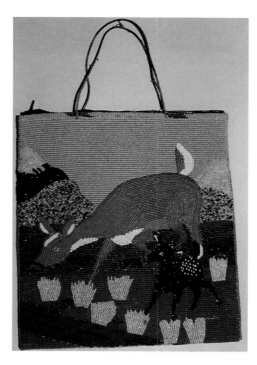

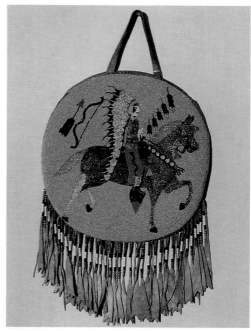

NEZ PERCE FULLY-BEADED FLAT BAG
c.1900
White bkgrd. with red white heart, apple green, t. gold, amethyst, t. blue and white. Striking geometric design of opposing triangles. Backed with red wool; bound with orange muslin. 2-color navy calico lined. Exc. cond. 9" W. X 11". Est. 450/800 **SOLD $475(90)**

FLATHEAD FULLY-BEADED PICTORIAL BAG
c.1935
Purchased from Cecile Vanderburg on the Flathead Res. Exceptional quality piece. 1) Indian head with feather war bonnet contour-beaded on periwinkle bkgrd. 2.) Doe and fawn scenic pred. lt. blue, bright green and many tones of brown. Over 25 different bead-colors incl. tri-cuts. Calico-lined. 10.25" X 9.38" W. *NOTE: High price determined by highly desirable pictorial style subject matter.* Est. 1500-2500 **SOLD $700(91)**

CHIPPEWA-CREE PICTORIAL FULLY-BEADED FLAT BAG c.1920
Belonged to Louise Flurey. Rocky Mountain House, Alberta. Purchased from her son, William, and granddaughter, Roseanna. Well-executed horse with Indian rider wearing trailer bonnet and carrying feather lance. Bow and arrow upper left. Lt. blue bkgrd. with red and black plus varying shades of grey, white and tri-cut metallic beads. Bottom buckskin tab fringe with lt. blue, white and black tile beads. Apx. 14"W X 15" plus fringe. *NOTE: High price determined by highly desirable pictorial style subject matter.* Est. 1500-2500 **SOLD $1700(96)**

PLATEAU FULLY-BEADED FLAT BAG
c.1920
Lt. blue bkgrd. with black and white eagle and red, white and blue American flag. Border is single line each red, white and blue. Binding and back are dk. purple velvet. Buckskin handle. Purple floral calico lining. 10" diam. VG cond. Est. 275-450 **SOLD $275(95)**

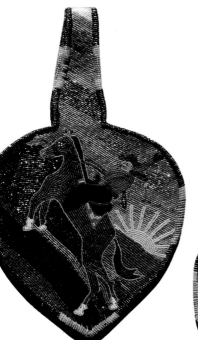

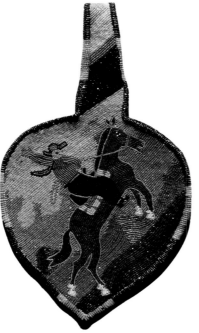

NEZ PERCE FULLY-BEADED PICTORIAL BAG
c.1910
Each side is a different cowboy scene reminiscent of Pendleton Round-up Days. Marvelous blend of over 30 subtle bead colors incl. metallic grey and many tri-cuts; mauves, greens, roses, gr. yellow, etc. Spectacular piece- now worth much more due to unique cowboy motif and fine craftsmanship. Exc. cond. 15" X 9" W. Est. 1500-2500(96) **SOLD $475(89)**

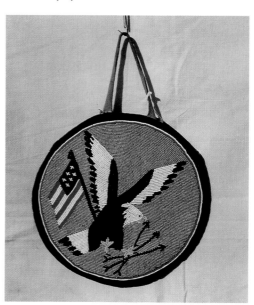

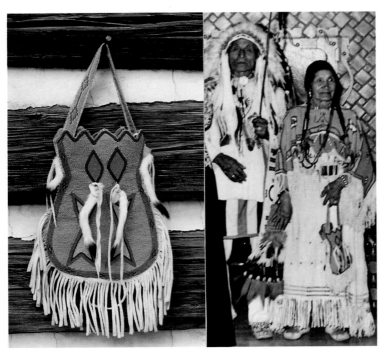

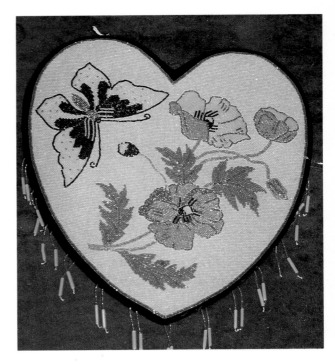

BLACKFEET BEADED BAG c.1930
This bag belonged to and was probably made by Julia Wades-In-The-Water, who was one of the most famous Blackfeet women. See photo of Julia (with her husband) holding this bag. A notarized Certificate of Authenticity accompanies this bag. It was collected by Harold and Irene Hanneman who owned a store on the Blackfeet Reservation from 1936-1962. Tulip shaped with beaded handle. Fringed. 6 carved bone elk teeth and 4 ermine tails. Design is same on both sides. Beaded on white buckskin; lt. blue bkgrd. with designs in white lined red, gr. blue, mustard yellow, cobalt blue and orange cut beads. Expertly applique stitched. Perfect cond. except for a 1" row of missing gr. blue beads. This bag can only appreciate in value. **Without the photo this bag would be worth less-prob. about $500.** Overall L (excl. handle) is 13.75". Est. 1200-3000 **SOLD $1000(95)**

LARGE NEZ PERCE FULLY-BEADED BAG c.1940
Heart-shaped. All tri-cuts: lt. blue bkgrd. with yellow, dk. blue iris and gold iris beads. Calif. poppies are orange, gold and yellow outlined in red; 3 colors of green in leaves and stems. Twisted buckskin handle. Red iris tri-cut fringe with orange facets. Black velvet bound; lined with green calico. Back is dramatic orange wool felt with applique black felt design (not shown). 14" X 14". Est.500/650 **SOLD $350(92)**

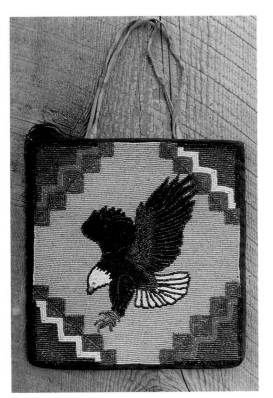

LARGE NEZ PERCE FULLY-BEADED FLAT BAG c.1940
Cute kitty and puppy motif. Blue bkgrd. with apple green for grass. Basket is yellow outlined with black tri-cuts. Kitty is opalescent white and dog rust-both with metallic outlines. Dk. red corduroy backed-red velvet bound-calico lined. 13"W X 15"H. Exc. shape. Est.375-500

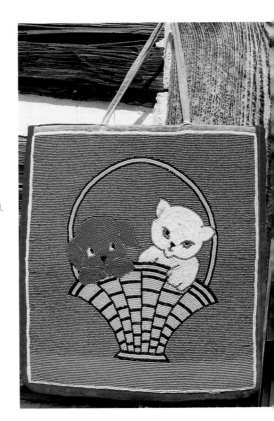

NEZ PERCE FULLY-BEADED FLAT BAG c.1910
Made by Nemo Spaulding. Dynamic eagle motif in dk. brown, grey, metallic, and iris on lt. blue bkgrd. Geometric design in corners in tri-cuts;green,royal blue, rose, and soft orange. Calico lined; black cotton backed. Exc. cond. 9" W X 10" H. Est. 550/850

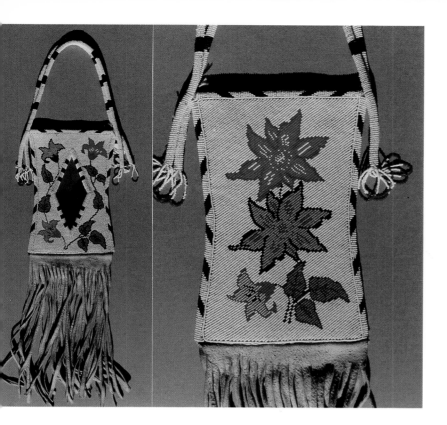

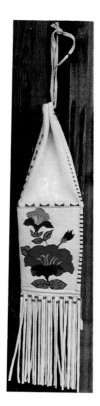

CROW FULLY-BEADED MIRROR BAG c.1960
Collected at Hardin, Montana, on the Crow Res. This style of bag is used by Crow men with mirror showing so that they can arrange their hair and face paint at Pow-Wows and later carry as part of the dance costume. Unique Crow applique beadwork with typical floral patterns positioned in diagonal bead lines. Size 13° beads in all opaques: red, greens, blues and orange on white bkgrd. Diamond shape cut-out for mirror and outside edges and handles bead-wrapped in white and dk. blue stripe. Apx. 24"L incl. buckskin fringe X 7" W. Est. 575-850 **SOLD $475(90)**

CROW PIPE BAG Contemporary.
Unique Crow-style beadwork similar to preceding mirror bag. White brain tan hide. Pred. white 2-sided beaded panel with red, lavender, dk. blue and green diagonal stitch floral design (same both sides). White and red beaded trim. Apx. 30" L X 6" W. Est.350-500(96) **SOLD $175(87)**

Small Bags

BELT POUCHES, PURSES AND STRIKE-A-LITES

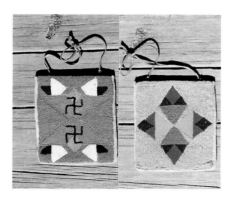

PLATEAU FULLY-BEADED FLAT BAG c. 1900
Beaded both sides in different geometric designs. 1) two black swastikas (friendship design) against pumpkin triangles with cobalt, white and lime green elements on med. blue bkgrd. 2) Lt. turquoise with red, t. cobalt, med. green, and mustard design. Black silk binding at top opening. Calico lining with buckskin binding and handle. VG cond. 6" W. X 6.25". Est. 400-600 **SOLD $350(96)**

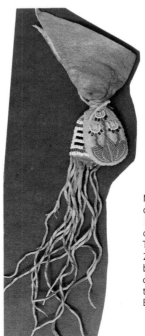

NEZ PERCE SET OF 2 MEDICINE POUCHES c.1890
1) Floral pattern in lt. green and pumpkin cuts; pale blue. Chey. pink, black and brick. Triangular buckskin top flap. 2.25" X 1.5" W. 2) Brick-stitched panel in white, black and brick stripes with long buckskin fringes contains old dentallium. 2.25" W. Tied together long ago with thong. Hangs 15". Est.300-450 **SOLD $380(93)**

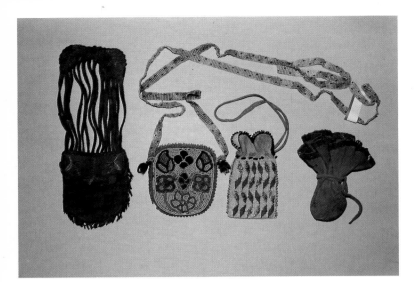

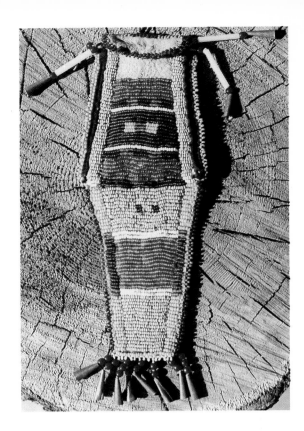

Left to Right: PLATEAU SILK EMBROIDERED BUCKSKIN
"PUZZLE" BAG
Dark patina from age and use-embroidery all intact. 9" X 3" W.
Est. 110-150 **SOLD $135(97)**

ATHABASCAN FULLY-BEADED POUCH c.1890
Beaded both sides in similar contoured design. Lt. periwinkle
bkgrd. with t. rose, C. pink, t. garnet and other pastels.
Diagonally edge beaded in t. gold over red muslin welt all
around. Red and blue wool tassels at strap fastening. Red calico
lining. Loom beaded clear with cobalt strap hangs 30"L. Exc.
cond. Pouch 3" X 3.5". Est. 175-300 **SOLD $200(97)**

WASCO LOOM BEADED POUCH c.1900
Plateau-Columbia R. tribe. Buckskin lining. Opal. white with
slanting diamond all-over design in apple green and amethyst.
Beaded both sides. Black and Chey. pink edge-beaded top with
drawstring. 4.25" X 2.5" W. Exc. cond. Est. 150-225 **SOLD
$125(97)**

PLATEAU BEADED BUCKSKIN MEDICINE BAG c.1870
RARE. Still contains original red-ochre. Heavy patina of ochre.
Configuration is a circle tied with thong. 1/2" W. fancy edge-
beaded in pred. gr. blue cuts with red, lt. blue, greens and
cobalt. Exc. cond. 4.5"H. Est. 300-500 **SOLD $250(97)**

CROW FULLY-BEADED POUCH c.1880
Rare. Beaded one side; fully-beaded tab trimmed with cobalt
beads and 11 tin cones. Beads are Crow pink, gr. yellow, gr.
green and t. gold. Narrow black silk trim on both sides. 9" total
L. Pouch is 3" X 3.5" L. Est.500-800(96) **$275(87)**

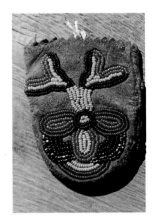

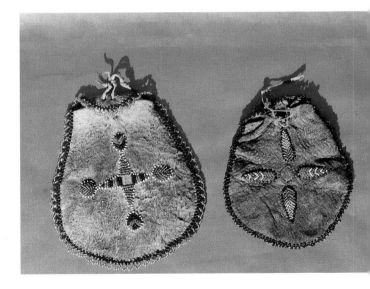

CROW(?) PARTIALLY-BEADED MEDICINE POUCH c.1890
T. rose, Crow pink, gr. blue, t. cobalt, gr. yellow and metallic
cuts. Abstract floral design same both sides. Polka dot calico
lining. Dk. patina shows age and use. Completely intact. Exc.
cond. 2.5" W. X 3.25". Est. 195-295 **SOLD $100(95)**

SIOUX PARTIALLY-BEADED BUCKSKIN POUCHES c.1880
Cut beads in Chey. pink, apple green, rose white heart, cobalt,
t. gold and pale blue. Buckskin shows age with dark patina.
Sinew-sewn. Exc. cond.
LEFT TO RIGHT: Edge beaded in t. rose and cobalt. 4.5" X 5.5" H.
Est. 175-350 **SOLD $200(94)**
Edge beaded in cobalt. 3.5" X 4.5" H. Est. 175-350 **SOLD
$200(94)**

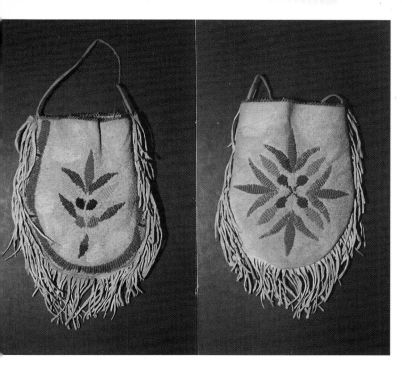

SIOUX PARTIALLY-BEADED BUCKSKIN POUCH c.1890
Sioux green, t. rose, gr. yellow and cobalt stylized floral pattern; different each side. Rose and green edge-beaded top. Very fine buckskin fringes all-around. Good patina. 5" X 4"W. Est. 250/400 **SOLD $200(91)**

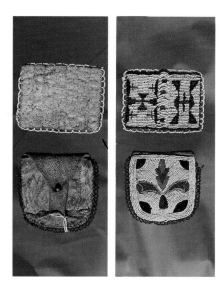

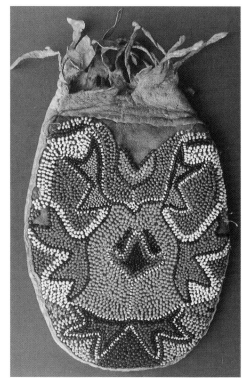

TOP (left and right): SIOUX FULLY-BEADED CIGARETTE PAPER HOLDER c.1880
White bkgrd. with t. grey-green, t. cobalt, rose white heart and brass facets. White edge-beaded and sinew-sewn-all beads are intact. Perfect cond. Good patina. 4 X 3.25". Est. 250-475
SOLD $300(95)
BOTTOM (left and right): FLATHEAD BELT POUCH c.1890
Fully-beaded front in contoured beadwork white lined red, t. yellow, purple and dk. green cut beads; also gr. and lt. blue. Buckskin back with belt loop and brass button-down flap on back. Some beads loose on edging. Apx. 4" X 4". Est. 200-300
SOLD $250(95)

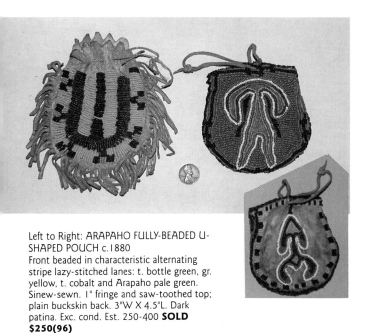

Left to Right: ARAPAHO FULLY-BEADED U-SHAPED POUCH c.1880
Front beaded in characteristic alternating stripe lazy-stitched lanes: t. bottle green, gr. yellow, t. cobalt and Arapaho pale green. Sinew-sewn. 1" fringe and saw-toothed top; plain buckskin back. 3"W X 4.5"L. Dark patina. Exc. cond. Est. 250-400 **SOLD $250(96)**

PLATEAU U-SHAPED BEADED POUCH c.1870?
Different each side: Apple green bkgrd. with unusual abstract shape in t. cranberry, rose white heart, t. gold white and periwinkle bordered with dk. cobalt. Other side abstract shape partially beaded in Forest green, white lined rose and gr. yellow with border of alt. gr. yellow and dk. cobalt outlined in dk. cobalt. 4" X 3L". Good patina. Exc. cond. Est. 300-400 **SOLD $300(96)**

SHOSHONE OR UTE FULLY-BEADED OVAL SHAPED POUCH c.1870
Rare. Unusual bead pattern and sewing technique; each bead sewn separately. Abstract pattern in beautiful pastels: gr. yellow, blue-green cobalt, gr. robin's egg blue, Crow pink, periwinkle, tiny 14° cut rose white heart and white. Apx. 50% are cut beads. Green muslin lined. Top has buckskin fringe. 7"L X 4.5". Est. 450-750 **SOLD $1585(94)**

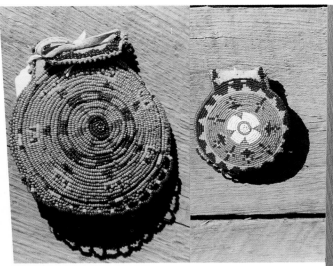

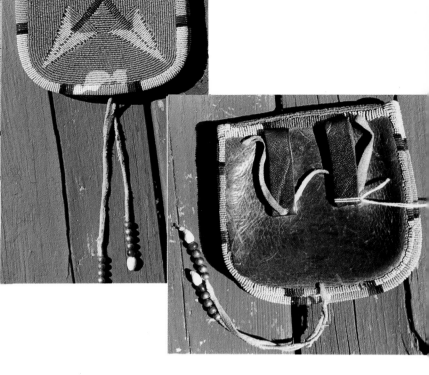

NORTHERN UTE POUCH c.1880
Fully-beaded both sides with fold over flap at opening. Sinew and thread sewn with lt. blue, gr. yellow, dk. blue, white, lt. green, white lined rose and metallic gold faceted beads. Exc. cond. Apx. 4" X 4.5". Est. 300-450 **SOLD $325(94)**

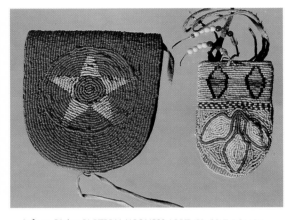

Left to Right: PLATEAU HARNESS LEATHER BELT POUCH
c. 1890
Fully-beaded front flap in star motif in pink, apple green and t. yellow on periwinkle bkgrd. Back has buckskin belt loops. VG cond. Nice patina. 3.75" X 4.25". Est. 375-600 **SOLD $375(94)**
PLATEAU FULLY-BEADED (BOTH SIDES) MEDICINE POUCH
c. 1880
Contour beaded in **all cut beads**. Lt. blue bkgrd. with abstract leaf and diamonds: gr. yellow leaves outlined in rose white hearts; orange diamonds outlined in black with t. turquoise stripe. Sides lazy-stitched in pink and rose cuts. Same design both sides. Bead dangles. 3.25" X 2 .25"W. Est. 250-395 **SOLD $275(94)**

NEZ PERCE FULLY-BEADED BELT POUCH c.1890
Given to Owhi, a famous Yakima Indian, at Chief Joseph Memorial Celebration in 1905. (Owhi joined Chief Joseph's band during the Nez Perce Wars.) Includes signed document of purchase. Pouch front has apple green bkgrd. with crossed arrow motif in cut beads; t. rose, gr. yellow, cobalt and pearl. Border all cut beads: lt. blue, t. rose, cobalt and periwinkle. Flap red calico-lined. Harness leather pouch also has cut bead rolled beaded edge. Nice patina. Thong ties with brass beads, t. rose and olivella shells. Apx. 5.5" sq. Exc. cond. Est.1200/1800 **SOLD $1275(91)**

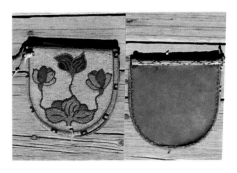

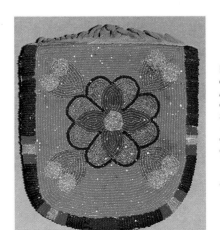

PLATEAU FULLY-BEADED BELT POUCH
c.1890
All cut tiny beads (apx. size 14°) gr. robin's egg blue bkgrd. with t. gold, t. pale yellow, and white lined rose abstract floral motif. Pale t. green leaves. Surrounding border is t. cobalt with red and t. yellow stripes. T. cobalt and turquoise bugle beads border back of pouch.
1/2" buckskin fringe at top. Exc. patina, colors and cond. 5" L X 4.5" W. Est. 250-500 **SOLD $306(95)**

CROW BELT POUCH c. 1890
Old-style floral patterns. Bkgrd. is pearl white;design is applique stitched in dk. t. green, white lined red, Chey. pink, lt. green, white lined rose, periwinkle, yellow, cobalt, med. blue and cut bead t. rose. 2 thong dangles with lt.blue and gold basket beads one side; other side are missing. Pouch is made from brown cowhide. Thread-stitched. Patina and designs and cond. are excellent. 6.5" X 6.5" Est. 850-1200

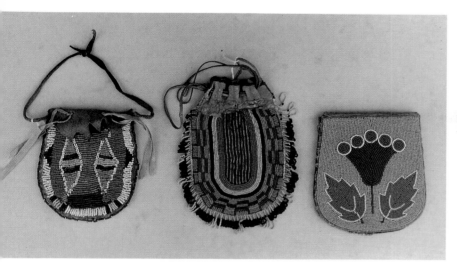

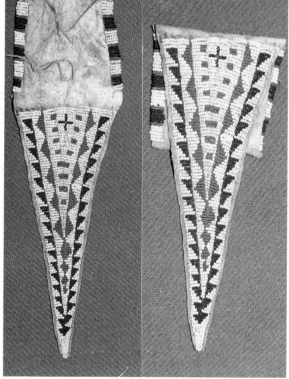

Left to Right: CROW SMALL BEADED POUCH c.1880
Front beaded in trans. pink, trans. rose, apple green, lt. blue, gr. yellow and emerald green geometric motif. T. green edge-beaded. Silk ribbon ties on top flap. Buckskin backed. Dark patina. 4"W X 5"L. Est.450-650 **SOLD $400(93)**

UTE DRAWSTRING TOP BAG c.1890
Fully-beaded 1 side in t. cobalt, gr. robin's egg blue, t. rose, apple green, and gr. yellow. 3/4" bead loop fringe all-around in opalescent white, alternating cobalt and gr. yellow. T. rose edging at top. Opposite side has partially beaded heart shape in diagonally beaded brass and t. green beads. (not shown) Est.600-700 **SOLD $550(93)**

FULLY-BEADED BELT POUCH c.1870
Crow or Plateau. Applique stitched unusual stylized flower: lt. blue bkgrd. with t. navy, white lined rose and blue outline. (This pouch originally had a beaded border on the edge which has been cut off leaving the sinew threads.) Back panels are made from old boot leather which shows the design stitching as on Cavalry boots. Exc. cond. Est.300-500 **SOLD $250(93)**

SIOUX/CHEYENNE TRIANGULAR FLAP BELT POUCH c.1875
This is a sought-after, un-common and early style. Classical design of cross, triangle and bar motifs: white bkgrd. with t. navy, rose white heart and Sioux green. Apx. 4.5" sq. pouch 10"L flap. Exc. patina and cond. Est. 1100-2500 **SOLD $1800(96)**

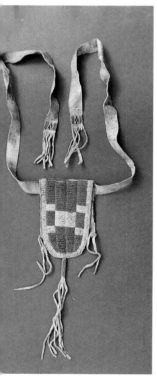

UTE FLAP POUCH c. 1860.
RARE. Lazy-stitched beadwork in lt. blue, Sioux green, med. blue and t. rose. Sinew-sewn on white buckskin. Belt is sewn to back of pouch (52"L) with row of beadwork and fringe on either end. This is a very rare example in exc. cond. Good natural patina. Pouch is 4" sq. with 6" flap Est. 1200-2000 **SOLD $1100(95)**

Top to Bottom: PLATEAU BEADED HEAVY HARNESS LEATHER BAG c.1880
One side fully-beaded in turquoise bkgrd. with delicate stylized central floral motif: pale blue t. cut greens, mustard, cut t. gold, trans, cut cobalt and red-some very tiny size. Back is partially-beaded abstract floral in Crow pinks, cobalt and gr. yellow. Narrow flap and handle are gold velvet. Back is heavy leather covered with yellow-ochred buckskin. Size 3.63" X 3.75" L. Est. 500-700.

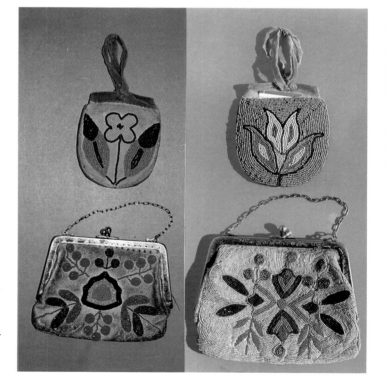

PLATEAU CONTOUR-BEADED CLUTCH PURSE c. 1890
All tiny cut beads in pastel shades incl. rose white heart in even smaller cut beads. One side fully-beaded and other side partially beaded stylized floral motif with red cherries and green leaves. Central motif is robin's egg blue, dk. cobalt and opal. white. Buckskin covered. Stripe satin lined. Clasp has remnants of red bead edging both sides. All beads intact. Good patina. 6"W X 4.75". Est. 280-450 **SOLD $280(95)**

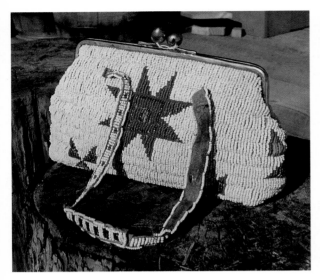

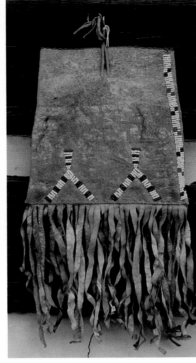

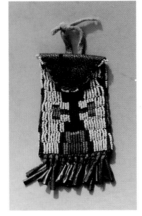

SIOUX TOBACCO BAG c.1880
Buckskin decorated with white, t. blue, red white heart, green and orange seed beads. VG cond. 7" W X 7" H. + 7" buckskin fringe. Est. 150-300 **SOLD $150(89)**

SIOUX FULLY-BEADED CLASP PURSE c.1880
White bkgrd. lazy-stitched with classic geometric motifs; red white hearts, cobalt, apple green, periwinkle, metallic facets and gr. yellow. Bottom has 4 beaded rectangles (not shown), each side similar design with diff. colors. Leather strap handle also beaded. Lined in pinstripe indigo calico. Exc. cond. 9" X 5". Est. 400/650 **SOLD $375(90)**

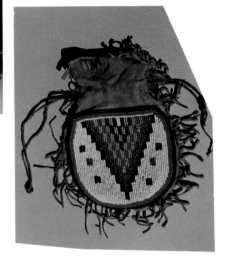

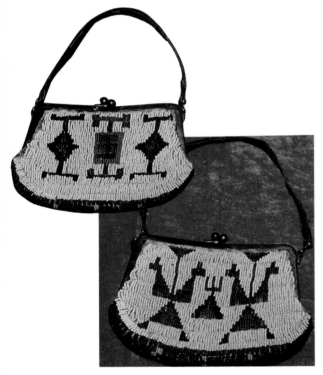

BLACKFOOT TOBACCO BAG c.1900
Beaded 1 side-white bkgrd. with step pyramid in soft hues of blue, rose and pink. Outlined in mustard. 6.5" X 4.5". Est. 200-350 **SOLD $260(89)**

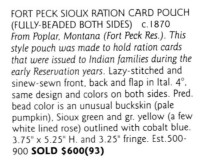

UTE(?) FULLY-BEADED STRIKE-A-LITE POUCH ON HARNESS LEATHER c.1870
Lazy-stitched front is white with turquoise, rose white heart, t. navy and gr. yellow geometric design. 3/4" tin cones on bottom. Single line of white beads missing; otherwise, intact. Good patina. 4.5" incl. fringe X 2.5" W. at bottom. Est. 550-750 **SOLD $525(94)**
NOTE: When purchasing this style of pouch (also see preceding No. Plains strike-a-lite) at any other than a bargain price, be sure to verify it's age and authenticity. Many similar replicas have been made in recent years.

SIOUX FULLY-BEADED CLASP PURSE c.1890
Beaded both sides in delicate, classic patterns; t. rose, t. blue, pumpkin, t. yellow, t. green, white center red, Sioux green and dk. blue on white bkgrd. 7" X 5" plus strap handle. Est. 300-500 **SOLD $250(88)**

FORT PECK SIOUX RATION CARD POUCH (FULLY-BEADED BOTH SIDES) c.1870
From Poplar, Montana (Fort Peck Res.). This style pouch was made to hold ration cards that were issued to Indian families during the early Reservation years. Lazy-stitched and sinew-sewn front, back and flap in Ital. 4°, same design and colors on both sides. Pred. bead color is an unusual buckskin (pale pumpkin), Sioux green and gr. yellow (a few white lined rose) outlined with cobalt blue. 3.75" x 5.25" H. and 3.25" fringe. Est.500-900 **SOLD $600(93)**

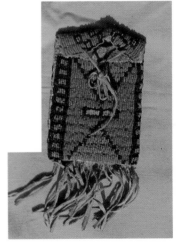

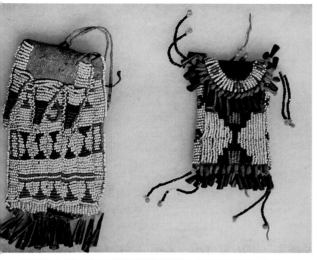

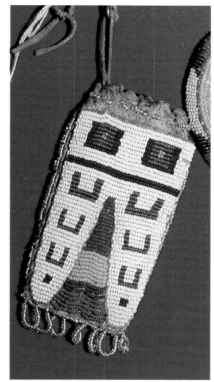

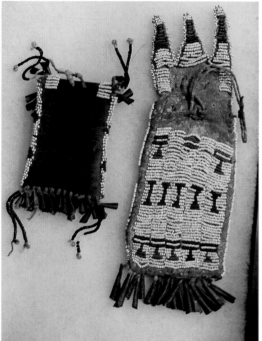

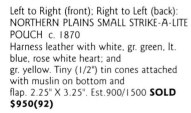

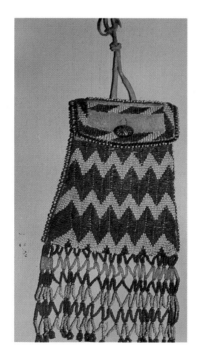

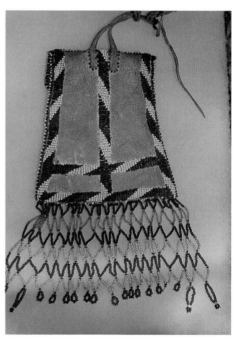

ASSINIBOINE FULLY-BEADED POUCH
c.1880
Made from a set of moccasin toe flaps. This is an example of recycled beadwork-creating an entirely new item. Both sides similar. White bkgrd. white lined rose and cobalt horse track design on the original flaps;gr. yellow, gr.blue and Sioux green form the added triangle. Clear loop beaded fringe and edge-beading with buckskin drawstring at top. Est. 300-600 **SOLD $350(94)**

Left to Right (front); Right to Left (back):
NORTHERN PLAINS SMALL STRIKE-A-LITE POUCH c.1870
Harness leather with white, gr. green, lt. blue, rose white heart; and gr. yellow. Tiny (1/2") tin cones attached with muslin on bottom and flap. 2.25" X 3.25". Est.900/1500 **SOLD $950(92)**

SO. PLAINS FULLY-BEADED BELT POUCH
c.1860
Probably Ute. Delicate color combination of white lined rose, greasy green and white in vertical lazy-stitch pattern on both sides with addition of dk. blue motifs on back. Triple appendages on flap also beaded. Tin cone fringe. White edge-beaded. Apx. 6". Exc. patina and cond. Est. 900-1500 **SOLD $950(92)**

APACHE BELT POUCH c.1870
Characteristic vertical lazy-stitched "zig-zag" pattern in t. cranberry red, white and dk. cobalt. Unusual net-fringe in same colors plus 1 row opalescent white. Edge-beaded in all 3 colors. Metal button flap closure. Apx. 4"W X 7.5" incl. fringe. Est. 1500-2500 **SOLD $1000(90)**

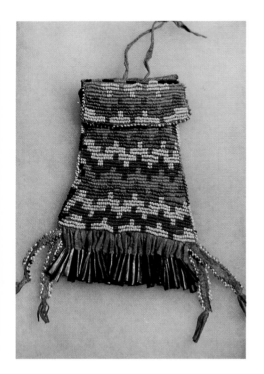

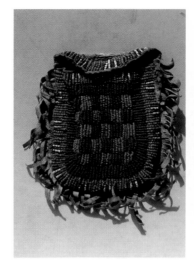
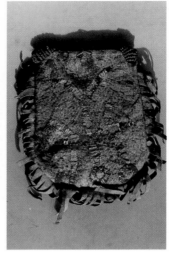

SO. CHEYENNE(?) BEADED and QUILLED POUCH c.1880
Fully beaded checkerboard-style on front in brick, lt. blue, white and rose white heart. Other side is partially sewn quill work in multi-color abstract floral design (50% bug-eaten.) 4.5" H. X 3.5"W. with 1" buckskin fringe. Est. 400-600 **SOLD $450(94)**

APACHE BELT POUCH c.1870
Sinew-sewn with white, lt. blue, gr. yellow and white lined red beads. Fully-beaded front and flap with bottom tin cones and buckskin edge-beaded dangles either side. Exc. cond. Est. 900-1800

SIOUX PARTIALLY-BEADED OVAL POUCH c.1880
Checkerboard pattern with double alternating rows of white, gr. yellow and forest green. Other side (not shown) has cross in cobalt and white (a few rows beads missing). 5" buckskin thong drop on bottom. Nice dk. patina. Apx. 7"L X 5" W. Est. 375-500 **SOLD $310(95)**

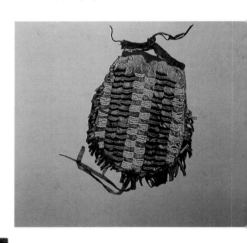

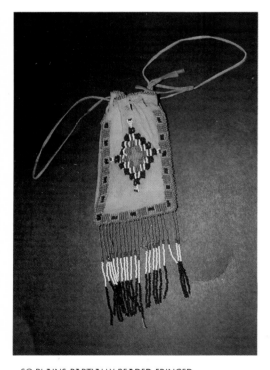

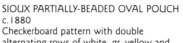

SO.PLAINS PARTIALLY BEADED FRINGED POUCH c.1910
Possibly Apache. Periwinkle, turquoise, pumpkin, white, and red white heart geometric designs. Fringe is periwinkle, cobalt, and red white heart. 1-1/2 strings missing on bottom fringe. 4.5" fringe. 3.75" W. Hangs 10"L. Est.200-350 **SOLD $230(93)**

BANNOCK(?) HORSESHOE-SHAPED FULLY-BEADED BAG c.1900
Lt. blue bkgrd. with unusual "spidery" beadwork design in red white heart, gr. yellow, apple green, amethyst, and pink. Applique stitched. Amethyst and lt. blue edge-beaded top. Leather backed. Apx. 4" fringe + 2" "salt and pepper" beaded fringe. 18" leather handle and outside of bag edge-beaded in t. blue. Good patina. Pristine cond. Hangs 20 ". 6.75" W X 7.75" pouch. Est.500-800 **SOLD $475(93)**

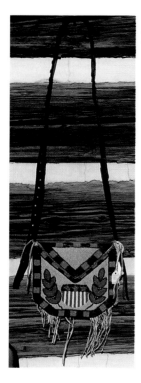

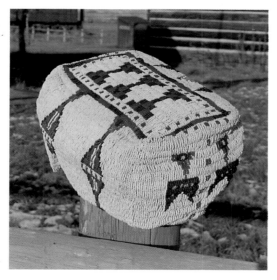

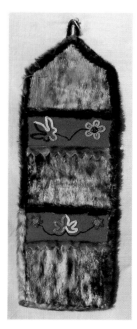

BLACKFEET SHOULDER BAG c.1880
Beaded front and flap in lt. blue with amethyst and orange border; gr. green, t. green leaf design; red white heart, white, brass facet and dk. blue flag motif. Strap is heavy belt leather with brass tacks and copper rivets. Bottom has 4" buckskin fringe partially missing. VG cond. Hangs 28". Est. 375-600 **SOLD $300(90)**

FORT PECK SIOUX PHYSICIAN'S BAG COVER c.1880
Belonged to owner's Sioux grandmother at Poplar, Mont., on the Fort Peck Res. This piece was once sewn over a Dr.'s bag. Fully-beaded white buckskin with sinew-sewn lazy-stitch. Ital. 4° and 5° white bkgrd. with classic Sioux geometric designs in cobalt blue, white lined red, gr. green, t. red, gr. yellow, t. dk. green, lt. blue, and gold-tone metallic facets. Perfect cond. Pictured bottom up. 9"L X 5"H. X 5" W. Est. 600-900 **SOLD $760(93)**

TLINGIT SEALSKIN WALL POUCH c.1895
Red wool panels partially beaded in gr. yellow, dk. blue, white, and t.amber abstract floral. Backing is black pin-striped gabardine. A few moth holes; otherwise, good cond. 6.5"W X 22". Est.100-150 **SOLD $85(92)**

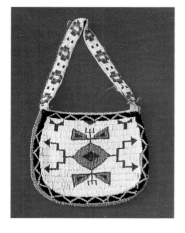

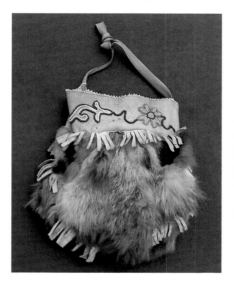

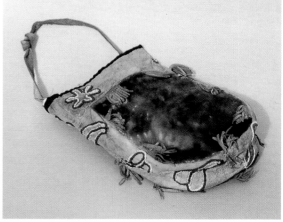

SIOUX FULLY-BEADED (BOTH SIDES) PURSE c.1910
Both sides identical. White bkgrd. with typical Sioux geometric lazy-stitched pattern in med. blue, cobalt and rose. Border is black and yellow with blue lazy-stitched edge. Handle is fully-beaded in white, t red, periwinkle and cobalt;edge-beaded in red. A few red beads missing on handle. Beaded on heavy buckskin. 7.75"W X 6.25"L. Est. 275-450 **SOLD $300(94)**

TLINGIT PARTIALLY-BEADED FOX FUR POUCH c.1880
Characteristic abstract floral motif across buckskin top in gr. yellow, white, cobalt, gr. blue and t. emerald green. White edge-beaded top. 1" buckskin fringe. Muslin lined. Exc. cond. 7.5"L X 6"W. Est. 275-450 **SOLD $178(94)**

ATHABASCAN SEALSKIN POUCH c.1870
Top and sides are partially beaded buckskin in abstract floral:white, gr. blue, white center rose, t. green and cobalt. Tufts of buckskin fringe. Same both sides. Top bound with black silk ribbon. Silk lining. VG cond. 8"L. Est. 250-350 **SOLD $250(96)**

TLINGIT WOVEN BEADWORK BAG c. 1900
Different each side. Netted panels: A) Lt. blue, periwinkle, and t. green with t. pink and t. green applique on black leather. B) Lt. blue, t. yellow and t. green with t. pink, white, lt. blue and cut pink geometric on black leather. Bottom loop dangles; t. rose, gr. yellow and gr. blue. 7.25 "L incl. dangles X 4". Est. 95-125 **SOLD $85(91)**

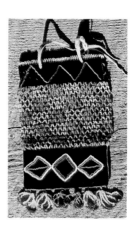

Wall Pockets

Embossed pouches

The following pouches are fine examples of 19th century Iroquois **embossed beadwork** (*See Bead Glossary*). Usually done on black velvet with similar designs on both sides. Colors are mostly clear and transl.ie;gr. yellow, gr. blue, t. rose, pink, rose white heart, white, t. green, t. gold, and opalescent white. (*Also see Iroquois whimsies on p. 113-114.*)

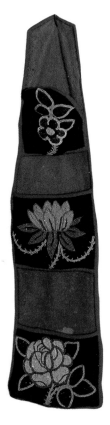

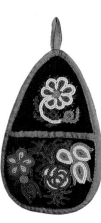

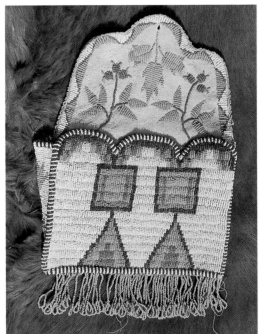

FORT PECK SIOUX WALL POCKET c.1880
Belonged to the owner's Sioux grandmother from Poplar, Mont. (Fort Peck Res.) Probably made to hold photos, important documents or Bible(?). All buckskin in elegant pastels of blue and pink. Lazy-stitched with sinew in Ital. 4° and 5° with white bkgrd. geometric designs in gr. pink, lt. blue, cobalt and Sioux green. Distinctive striped borders with alternating white and cobalt bead rows. Front and side panels are fully-beaded. Top section is partially beaded in dainty floral pattern in with lined red and pink flowers with lt. blue leaves. Lazy-stitched border in same colors. Bottom fringed with seed bead dangles (on thread) of lt. blue with pink loops. Exc. cond. 8" W. X 13" H. Est. 500-1200 **SOLD $450(93)**

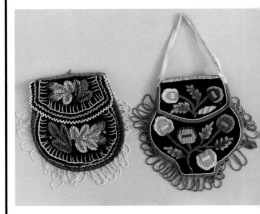

Left to Right: PONY BEADED, U-SHAPED POUCH c.1850
Leaf designs. Trans. pony beads with bead loop fringe. Red and green muslin bound. Faded green chintz lining. Torn slightly at top;otherwise, exc. cond. Hangs 8" incl. fringes. 6.5" W. Est. 175-300 **SOLD $275(93)**
SEED BEADED BEAVER-TAIL SHAPED POUCH c.1860
Typical floral design. Gr. blue beaded loop fringe. Silk ribbon handle. Exc. cond. (only a few beads missing.) Hangs 12"L. Pouch is 6.5"L X 6" W. Est. 195-300 **SOLD $235(93)**

Left to Right: NEZ PERCE BEADED WOOL WALL POCKET c.1890
Bright green wool with black pockets bound in red wool. Unique beaded floral patterns in 13° **all cut beads**: Chey. pink, pink white lined, t. rose, periwinkle, cobalt, and emerald green. Central panel is a water lily in gr. yellow, pumpkin, apple green, cobalt and periwinkle. Pockets and backing are plaid gingham. Top 3" W; 21"L. Bottom 5.25" W. Exc. shape. Est. 375-500 **SOLD $325(95)**

CHIPPEWA BEADED WOOL WALL POCKET c.1890
Asymmetric floral patterns on heavy black wool in pink, white lined rose, gr. blue, mustard, metal facets, apple green, etc. All soft pastel hues. Rose satin binding; black satin backing and hanging loop. Exc. shape. 5.25" X 8.25". Est. 250-375 **SOLD $285(93)**

CHIPPEWA-CREE WALL POCKET c.1880
Black wool with red silk binding. Applique-stitched bi-laterally symmetrical beadwork in many pastel colors including white lined rose, gr. blue and gr. yellow. Single line pale blue bead borders the binding which has scalloped beaded edging in rose white hearts. VG cond. Apx. 7" X 10". Est. 250-400 **SOLD $175(87)**

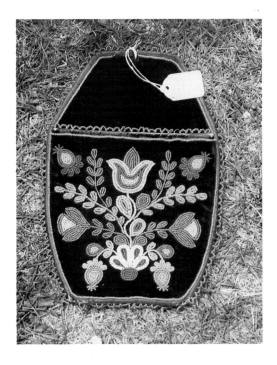

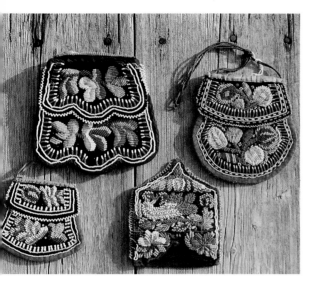

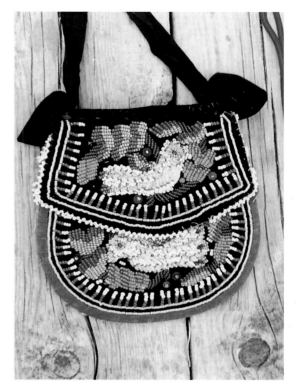

TO RIGHT (top to bottom): LARGE IROQUOIS POUCH c.
)
..d with black muslin. Velvet and binding in exc. shape.
.. of the gr. blue and white border missing I side; apx. I"
.. edge beads gone other side. Zipper added to the top. VG
.. 6.75" X 7". Est. 180-350 **SOLD $180(94)**

..QUOIS SEED BEADED POUCH c.1870.
.. patterns with rich colors all outlined in gr. blue, pink,
.. and pumpkin geometric designs. Red muslin bound. Flap
..-beaded in trans. beads. Green cotton cord at top. 7.5" H. X
.." W. Est. 180-350 **SOLD $225(94)**

..LL IROQUOIS POUCH c.1870
..er and edge beads are white. Red muslin bound (worn in a
..spots). Some white border and edge beads
..ing;otherwise intact. 4.5'" H. X 5"W. Est. 125-250 **SOLD**
..(94)

..QUOIS FOLDING SEWING KIT c.1860.
..orate bird and floral designs. Muslin compartments on
..e. Some beaded border and I" of edge beads missing;
..rwise, beadwork intact. 6.25" X 5" open. Est. 65-125
..D $110(94)

IROQUOIS BEADED BAG With STYLIZED BIRD DESIGNS c. 1840
Embossed beading in lt.blue, gr. blue, metal facets, white lined
rose, Chey. pink, t. forest green, mustard, white, opal and clear
in sizes 13° to pony bead. Black velvet with brass sequins and
red cotton cloth binding. Paper cut-out designs under beading.
A few beads missing. Has secret pockets under flaps. 6.25" sq.
Est. 300-500 **SOLD $400(96)**

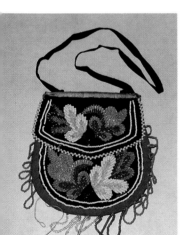

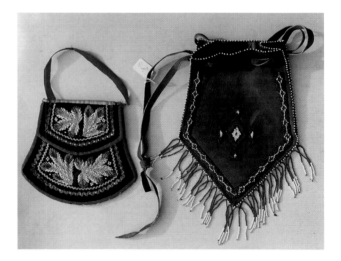

Left to Right: IROQUOIS BLACK VELVET PONY BEADED POUCH
c.1870
Beaded both sides. Embossed leaf design in white, opalescent
white, rose white heart, gr. blue and lt. blue outlined with
metallic rick-rack. Red cotton bound (worn through on bottom
2"); otherwise exc. shape. No beads missing. 7.5"L X 5.75" top
W. X 8.25" bottom W. Est. 180-300 **SOLD $175(94)**

NIAGARA FALLS PARTIALLY-BEADED COMM. LEATHER POUCH
c.1920
Words "Niagara Falls" burned on upper inside edge. Dk. brown
color. Gusset. Geometric motifs and border in t. green, t. red and
white seed beads. Edge beaded both front and back panels. Incl
documentation papers. All beads intact. Exc. cond. 14"L incl. 3"
beaded fringe. Est. 75-150 **SOLD $95(94)**

..OQUOIS BEADED BAG c.1860
..nbossed beading on both sides in leaf
..tterns: gold, blues, red, pink and green
..ed beads. Black velvet panels are red
..uslin bound. Flap is porcelain white edge-
..aded. Bead loop fringe is apx. 20% gone.
..ack silk ribbon handle. Muslin lined. VG
..nd. Apx. 4.5" X 5" W. Est. 200-325
..LD $200(96)

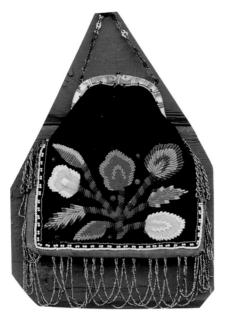

SENECA BEADED PURSE c.1880
Black velvet with silver cut bead dangles and brass sequin trim. Multi-colored floral design on both sides. An unusual piece. Exc. cond. 7" L. X 6.5" W., excl. dangles. Est. 150-250(96) **SOLD $85(89)**

Top to Bottom: **IROQUOIS BEADED PIN CUSHION** c.1890
Beads primarily trans. ponies with turq., trans. rose, yellow and green with red and silver-lined basket beads. Bird and leaf central motif-leaf border. Velvet and muslin bound-back is yellow chintz. Beads intact-cloth faded. 8" X 6". Est. 40-75 **SOLD $43(95)**

IROQUOIS BEADED TINY PURSE c.1870
Clear ponies with green and red-lined basket beads. Red cloth apx. 50% moth eaten. All beads intact. Hangs 7" X 3.5". Est. 25-50 **SOLD $30(95)**

IROQUOIS BEADED POUCH c.1870
All clear pony and seed beads with a few basket beads. Handle and loop bottom fringe all beads. Leaf motif on fine red wool (slightly moth eaten back only). All beads intact. Hangs 7" total L. X 3.5". Est. 60-95 **SOLD $70(95)**

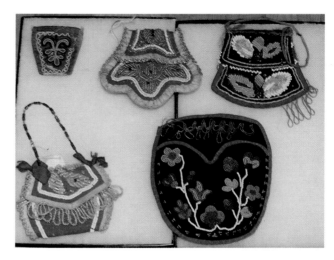

Left to Right (top to bottom): **TINY MICMAC (?) POUCH** c.1850
Gr. yellow and gr. blue abstract floral motif; white "zigzag" border on red wool. Faded green muslin binding. Border beads 1/4 gone; otherwise, exc. cond. Apx. 3" W X 3"H. Est. 100-200

IROQUOIS POUCH c.1870
Clear pony embossed beadwork on red muslin outlined with white beads. Muslin bound with clear bead edging-missing on lower edge. 4.5"H. X 5". Est. 75-95 **SOLD $50(89)**

IROQUOIS 2-FLAP POUCH c.1860
Multi-color embossed designs on navy velvet (both sides). White beaded edging and lt. green bead dangles (majority gone) need repair. 4" H. X 5". Est.65-85 **$60(89)**

IROQUOIS SEWING KIT c.1860
Clear pony bead embossed on red muslin with white pony bead border and clear pony bead dangles. Red silk ribbon bows; green basket bead handle; lined with polished cotton. Exc. cond. 3.5" X 4.5", folded. Est.75-95 **$75(89)**

CHIPPEWA BLACK VELVET WALL POUCH c.1890
Beaded one side in pink, gr. blue, t. rose, pumpkin, t. gold and white seed bead floral designs. Red muslin bound;clear and t. rose bead dangles. Lined with 2 diff. navy and white calicos. VG cond. 6.5" X 6". Est.175-225 **SOLD $165(89)**

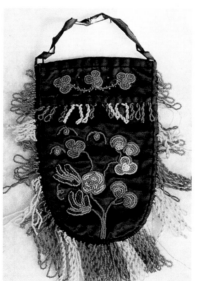

CHIPPEWA CLOTH BEADED FLORAL BAG c.1890
Floral elements in t. rose, rose white heart, pink, apple green, gr. blue, periwinkle, lt. blue, trans. green and tiny faceted brass beads. Seed bead loop fringe in gr. blue, gr. yellow, and t. turquoise. Bound and backed with black cotton. Silk ribbon handle. Some outside fringe missing and binding slightly frayed at pocket opening. All else intact. Apx. 5"W X 7.5"L. Est.175/250 **SOLD $175(93)**

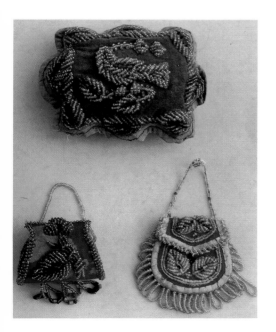

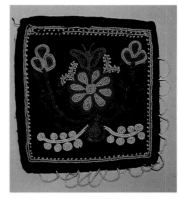

CHIPPEWA BROWN VELVET BEADED POUCH c.1890
Beautiful pastel shades of old pink, t. pink, rose white heart, soft trans. greens, gr. blue and pale blue. Embroidered borders. Muslin-lined. White bead loop fringe missing on one side;otherwise, in VG shape. Est.185-250 **SOLD $175(91)**

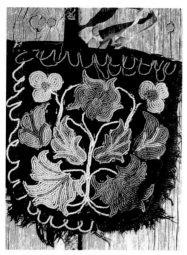

CHIPPEWA POUCH c.1875
Fenstermaker Collection. Black velvet with pastel floral motif in gr. yellow, gr. blue, gr. green, white center rose, pearl white, and metallic seed beads. Black silk fringe with pink silk ribbon trim. 7" X 8". Est. 200-300 **SOLD $165(88)**

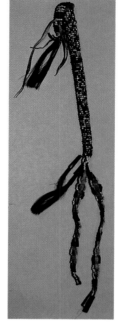

PLAINS BEADED AWL CASE c.1870.
"Salt and Pepper" bead wrapped with white and dk. green trans. lazy-stitched flap and edging on beaded tabs. Horsehair and tin cone trim. Exc. old piece. Hangs 14". Est.175-275 **SOLD $200(90)**

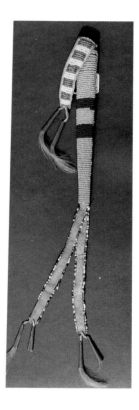

NO. PLAINS FULLY-BEADED AWL CASE c.1890
Bead-wrapped in Cheyenne pink, cobalt and gr. yellow wide stripes. Flap is white, Sioux green and pumpkin with 2 tin cones with yellow horsehair attachments. Bottom tabs are "salt and pepper" edge-beaded plus 4 tin cones with yellow horsehair (2 missing). Exc. shape. Hangs 15". Est.250-400 **SOLD $275(93)**

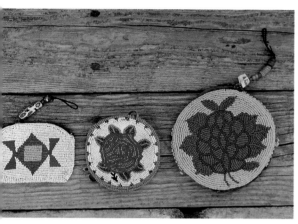

RIGHT: Corn yellow applique bkgrd. with periwinkle flower outlined in cranberry with Sioux green leaves. Same design both sides. Yellow bead edging apx. 50% intact. Zipper with trade bead pull. 5" diam. Est. 45-90 **SOLD $45(95)**
CENTER: White bkgrd. flat stitched both sides 1) single flower in reds with 2 color green leaves. 2) Geometric multi-color with buffalo nickel thong belt loop. All beads intact. 3.5" diam. Est. 30-75 **SOLD $60(95)**
LEFT: RECTANGULAR FULLY-BEADED COIN PURSE with zipper and trade bead pull. White flat stitch bkgrd. with similar geometric pattern both sides 1) Amethyst with red and corn yellow. 2) Tri-cuts in t. turq., red and blue. Exc. shape. 3" X 4". Est. 30-75 **SOLD $50(95)**

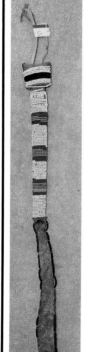

PLAINS FULLY-BEADED AWL CASE c.1880
Buckskin covered rawhide. Bead-wrapped in white with gr. blue and Crow pink stripes. Top is white with t. cobalt and t. emerald green. Buckskin drop edge-beaded in alt. t. cobalt and t. grey-green. 15.5" L. Est. 300-400

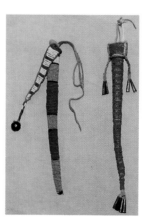

Left to Right: SIOUX BEADED AWL CASE c.1900
Rose white heart, cobalt, white and lt. blue bead wrapped. Flap is white and rose white heart with elk tooth at top. Large jet black faceted trade bead dangle on flap. 8.5" L. Est.250/375 **SOLD $200(92)**
NO. PLAINS BEADED AWL CASE c.1893
Ex. Buffalo Bill Museum in Buffalo, NY. Date stamped inside.
Rawhide case bead-wrapped in alt. red-orange and t. lt. green beads. 4 tin cones on thong dangles and 4 on cap with twisted thongs. 10" L. Good cond. Est.250/350 **SOLD $250(92)**

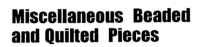

Miscellaneous Beaded and Quilted Pieces

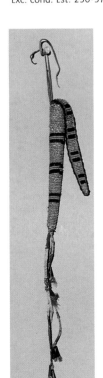

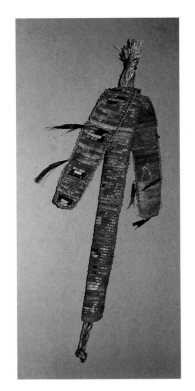

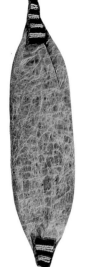

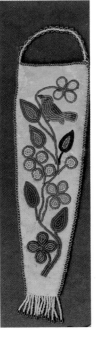

BUFFALO BLADDER QUILL CONTAINER c.1870
(See page 120). Each end decorated with t. forest green and white stripe beadwork on buckskin. Stuffed with undyed porcupine quills. Exc. cond. Est. 200-350 **SOLD $425(95)**

NO. PLAINS BEADED AWL CASE c. 1880
Buckskin wrapped heavy rawhide insert. Pastel bead colors: rose white heart, lt. blue, cobalt and "salt and pepper" wrapped;buckskin drops edged in lt. blue and rose white heart with 3 tin cones with red feather fluffs. Case is 8" hangs apx. 15" Exc. cond. Est. 250-375 **SOLD $275(94)**

SIOUX FULLY-QUILLED PIPE STEM HOLDER(?) c.1880
Rare. Completely covered in 1/4" wide sewn quill work in red with indigo and white early concentric block design. Smoked buckskin with 2 identical flaps edge-beaded in periwinkle. Sinew-sewn. Small tin cones with red horsehair tufts (a few missing) embellish flaps. Bottom of case is open-shows no evidence of ever being closed. Good patina. (Sweet grass inside case) Quill work apx. 85% intact. 12"L X 3" top tapering to 1". Est. 1100-1750 **SOLD $1100(96)**

NO. PLAINS FULLY-BEADED AWL CASE c.1900
Bead-wrapping and flap in clear, t. forest green, gr. yellow, and amethyst. Flap edge-beaded in t. green. Buckskin over rawhide. 3 quill-wrapped thong drops on bottom with tin cones and red feather fluffs in red, purple and white. (Intact quill work on one; others only partial.) 15"L . Good cond. Est. 250-375 **SOLD $200(96)**

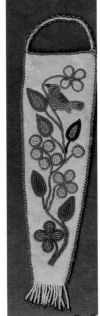

CREE PARTIALLY-BEADED KNIFE (SCISSORS) CASE c.1890
Bird and floral motif in gr. blue, gr. green, apple green, Chey.pink, pink white heart, etc. and t. rose bead edging. Opalescent white and t. blue bead fringe on bottom. T. pink, clear and t. blue beaded handle. Pristine cond. 3" W. X 12" overall L. Est.225-375 **SOLD $250(93)**

Top to Bottom: CANADIAN-CREE PR. OF BEADED STRIPS c.1920
White bkgrd. with pale orange, t. red, dk. blue and t. blue; pink and white center red design elements. Muslin bound;white wool tassels. Backed with navy Hudson's Bay Co. stroud cloth with striped undyed selvedge (saved list). 12" X 2.25". Est. 125/175 **SOLD $70(89)**
CANADIAN PR. OF BEADED STRIPS c.1920
White bkgrd. with red tri-cut, pale blue and gold tiny bugle bead design motif. Red wool binding has disintegrated. 12.5" X 2.75". Est. 125/175 **SOLD $125(91)**

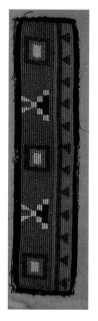

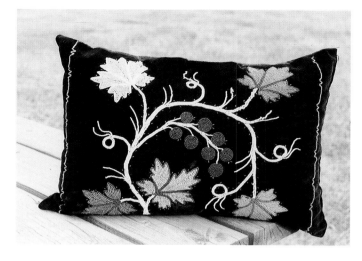

CREE PARTIALLY-BEADED VELVET PILLOW
c.1900
Black velvet with stylized asymmetric floral pattern. 2 pinks, 3 greens, t. gold, gr. yellow, cobalt, t. rose flowers with white stem and metal facets. A few white beads replaced with larger opal. white. Black rayon grosgrain back. A few worn spots on velvet nap; otherwise exc. cond. 14" X 20". Est. 200-450 **SOLD $325(97)**

BLACKFEET BEADED PANEL c.1890
Colorful applique-work with gr. yellow and transl. blue bkgrd. Geometric design in t red, white, pink and t. green. Bound with navy silk ribbon (partly disintegrated). Beadwork all intact. 12" X 2.75". Est.160/225 **SOLD $185(92)**

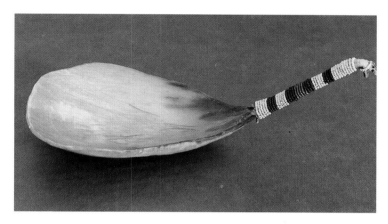

NORTHERN PLAINS COW HORN SPOON
c.1900
Bead-wrapped in white, old cobalt, and rose white heart over buckskin wrapped handle. Exc. patina. 11"L. Est.175-300 **SOLD $250(93)**

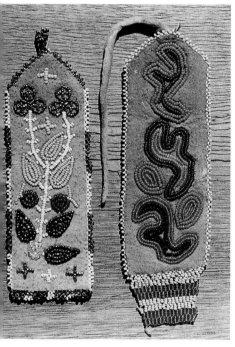

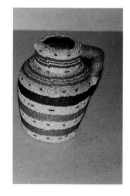

SIOUX FULLY-BEADED PITCHER c.1890
All-over pastel stripe pattern:opalescent white, t. pink, white lined rose, t. grey-green, t. gold, Chey. pink with brass facets. Ceramic pitcher (cloth-covered) bottom and handle totally beaded. Unusual. Perfect cond. 6" H. apx. 4"W at shoulder. 3" base. Est. 250-350 **SOLD $400(96)**

Left to Right: **CREE FLORAL BEADED WATCH FOB** c. 1910
Silver metallic, iris, pink, gr. yellow and white beads. Edge-beaded in alt. blues and white. Buckskin with cloth backing. Exc. cond. Apx. 6.5" L. Est. 95-150 **SOLD $100(94)**
TLINGIT BUCKSKIN BEADED WATCH FOB c.1900
Abstract floral in gr. blue, t. rose, trans dk. green, t. gold and black on buckskin with cloth backing. Woven extension is pale blue and t. gold. Pale blue edge-beaded. Apx. 8" L. Est/ 125-175. **SOLD $125(94)**

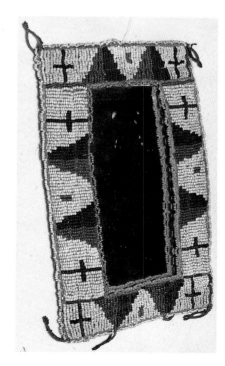

SIOUX BEADED MIRROR FRAME c.1880
Buckskin frame sinew-sewn in white with cobalt, apple green and rose white heart cross and triangle designs. Size 14° or smaller gr. blue dangles in each corner. Completely intact original cond. 5" X 8" Est. 450-800 **SOLD $475(94)**

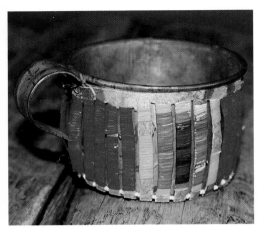

SIOUX QUILLED PARFLECHE TIN CUP
c.1880
Bright and unfaded red with yellow
rectangles around turquoise and purple quill
wrapped slats of old painted parfleche.
Bottom slats are connected with tiny white
seed beads. Very few quills missing or
damaged. 3" diam. X 2" H. Est. 350-550
SOLD $475(95)

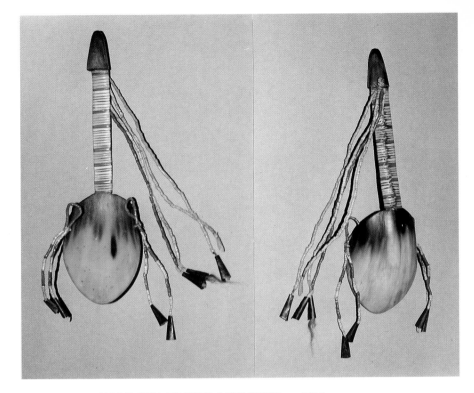

PLAINS QUILL-WRAPPED HORN SPOON c.1890
Yellow, white and red-orange striped quill handle. Thong dangles
are completely covered with wrapped quills: 2 all white, 1
yellow, 1 orange with tin cones at end. Looped quill dangles on
spoon are white and red alt. stripes with tin cones on ends.
Only 1 tin cone missing. Exc. age patina. Sinew-sewn. Exc.
cond. Est. 560-750 **SOLD $610(97)**

WHIMSIES & PINCUSHIONS

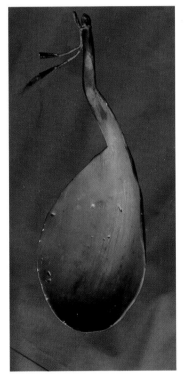

SIOUX HORN SPOON with 2 tin cones
hanging from buckskin thongs. Fragments of
red quill work and horsehair. Pencil writing
on back barely readable "Sioux-----5, 1900----
S.D." 11.5" L. Est. 200-300 **SOLD
$225(95)**

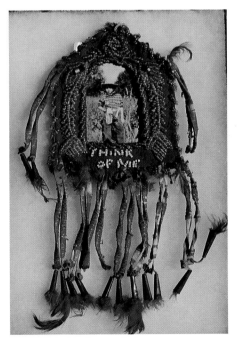

IROQUOIS NIAGARA FALLS PICTURE
FRAME With SIOUX QUILLED DANGLES
c.1890
Frames snapshot of an Indian boy. Clear and
blue pony beadwork. Red quill wrapped
dangles are made of painted rawhide with
tin cones and red feather fluffs and appear
to have been added long ago. Chintz-
backed. Very interesting piece. Good cond.
4.5" X 5.75". Dangles 5.5". Est. 175/250
SOLD $170(92)

IROQUOIS (MOHAWK) EMBOSSED
BEADED PIN CUSHION c.1890
Central panel: purple velvet with pony
beads in abstract floral motif; clear, t.
yellow, t. rose, t. grey-green. Bordered in
heavy embossed leaves in same colors with
pastel basket beads. Muslin bound. Clear
pony beaded loop fringe (apx. 50%
missing). Rest is intact. Faded rose chintz
back. 8" X 9". Est.125-185

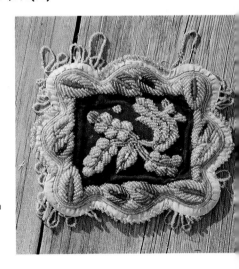

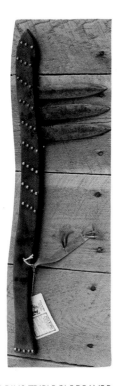

SIOUX STONE HEAD WAR CLUB c.1920
Natural branch handle wrapped with "salt and pepper" beads. Also has brass tacks. Rawhide holds stone head firmly intact. Wood split at top; otherwise, exc. cond. 20.5" L. Est. 150/250 **SOLD $175(92)**

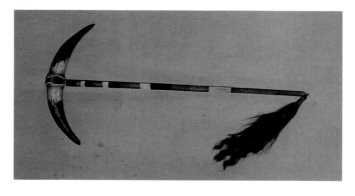

CHEYENNE CEREMONIAL HORN DANCE WAND c.1930
Bead-wrapped buckskin covered handle in beautiful shades of dk. blue, white, t. gold, transl. pink and t. rose. Bead sewn buckskin attachment to horn in same colors plus gr. blue. Red horse hair drop hangs 12". 29" X 14" across. Est.400-550 **SOLD $310(92)**

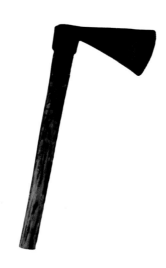

LARGE HEAVY CAST IRON TRADE AXE with rough wooden handle. c.1860s Round hole. Handle appears more recent. Head is 8.75"L and has minor rusting. Handle is 18"L.Est. 125-300 **SOLD $125(96)**

NORTHERN PLAINS TRIPLE BLADE WAR CLUB c.1915-1930 *Collected at Heart Butte, Mont. on the Blackfeet Res. by a schoolteacher, Mr. Lewis, around 1950.* A good example of a popular Blackfeet-style war club. Each blade is decorated with filed notches. The wooden part is made from the handle of an old Swedish wood saw. The blades are fitted and riveted into the wooden handle which is decorated with brass tacks and covered with a light coat of blue-green Indian paint (faded on one side from exposure to light). The top side of the handle has 2 inlays of lead etched with line and dot designs; buckskin dangle painted with red ochre and trimmed with 4 tin cones and yellow horsehair. 27"L. Each blade is 5.75". Est.500/1500 **SOLD $550(93)**

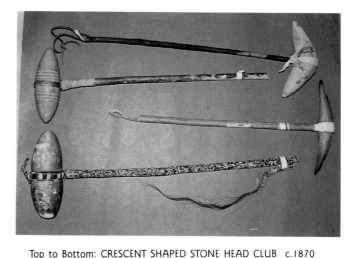

Top to Bottom: **CRESCENT SHAPED STONE HEAD CLUB** c.1870
Grey-brown hard stone has 1" x .5" flake missing from surface (1/8" deep and old) and a 1.75" x 3" oval appears to have been separated from one side and put back. Old choke cherry handle with bark on it might have been added later. White buckskin tie holds head to handle. Unusual shape. Head appears very old-measures 7"L. Club is 20.5"L. Est. 150-300

SIOUX (?) STONE HEAD WAR CLUB c.1870
Large 6.75" long tan bauxite head with six grooves carved into surface. The head is attached with rawhide and the wooden handle is covered with sinew sewn buckskin and rawhide. 20" L. Exc. example. Est. 375-500 **SOLD $375(96)**

SIOUX COW HORN HEAD WAR CLUB (OR CEREMONIAL WAND) c.1880
from Yankton, So.Dak. Light colored cow horns are attached to a wood handle with rawhide. The same rawhide is then sinew sewn over the wood handle with a hanging loop at the end. Minor worm damage to horns (actually helps guarantee age and hardly shows (same for minor mouse bites on rawhide). Horns are 8.5"L. Total is 19.5"L. Est. 300-450 **SOLD $300(96)**

SIOUX WAR CLUB c.1870 with repairs about 1930s.
Large 8" white bauxite head has turned brown with age. One point has been dulled by use and other was broken off and glued back on. Stone head is attached to handle with rawhide and old (1870) sinew sewn beaded band. Size 13° colors are white lined rose, white and cobalt blue-apx. 1/4 are missing. Wood handle is cloth covered and wrapped with newer (c.1930's) Italian size 4° "salt and pepper" mixed seed beads. Thread sewn. Has beaded dangle with remnants of orange horse hair attached to end of handle. 23" total L. Est.300-500

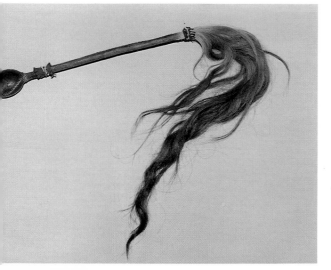

APACHE "PONYTAIL" WAR CLUB c.1880
Handle covered with buckskin and tail (1 piece). Buckskin covered stone head. White, periwinkle and black bead-wrapped leather fringes embellish handle. Exc. original cond. 18" club only-36" total L. Est.400/600(96) **SOLD $325(91)**

121

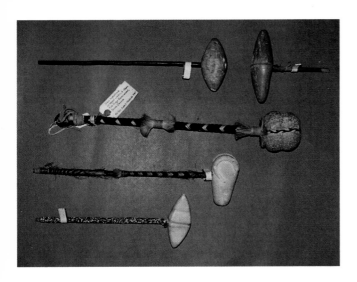

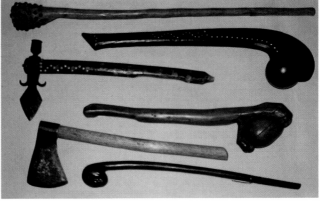

Top to Bottom; BROWN STONE HEAD CLUB with old wooden handle c.1880 Nicely shaped head with exc. age patina. 4.5" L. Plain handle shows dark patina and looks very old. 15"L. Est. 160-250 **SOLD $160(96)**

(Top right): BROWN BAUXITE WAR CLUB HEAD with broken handle c.1870 Head still has rawhide and sinew attachment to handle fragment 7/8" sq. chip missing from one corner of head. Authentic example. 6.5" head with handle 7"L. Est. 125-200 **SOLD $100(96)**

SIOUX STONE HEAD CLUB With HORSE HAIR WRAPPED HANDLE c.1900 *Tag says "From Pine Ridge Reservation, S.D. Ex-coll. Evans Trading Post."* Unusually shaped brownish-grey pecked stone head with two grooves. 3" club. White and black horsehair is braided with white tufts that are sinew wrapped onto the wooden handle. Exc. cond.19.5"L. Est. 300-500 **SOLD $300(96)**

TURTLE MT. SIOUX WAR CLUB c.1890 White bauxite head shaped like a mountain sheep. White and black horsehair braided to wood handle with sinew and red fluffs. 2" section of horsehair has minor damage. Head is 4.25"L. Handle is 16" L. Est. 250-350

SMALL SIOUX WAR CLUB With FOUR SIDED WHITE BAUXITE STONE HEAD c.1900 Cloth covered wood handle is wrapped with salt and pepper beads. 2 small tin cones on handles near head, 4.5"L. 12.25" total L. Exc. cond. Est. 125-250 **SOLD $150(96)**

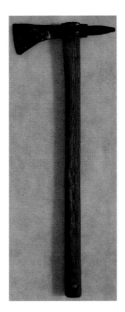

FORGED IRON SPIKED TOMAHAWK Contemp. Iron head is rather crude and appears to be of recent make. Head is 6"L. with handle 17"L. Est. 85-150 **SOLD $65(96)**

Top to bottom: LONG WOOD CLUB(?) With TACKED ROOT BURL c.1880? Could be early pioneer implement. Has iron tacks and old brass tacks. Nice patina. 30"L. Est. 95-200 **SOLD $105(96)**

BALL HEADED WOODEN WAR CLUB c.1950 Darkly stained wood decorated with brass tacks. Wood ball has been expertly attached to handle. 22.5"L. Est. 125-250 **SOLD $125(96)**

IRON SPONTOON PIPE TOMAHAWK c.1950 or later. Tacked and file burned handle. Head appears to be cast and whole axe has been cleverly aged. Head 7.75"L. Hawk 18"L Est. 150-300 **SOLD $150(96)**

WOODEN WAR CLUB With CARVED EAGLE CLAW c.1930 The carving portrays a ball or egg grasped in an eagle talon. Shows considerable workmanship and some aging. 19"L. Est. 200-350 **SOLD $175(96)** *NOTE: previously sold in '93 with documentation tag and leather thong at a higher price, see p. XXX. Important reminder that documentation usually increases the value of an item.*

IRON TRADE AXE With HARD WOOD HANDLE Head could be old but looks to be 20th century. Cast iron head is 6"L with very fine dimensions and oval hole. 17.25L. Est. 125-250 **SOLD $75(96)**

WOODEN WAR CLUB With SMALL BALL HEAD OF ROOT WOOD 19th Century. Unknown provenance-could be Indian, South Seas, Chinese, ? Appears old. Very delicate and hard wood. Handle is decorated with many hollowed dots. Dark brown highly polished with exc. patina. 19.5"L. Est. 150-300 **SOLD $150(96)**

Bows and Arrows

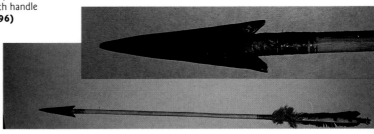

SIOUX ARROW c.1870 *From a closed museum in Deadwood, SD.* Metal trade point (2.75"). Sinew-wrapped; painted red stripe. Feathers are completely intact with small red fluffs at base of each. Exc. patina. 23"L. Est. 250-350 **SOLD $600(96)** Note: This unexpected high price resulted from competitive auction bidding.

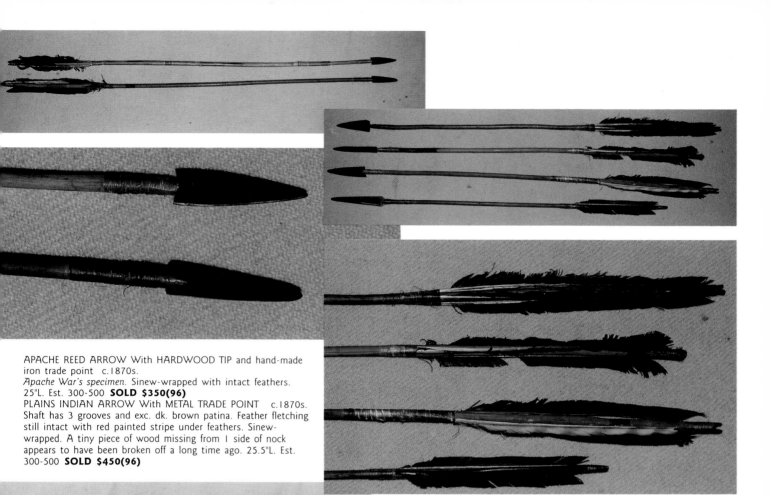

APACHE REED ARROW With HARDWOOD TIP and hand-made iron trade point c.1870s.
Apache War's specimen. Sinew-wrapped with intact feathers. 25"L. Est. 300-500 **SOLD $350(96)**

PLAINS INDIAN ARROW With METAL TRADE POINT c.1870s. Shaft has 3 grooves and exc. dk. brown patina. Feather fletching still intact with red painted stripe under feathers. Sinew-wrapped. A tiny piece of wood missing from 1 side of nock appears to have been broken off a long time ago. 25.5"L. Est. 300-500 **SOLD $450(96)**

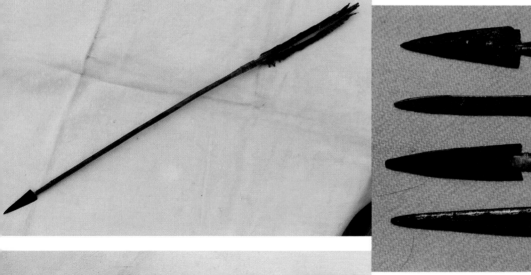

LOT OF 4 PLAINS ARROWS c.1870
Metal trade points and feather fletching. Feathers and points are held in place with sinew wrapping. All 4 have dark patina. Est. 1000-1600 **SOLD $1100(96) lot**

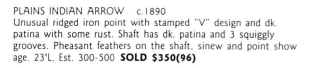

PLAINS INDIAN ARROW c.1890
Unusual ridged iron point with stamped "V" design and dk. patina with some rust. Shaft has dk. patina and 3 squiggly grooves. Pheasant feathers on the shaft, sinew and point show age. 23"L, Est. 300-500 **SOLD $350(96)**

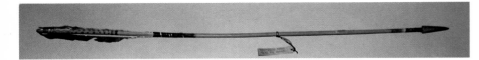

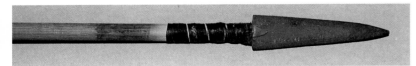

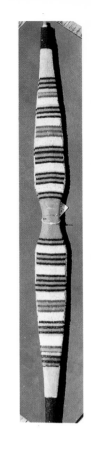

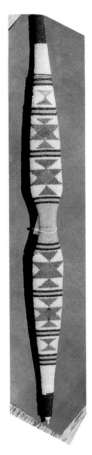

PLAINS INDIAN ARROW With METAL TRADE POINT c.1870
Sinew-wrapped at point with feathers. 2 feathers are intact with
some bug damage. The ends of 3rd feather are still protruding
from under the sinew wrapping. Nock is in perfect shape. Red
and blue stripes and dots painted under the feathers(unusual
design). Metal point has surface rust. 2.5"L. Est. 150-300 **SOLD
$450(97)**

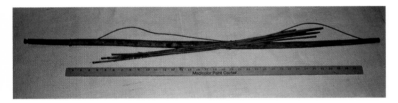

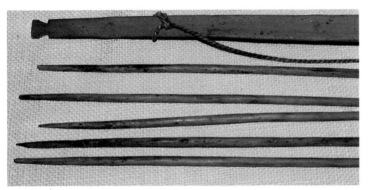

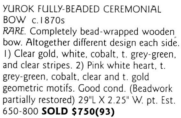

**YUROK FULLY-BEADED CEREMONIAL
BOW** c.1870s
RARE. Completely bead-wrapped wooden
bow. Altogether different design each side.
1) Clear gold, white, cobalt, t. grey-green,
and clear stripes. 2) Pink white heart, t.
grey-green, cobalt, clear and t. gold
geometric motifs. Good cond. (Beadwork
partially restored) 29"L X 2.25" W. pt. Est.
650-800 **SOLD $750(93)**

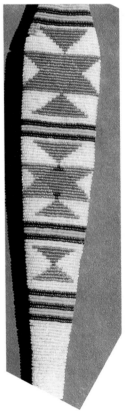

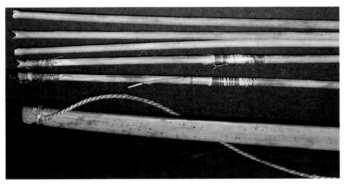

NEZ PERCE BOW and 5 ARROWS c.1860
Recently collected from Indian family on the Res. nr. Lewiston, Ida.
The bow is especially nice with carved notches and the original
hemp (rare) twisted string. 2 of the arrows have remnants of
feather and sinew wrapping. The arrow nocks are carved and
have a good taper. The tips are pointed **and never had any
points attached.** Both the bow and arrows have dark patina
and numerous fly speck dots, indicating considerable age. Bow
is 44.5"L and arrows aver. 26.5"L Est. 600-1000 **SOLD
$850(97)**

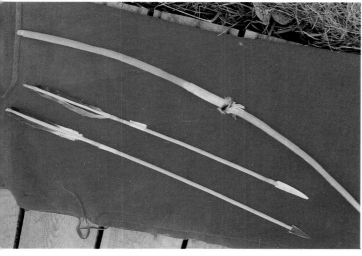

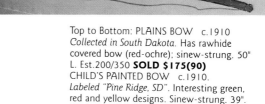

Top to Bottom: PLAINS BOW c.1910
Collected in South Dakota. Has rawhide
covered bow (red-ochre); sinew-strung. 50"
L. Est.200/350 **SOLD $175(90)**
CHILD'S PAINTED BOW c.1910.
Labeled "Pine Ridge, SD". Interesting green,
red and yellow designs. Sinew-strung. 39".
Est.100-200 **SOLD $95(90)**

BLACKFEET BOW and 2 ARROWS c.1890-1910
Possible medicine ceremony set. Bow's hand-grip partially
missing. 1/2 red-ochred. 38"L. Sinew-wrapped arrows 1) 3.5"
bone tip. 2) trade metal tip. Each is 31"L. Est.250-400 **SOLD
$275(93)**

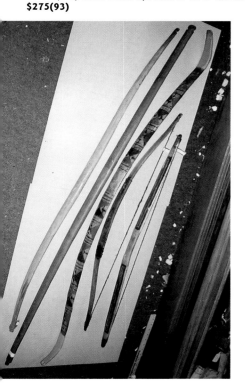

Left to right: CHEYENNE ASH(?) DOUBLE CURVED BOW c.1860
Has double nock on bottom and single on top which is typical for old Cheyenne bows.
Remnants of a twisted sinew string are still wrapped around the double nock. The hand grip
area has been shaped and smoothed. Exc. patina. 48.5"L. Est. 400-500 **SOLD $515(96)**
UNUSUAL EASTERN STYLE BOW 19th c.
Appears old. Straight with slight curve. A double nock on one end and a dowel like protru-
sion on other end. This bow is similar to the famous "Sudbury Bow" taken from an Indian at
Sudbury, Mass. in 1660 that has been in The Peabody Museum since 1826.* The Sudbury
Bow is made from red hickory and this bow has a dark reddish color. Also, the shaft is oval
shaped which thickens towards the shaped hand grip center. A very strong bow as the wood
is quite thick. Hand grip is 4" diameter. Exc. patina and cond. 55.75"L. Est. 250-500
*See Waldorf, D. C., *The Art of Making Primitive Bows and Arrows*, Branson. Mound Builder
Books 1985:18.
MOHAVE RE-CURVED BOW WITH PAINTED DESIGNS in red and black. c.1880
Superb example and rare.Has blue-grey cord string wrapped on both re-curves. The string
does not appear as old as the rest of the bow, but it is clearly evident by the change in patina
coloring (under string) that the re-curves were originally wrapped. Exc. age patina and cond.
55" from tip to tip. Est.500-800 **SOLD $500(96)**
CONTEMP. PLAINS STYLE BOW with slight re-curve. Double nocks on both ends. Twisted
rawhide string. Rawhide covered hand grip. Dark imitation patina. Not for use-wall hanger
only. 37"L. Est. 90-150 **SOLD $101(96)**
CONTEMP. PLAINS STYLE FLAT BOW With SHAPED HAND GRIP Covered with laced on
rawhide that has a geometric design painted in black, red, and green on front. Twisted
rawhide string with double nocks. Dark brown imitation patina. Exc. cond. 36"L. Est. 90-150
SOLD $150(96)

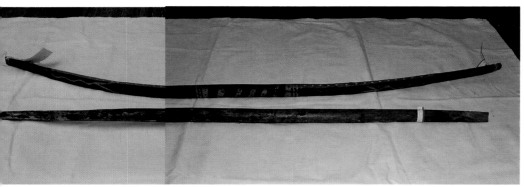

TOP TO BOTTOM: PAINTED (OSAGE
ORANGE?) WOODEN BOW c.1870
Tag reads "Pawnee." Bow painted on all 4
sides in blue, red, yellow, orange and green
in dots, straight and zig-zag lines and a
snake-like figure. Remnants of sinew string
at either end. Has a pronounced re-curve.
51"L. Est. 500-650 **SOLD $650(95)**
SIOUX(?)HARDWOOD BOW c.1870 or
earlier
So. Dakota collection. Slight re-curve. 1 end
shows light signs of wood decay with a few
splinters missing (as if it sat against the
ground for a time). Patina suggests that this
bow is very old. 44.5" L. Est. 350-500
SOLD $475(95)

Weapon Cases

NOTE: Knives, guns, pistols &
rifles are listed under Trade Goods in
the companion volume.

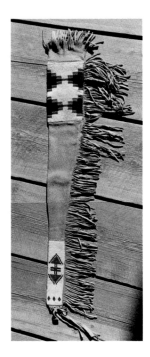

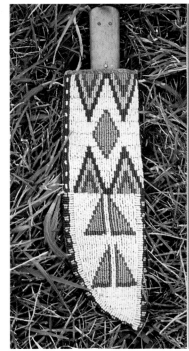

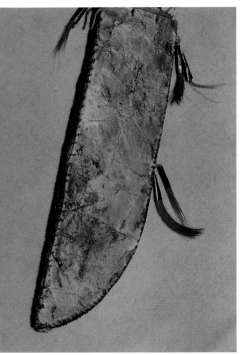

SIOUX KNIFE CASE c.1890.
Fully-beaded buckskin front on parfleche case. Seed-beaded in
predominantly white, dk. blue, gr. yellow, periwinkle blue, and
red white hearts. Trimmed with tin cones and horsehair. 10" L. X
3". VG cond. Est. 800-1200(96) **SOLD $575(88)**

BLACKFEET RIFLE SCABBARD c.1885
Made of fringed smoked elk hide. 2 fully-
beaded applique (flat stitch) panels on
front:white with step pyramids in deep
cobalt with turquoise and t. rose is 9" X
5.75". Smaller panel is 10" X 2.75": white
with 3 diamonds in rose outlined in
cobalt;cross and step triangles in t. navy,
med. green, t. rose-red and gr. yellow.
Superb cond. 41"L. Est. 2750-4500 **SOLD
$3750(95)**

SIOUX FULLY-BEADED KNIFE CASE With
KNIFE c.1930
Ital. 4° beads:bkgrd. lt. blue, geometric
designs in red, white yellow, dk. blue, and t.
green. Belt loop on back and buckskin
thongs for hanging. Sinew-sewn and no
beads missing. Knife has file-burned designs
on wooden handle. Shows patina and wear;
exc. cond. 11.5"L X1.75" incl. knife.
Est.300-500 **SOLD $275(93)**

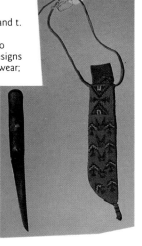

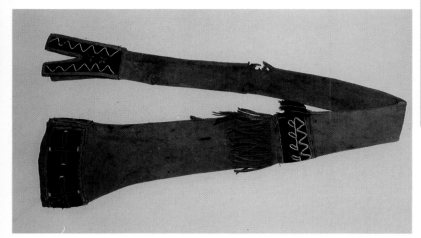

EARLY ATHABASCAN RIFLE SCABBARD c.1850?
RARE. Fine black wool inlay partially beaded with gr. yellow, gr.
green, and white cross and zig-zag motifs. Black and red wool
central tassels strung with rose white hearts and t. pony beads.
Supple buckskin. Some moth damage to wool and buckskin, 2
damage holes (1" and 1.5"). 55" L. incl. 5" drop. 7" W. tapering to
2.25". Est. 1650-2500 **SOLD $1500(97)**

**NORTHERN PLAINS FULLY-BEADED KNIFE
CASE** c.1880
Both sides lazy-stitched with lt. periwinkle
bkgrd., rose white heart, gr. yellow and
cobalt. Sinew-sewn on buckskin. 7" + 3"
bead-wrapped thong dangles. Inlaid lead
handled knife. Exc. cond. Est.1000/1500
SOLD $1000(92)

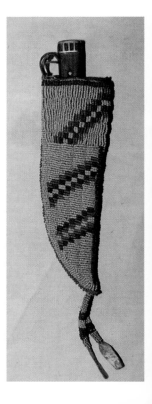

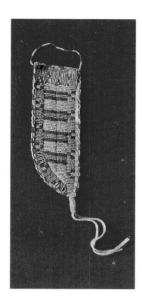

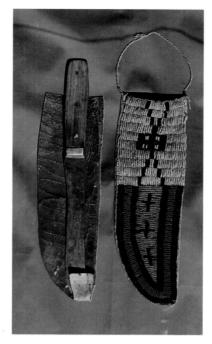

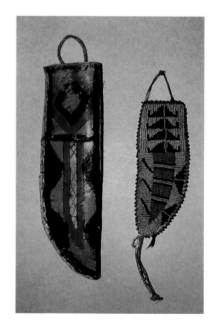

SIOUX FULLY-BEADED KNIFE CASE c.1880
A choice color combination of gr. yellow, periwinkle and rose white heart in central stripe and geometric patterns. Lazy-stitched and sinew-sewn on heavy buckskin. Pristine cond. Sheath is 7.25 X 2.5" wide at top. Hangs 15". Est. 700-1200 **SOLD $750(94)**

SIOUX SMALL FULLY-BEADED KNIFE CASE c.1890
White lazy-stitch bkgrd. with Sioux green, cobalt and white lined rose in geometric pattern. Sinew-sewn. All beads intact. Perfect cond. 6" L +7" bead-wrapped thong drop in same colors. Est. 400-600 **SOLD $500(95)**

SIOUX FULLY-BEADED KNIFE CASE With KNIFE c.1870
RARE. Made for Indian use rather than the tourist trade. The rare buffalo hide liner, with folded tip, is a type that is only seen in very early knife sheaths. Old-time bead color designs. Top: opalescent white with gr. yellow and t. cobalt motif. Bottom: t. pale rose, cobalt, cranberry white heart, and emerald green concentric stripes. Sinew-sewn. Russell Green River knife. Fine shape (1 row white beads missing). Apx. 9.5"L. Est. 1200-1800 **SOLD $1100(95)**

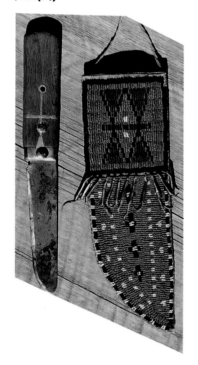

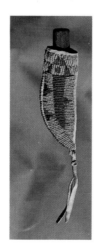

SIOUX LARGE FULLY-BEADED KNIFE SHEATH With KNIFE c.1870
Lazy-stitched and sinew-sewn. Transl. periwinkle bkgrd. with t. green, t. yellow, rose white lined, dk. cobalt and white intricate geometric patterns. Tin cone fringed thongs. Twisted buckskin thong Rawhide back. Superb patina. 10" knife has lead inlay. 10" L. Est. 1850-2500 **SOLD $1700(95)**

CHEYENNE SMALL KNIFE CASE With AWL c. 1880
Gr. yellow bkgrd. with gr. green central stripe and gr. blue triangles with rose white heart. Lazy-stitched and sinew-sewn. Gr. green edge beading. 2-3 beads missing in 1 row only. Exc. shape and patina. 5"L with 4" thong drop. Old awl 5.5" L. Est. 300-500 **SOLD $325(95)**

Left to right: SIOUX PAINTED PARFLECHE KNIFE CASE c.1900
Dark rich colors: indigo, dk. green, dk. red and yellow ochre with characteristic fine black outlines. Back also painted (not shown):4 red "X" designs bordered in dk. cobalt and fine black lines. Sinew-sewn. Sizing has sheen and old patina. Buckskin top loop. Exc cond. Unfaded and pristine. 10.5"L X 3" top W. Est. 400-600 **SOLD $475(96)**
SIOUX FULLY-BEADED KNIFE SHEATH c. 1880
Predominantly porcelain white with apple green, t. cobalt and gr. yellow. Diagonally edge-beaded in t. rose. All sinew-sewn. Bottom rawhide drop painted green with faded wrapped quill work (missing tin cones). Exc. cond. 6.75"L + 3" drop. Est.440-650 **SOLD $650(96)**

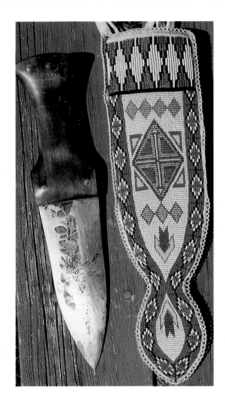

ROCKY BOY FULLY-BEADED DAGGER CASE
and HAND-FORGED DAG KNIFE c.1970
*Made by the late Emma Chief Stick
(Chippewa-Cree).* Intricate geometric
pattern in lt. blue, red-orange, t. blue, gr.
pink, black cuts with yellow and white bead
edging. Buckskin backed. 15"L X 4.5" W.
Fitted to a hand-forged dag *made by Larry
Ford of Frenchtown, Mont.* 13.25" L. Est.450/
750

Shields

NOTE: See Replica shields in companion volume and
also discussion of shields in Artifake Photo Comparison
section, Chapter 8.

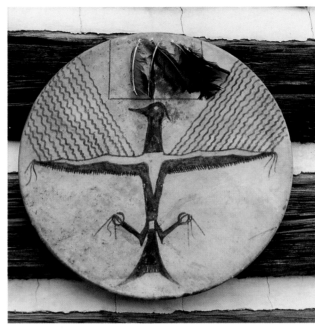

SIOUX RAWHIDE SHIELD c.1903
*Collected on the Pine Ridge Res. by Mary
Secrest, school-teacher, between 1918-1924;
purchased from her estate after her death.
Believed to have been made by No Two Horns
(1852-1942), Hunkpapa Lakota, Standing
Rock, No. Dak. (Signed documentation
accompanies shield). After "retiring" his own
personal shield, he made copies of it for sale.*
Cowhide stretched over iron rings.
Characteristic and distinctive bird motif in
black pigment. Clipped black feathers at top.
Back is laced with heavy rawhide strips;
natural bone handle. Good natural age
patina. Exc. sturdy condition. 16.38" diam.
Est. 3000-5000 **SOLD $3500(97)**
See Wooley and Horse Capture, "Joseph No
Two Horns" *American Indian Art Magazine*,
Scottsdale. Summer 1993: 32-43.
Similar shields sold at Sotheby's in 1992
and at Dunnings, Winter 1995: lots 2184
and 2185.

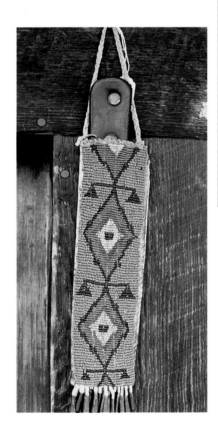

UTE KNIFE CASE c. 1870.
Fully-beaded predominantly periwinkle blue,
with Sioux green, milky white, dk. blue t.
and white center rose seed beads with rows
of tin cones as fringe. Includes original knife
with heavy leather copper riveted handle. 9"
X 2+". Est. 500-800 **SOLD $395(88)**

IV. Horse Gear

Note: Saddle bags are listed under Bags.

Saddles & Saddle Parts

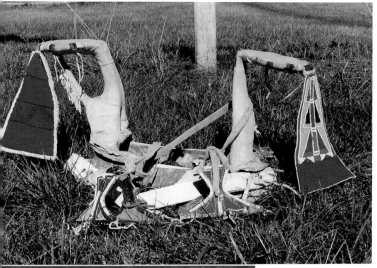

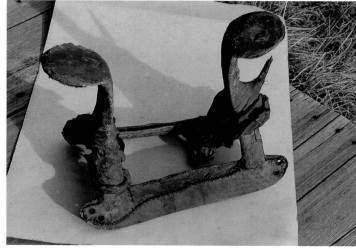

CROW WOMAN'S HIGH POMMEL RIDING SADDLE c.1860
From Frontier Town collection nr. Helena, Mont. Wood saddle covered with rawhide and stitched with sinew. Both spoon-billed pommels are covered with buckskin. Good solid cond. with mouse teeth marks on most edges of rawhide. Exc. patina and age. 18"L X 14" H. X 11.5" With Est. 600-1200 **SOLD $800(95)**

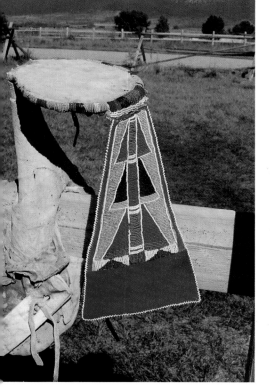

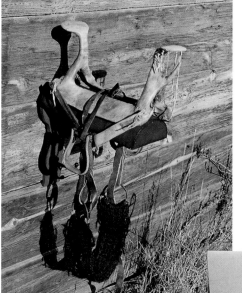

CROW WOMAN'S HIGH POMMEL RIDING SADDLE c.1870
Carved wood pommel and cantle with flat spoon-shaped tops covered with buckskin and thongs attached. Wood side pieces and all covered with sinew-stitched rawhide. Indian-made horsehair cinch; painted parfleche and buffalo rigging straps. Commercial wood and metal stirrups. Exc. usable cond. 22.5"L X 14"H X 9"W. Est. 1200-2500 **SOLD $1600(94)**

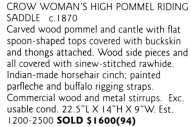

CROW WOMAN'S HIGH POMMEL RIDING SADDLE c. 1890
Unusually complete. Wooden saddle covered with rawhide and buckskin. Trade wool drops (see detail photo with Crow stitched beadwork) from each bead-edged pommel. Includes red cloth inlaid beaded stirrups. Est. 2000-3500 **SOLD $1800(90)**

CROW WOMAN'S HIGH POMMEL RIDING SADDLE c.1870
Wooden saddle covered with rawhide and sinew-stitched. 1 spoon-billed pommel still covered with buckskin. Good solid cond. Exc. patina and age. Largest spoon-6" diam. Large size: 10"W X 14.5"H 20"L. Est. 600-1200 **SOLD $850(96)**

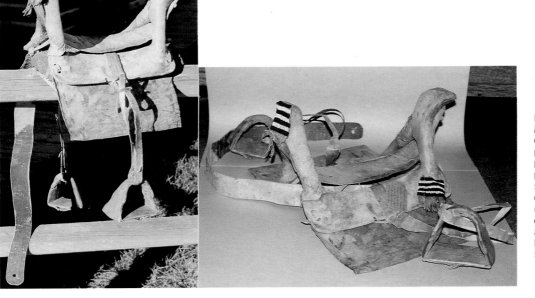

BLACKFOOT SADDLE c.1860
Pre-Reservation Period from the B.W. Thayer Coll. All original and complete. Double pommels. Rawhide sling with wooden pegs; buffalo hide belly band. Parfleche painted side flaps, each 14" X 8". Sinew-sewn beaded pommel flaps are white and dk. cobalt alternating lazy-stitched rows (One un-stitched but complete). Rawhide-covered stirrups-sinew sewn. Shows use and rich patina of age. Exc. cond. 16" L X 11" H X14.5" W. Est. 1200-2000 **SOLD $3250(96)**

PRAIRIE CHICKEN SNARE SADDLES: With ORIGINAL STIRRUPS. c.1870
Nez Perce. This type of saddle was also popular with the Blackfeet who gave them the name "prairie chicken snare". Elk antler steamed into round shape, forms the pommel and cantle, and is attached to wide, flat side pieces of wood. Entirely sinew-sewn and covered with red-ochred rawhide. Some of the rawhide rigging is made from painted parfleche. Some edges of rawhide show mouse damage. Stirrups 5" X 6" with sinew-sewn rawhide covers. 21"L X 11.5"W X 9" H. Est. 800-1500 **SOLD $850(94)** Note: A similar saddle can be seen in Hail, Barbara A., *Hua Kola*, Bristol, Brown Univ. 1980: 227 #29, which is identified as Crow.)

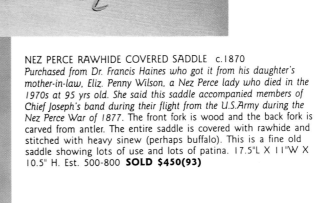

PRAIRIE CHICKEN SNARE SADDLE c.187
Recently purchased from a Nez Perce family on the Res. in Ida. (See previous saddle for construction and history info.) Includes rawhide pads and rigging. The pads appear to be buffalo hide. This is an old Indian-used saddle. 18"L X 10"W 9.5"H. Est. 800-1500 **SOLD $850(97)**

NEZ PERCE RAWHIDE COVERED SADDLE c.1870
Purchased from Dr. Francis Haines who got it from his daughter's mother-in-law, Eliz. Penny Wilson, a Nez Perce lady who died in the 1970s at 95 yrs old. She said this saddle accompanied members of Chief Joseph's band during their flight from the U.S.Army during the Nez Perce War of 1877. The front fork is wood and the back fork is carved from antler. The entire saddle is covered with rawhide and stitched with heavy sinew (perhaps buffalo). This is a fine old saddle showing lots of use and lots of patina. 17.5"L X 11"W X 10.5" H. Est. 500-800 **SOLD $450(93)**

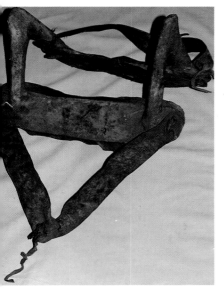

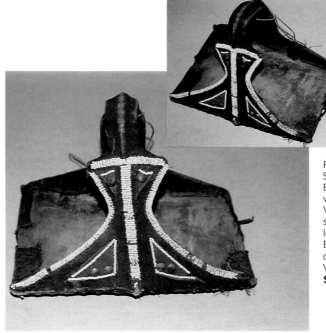

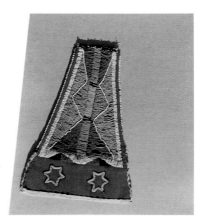

**PR. OF CROW RAWHIDE BEADED
STIRRUPS** c.1860
Blackened rawhide, sinew laced; cut-outs
with red wool inlay and 2 brass tacks.
White lazy-stitched beadwork is sinew-
sewn and apx. 80% intact (one is missing
lower cloth inlay and tacks). Dark patina.
Bottom seam reveals painted parfleche
designs on underside. Large size. 9" L X 6"
W X 7" H. Est. 1000-1500 **Sold
$1250(97)**

NEZ PERCE RAWHIDE COVERED SADDLE
c.1870
*This style saddle was used by Chief Joseph's
band during the 1877 Nez Perce Wars.* The
front and back forks are carved from antler
and the entire saddle is covered with
rawhide. Complete with rawhide riggings
and pads still tied with original buckskin.
19"L 22" H. Exc. patina Est. 700-1200
SOLD $700(95)

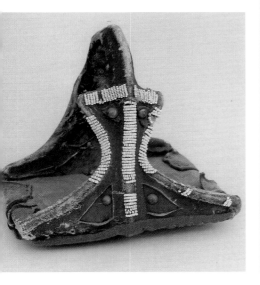

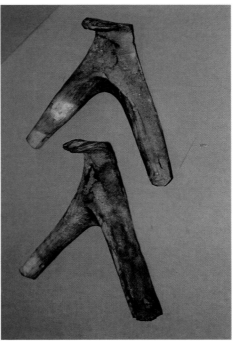

**FLATHEAD ELK ANTLER POMMEL and
CANTLE**
From an early rawhide covered Indian
saddle. One is missing an inch or 2 from the
ends. Apx. 10" X12". Est. 50-150 **SOLD
$60(95)**

FLATHEAD RAWHIDE BEADED STIRRUP
c.1880
From Louise Conko in Ronan, Mont. Wood
base, red wool inlay and applique with 4
brass tacks. White seed bead lazy-stitched.
Sinew-sewn. 1/2 of beadwork is missing.
Exc. overall patina. 6.5" H. X 6.5" L X 5" W.
Est.400-600 **SOLD $250(93)**

BLACKFEET SADDLE PARTS c.1870
Carved elk antler pommel and cantle for an
old-style Indian saddle, where they would
be covered with rawhide. Exc. patina of age.
Apx. 8.5" H. X 8.5" W. Est. 200-350 **SOLD
$175(96)**

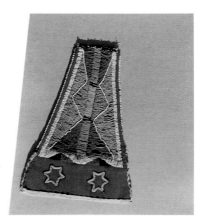

CROW SADDLE POMMEL DROP
Sinew-sewn on smoked hide with red trade
cloth bottom. White pony beaded edging
with a few beads missing on one side. Crow
stitched with white edging and design in lt.
blue, Cheyenne pink, gr. yellow, dk. cobalt
and white lined rose. 8" X 11.5" Est. 800-
1200 **SOLD $850(95)**

Saddle Blankets and Ornaments

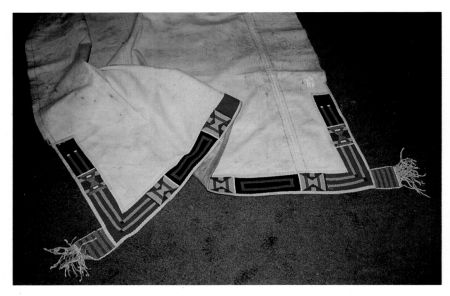

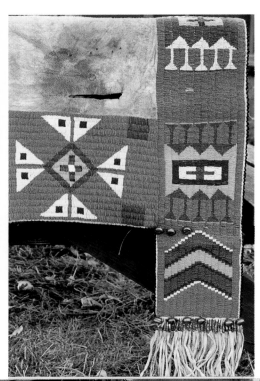

CROW BEADED SADDLE BLANKET c.1900
Purchased from Eliz. Smart Enemy (belonged to her Uncle Bull Don't Fall Down). Classical form of trapezoidal canvas with 3" partially beaded cloth panels (alt. red and navy trade wool) red white heart and white on navy wool; lt. blue and t. cobalt on red wool. Fully beaded sections hourglass design-same bead colors + t. lt. green, t. red and gr. yellow. Muslin bound. Canvas shows use. Fully-beaded buckskin corner tabs in rose white heart and apple green stripes; edge-beaded in white. 7"L incl. fringe. 28" beaded L. X 38" W. Est. 1500-3000 **SOLD $1500(97)**

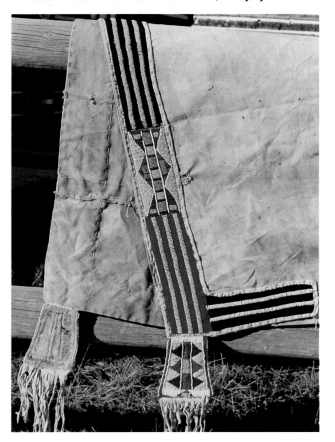

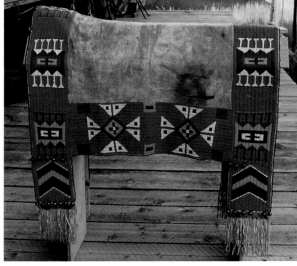

CROW BEADED SADDLE BLANKET c.1880
Alt. red and navy trade wool panels with beaded stripes in white, lt. periwinkle and gr. yellow. 3 fully-beaded panels are unusually beautiful: pale blue, lt. blue, rose white heart, forest green, cobalt, Crow pink, apple green with white outline. Trapezoidal beaded drops same colors diff. design-red wool border and white edge-beaded. Exc. cond. Heavy canvas shows use. 5"L buckskin fringes. 72"L X 64"W fully opened. Est. 2500-4000

SIOUX BEADED SADDLE BLANKET c.1895
This is the nicest we've ever seen. Very attractive color combination: Sioux blue (periwinkle) bkgrd., green, white center rose, yellow, cobalt blue and white seed beads sinew-sewn in unusually wide lazy-stitched panels. Edge-beaded with tiny black bugles; buckskin fringe strung with red and silver basket beads and brass hawk bells. Entire blanket is yellow-ochred Indian-tanned buffalo (or elk hide) lined with muslin. 72"X 36" W. Bottom is 16 rows-8" wide; side panels are 12 rows-6" wide. Est. 4000-6000 **SOLD $3950(88)**

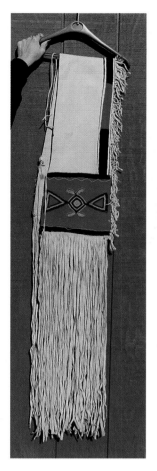

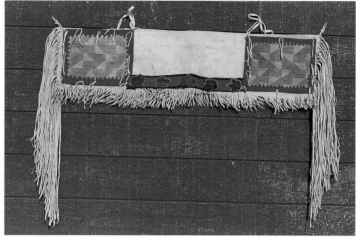

NEZ PERCE CORN HUSK SADDLE DROP c.1900
Made from heavy white Indian-tanned elk hide. Corn husk panels are bound with red wool cut into a saw-toothed edging. The corn husk and hemp are varying natural shades of brown which look old. Connecting the 2 panels is a red wool band bound with purple ribbon and 5 green, brown, and yellow beaded leaves attached with multiple brass spots. The buckskin and corn husk portions appear to be very old while the red wool could be a more recent addition. Exc. cond. 8'2" L X 14" W incl. fringe. Panels are 10" X 13". Est. 1200-1800 **SOLD $1100(93)**

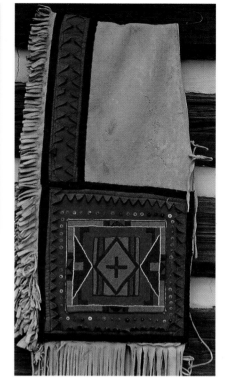

PLATEAU SADDLE DROP c. 1880 or earlier.
Red and black trade wool over heavy buckskin with LONG (36") heavy buckskin fringe. Sinew-sewn beadwork is gr. yellow, bottle green, and lt. blue. Wool side panels are alt. red and black overlaid with buckskin strips-3" buckskin fringe. Fine old piece in exc. cond. 10.5"W X 60"L (each side). Est. 1000-1800 **SOLD $1000(97)**

NEZ PERCE BEADED SADDLE DROP c.1890
Purchased from Abe Lincoln's Trading Post, Toppenish, Wash. in 1971. Geometric beaded panel (7" sq.) has red white heart, mustard, dk. blue, lt. blue, t. green on red wool panel embellished with large brass sequins. Heavy green wool pinked fabric on red wool panels is bound with black wool. Exc. cond. 48" plus 39" fringe each side. Est. 1200/1800 **SOLD $1650(90)**

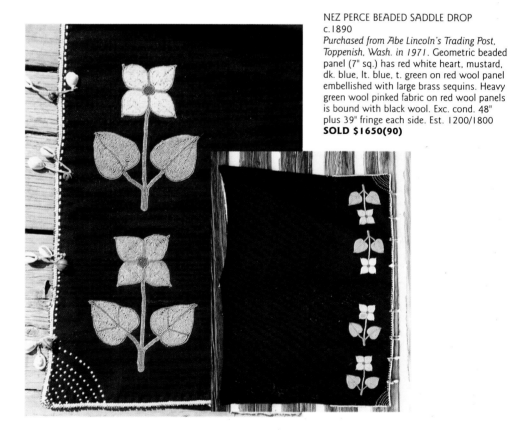

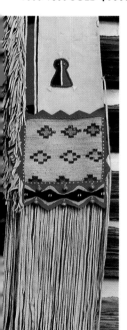

PLATEAU CORN HUSK SADDLE DROP c.1890
Made from elk hide to drape over horse behind the saddle with fringe hanging almost to the ground. Elaborate trade cloth overlay with beadwork and brass hawk bell ornamentation. Some exc. restoration work. Exc. shape. Est. 3500-5000 **SOLD $3410(91)**

NEZ PERCE PARTIALLY-BEADED SADDLE BLANKET c.1900
4 large stylized flowers on black wool. Petals are opalescent white (clear and lustre) outlined in t. gold; brick centers. Stems are 2 shades of t. tri-cut; leaves are lt. blue heart-shaped. 1/2 border edge-beaded with 2 rows white ponies plus alt. rose white heart, gr. blue and pony trader blue. 2 corners have spot beaded white ponies. Beaded side ornamented with large cowrie and brass hawk bell dangles on buckskin thongs. 51" X apx. 36". Exc usable shape. Est. 750-1200 **SOLD $550(96)**

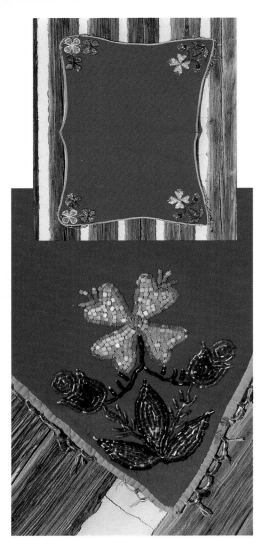

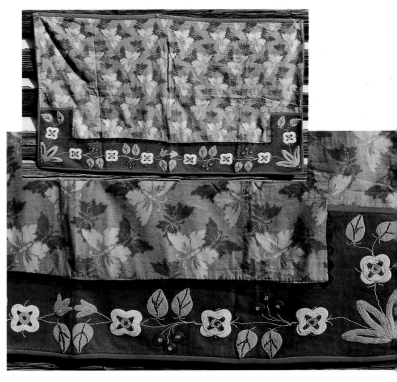

NEZ PERCE PARTIALLY-BEADED SADDLE BLANKET c.1915
Abstract floral pattern on dark green wool felt border in porcelain white, clear, t. rose, gr. yellow and cobalt. Muted purple and white all-over butterfly motif cotton flannel (both sides). Bound on 3 sides with orange wool felt. Very light use. 57" X 35". Est. 750-1200 **SOLD $650(96)'**

BLACKFOOT PARTIALLY-BEADED SADDLE BLANKET c.1900
Red twill trade wool with showy basket-beaded stylized floral motifs in each corner. T. gold, t. silver, satin lt. blue, satin white, t. cobalt. Edge-bead corner loops apx. 50% missing. Yellow muslin binding. Shows use-back muslin soiled from wear. Est. 575-900 **SOLD $500(96)**

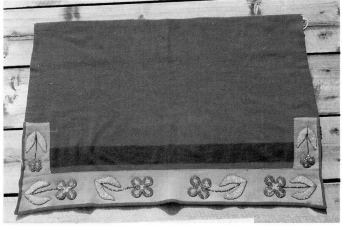

NEZ PERCE SADDLE BLANKET c.1900
Made from a 2-1/2 point Hudson's Bay blanket (point marks seen under heavy green felt border.) Partially beaded in stylized flowers:tri-cut rose, yellow, and blue. Good cond. 36" X 52". Est. 750-975 **SOLD $800(94)**

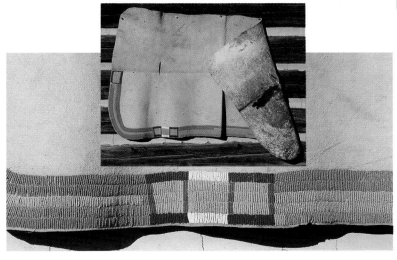

NO. PLAINS PARTIALLY-BEADED SADDLE BLANKET c.1880
Made of buffalo hide (some hair-on back side). Sinew-sewn and lazy-stitched. Simple geometric border along long side: 3 shades of blue, white, gr. yellow and rose white heart. Exc cond. Est. 1500-3000 **SOLD $1500(96)**

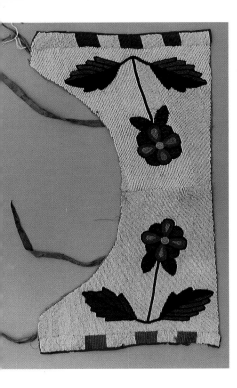

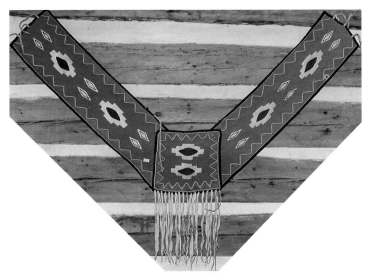

PLATEAU TRADE CLOTH MARTINGALE c.1920
Collected on the Yakima Res., c.1950. Red wool bkgrd. with purple wool zig-zag borders outlined in lt. blue seed beads. Center panel has white selvedge showing at bottom. Buckskin applique diamonds with t. blue beadwork. Black wool binding. Muslin backing shows use. 10" heavy buckskin fringe at bottom. 49" X 7.5" W. Est.700-1500 **SOLD $750(93)**

CROW SADDLE ORNAMENT c. 1910. This unusual piece is fully seed-beaded in floral designs on a white bkgrd. This decoration was tied onto the back of a Cowboy-style riding saddle. It probably had long angora drops attached. 11" X 19". Est. 400-600 **SOLD $250(86)**

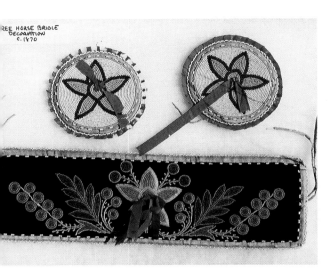

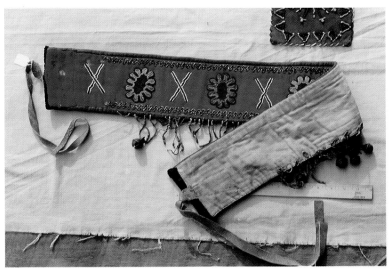

CAYUSE PARTIALLY-BEADED RED TRADE CLOTH MARTINGALE c.1880
Abstract floral and cross patterns bordered by 3-cut metallic zig-zag designs. Flowers are alternating Crow pink and gr. green outlined in t. navy; crosses are black outlined in white. Bound with green wool felt and backed with muslin. Back shows wear. 40"L X 5.5"W + 4" beaded dangles in grey-green oval beads with 1" brass sleigh bells (apx. 50% missing.) VG cond. Est. 575-850 **SOLD $625(94)**

CREE HORSE BRIDLE DECORATION SET (3 PIECES) c.1870
Black velvet bound with green silk ribbon and floral beaded in t.beads: rose, green, gold and other very subtle pastels. 14" X 4". The 2 matching (4.5") rosettes are fully-beaded with white bkgrd.; lt. blue and dk. blue stylized flowers. Edged with red and green silk ribbons and white bead edging. Floral gingham lined. Est. 350/550 **SOLD $250(91)**

RIDING QUIRTS

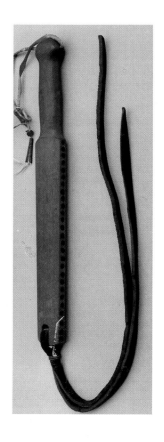

BLACKFEET WOODEN QUIRT c. 1890
RARE. Collected at Browning, Mont. Dk.
brown carved wood handle with burned
dots on 2 sides. The harness leather strap
is attached through a burned hole and
held in place with wrapped copper wire.
The handle has red painted buckskin
thong with 2 blue beads and copper cone
attached for a wrist strap. 36" total L.
Est.350-850 **SOLD $450(95)**

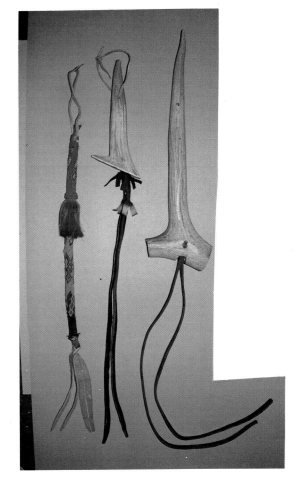

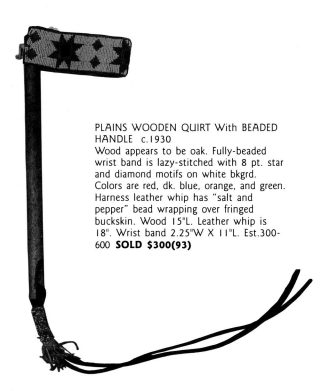

PLAINS WOODEN QUIRT With BEADED
HANDLE c.1930
Wood appears to be oak. Fully-beaded
wrist band is lazy-stitched with 8 pt. star
and diamond motifs on white bkgrd.
Colors are red, dk. blue, orange, and green.
Harness leather whip has "salt and
pepper" bead wrapping over fringed
buckskin. Wood 15"L. Leather whip is
18". Wrist band 2.25"W X 11"L. Est.300-
600 **SOLD $300(93)**

Left to right: HALF-HITCHED HORSEHAIR QUIRT
c.1870
Dyed pumpkin, orange and purple with natural white
and dk. brown. Natural horsehair fringed center
section. New moose hide whip and sinew-attached
wrist strap. Shows some wear. Hangs 30"L. Est. 100-
200 **SOLD $175(96)**
PLATEAU ELK ANTLER QUIRT c.1930 or earlier.
Characteristic flared bottom. Harness leather whip
with old fringed green undyed selvedge trade wool at
attachment. Exc. cond. 31" total L. Est. 200-275
SOLD $200(96)
SIMILAR. Unusual style. Large elk antler with old
patina and cracks of age. Heavy harness leather
whip. Antler 19". Hangs 43" total L. Est. 100-200
SOLD $150(96)

V. Children's Items, Tipis, Games, Musical Instruments and Contemporary Art

DOLLS

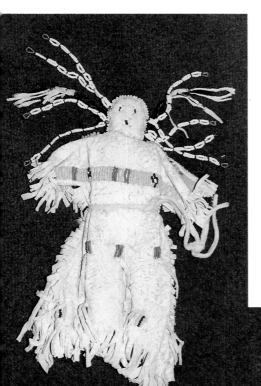

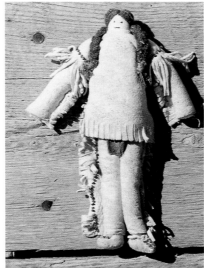

BLACKFEET MALE DOLL c.1900
All buckskin clothing with row of alt. red and t. cobalt beads on leggings and sleeve seam. Muslin body. Cotton thread hair and navy cotton breech clout. T. red and t. yellow beads on buckskin moccasins. Exc. cond. 7.25" H. Est. 300-450 **SOLD $175(95)**

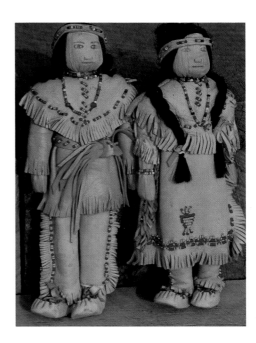

SIOUX FEMALE DOLL c.1890
Braided buffalo hair with sinew-sewn partially beaded buckskin dress. Strung white seed beads with rose white heart loops form simulated dentallium earrings. Exc. cond. 10"L. Est. 1000-1600 **SOLD $1000(94)**

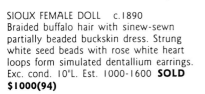

PAIR OF IROQUOIS CORN HUSK DOLLS c.1930
Tan commercial leather outfits, incl. moccasins all beaded in multi-colors, plus necklaces, bracelets, headbands. Female has human hair wig and muslin petticoat and bloomers. Male has black sock wig. Exc. cond. 10" H. Est. 200-450 **SOLD $301(94)**

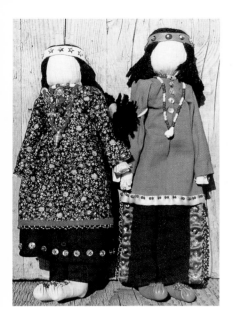

PR. OF SENECA CORNHUSK DOLLS
Contemp.
Allegheny Res., NY. Calico-garbed
traditional dress male and female. Each has
bead necklace, beaded leather moccasins
and headband with black yarn hair. Sequin
and beadwork trim. 9"H. Est. 75-125 pair

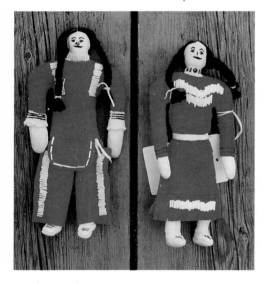

PR. OF BLACKFEET BUCKSKIN DOLLS
c.1989
Red trade cloth outfits. Black yarn braids.
White quill sewn decoration. 9.5" H. Est.
75/125 **SOLD $110(91)**

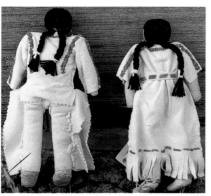

ESKIMO DOLL and BABY c.1890
Unusual piece. All fur (coat and mukluks),
leather and wood (carved faces). Mother is
carrying hand-carved spoon and a leather
basket. Sealskin, beaver and wolf(?). Slight
moth-damage on back only; otherwise, exc.
cond. 11" H. Est.300/500 **SOLD $300(91)**

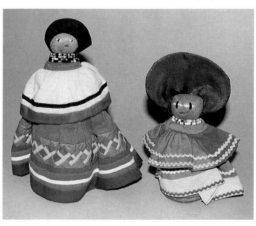

Left to Right: SEMINOLE DOLLS c.1930s
Coconut husk body with embroidered faces.
Colorful cotton dresses and black cotton
hats. 8" H. has patchwork skirt. Est. 50-100
6" H. Rick rack trim. Est. 40-85 **SOLD $35
Each(97)**

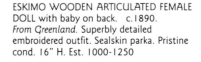

ESKIMO WOODEN ARTICULATED FEMALE
DOLL with baby on back. c.1890.
From Greenland. Superbly detailed
embroidered outfit. Sealskin parka. Pristine
cond. 16" H. Est. 1000-1250

ROCKY BOY DOLLS c. 1980
Chippewa-Cree from Mont. Male and
female, dressed in soft white buckskin
outfits beaded in red and blue seed beads.
Braids are black wool crewel thread. 8" H.
Est. 150-250 pair **SOLD $85(88)**

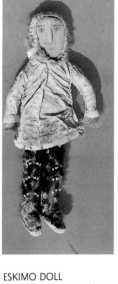

MALE ESKIMO DOLL
Carved wood leather parka has remnants of
fur. Pants are caribou with multi-color bead
horizontal trim also on mukluks. 9" H. Est.
75-125

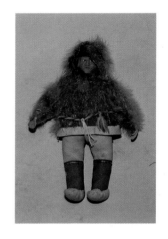

ESKIMO DOLL c.1900
Sealskin parka and buckskin pants and
mukluks. Carved and painted wooden face.
Wool yarn belt. Red cloth leggings. Light
patina. VG cond. Est.100-200 **SOLD
$130(93)**

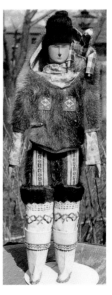

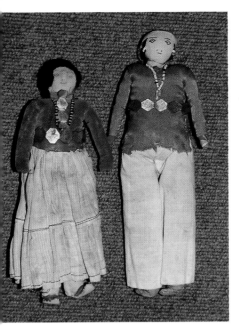

Note: For reference information on the following Skookum dolls: see Eller, Paula J., "The Skookum Indian Story", *Doll World Magazine*. Berne, IN. April 1988: 62-64.

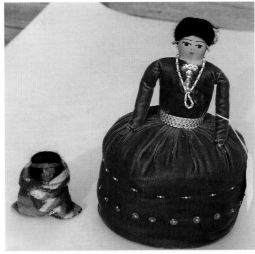

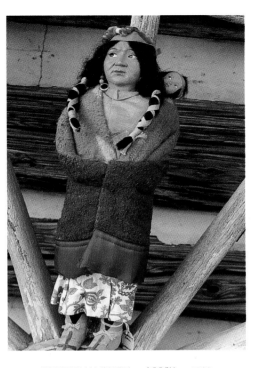

PAIR OF NAVAJO DOLLS c.1915
Muslin covered bodies. Female has striped tiered muslin shirt and rust velvet blouse with tin concha belt and neck piece. Hard-sole mocs. Natural dk. wool spun hair. Male has black rayon head scarf, bead jewelry and same belt and mocs as female. Embroidered faces. Faded but VG cond. 9" H. Est. 85-150
SOLD $110(95)

Left to Right: SKOOKUM SHORT DOLL c.1940
Blanket wrapped. Composition face with red headband. Good cond. 3" H. Est. 20-50
SOLD $35(94)
LARGE NAVAJO PINCUSHION STYLE DOLL c.1940
Blue velvet dress has sequins and bead trim. Beaded jewelry. Muslin painted face-black wool hair. Woven braid belt. Chintz bottom. Exc. cond. 11" H. X 6.5" diam. bottom. Est. 20-75 **SOLD $27(94)**

SKOOKUM WOMAN and BABY c.1920.
Blanket-wrapped with calico skirt and orange cotton shirt. Painted leather moccasins, chenille beaded leather head band and beaded earrings. Human hair wigs with composition faces. Exc. cond. 17" H. Est. 250-400(96) **SOLD $125(88)**

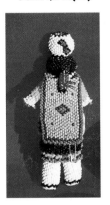

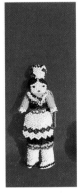

ZUNI FULLY-BEADED FEMALE DOLL c.1940
Entire doll is made of net-beadwork (brick stitch); apron, shirt, petticoat, and moccasins even bowl balanced on head. Also traditional hair-tie, shawl and necklace. All pieces done separately in multi-colors. Exc. cond. 5" H. Est. 95-150
SOLD $80(94)

FEMALE SKOOKUM DOLL IN ORIGINAL BOX c.1940
Numbered #4030 and labeled "Bully Good". Cardboard box has red and black geometric Indian design. Beacon blanket wrap and magenta wooden bead necklace, painted face, calico skirt and scarf, and cotton headband, molded moccasins. Exc. cond. 10" H. Est. 100-175 **SOLD $75(90)**

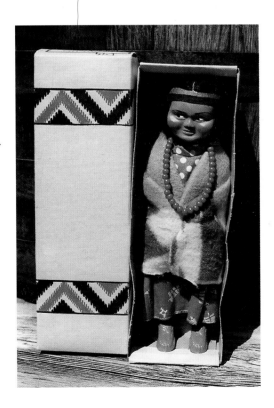

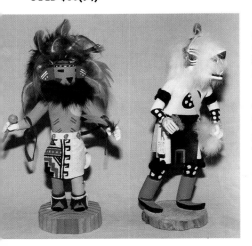

Left to Right: "SILENT WARRIOR" HOPI KACHINA Contemp.
Signed "90-CVG". Natural wood base, painted leather kilt and leather-trimmed moccasins. Carries wood rattle and feather. Black fur around neck and back of head. Exc. cond. 11" H. X 3.25" round base. Est. 60/95
SOLD $70(92)
HOPI WHITE WOLF KACHINA
Signed "L. Barber". Carved wood painted white with black and turquoise moccasins. Black leather kilt with yarn and feather embellishments. Natural wood base. 10" H. Est. 60/85 **SOLD $70(92)**

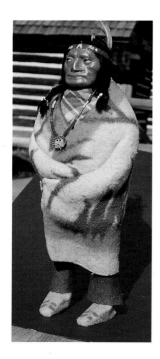

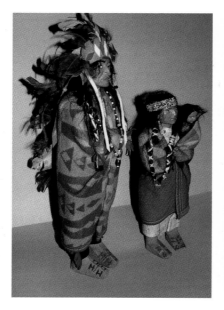

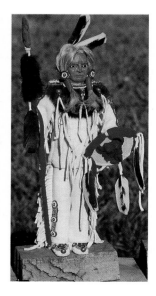

MALE SKOOKUM DOLL c.1940
Beacon blanket wrapped with purple felt fringed leggings and yellow felt painted moccasins. Plaid neck scarf. Painted red tape headband with 1 feather. Seed bead necklace with "face" pendant. White pony bead ties for braids. Nose tip chipped and painted. VG cond. 14.5" H. Est. 150-195 **SOLD $125(96)**

PR. OF LARGE MALE and FEMALE SKOOKUM DOLLS c.1916
With label on foot (see detail photo) which determines pre-1949 manufacture. Each has Beacon-style blanket wrap bound with ribbon, raffia-wrapped braids, painted leather moccasins and human hair wigs. Realistic composition faces.
MALE: Wears single trailer bonnet with leather brow band and back drop which hangs 11" down back. Calico shirt. Feathers are red hackle and purple and yellow fluffs. Brown felt leggings have red felt side fringe. Long bead necklace is Peking t. green and t. blue ovals, porcelain, t. rose, white and black seed beads. 19" H.
FEMALE: and baby. Calico dress with dk. green felt underskirt. Long beaded earrings with copper rings. "Salt and pepper" beaded headband (3/4" W) with multi-color feather fluffs. Both faces have been cracked and repaired (not noticeable on man; on woman only when closely inspected); otherwise exc. cond. 15"H. Est. **SOLD PR. $800(96)**

MALE CREE DOLL Contemp.
Signed and carved by Frank Little Boy. Wood upper body, face and hands. Detailed face with glass bead eyes. Grey "wig" hair with beaded hair ties. White fringed Indian-tanned outfit including moccasins. Beadwork on shirt, pants and mocs; red, orange, white and turquoise. 1 hand holds 19" lance wrapped with red cloth and fur; other holds buckskin shield trimmed with red cloth, feather drops and wood buffalo head. Natural wood base. 15" H. Est. 250-450 **SOLD $225(95)**

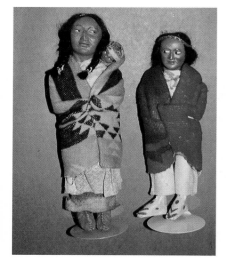

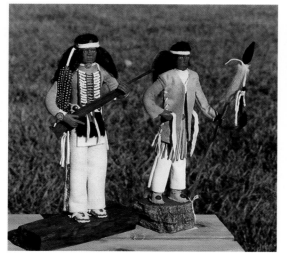

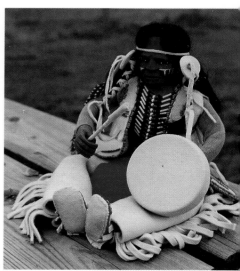

Left to Right: FEMALE SKOOKUM With BABY c.1920
Calico skirt and underblouse. Old-time yellow and green (tattered) Beacon blanket wrap. Leather painted (faded) moccasins. Baby's hair has worn off-has headband. Fair cond. 11" H. Est. 150-250 **SOLD $225(96)** *Note: High price in spite of imperfect condition here due to rarity of eyes looking right (not left like most Skookums)*
MALE SKOOKUM DOLL c. 1920-30
Red and blue Beacon blanket wrap with calico at neck. Cream felt leggings with painted paper moccasins. Short hair with red and metallic braid headband. Slight chip on face-doesn't show-same color as face. 10" H. Est. 75-125 **SOLD $85(96)**

LEFT TO RIGHT: CHIPPEWA-CREE "GERONIMO" DOLL Contemp
Carved and signed by Frank Little Boy. All wood body, face and hands. Bead eyes. Long dk. brown "wig" hair. Bead choker, bracelet and breastplate. White Indian-tanned pants with cut bead strip. Navy breech clout is white selvedge trade wool. Beaded moccasins. Holds 9" carved rifle. 14" H. **Est. 250-400 SOLD $300(95)**
CREE DOLL With LANCE Contemp.
Signed and carved by Sid Gosselin. Wood upper body, face and hands. Bead eyes. Long dk. brown "wig" hair. Imitation buckskin shirt with smoked brain tanned jacket. White buckskin pants. Holds 14" carved lance wrapped with fur. 13" H. incl. base. Est. 100-195

INDIAN DRUMMER DOLL Contemp.
By Chippewa-Cree artist Frank Little Boy. Wooden face, hands and upper body. Seated holding buckskin covered drum with drumstick. Long black hair-2 pink conch shell hair ties. Face painted with red and white war paint. Bead eyes. Wears breastplate, white Indian-tan fringed buckskin vest and leggings with red breech clout. Partially beaded moccasins and vest. 8" H. Est. 225-495

140

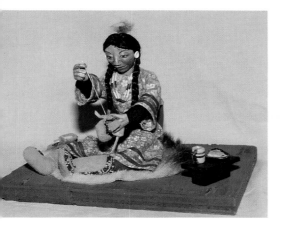

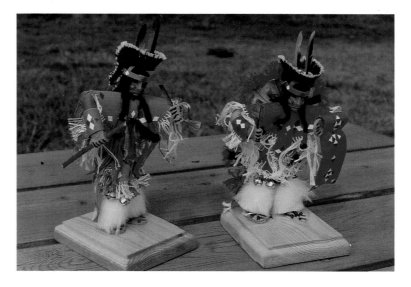

"LAST STITCH" DOLL DIORAMA. Contemp.
Miniature by Melvina Brave Rock, Blackfoot artist, Canada.
Blackfoot woman in ribbon-trimmed calico dress sews a pr.of moccasins. Sculpted hands and face-beaded belt with knife sheath and beaded belt pouch. She also wears beaded moccasins and leggings. Coffee cup, plate of jerky and Bannock bread-beeswax and beads are all handy! Sits on fur rug. Mounted on painted wood 7" X 9" X 6.5" H. Est. 275/450 **SOLD $275 (94)**

BLACKFEET POW WOW DANCER DOLLS Contemp.
Made and signed by Evelyn No Runner of Browning, Mont. Each is 9'" H. on 3.5" X 4" wooden stand.
RIGHT: Fancy Dancer has bright pink and turq. cloth and yarn outfit. Roach is bristle and tiny feathers with yarn. Leather hands and moccasins, tiny brass bells adorn white fluff leggings. Full-length bustle in magenta, turq. and white yarn.
LEFT: Grass Dancer has pred. turq.with bright pink and white yarn decoration. Carries dance stick with feather.
Est. 75/95 **SOLD $75 EACH(92)**

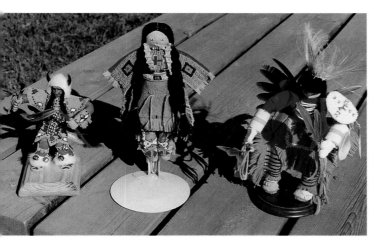

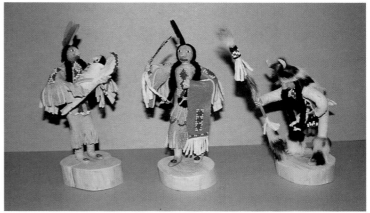

Left: BLACKFEET MAN BUFFALO HORN DANCER DOLL Contemp.
Made and signed by Thomas and Evelyn No Runner from Browning, Mont. Detailed piece:feather bustle, seed beaded breastplate and real claw horn bonnet. Carved wood face-mini dance bells. Turquoise shirt with feather cape, gloves, apron, and moccasins painted with blue and white geometrics. Holds feather dance stick and feather. Wooden base. 7"H X 3" X 4". Est 90-125 **SOLD $90(93)**
Center: See description under Replicas in the companion volume.
Right: BLACKFEET TRADITIONAL DANCER Contemp.
Signed "Big Beaver-Browning, MT". Red cloth shirt with commercial leather fringed and beaded dance apron; painted striped and fringed leggings; white and yellow beaded gauntlets and moccasins. Deer hair roach. All feather bustle. 7" H with wooden stand 4" diam. Est. 75-95 **SOLD $95(93**

SHOSHONE MINIATURE FIGURES *made at Fort Hall, Ida.* Contemp.
Left to Right: FIGURE With CRADLE BOARD Brain-tanned buckskin with maroon,white and periwinkle beadwork. Black yarn hair with bead eyes. Standing on wooden block. 6.5"high. Est. 75-110 **SOLD $95(96)**
DANCER With GREEN BLANKET *Signed by Dianne Ottogary.* Same as above with green, maroon, and copper beadwork. Holding feather fan. Est. 75-110
"DANCING CHIEF" *Signed "Benjamin Ottogary."* Dressed in white brain tan and fur. Beadwork is red, white and black. Holds a wooden, fur wrapped dance staff. 6.5"H Est. 75-110 **SOLD $125(96)**

PR. OF MALE and FEMALE BLACKFEET DOLLS Contemp.
Indian-made. Each has buckskin garments, face and hands.
FEMALE: Fringed dress with red and brick bead work. Real hair with fur-wraps and bead work ties. 6" H.
MALE: Fringed shirt and leggings with blue and black beadwork. Tiny bead breastplate. Fur horn headdress with porky claws for horns. 7"H. Est. 85-150 pair **SOLD $125 PR.(94)**

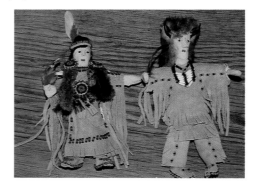

Baby Carriers and Cradle Boards

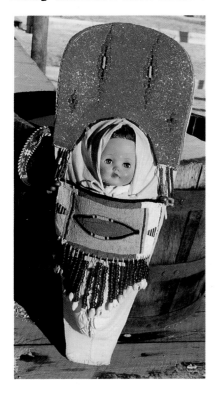

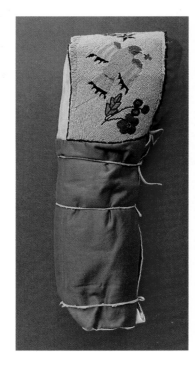

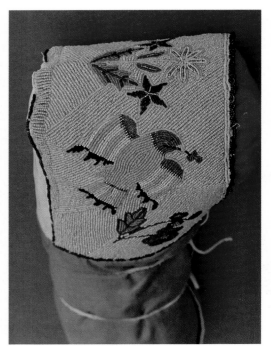

FLATHEAD DOLL CRADLE BOARD
c.1930
Belonged to Ellen Big Sam. Fully-beaded tri-cut top; orange bkgrd. with multi-color geometric designs and tile bead with brass hawk bell dangles. *NOTE: Bib is rectangular panel from a c.1880 Crow blanket strip** which is pred. Crow pink with green, white, rose white heart, and gr. yellow. Later added graduated t. green Crow bead and white olivella shell dangles. Muslin-covered board with Indian-tanned fringes on back. Exc. cond. 29" X 10.5" Est. 500-1000
SOLD $800(89)
**See Artifake section, p. 195, for detail photo on strip, etc.*

FT. PECK-ASSINIBOINE SOFT DOLL CRADLE BOARD With FULLY-BEADED TOP c.1900
Bird and flower motif. Contoured pale turquoise bkgrd. with delicate pastel designs in cuts: lt. periwinkle, rose white heart, silver metallic, emerald, cobalt, black, t. lt. green, Chey. pink, t. red and opalescent white. Edge-beaded in emerald green. Buckskin back and thongs. Skirt and lining of rose polished cotton. Exc. cond. 18" H. X 5.5" deep X apx. 5" W. Est. 950-2000

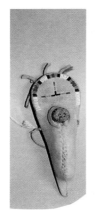

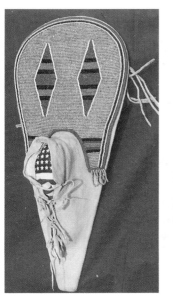

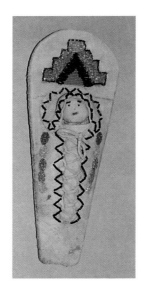

ARAPAHO TOY CRADLE BOARD c.1930
Buckskin covered board with calico headed baby. Cut beaded decoration in white, red, t. amber and dk. green. Exc. shape. 6". Est. 100/200 **SOLD $70(92)**

PLATEAU PARTIALLY-BEADED DOLL CRADLE BOARD c.1930
Tri-cut beaded in rose, copper, black and clear;seed beads-periwinkle and cobalt. Buckskin covered with buckskin doll. Exc. cond. 11.5"L X 4.25" W. Est. 500-750

YAKIMA DOLL CRADLE BOARD With FULLY BEADED TOP c.1920
Double striped diamonds on pale t. rose bkgrd. applique stitched. Diamonds are orange white heart, apple green, and dk. cobalt outlined in white. Apple green bead loop fringe. Top bound with rose silk ribbon. Bottom is buckskin with fringe on back. Exc. shape.15" H. X 6.5". Est. 800-1200 **SOLD $750(94)**

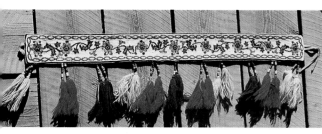

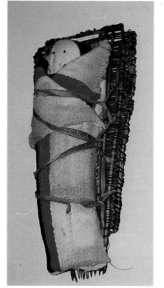

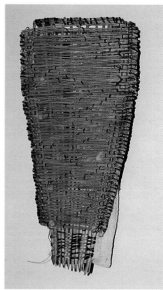

PAIUTE BASKETRY CRADLE Typed label reads *"Paiute Cradle Frame, Great Basin, UTAH, Early 19th Century."*
Open twine fibers-coiled on sides and laced with dk. bark strips. Back reinforced with lashed willow. "Baby" is sock head wrapped with old Navajo blanket section added by the collector; bound with old striped (faded) muslin strips which appear to be very old and original to the cradle. 20"L 9.5" W. at top tapering to 5"W. bottom. Exc. cond. Est. 400-600

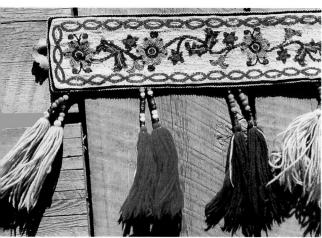

ATHABASCAN BEADED BABY CARRIER STRAP c.1900
Fully-beaded. White bkgrd. with varied floral pattern. Crow pinks and deep rose iris flowers;cobalt and red tri-cut flowers. Leaves are emerald tri-cuts with orange and pink satin tri-cuts. Bordered with cranberry tri-cut chain design. Black velvet welt is white edge-beaded. 6" yarn tassels in alt. red, white and blue suspended from 3" drops with trade beads (multi-color padres and wire-wound Crow). Canvas back shows patina of age. Moose hide fasteners. Perfect cond. 5"W X 48"L. Est. 1200-1800

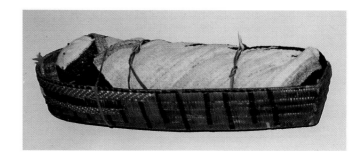

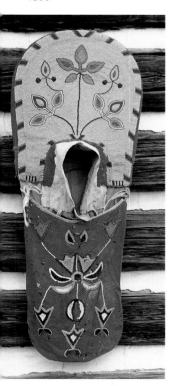

FLATHEAD BABY CRADLE c.1915
Abstract floral fully-beaded top and partially-beaded cloth bottom. Buckskin cover stretched over wooden board. Red cloth skirt on botton front section has some moth damage. Beadwork all intact. Apx. 30"L. Est. 2000-2500 **SOLD $1800(95)**

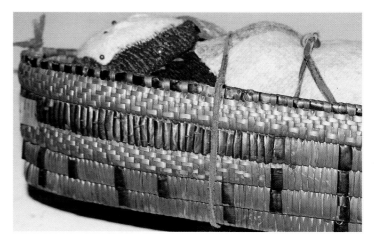

SALISH IMBRICATED BASKETRY CRADLE
RARE. Label says *"Lillooet tribe, West. B.C".* Coffin shaped;elaborate imbrication of all-natural fibers: red cherry bark, black bark, lt. brown and cedar root. (See detail). Sock head "baby" wrapped in Navajo blanket section added later by the collector. Exc. cond. 22"L X 4"H X 7.5" W. pt. Est. 450-800
See similar basket in Jones, Joan M., *The Art and Style of Western Basketry*, p. 23 (Salish, B. C.). and in Lobb, A., *Indian Baskets of the Pacific NW and Alaska*, p. 52 and 58.

143

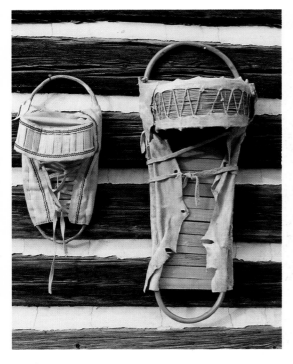

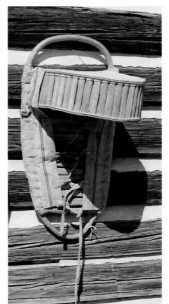

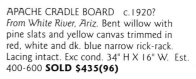

APACHE CRADLE BOARD c.1920?
From White River, Ariz. Bent willow with pine slats and yellow canvas trimmed in red, white and dk. blue narrow rick-rack. Lacing intact. Exc cond. 34" H X 16" W. Est. 400-600 **SOLD $435(96)**

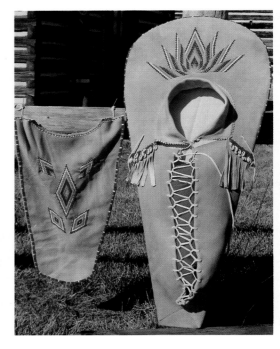

Left to Right: **APACHE DOLL CRADLE BOARD** c.1979
Tag reads "from Ella....grand-daughter Canyon Inn White R., Arizona Apache Reservation March 1979..made of cactus". Probably made from willow with pine slats. Gold cotton carrier with red, white and blue rick-rack. Exc. cond. 20.5"L X 9"W X 7" deep. Est. 125-275
APACHE FULL-SIZED CRADLE BOARD c.1890
Yellow ochred buckskin covered wooden frame. Undecorated. Patina shows age. VG cond. 34.5"L X 13"W X 9" deep. Est. 300-450

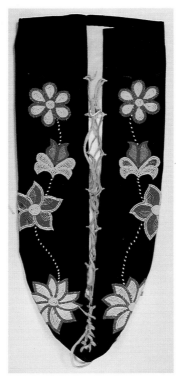

KOOTENAI INDIAN-TANNED HIDE COVERED CRADLE BOARD Contemp.
Made and tanned by Sophie Matt from the Flathead Res. Partially beaded with characteristic geometric patterns in red, yellow, rust, white and orange. Bib covering shown separately. Made from several fine quality smoked deer hides that this tribe is known for. Embellished with cowries and red facet beads. 36"H X 16.5". Est. 450/650 **SOLD $500(93)**

FLATHEAD BLANKET BABY CARRIER c.1980
Pendleton geometric blanket in dk. blue,yellow, orange and red with leather thong lacings. Fully-lined. Blanket shows wear. Used cond. 11" X 22" long. Est. 30/ 60 **SOLD $50(90)**

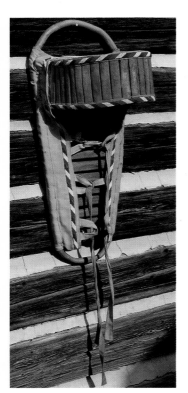

CHIPPEWA-CREE BLACK VELVET BEADED BABY CARRIER c.1960
Rayon velvet with muslin lining. Colorful multi-colored floral motif in tri-cut and opaque beads. Brain-tan smoked lacing. 25" X 10". Exc. cond. Est. 150/200 **SOLD $150(90)**

APACHE FULL-SIZE CRADLE BOARD c.1915
From White River, Ariz. Bent willow with pine slats stained yellow with yellow canvas trimmed with red, white, blue diagonal stripe pattern beadwork on both sides and around top slats. VG cond. Lacing intact. 32" H. X 13.5" W. Est. 500-750 **SOLD $600(95)**

144

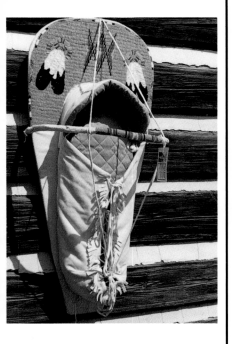

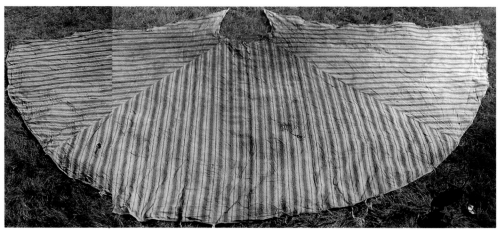

OLD-TIME AWNING CANVAS TIPI c.1910
HISTORIC and RARE. Using striped awning canvas was popular around the turn-of-the century esp. with the Nez Perce and related tribes. There is a Boos photo of a Flathead camp c.1907 and a Doubleday photo of Pendleton Round-up in the 1920's showing several tipis of this style in use. Indigo stripes. Machine and hand-sewn with lacing pin holes and loops for pegs. The patina and darkened smoke flaps tell tales of many camp fires and ceremonies. This tipi is in usable good cond. 6 well-repaired tears and several small ones that need repairing. Back: 11'; front: 14'. Est. 500-1200 **SOLD $600(94)**

SPOKANE FULLY-BEADED CRADLE BOARD
c.1985
Lime green bkgrd. lazy-stitched with cut-bead design elements and geometric border. White, black, pink, yellow and red. Bag and hood made of white corduroy (looks and hangs like buckskin) lined with lime green quilled cotton. Buckskin covered and bead-wrapped willow head protector bar. 36"H. Est.425-575 **SOLD $450(93)**

ipis and Tipi Liners

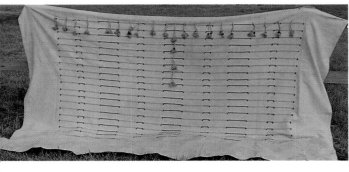

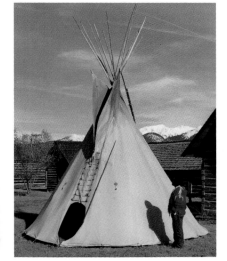

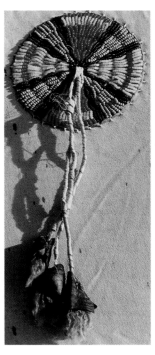

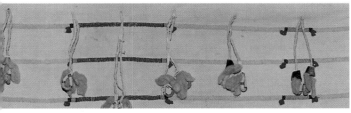

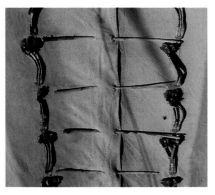

CLASSIC CHEYENNE BEADED TIPI LINER c.1890_
This type of beading and color combination is in the sacred Cheyenne beadwork style which can only be done by certain women who have the ceremonial rights. 3/8" wide sinew-sewn beaded stripes on canvas in gr. yellow, red white heart, lt. blue, and cobalt with red trade wool tufts spaced at each color change. Mountain goat and deer toes hang on corn husk wrapped buckskin dangles (yellow, red, green, and black) with yellow-dyed un-spun wool tufts at ends. Exc. usable cond. 6'10" W X 10'8" L. Est.3000-5000 **SOLD $3250(91)**

18' CHEYENNE DECORATED CANVAS TIPI c.1940
This tipi was used in the movie "Son of the Morning Star" which was filmed in So.Dakota, summer, 1990. 16 corn husk-wrapped dangles (detail photo) with wrapped loops and dew claws at ends on either side of the tipi pins. Around the cover above door level, are 4 beaded rosettes (detail photo) with 3 cornhusk wrapped dangles tipped with dew claws and wool tufts. These ornaments are typically used on tipis that have been constructed by the sacred Cheyenne women's sewing societies. A light spray of grey paint was applied to the white canvas for the movie which adds a patina to it. A few small repairs and patches but tipi is in VG and usable cond. Est.600/1000 **SOLD $550(91)**

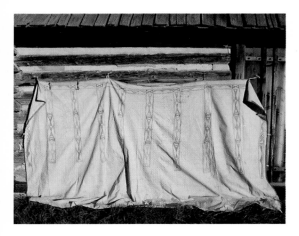

BLACKFEET TIPI LINER c.1900
Canvas with black, red-orange, and blue painted designs. Minor fading in design. Completely hand-stitched with red cotton cloth and white canvas binding. Cloth ties at top. Exc. cond. and patina.10'3" long. 6'2" high. Est. 500-750 **SOLD $500(96)**

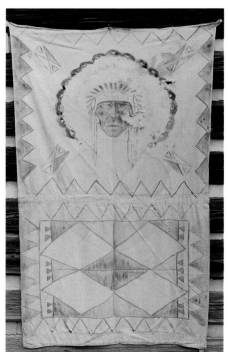

BLACKFEET PAINTED CANVAS TIPI DOOR
c.1930
Acquired from Cecile Horn, an elderly Blackfeet woman from Browning, Mont. Belonged to her mother Agnes Big Load and was in use during the 1930s. Made from flour sack weight canvas and appears to have been painted with old powder paints or water colors. In addition to geometric designs there is a realistic Indian face with war bonnet in faded green, yellow and cobalt. At bottom and middle is a rolled tube of canvas through which a willow stick can be installed to give the door stiffness. Double-thick canvas. Fair cond. 35" X 58"l. Est. 95-150 **SOLD $135(93)**

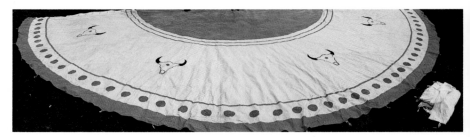

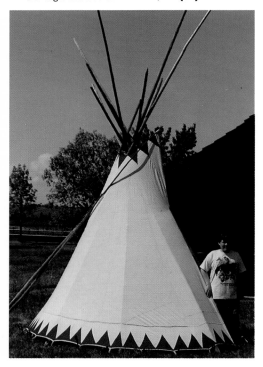

YAKIMA (PLATEAU) SMALL TIPI c.1950
Made from "Utah-Idaho Sugar Co." sacks with royal blue sailcloth appliqued triangle motifs around bottom and on flaps. Most of the tipi is hand-stitched with some machine sewing. Exc. cond. 10.5' diam. Est. 175-300 **SOLD $200(96)**

BLACKFEET CANVAS TIPI and LINER
c.1980s.
Painted buffalo skull designs. Heavy weight canvas with top, bottom and stripes in turquoise paint. Red circles around bottom and black circles on flaps representing stars. Has four buffalo skulls around mid section, outlined in black with red circles on forehead. Includes white canvas tipi liner. In exc. very usable cond. Only two small tears. Measures 18' from top pole tie to front bottom. Est. 300-500 **SOLD $350(96)**

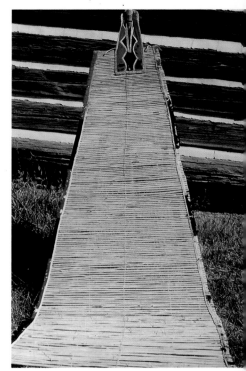

Backrests and Tipi Models

ASSINIBOINE WILLOW BACKREST c.1880
Purchased on the Ft. Peck Res. from Joe Russell of Poplar, Mont. It has 5 sinew laces running through and around willows to hold it together. The edges are bound with red and black wool that has been trimmed with flowered calico cotton. The hanging strap is red and black wool cut into a scalloped design and bound with plain and calico cloth. About 1/3 of the wool has disintegrated due to moth damage; otherwise, VG cond. 4'9" L X 10.5" W. at top and 35.5" bottom W. Est.600-1200 **SOLD $600(93)**

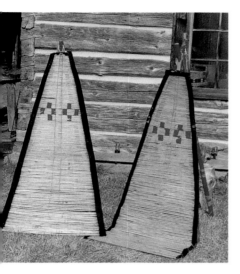

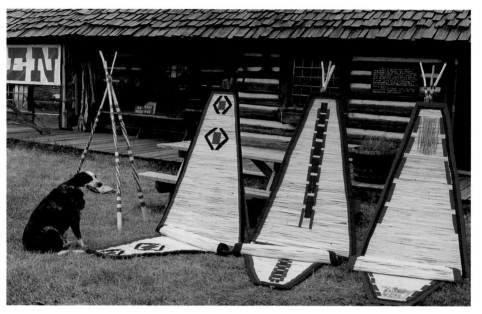

PIEGAN (BLACKFOOT) WILLOW BACKRESTS c.1890
Purchased from Old Lady Mustache's tipi at a Pow Wow on the Piegan Res., Brockett, Canada in 1962. Fine willow sticks laced together with buckskin lacing and sinew. Edge binding is black wool gabardine (1 edge has brown blanket wool underneath). Red wool strips woven through willow into cross designs. Slight wool moth damage. 62" L Bottom w. 32". Top 8" W. It is hard to find an old matched pair. Est. 800-1500 **SOLD $850(97)**

Left to Right: BLOOD (CANADIAN BLACKFOOT) *made by Mary Mills and family (see tipi models also made by them)*
CARVED TIPI BACK REST TRIPOD Contemp.
Pine; designs carved into the bark. Average 70"L., apx. 1.5" diam. Buckskin ties. Est. 50-85 **SOLD $85(97)**
WILLOW BACKRESTS Contemp.
All are in new cond. Similar set **SOLD $300(94)**
SET of 2 with red and deep purple wool and felt binding and trim. laced with imitation sinew. 55" L. 10" W. at top, 36" W. at bottom. Est. 250-350 pair **SOLD $275(97)**
SAME. Royal blue and red wool binding and woven trim. 53"L. Est. 250-350 pair **SOLD $275(97)**
SAME. Pred. red with dk. blue binding and trim. Long leather fringe hangs from top center. 53"L. Est. 250-350 pair **SOLD $275(97)**

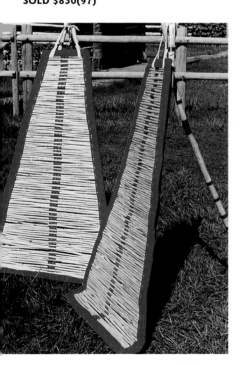

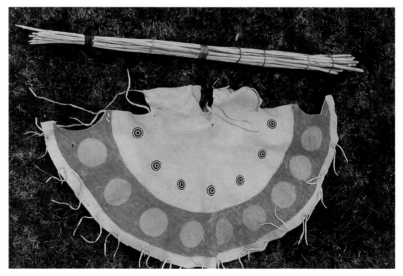

PR. OF BLACKFEET WILLOW BACKRESTS With CARVED TRIPODS c. 1989
Made by Tyrone White Grass of Browning. Mont. Red wool edged on all sides; blue calico strip down center. 60" X 11". Tapers to 31" bottom. Est. 250/350 **SOLD $285(90)**

BLACKFEET CHILD'S TOY TIPI c.1940
Made of Indian-tanned buckskin. Bottom 1/2 red ochre painted with yellow ochre circles. 7 seed-beaded rosettes in alt. yellow and dk. blue concentric circles. Newly carved willow poles (15) 4'L. 22" cover. Est. 350-500 **SOLD $275(94)**

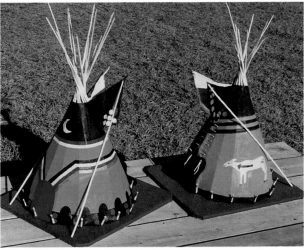

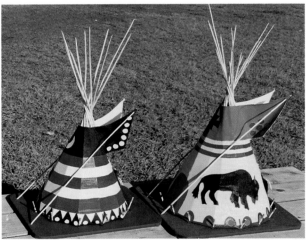

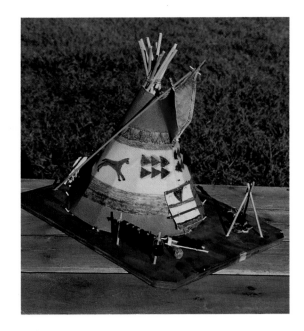

BLACKFEET TIPI DIORAMA *by Fred Grant.*
Canvas cover painted red-ochre with central
panel white with horses and triangles.
Inside are tiny model tipi backrests with
buffalo robes and stone fire pit. Outside is
jerked meat drying rack, cooking tripod,
little logs, baby carrier and tiny painted
parfleche bag. Tipi with poles 17" H. Base
15.25" X 19.5". Est. 150-300 **SOLD
$175(94)**

Games, Toy, Miniatures

TOP:
Left to right: BLACKFOOT RAINBOW MODEL TIPI
*Made by Canadian Mary Mills who says, "Bottom strip
means earth, circles are animal holes, slabs are hills and
rocks. Black top signifies night. Crescent moon; circles
are Big Dipper."*
Canvas painted blue. Mounted on green felt covered
wooden base 16" X 17". Stands 26" H. with poles.
Est. 175-300
BLACKFOOT (ORANGE) DEER MODEL TIPI
Yellow male and female deer with "spirit lines" face
doorway; flaps have 6 stars (children constellation) and
7 stars (Big Dipper). 25" H. with poles. Base is 16" X
17.5" green felt covered board. Est. 175-300 **SOLD
$175(94)**
BOTTOM:
Left to Right: NIGHT and DAY" MODEL TIPI
Bold red (night) and white (day) stripes painted
canvas. Symbols according to Mary: "7 stars-Big
Dipper, 6 stars- children (constellation), bottom circles
are animal holes, triangles are mountains". Green felt
board base 16" X 13". Tipi with poles is 23" H.
Est. 125-250
BUFFALO TIPI MODEL
Painted yellow. *This is a long story from Mary having to
do with the 1st buffalo and the sacred sun dance.* Top
painted blue with Maltese cross and constellation
symbols. Bottom symbols *"blue circles- water holes;
red humps are hills".* 24" H. X 16" X 17.5" base. Est.
175-300

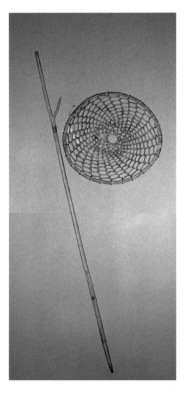

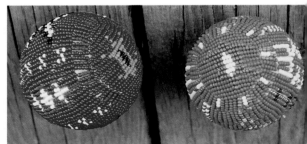

ROCKY BOY (CREE) BEADED BALLS
c. 1989
Lazy-stitched. Specify predominant
color; red, dk. green, white, or lt.
blue. 2.75" diam. Est. 50/95 each
SOLD $50 each (90)

SIOUX HOOP and ARROW GAME c.1900
Old tag on hoop reads, *"Richard Red Bow,
$2.00".* The rawhide laced hoop is made
from a bent willow branch that is painted
blue and the willow arrow is painted yellow.
The hoop is rolled on the ground with the
players scoring points by spearing it. Est.
300-400

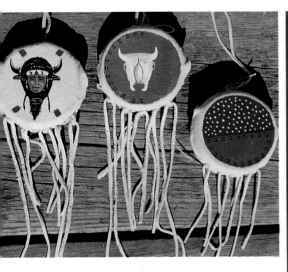

ROCKY BOY (CREE) HAND-PAINTED
BUCKSKIN MINI-DRUMS
c.1987
Unique design both sides. Buckskin fringe.
2.5" diam. Est. 30/45 each **SOLD $30(90)
each**

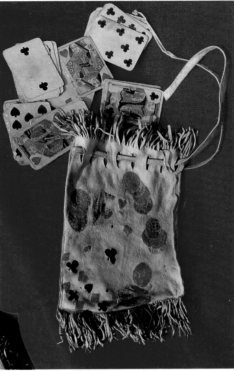

ATHABASCAN BUCKSKIN GAMBLING BAG
c.1880.
RARE. Includes 19th century full deck of
playing cards. Bag is painted 1 side with red
and blue chips, card, and card symbols.
Drawstring; fringed 2" on top and 3"
bottom. Exc. patina and cond. 14"L incl.
fringe. Est. 375-500 **SOLD $410(94)**

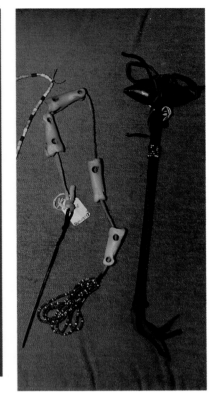

Left: SIOUX PIN and BONE GAME c.1930
Early style. Incised deer-toe bones on leather thong
with "salt and pepper" bead dangles attached to
hand-forged iron pin. Est.75-150(96) **SOLD
$20(89)**
Right: CATLINITE MINI-WAR CLUB c.1930
Red ochred leather covered handle with "salt and
pepper" beaded section. 3" head-12" total L. Est.
50-100 **SOLD $45(89)**

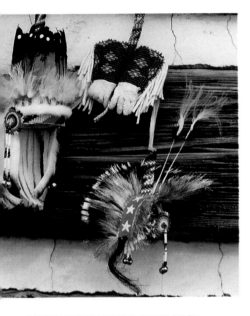

MINIATURES BY MELVINA BRAVE ROCK,
BLACKFOOT ARTIST Contemp.
LEFT: Stand-up bonnet has red thread
wrapped and painted feathers and fluffs.
Red, yellow, and black beaded brow band
and rosettes with quill and miniature bell
dangles. Hangs 7". Est. 75/95 **SOLD
$80(92)**
BOTTOM: Dance Roach with painted stars
on blue bkgrd. Red, white and blue beaded
brow band rosettes. Deer and horsehair
painted red and tipped with white. Hangs
7". Est. 75/95 **SOLD $75(92)**
TOP RIGHT: Beaded gloves hold tiny sweet
grass braid. Wired gloves beaded in dk.
blue, red and yellow fringed. Hangs 5". Est.
75/95 **SOLD $75(90)**

Musical Instruments
Drums, Rattles, Etc.

MIDIWIWIN WATER DRUM c.1900.
*RARE. Chippewa Grand Medicine Society
drum from Turtle Mountain, ND. Belonged to
Howard Kenowa. Made of painted
basswood with buckskin top.* 16" H. X 11".
Est. 800-1500(96) **SOLD $650(87)**

BLACKFOOT PAINTED HAND DRUMS and STICKS
Contemp.
From the Blood Res. (Canada) Very colorful and
nicely detailed.
TOP (left to right): Bear and bullet with stripes.
Red, blue, green, black and yellow. 8.5" X 2.5". Est.
65/90 **SOLD $75(91)**
yellow bkgrd. black fetish bear also red, blue, green
and white. 8" X 2.5". Est.65/90 **SOLD $75(91)**
BOTTOM: Buffalo skull and 2 Indian faces with
red, green, yellow border. 16" X 3". Est.125-250
SOLD $125(91)

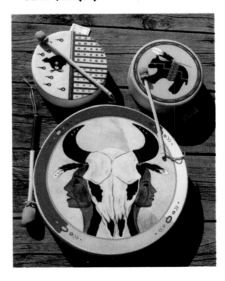

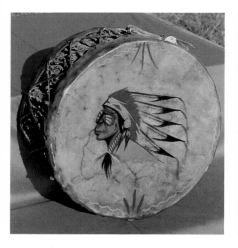

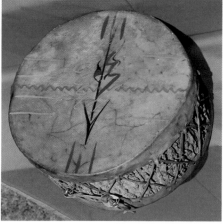

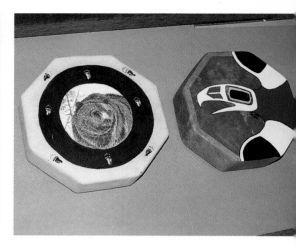

LARGE INDIAN-MADE PAINTED (BOTH SIDES) DRUM c.1940
Printed tag says "Indian-made". Bark-covered wooden base covered and laced with heavy tan color rawhide. I side painted head Indian Chief-other is arrow design. Expertly painted old-time designs. Durable-good sound. Est. 200-300 **SOLD $200(94)**

Left to Right: PAINTED HAND DRUM Contemp.
Signed "93 ECM". Realistic bear and tracks. Brain-tan over heavy wood frame. Rawhide laced underneath. Exc. cond. 11.5" diam. Est. 75-95 **SOLD $80(96)**
BLACKFEET PAINTED HAND DRUM Contemp.
Underside is signed "J.Pepion". Stylized eagle motif. Rawhide covered and laced. Exc. cond. 11" diam. Est. 55-80 **SOLD $50(96)**

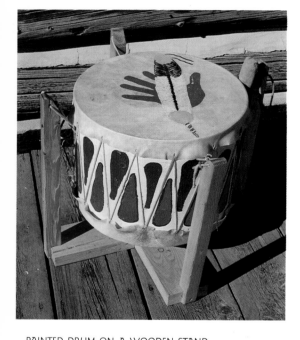

NEZ PERCE CEDAR COURTING FLUTE
Incised geometric designs. 20.5" L. 1" diam.
SIMILAR with different incised designs. Est. each 95-135 **$125 each (94)**

PAINTED DRUM ON A WOODEN STAND Contemp.
Tribe unknown. Feather and band motif with red and blue geometric on side with drumstick (included but not shown). 21"H X 17" diam.. Est. 150/195 **SOLD $95(91)**

LEFT TO RIGHT: SIOUX-MADE INDIAN DRUM Contemp.
Thick cream-color rawhide laced over hollowed log base. 9" H. X 12" diam. Est. 90-175 **SOLD $85(94)**
SIOUX-MADE DRUM With PAINTED HORSE DESIGN
Same construction as preceding. Rawhide handle. 13" diam. X 6". Est. 90-175 **SOLD $105(94)**
8 PT. STAR DESIGN
Same as preceding. 11" diam. X 5.5". Est. 90-175 **SOLD $75(94)**

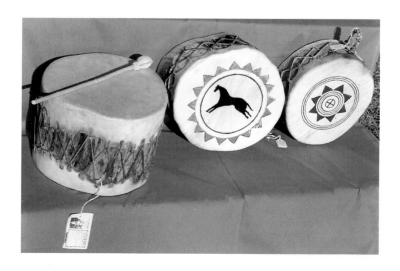

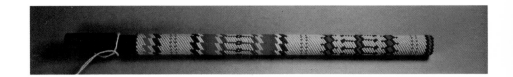

UMATILLA FULLY-BEADED WHISTLE Contemp.
Peyote-stitched. Pale blue bkgrd with red, yellow, cobalt,white, green,
and dk. red intricate geometric pattern tightly woven. Black plastic
whistle. 1/2" diam. X 11.75". Est. 85-150 **SOLD $85(93)**

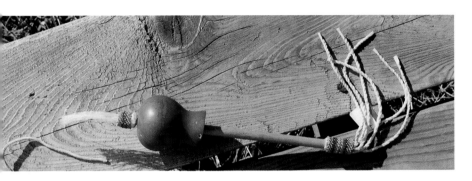

CROW PEYOTE GOURD RATTLE Contemp.
Cut bead peyote stitch embellished top and lower handle. Horsehair on
top and twisted buckskin thong drops at bottom. Exc. shape. 9"L. Est.
60-95 **SOLD $77(95)**

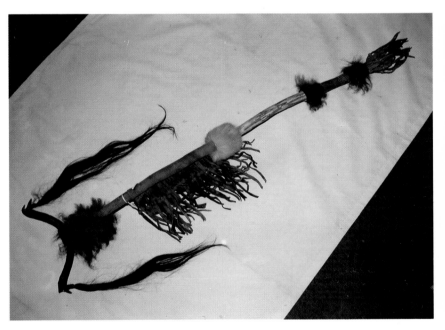

FLATHEAD INDIAN-MADE DANCE STICK Contemp.
Wood handle wrapped with fringed buckskin and fur. Horn top with
human hair. Total L. 37". Est. 45-75 **SOLD $60(95)**

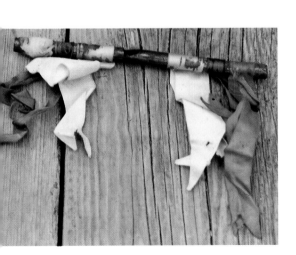

BLACKFEET SUN DANCE WHISTLE
c. 1910
*RARE. Flaherty Collection. Collected from
Margaret Running Crane of Browning, Mont.*
Made from an iron tube;decorated with
green, pink and orange faded ribbons.
Inner plug of wax would have to be
replaced to make it whistle again. 6.5"L
Est. 75-150 **SOLD $85(95)**

151

CONTEMPORARY ART
Carvings, Tourist Beadwork, Etc.

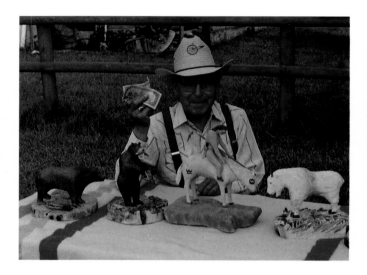

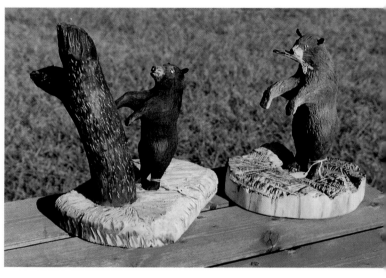

Traditional Blackfeet Wood carvings made by Fred Grant, Blackfeet carver and craftsman from Browning, Mont. shown in photo with some of his carvings. Following the footsteps of the famous Blackfeet wood carver John Clarke, he chose to carve wildlife from nearby Glacier National Park. The value is sure to increase in the years to come.

Left to Right: STANDING BLACK BEAR CLAWING A TREE *Signed "F. Grant"*. Base nat.wood 8" X 11.5". Apx. 13" H. Est. 90-250 **SOLD $150(94)**
STANDING GRIZZLY BEAR HOLDING A RAINBOW TROUT *Signed "F.G."* Brass tacks for eyes. All carved wood. Round nat. wood base 9" diam. 14" H. Est. 90-250 **SOLD $100(94)**

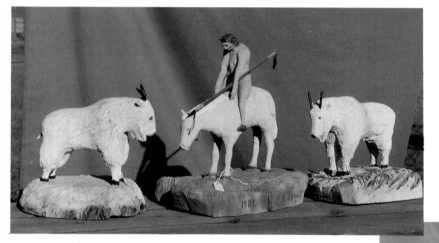

Left to Right: GRIZZLY BEAR "F.G." Eyes are brass tacks. Log and rock o natural wood round base 9" diam. 8" H. Est. 90-250 **SOLD $90(94)**
SIMILAR. Both bear and base stained lt. and dk. brown. Rectangular ba 8.5" X 6" X 8" H. Est. 90-250 **SOLD $90(94)**
BLACK BEAR Natural wood base. Brass tacks for eyes. 6" X 9.5". 10" H Est. 90-250 **SOLD $90(94)**

Right to Left: MOUNTAIN GOAT *Signed "F.Grant"*
Painted off-white with dk. brown, horns, hooves and nose. Eyes are brass wood screws. Base 10" X 7". Apx. 10" H. Est. 90-250 **SOLD $90(94)**
END OF THE TRAIL *"1981 F. Grant."*
Entirely detailed in wood. Grey horse with black circle around eye and brown hooves. Indian is flesh-colored with red breech clout and face paint; carrying painted lance with carved feathers. Natural carved wooden base. Apx. 15" H. Est. 90-250 **SOLD $90(94)**
MOUNTAIN GOAT Similar to preceding. Est. 90-250

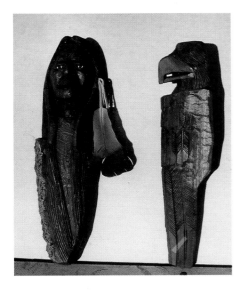

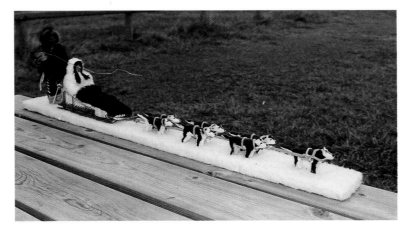

CHIPPEWA-CREE CARVED DOG SLED *Signed Sid Gosseilin.* Contemp. Sled, riders and dogs carved from wood. Driver has copper whip extending towards dogs. Rider sits in sled. Both are outfitted with fake fur coats, long black hair, beaded eyes. Sled pulled by 7 black and white carved Huskies. Base covered with white fake fur fabric (looks like snow.) 37" total L. 9" H. Est. 250-500 **SOLD $350(95)**

2 CREE (TURTLE MTN.) WOODEN CARVINGS *Signed by Jack Little Boy.* Contemp.
LEFT: Indian-face with real feather and beads for eyes.13"L. Est.40-95 **SOLD $60(94)**
RIGHT: Eagle head carving with feather detailing. 12.5". Est.40-95 **SOLD $60(94)**

CARTOON CHARACTERS CONTEMP. BEADWORK
FAR LEFT: Donald Duck bolo tie. *Made by Cree artist George Little Boy.* Est. 40-75 **SOLD $40(95)**

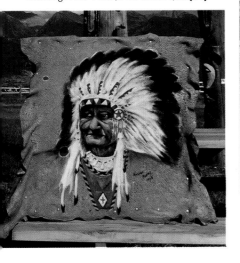

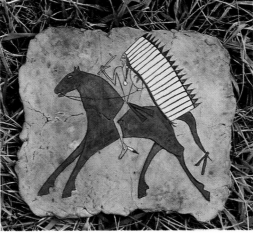

INDIAN PAINTING ON INDIAN TANNED HIDE c.1968
Signed by Flathead artist "Nadine Adams 1968." Sioux Indian with war bonnet, very life-like vibrant portrait. Apx. 36"H X 29" W. Est. 275/400 **SOLD $300(93)**

INDIAN ON HORSEBACK CERAMIC PLAQUE *by Glenn LaFontaine, Contemp. Indian sculptor.*
Stylized Indian ledger drawing-style. Earth-tone bkgrd; red ochre horse; black and white trailer bonnet. 7.5" X 8". Est. 75-150 **SOLD $50(94)**

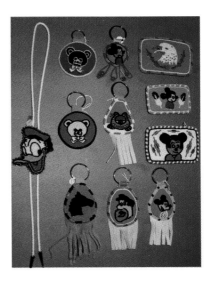

The following beadwork pieces were all made by an 10 year old Flathead Indian boy: Key chains representing Garfield, Mickey, Fred Flintstone, horse head and 2 Teddy bears. Some buckskin fringed-1 has beaded loop fringe. Est. 15-20 EACH
Upper Right: BELT BUCKLES, each fully-beaded. Ranging in size 3.75-4.5"W to 2.25-3" H. Est. 25-65 **SOLD $35(95) EACH**

CONTEMP. BEADED SHIELD *made by Cree artist George Little Boy.* 3-D "picture beadwork" sculptural face and white beaded dress jewelry and moccasins; tiny beaded wolf on fur handbag (actually opens!) Some beads as small as size 28°. Red felt bkgrd. with felt mountains and sun. Fur wrapped bottom. 15" diam. Est. 200-500 **SOLD $200(95)**

Left to Right: FLATHEAD SALT and PEPPER SHAKERS
Fully-beaded peyote stitched in med.blue, t.red, orange and yellow. Brain-tan bottom. Brand new cond. 3" H. Est. 40-75 **SOLD $35(96)**
FLATHEAD TOOTHPICK HOLDER
Completely peyote stitched in black,white and red. Brain tan bottom. New cond. 2" H. Est. 15-25 **SOLD $15(96)**

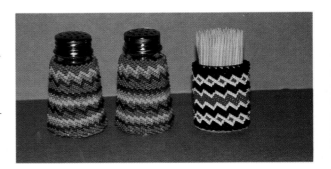

VI. Basketry

Woven Fiber Bags

The designs on twined corn husk bags are woven in either yarn or dyed corn husk. Those with corn husk designs often bring a higher price, due to the mistaken assumption that bags with yarn designs are not as old or valuable. The truth is that yarn design bags can also be very old as well as beautiful and should command equally high prices.

For specific reading on corn husk bags, see "Chap C. Dunning Collection," *Material Culture of the Plateau Indians*, E. Washington Historical Society Bulletin, 1985, and Mary Dodds Schlick, *Columbia River Basketry*, "Gifts of the Ancestors, Gift of the Earth," Seattle, Univ. of Washington Press, 1994.

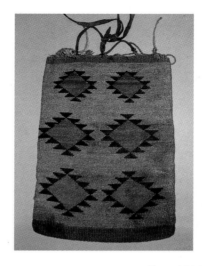
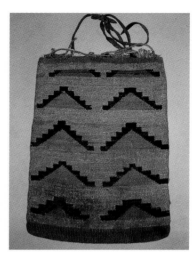

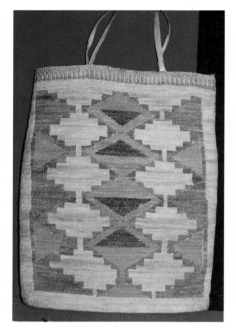
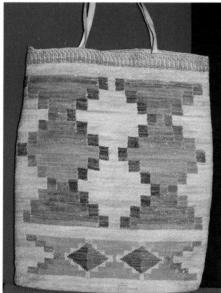

Above: LARGE NEZ PERCE CORN HUSK BAG c.1890
Large scale geometric-design bag (different each side). Colors are muted shades of orange, red, black and green. **All corn husk**. Exc. cond. 12.5" X 16" L. Est. 850-1400
SOLD $850(92)

Left: LARGE NEZ PERCE CORN HUSK BAG c.1890
Muted dyed colors different design each side:rose-red, gold and several shades of grey-green. **All corn husk** with hemp bottom and top band. Exc. cond. Good patina. 21"L X 16.5" bottom W-13.5" top With Est. 1250-1800 **SOLD $900(96)**

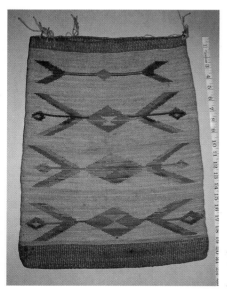
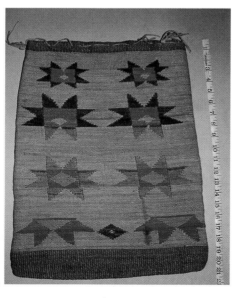

LARGE NEZ PERCE CORN HUSK BAG c.1890
Muted dyed colors different design each side:rose-red, gold and several shades of grey-green. **All corn husk** with hemp bottom and top band. Exc. cond. Good patina. 21"L X 16.5" bottom W-13.5" top With Est. 1250-1800 **SOLD $900(96)**

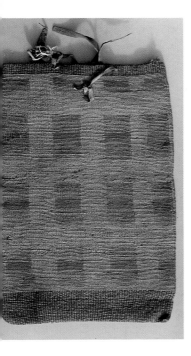
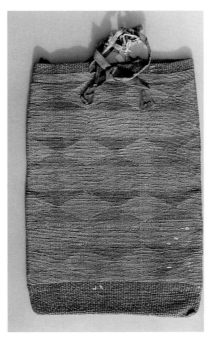
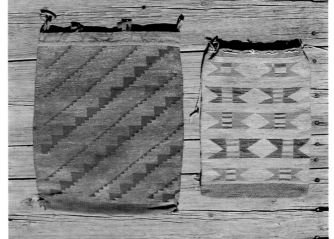

LARGE NEZ PERCE CORN HUSK BAG c.1880
One side) Rectangles in green and red. Other side) Green stacked triangles. Leather handles. **All corn husk** and fiber (bottom). Old bag shows Indian use. Good patina. Faded but otherwise exc. cond. 12"W X 18" L. Est. 400-600 **SOLD $350(91)**

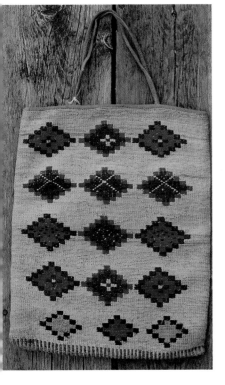
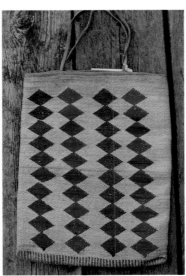

LARGE NEZ PERCE CORN HUSK BAG c.1910
Yarn diamond and step-diamond designs are red, indigo blue and lt. green. Nice patina showing age and use. Exc. cond. Apx. 11" X 18". Est. 600-1200

Left to Right (both photos): LARGE NEZ PERCE CORN HUSK BAG c.1870
Collected from the Iron Breast family of Browning, Mont. by Irene and Harold Hanneman who operated a store in Browning between 1936-1962, both of whom were adopted by Chief Wades-In-The-Water. This bag was made by the Nez Perce Indians and traded to the Blackfeet. A notarized Certificate of Authenticity with complete provenance accompanies this bag.* Constructed of corn husk and hemp with designs of wool yarn in red, green, purple, yellow and dk. green. Harness leather carrying strap and buckskin ties. It has the red medicine paint coloring which makes it almost certain that it was once part of an important medicine bundle. Shows wear (with several small holes) from much use and has a patina of age and medicine paint. 21.5" X 17" L. Est. 900-1600 **SOLD $850(96)**

NEZ PERCE CORN HUSK BAG c. 1880
Collected from a Blackfeet family at Browning, Mont. Same provenance as preceding bag. It has a notarized Certificate of Authenticity describing its collection history. The designs are purple, red-orange and green corn husk. **All corn husk** and Indian hemp. Highly possible that this bag was once part of a medicine bundle; however, it doesn't have the medicine paint patina.* Good age patina. Exc. cond. 17.5" X 12". Est. 1000-2000 **SOLD $900(97)**

**Note: It is an interesting fact that many large Nez Perce corn husk bags were traded to the Blackfeet, who used them to hold sacred medicine objects; in particular, rawhide rattles.*

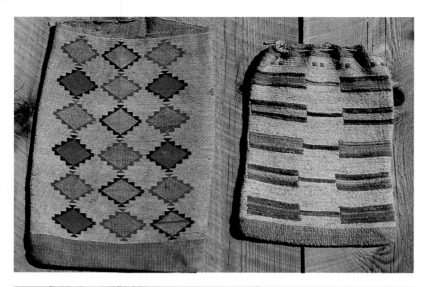

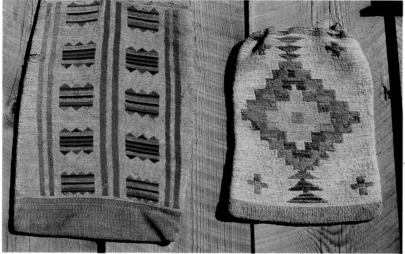

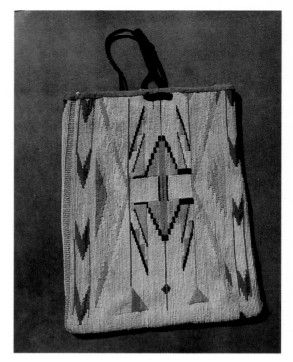

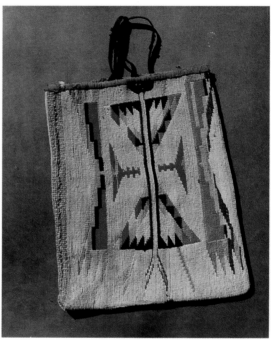

Left to Right: LARGE PEZ PERCE CORN HUSK BAG c.1880
Early geometric designs: One side has diamond patterns in red,
yellow green and indigo. The other side has same colors in
vertical stripe and 8-sided geometric motifs. Hemp bottom. Apx.
21" X 14". Est. 1500-2000

NEZ PERCE CORN HUSK BAG c.1900
Yellow, red, green, and purple in geometric design motifs: One
side has horizontal bar motif. Other side has large central
concentric diamond pattern. **All corn husk** and fiber. Hemp
bottom. 16.5" X 11.75". Est.450/550 **SOLD $350(91)**

PLATEAU CORN HUSK and YARN BAG
c.1870s
Unusual vertical weave and designs.
Brightly colored motif in pinks, reds,
purples, blues with black;different each side.
Worn silk rose-colored ribbon bound at top.
Black shoe lace makes top lacing. 12.5" H. X
9.5" W. Est. 800-950 **SOLD $650(93)**

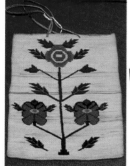

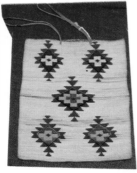

NEZ PERCE CORN HUSK BAG c.1900
*Belonged to Adeline Adams, daughter of
Jackson Sundown, the famous Nez Perce
Bronco Rider.* Very finely woven corn husk
and unusual floral design combine to make
this a choice example. Design in brightly
colored yarn; green, magenta, yellow flower
pattern one side; Turkey red, green,
mustard, pale pink and dk. blue geometric
pattern other side. Pristine cond. 9.5" W X
10.5" H. Est. 900/1200 **SOLD $950(92)**

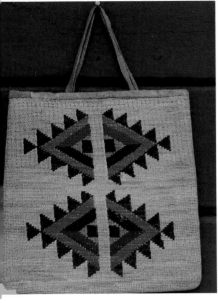

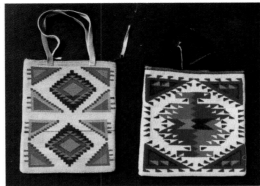

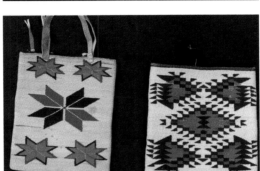

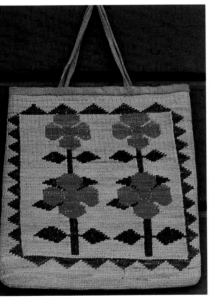

Left to Right (both sides): NEZ PERCE CORN HUSK and YARN TWINED BAG c.1900
Bright unfaded colors: One side has magenta, pink, purple, lt. and dk. green, rust and turquoise. 8 pt. star central motif; other side has double serrated diamonds. Top has smoked buckskin handles and zipper tab. Pristine cond. 8.5" W X 10.5" H. Est. 850-1250 **SOLD $900(94)**

NEZ PERCE CORN HUSK and YARN TWINED BAG c.1900
Bold and dramatic contrasting yarn patterns. Cobalt, orange, fuchsia, and 2 shades green. Other side has bright pink, burgundy, dk. and lt. green and cobalt. Superb workmanship. Lined and bound in lavender cotton. Black grosgrain ribbon handles. Pristine cond. 10" W X 10.5". Est. 700-900 **SOLD $650(94)**

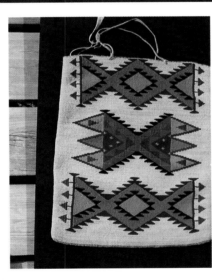

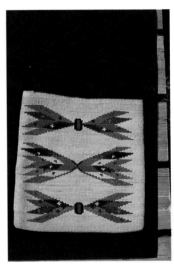

NEZ PERCE CORN HUSK BAG c. 1910
Bright unfaded colors. Pink and green floral one side; Pink, purple, and blue with dk. green geometric pattern on the other. Yarn is green, purple and blue. Exc. cond. Apx.10" X 10". Est. 800-1000 **SOLD $350(89)**

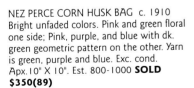

Left to Right(both sides): NEZ PERCE PICTORIAL CORN HUSK and YARN TWINED BAG c.1900
8 pine tree designs on 1 side; geometric on the other. Yarn designs in bright shades of: red, pink, green, purple, blue, black and orange. Pristine cond. Apx. 11" X 16". Est. 1500-2000 **SOLD $1200(93)**

NEZ PERCE PICTORIAL CORN HUSK and YARN TWINED BAG c.1900
6 green pine tree elements flank 2 central larger turquoise trees on one side; other side: 3 large bow-shaped multi-color designs. Bright and unfaded colors. Perfect cond. 11.25" X 11.5". Est. 800-1200 **SOLD $650(94)**

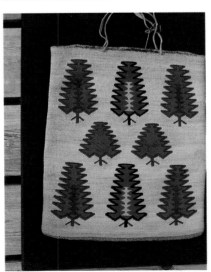

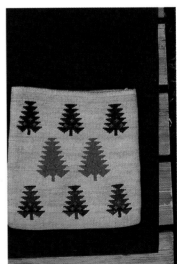

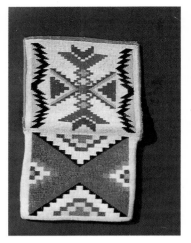
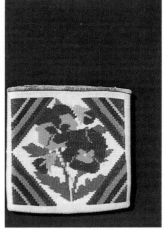

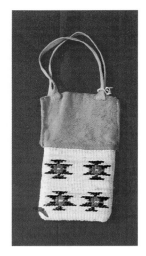

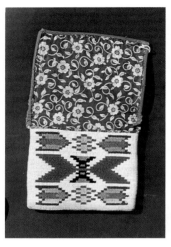
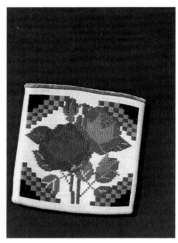

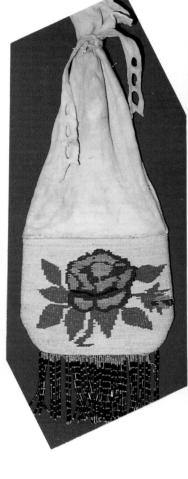

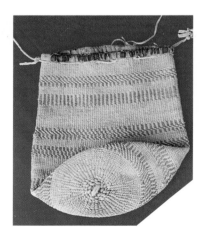

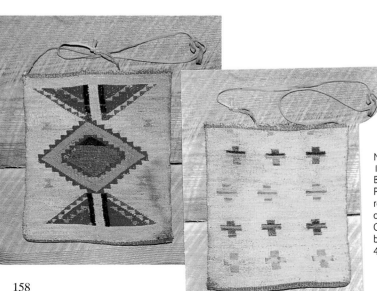

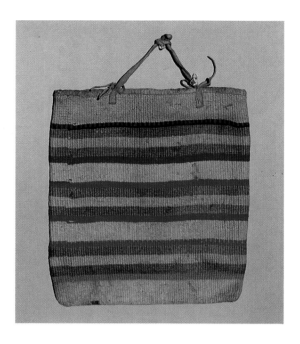

NEZ PERCE WOVEN YARN FLAT BAG c.1920
Colorful sturdy bag is probably a work or storage
piece. Buckskin binding, ties and handle. Some dark
stains (1 side only). Good cond. 13" X 14"H. Est. 55-
95 **SOLD $65(96)**

PLATEAU TULE MAT Contemp.
*Made by Jim Dick. Warm Springs Res., Ore. Tules grow
wild along the shores of lakes and ponds and were used
extensively for baskets, boats, etc. by the Indians in Oregon
and No. Calif.* This size is used to place utensils, etc.
at special ceremonies. Larger tule mats are used for
beds and lodge covers. 11.75" X16.5". Est. 20-40
SOLD $20(95)
Note: See Klamath baskets made of tule fibers, p. 162.

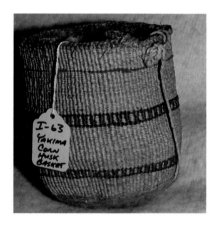

YAKIMA CORN HUSK SALLY BAG c.1880
Single row of red yarn; green husk design.
Hemp warp. Buckskin bottom. 5.5" H X 5"
diam. Est.250-350(96) **SOLD $100(90)**

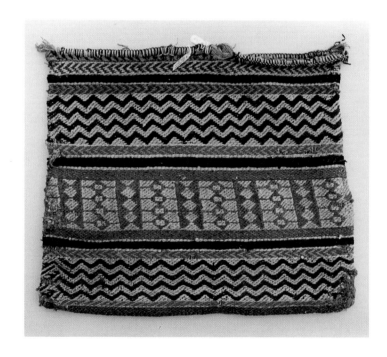

CHIPPEWA TWINED FIBER and YARN
STORAGE BAG c.1870
*Collected by Amos Gottschall at Red Lake,
Minn. in 1870s.* Intricate wool yarn designs
in black, red, blue-grey and brown
horizontal pattern. Shows wear with a
few holes. 16" X 14" Est. 500-800

159

Baskets
Regional listings

The following baskets are from the Cascades Region of the Pacific North-West. Unique to this area are imbricated stiff coiled baskets of cedar or spruce root bundles.

See Allan Lobb, *Indian Baskets of the Pacific Northwest and Alaska*, Portland, Ore. Graphic Arts Publishing Co.

General reference: Joan M. Jones, *The Art and Style of Western Indian Basketry*, Surry, B.C. Canada, Hancock House, 1989.

The Klickitat tribal style is further characterized by rim loops or "ears". Traditionally, the berry pickers tied these baskets to their waists. The full baskets were then covered with fern leaves tied with strings through the "ears".

For further info. on this unique basket style, see Nettie Kuneki, *The Heritage of Klickitat Basketry*, "A History and Art Preserved," Oregon Historical Society, 1982.

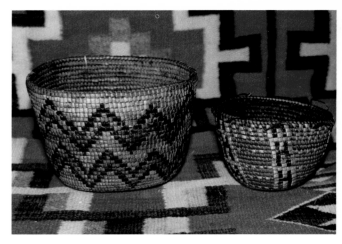

Left to Right: COWLITZ BASKET c.1880
Sturdy coiled basket with imbricated zig-zag pattern in dk. brown, med. brown with lt. brown background. Mint cond. 5.5" H. X 7.75"L X 6" W. Est. 700/900 **SOLD $575(92)**
SALISH IMBRICATED BASKET c.1880
Coiled from spruce root, bear grass, cedar bark and cattail. Unusual dark background with horizontal design elements. Dk. leather laced loops on rim. Patina reflects age, yet in mint cond. 5.5"W L 4.25"W X 4"H. Est.400-550 **SOLD $400(92)**

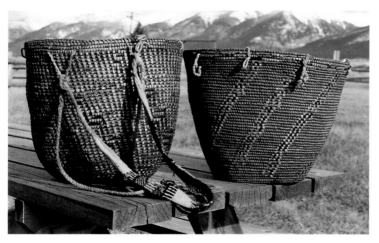

PLATEAU UTILITY BASKETS c.1900
Sturdy utilitarian imbricated baskets. These are museum quality pieces. S.W. Wash and N.W. Oregon origin. (See Lobb, p.92.)
Left to Right: BERRY BASKET with woven tumpline. All-over lt. bear grass imbrication with step diagonal pattern. Rich patina of use. 11"D. 13"H. 13.5" W. Est. 375-600 **SOLD $450(97)**
CEDAR with lt. and dk. bear grass diagonal design. Several twisted string loops sewn to rim. 11.5"D. 15" W. 12.5"H Est. 375-600

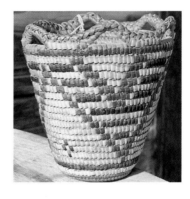

KLICKITAT IMBRICATED BASKET c.1900
Purchased on the Yakima Res. from an old collection. Characteristic loop rims. Cedar or spruce root coiled. 3 color imbrications in a chevron motif. Exceptional design, colors and cond. 2.5" diam. bottom-6.5"H.-5.25" diam. top. Est.550-850 **SOLD $575(93)**

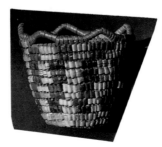

SMALL KLICKITAT IMBRICATED BASKET
Coiled cedar root fibers with dk. brown bear grass diagonal motif with characteristic loop rim "ears". 4.75" H. X 4.25" top diam. Est.300-600 **SOLD $325(93)**

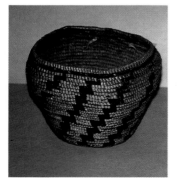

COWLITZ IMBRICATED BASKET 19th c.
*Cascades Region.*Characteristic stiff coils in cedar root, bear grass(dk. brown and tan) design is diagonal step pattern. Sturdy with rich dk. patina. Buckskin handle. Exc. cond. 7"H X 9" shoulder X 7.5" rim. Base 5" W. Est. 375-550 **SOLD $350(96)**

SMALL KLICKITAT BASKET
Unusual square shape with characteristic rim loops. Cedar root with black and yellowish bear grass imbrication in 3 stacked triangles each side. Very fine cond. 5.5" sq. X apx. 6" H.Est. 450-900 **SOLD $475(95)**

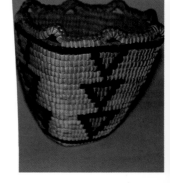

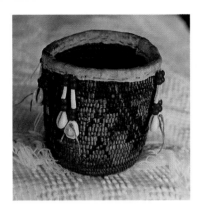

KLICKITAT IMBRICATED BASKET c.1890
Buckskin-covered rim with 4 groups
dentalium, cowrie shells, and cobalt bead
dangles. VG cond. 5" H. X 4" diam. Est.
350-550(96) **SOLD $238(89)**

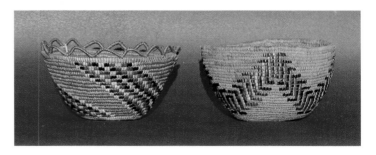

Left to Right: CHEHALIS LOOP RIM BASKET
Flared rim cedar root with diagonal imbrication in dk. and lt. bear
grass and cedar bark. Exc. cond. Top diam. 7.75" X 4" H. X 3.5"
bottom diam. Est. 500-800
PUGET SOUND IMBRICATED BASKET
Made of vegetable fiber in "geese in flight" design in multi-
colored dyed bear grass-greens; reds and browns. VG shape.
7.38" diam X 5" H. Est. 250-450 **SOLD $175(94)**

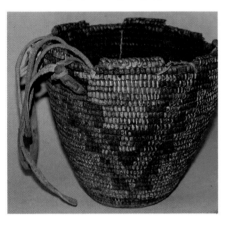

KLICKITAT BERRY BASKET c. 1870
*RARE documented piece. Belonged to Adeline
Adams, daughter of the famous Nez Perce
rodeo bronco rider, Jackson Sundown. She
was married to Eneas Adams on the Flathead
Res.* Still has buckskin carrying thongs. Top
loops are missing-shows heavy Indian use
and wear. 7" H. X 7" diam. Est. 250-500
SOLD $275(95)

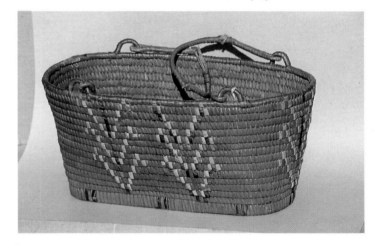

FRASER RIVER (Canada) BASKET c.1900
Imbricated motif is abstract "flying eagle" in dyed bear grass:red-
violet, indigo and natural white with cherry bark on base. Coiled
handles (over jute) are fragmented. Apx. 5% imbrication worn.
Sturdy. VG shape. 15"L X 8.5"W X 7.5"H. Est. 100-200 **SOLD
$115(96)**

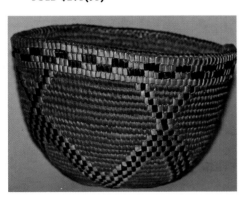

SUSQUAMISH BASKET *from Bainbridge Is.
WA.*
Fancy alternating cherry wood and golden
bear grass imbricated designs. Beautiful
patina-a superb example of this type. 8.25"
X 6.25" X 6"H. Est. 700-1000 **SOLD
$600(95)**

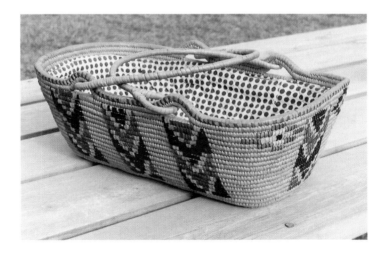

THOMPSON RIVER IMBRICATED PICNIC BASKET c.1900
From the N.W. Cascades region, British Columbia. Unusual
configuration. Cedar or spruce root coiled with chevron and
diamond geometric motifs in black bear grass and cherry bark-
this is the imbrication. Lined with brown polka dot quilted
chintz . Handles are intact. Pristine cond. 15.5" top L X 9.25" W
top. Est.500-800 **SOLD $400(93)**

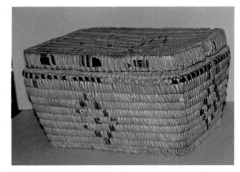

FRASER RIVER (Canada) STORAGE BASKET With LID c.1900
Trunk-style with imbrication in cherry bark and black dyed beargrass. Wide coils. Shows Indian use and wear. 1.5" coils of bkgrd. missing on bottom-5 slats cracked on top and one repaired on side. Bottom intact. Usable cond. 7"H X 8"W X 12"L. Est. 125-195 **SOLD $130(96)**

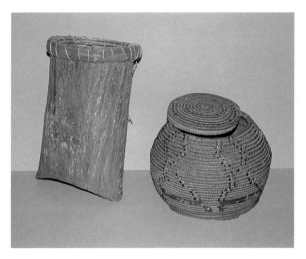

Left to Right: PLATEAU CEDAR BARK BERRY BASKET c.1900?
Laced with jute rope. Very sturdy and unusually exc. cond. 13" H. X 7". Est. 200-300 **SOLD $263(96)**
FRASER RIVER (Canada) LIDDED BASKET c.1900
Coiled spruce root(?) imbricated with natural red cherry bark and black and tan fibers. 1" rim coil missing;bottom rim 75% intact. Good cond. Lid 6" diam. Bottom 8.5" diam. Apx. 9.5" widest part. Est. 100-175 **SOLD $120(96)**

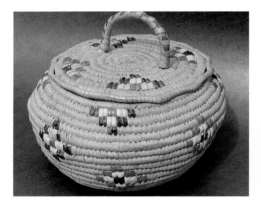

SALISH COILED LIDDED TOBACCO BASKET
c.1900
Purchased from Albert Chatsis, Saskatoon, Canada in 1979. Cedar or spruce root with cherry bark, white and black bear grass imbricated motifs. Characteristic "ear" loop around lid. Very sturdy. Fine cond. 6.5" With 6" H. Est.550-675 **SOLD $550(95)**

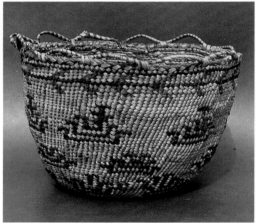

UPPER CHEHALIS (S.W. WASH.) WRAPPED TWINED BASKET
c.1880
Typical loop characteristic of this area. Fibers are squaw grass, cedar bark and cattails. Design is reddish-brown and black looks like a stylized man in a boat(?). One top loop missing; otherwise, exc. cond. 8.75" X 7" H. Est.450-600 **SOLD $450(94)**

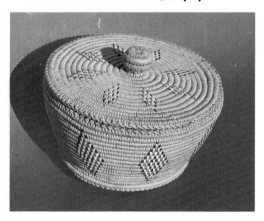

SALISH/FRAZER RIVER IMBRICATED BASKET With LID c.1880
Unusually fine coiling and imbrication in diamond motifs of horsetail root, black bear grass and cherry bark. Rich patina. Exc. cond. 6" diam. top X 3.5"H. X 4.63" bottom. Est. 700-900 **SOLD $750(95)**

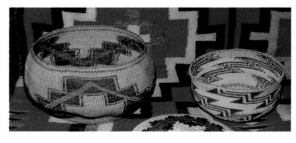

Left to Right: KLAMATH TWINED BASKET c.1880
Flexible and sturdy tule fibers with dk. brown geometric motif. Unusual configuration. Fine cond. 5" H. X 12" at widest part. Est. 500/800 **SOLD $475(92)**
KLAMATH TWINED BASKET c.1880
Intricate geometric bands. Tule fiber with red-brown design. 4 concentric geometric bands on bottom. Exc. shape. 4" H. X 7" W. Est.400/600 **SOLD $375(92)**

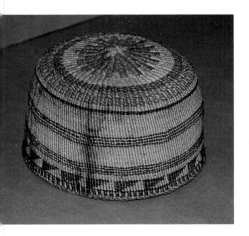

KLAMATH BASKET 19th Century.
N.E. Calif. 3 tones of natural brown fibre incl. tule-twined weave. Characteristic flexibility and strength. A few dark stains add to patina. 7" diam. Est. 110-195 **SOLD $171(96)**

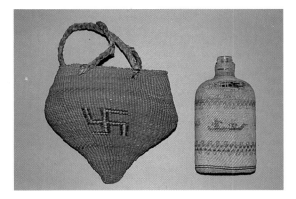

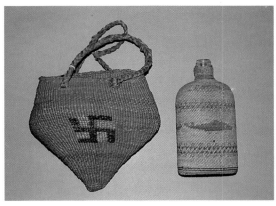

Left to Right: SILITZ (Oregon) TWINED BASKET c.1900
Unusual tapered hanging twined basket with different swastika pattern each side. Handle has a few fibre breaks; otherwise, exc. cond. 8"L X 8.5"W excl. handle. Est. 175-350 **SOLD $150(96)**
NOOTKA/MAKAH BASKET COVERED BOTTLE c.1900
Unusual twined bottle of beargrass with characteristic cedar plaited bottom. In color: 2 person whaler, duck and whale with geometrics. 1.5" worn through at shoulder also around neck. Somewhat faded from age. 8" H. X 4" W. Est. 90-175 **SOLD $80(96)**

KLAMATH ? GAMBLING TRAY
This style of basket has been made from tules, reeds, and cattails for thousands of years. This one appears quite old and might have been recovered from a cave. Rim is apx. 1/4 damaged with edge missing. 1" hole punched out of center; perhaps a "kill hole" as seen in pottery. Pattern is lt. and dk. stripes that have darkened with age. Flexible stable cond. 18" diam. 5.5" deep. Est. 300-500

The following three items are from John Quigley's famed Frontier Town near Helena, Montana, and were collected by him during the 1950s. He wintered in Arizona excavating and collecting relics. Included is a copy of a newspaper story with photos.

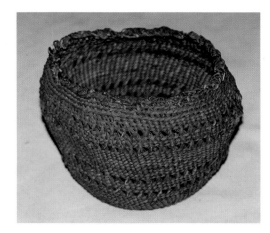

SPRUCE ROOT? CLAM BASKET
Type made by Oregon Coast tribes (Siletz, Tillamook, etc). Dk. brown patina shows great age with minor damage on rim. 8" diam. X 6" H. Est. 75-150 **SOLD $20(95)**

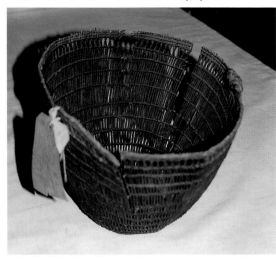

TWINED CLAM BASKET
Prob. Oregon Coast. Has old tag attached "Indian child's burden basket (a very rare specimen) collected and used by Lucy Thompson when she was a small girl c.1850. Yurok Tribe. Klamath R. Calif." Sides have almost broken in half. Patina indicates extreme age. 11" diam. 9" H. Est. 50-100 **SOLD $65(95)**

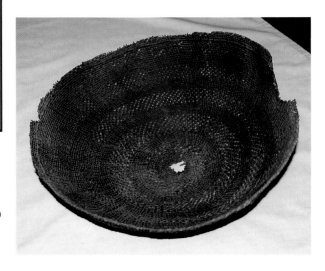

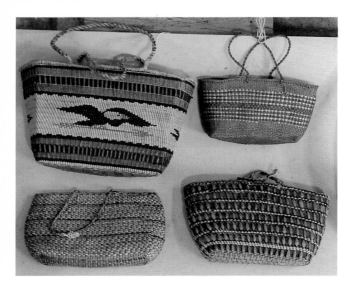

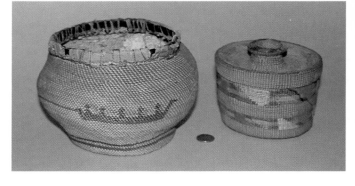

LOT OF 4 NORTH-WEST COAST (NOOTKA) CEDAR BARK
BASKETS c.1935
LEFT TO RIGHT (top to bottom): 1) Eagle motif (both sides) in
purple, yellow and pumpkin dyed twined grasses. Cedar bark
plaited bottom and borders. Handles intact. Slight damage and
bottom. Est. 95-150
2) Cedar bark. All plaited. Handles intact. Spruce root horizontal
design. Good cond. with 1" split on bottom. Apx. 10" W X 5" H.
Est. 40-80
3) Nehalem twined and plaited grass. c.1910. Orange and dk.
brown horizontal plaited. Slight damage:handle and bottom. 6"
H X 11" W X 1.5" D. Est. 50-90
4) Purple and natural grass twined alt. with plaited cedar bark. 1
end of handles broken off; otherwise, good cond. 6.5" H X 12" W
2" D. Est. 50-90
Lot of 4 baskets. Est. lot 225-420 **SOLD LOT $175(91)**

Left to right: NOOTKA/MAKAH BASKET c.1890
Unusual spherical shape. Twined beargrass with whale and 5
person boat. Top rim replaced with metal and cardboard sewn to
top long ago. Lid missing. Bottom cedar plaiting and sides. Good
patina. Fair cond. 6.5" W. pt. X 4.75"H. Est. 75-150 **SOLD
$80(96)**
TLINGIT RATTLE TOP BASKET c.1900
Finely twined thin walled with characteristic bands of "false
embroidery" in yellow, gold, coral and brown. Side tear glued (far
right in photo). Rattle top knob missing 1" piece. Fair to poor
cond. 3.5" H X 4.5"W Est. 100-195 **SOLD $90(96)**
NOTE: This basket with lid in exc. cond. would be worth $400-500.

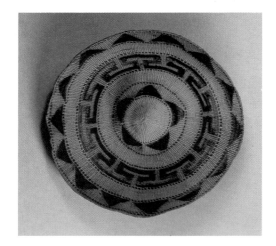

TLINGIT SPRUCE ROOT BASKETRY TRAY c.1890
Very rare configuration; almost sombrero shaped. Finely twined
in dk. and lt. brown and yellow. Star on bottom with fret
horizontal pattern. Exc. cond. 7.5" X apx. 2"H. Est.400-650
SOLD $300(92)

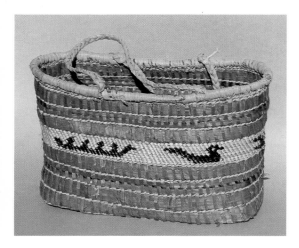

NOOTKA/MAKAH CARRYING BASKET c.1930
Plaited cedar bark; natural and dyed pink and green. Twined grass
central panel with dyed purple and blue figures:birds and 4 men
in a boat. Grass braided handles. Bright and unfaded. VG cond.
7"H X 5"W X 10.5" L. Est. 75-150 **SOLD $105(96)**

MAKAH/NOOTKA TWINED BASKETRY-
COVERED BOTTLE c.1890.
*Acquired in 1970 from the Pipestone Museum
in Hermiston, Ore. (Earl Chapin Coll.)* Typical
whaling boat motif and geometric design in
dyed bear grass with natural background.
Characteristic plaited cedar bark bottom.
Removable twined cap. Light age patina yet
unfaded and clear designs. Pristine cond.
8.25"L X apx. 3.5" W. Est. 400-500 **SOLD
$450(96)**

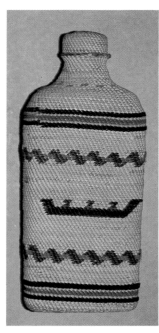

MAKAH/NOOTKA TWINED BASKET
c.1890
Colors still bright and unfaded: red, black
and green. Shows whale (2 sides) and
whaling boat with 4 hunters 1 with
harpoon (2 sides). Cedar bark checkerboard
pattern on bottom. Slight break in wrapping
1/2" on rim but rim intact. VG cond. 8"L X
5" w. Est.375-500 **SOLD $495(93)**
NOTE: The design on this basket adds greatly
to its value.

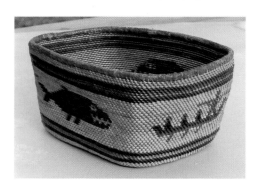

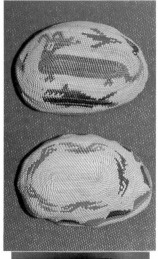

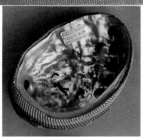

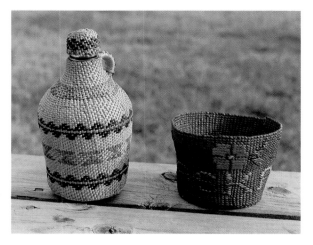

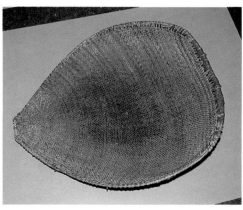

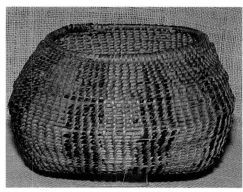

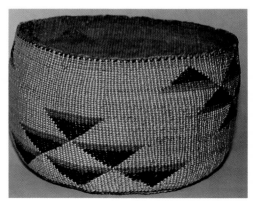

MAKAH/NOOTKA TWINED BASKETRY
ABALONE SHELLS c.1890
Rare. White squaw grass with dyed colored
figures in unusual design elements: Flying
birds circle with geometric border in pink,
green and purple. Dragon in center
surrounded by whale, 3 different birds and
striped border; dk. green purple, blue,
orange and pink. Unfaded. 4.25" L X 3" W.
Est. 600/900 **SOLD $600(92)**

"PANIMINT BERRY/SEED BASKET" c.1900
Consignor's attribution is to Death Valley.
Interesting configuration-flat back with
curved front. Single rod coil with devil's
claw vertical elements. Small 1" restoration
on rim; otherwise exc. cond. 9" X 7" X 5".
Est. 125-195 **SOLD $92(96)**

POMO (CALIF.) TWINED SEED BASKET 19th
c.
Fine old utilitarian basket made for Indian
use. Faint pattern of alt. stripes in brown
and tan. Bottom rim (redbud?) coils *repaired
in 1920 by Lucy Santa Rose, Pomo.* 16" W.
pt -apx. 18"L. Est. 195-350 **SOLD
$175(96)**

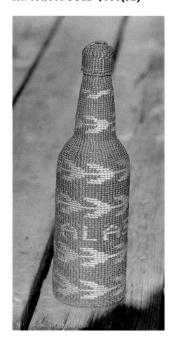

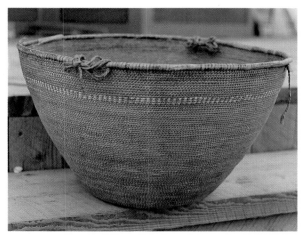

NO.CALIF. LARGE BASKET PROBABLY MONO c.1900
Finely coiled flared storage basket with 3 narrow rows of light-
colored stripes;willow rod rim with jute rope attachments. 12"
H. X 10" diam. bottom X 21" diam. top. Exc. cond. Est. 400-600
SOLD $475(89)

HUPA-KAROK BASKET
*Purchased on the Yakima Res. from an old
collection 30 years ago.* Characteristic fine
twined conifer root overlay with stacked
triangle motif in black Maidenhair fern stem
and rust-colored sedge?. Pristine flexible
piece. 5" X 8". Est. 500-800 **SOLD
$475(95)**

TWINED CEDAR ROOT and BEAR GRASS
COVERED BOTTLE c.1890
Lt. color (bear grass) is horizontal leaf and
chevron motif and "ALASKA". Removable
twined top. Fine cond. 12" H. Est. 400-600
SOLD $500(95)

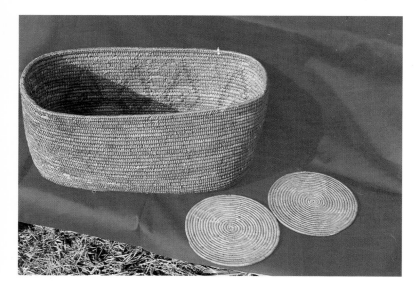

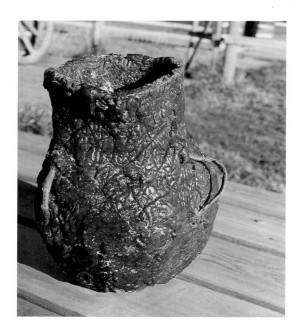

Top to Bottom: LARGE APACHE WILLOW COILED TUB-SHAPED BASKET
Interior subtle designs: diamond with cross inside in red. Rim completely intact. Rich lt. brown patina. A few random breaks in stitching. Exc. cond. 19"L X 9.5"W X 9.25"H. Est.175-350 **SOLD $250(94)**
2 MISSION BASKETRY PLAQUES
Juncas root stitched coils. Diamond design and petal designs. (Not seen in photo due to faded colors). Some breaks on one, other perfect. Apx. 7". Est. 50-75 **SOLD $50(94)**

APACHE WATER BOTTLE c.1920
Heavily encrusted with pinon. Deep terra cotta color. 2 side handles. Good cond. 9.5" H. X 6" widest pt. Est. 300-450

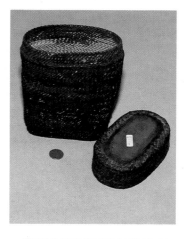

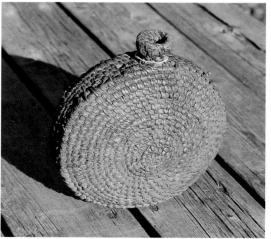

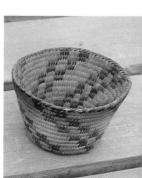

APACHE PITCHED BINOCULAR CASE
c.1890
Probably waterproofed with pinon gum. Strong fiber with wood top and bottom. 7"H.X 5". Est.185/295

APACHE BASKETRY CANTEEN c.1880.
Coiled fibers. Rich texture. Apx. 7.5" diam. Exc. cond. Est. 250-400 **SOLD $250(95)**

PAPAGO KANGAROO RAT MOTIF BASKET
c.1940
RARE. Unusual design in dk. brown. Coiled of bear grass and/or yucca. Breaks on top indicate where handle used to be; otherwise exc. cond. 13" diam. 8"H. Est.250-350

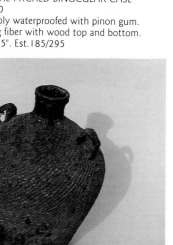

OLD PIMA-PAPAGO SMALL BASKET c.1890
Narrow coils of split cattail stems stitched with willow with diagonal designs in dk. brown devil's claw fiber. Exc. cond. Rich dark patina shows image. 3" H. 4.5" top diam. 3" base. Est.150-250 **SOLD $175(94)**

OLD PAIUTE WATER BOTTLE c.1900
Pinon pitch covering well-worn to reveal interesting rich texture and terra cotta color. 2 handles are intact. Sturdy piece with good patina. VG cond. 8" H. X 6" diam. shoulder. Est. 350-500 **SOLD $355(94)**

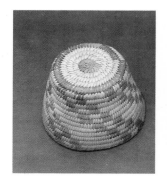

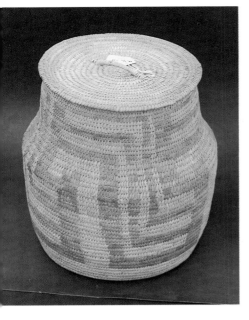

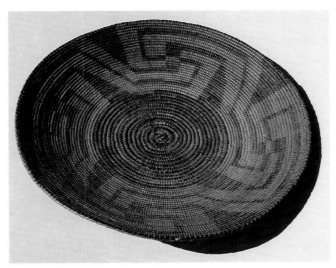

PIMA-PAPAGO LARGE LIDDED BASKET
c.1915
Yellow-tan overall fret pattern. Hard to find old piece with lid. Exc. cond. 11"H. X 9" W. Est. 500-650 **SOLD $475(93)**

PIMA ROUND BASKET TRAY c.1890
Characteristic fret design elements in devil's claw? over willow or cattail. Rich dark patina yet design still prominent. No breaks or fading. Exc. cond. 13.25" diam. Est. 450-650 **SOLD $475(96)**

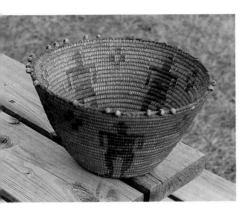

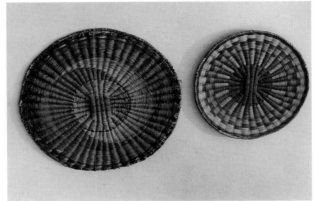

Left to Right: **HOPI WICKER PLAQUES**
Whirlwind pattern (faded on front-prominent on back) in rich shades of red, dk. green, green and black. A few breaks; otherwise, good cond. 14.5". Est. 95-175
SOLD $75(94)
Bands of green, black, gold and natural. Faded front only. Good cond. 12" diam. Est.75-150 **SOLD $62(94)**

PIMA FIGURED and BEAD TOP BASKET
c.1900
Beautiful finely coiled basket with 5 full stylized human figures and padre beads (apx. 1/4 missing) sewn along rim. Flared. Willow stitched split cattail(?). Exc. deep rich patina of age makes this a highly desirable collector's piece. 10" top diam. 5" bottom diam. Est. 600-800 **SOLD $700(94)**

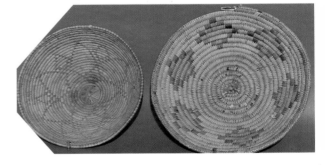

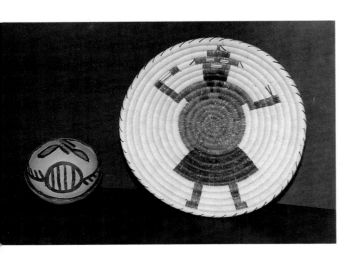

Right: **HOPI COILED BASKET** Contemp. Mudhead figure in rust and black. Very fine cond. 10.5" W. 2" deep. Est.250-325 **SOLD $250(93)**

Left: **COCHITI PUEBLO POLYCHROME SMALL BOWL** c.1900-1920
Tagged "Ysleta 1900". Buff, black and orange stylized design. Attractive piece. 4.5"W X 2"H. Est. 75-125 **SOLD $80(93)**

Left to Right: **JICARILLA APACHE BASKET-NEW MEXICO** c.1900-20.
Diamond motif multi-colors that are faded. 2 rim-breaks and several random breaks. Fair cond. 12" diam. 2.5" deep. Est. 95-150
MISSION BOWL-SHAPED BASKET
c.1900-20
Fine example of the exc. coiled basketry of the So. Calif. "Cahiulla" tribe. Rose-colored pedal designs with blue geometrics around rim (alt. red, blue and natural). Lightly faded overall adds to fine patina. 9.75" X 3.5". Est. 300-500

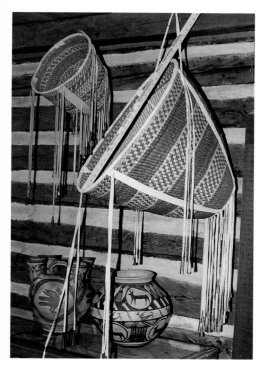

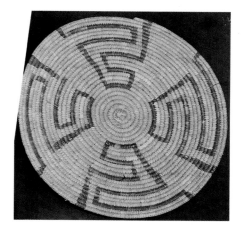

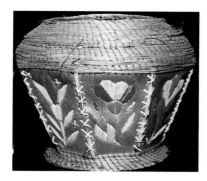

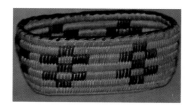

PAPAGO COILED BASKETRY TRAY c.1920
Natural with dk. brown devil's claw interlocking scroll design-striking pattern. 2 tiny breaks in coiling; otherwise, exc. cond. 16" diam. Est. 200-350

CHIPPEWA PORCUPINE QUILL BARK BASKET c.1880.
Pine needle coiled bottom and top (broken row goes 1/2 way around middle). Quills mostly intact; bright colors red, orange, and lt. green. Fair cond. 5" H X 6.5" diam. Est. 85/150 **SOLD $95(90)**

NOTE; See pottery section for pot description (bottom of photo)
Right to Left (top): HUGH APACHE TWINED WILLOW BURDEN BASKET Contemp.
Diagonal checkerboard alternating with brown stripes. Leather dangles with tin cones hang 20" at bottom and 32" at sides. Exc. cond. 26" diam. X 22" H. Est. 800-1200
APACHE WILLOW TWINED BURDEN BASKET Contemp.
Alternating lt. and dk. brown stripes with lt. diag. bars in dk. brown. Exc. cond. 13" diam. X 11" H. + 9" leather with tin cone dangles. Top dangles hang 20"L. Est. 300-450

SMALL PAPAGO OVAL COILED BASKET c.1890
Cross motif in devil's claw fiber over yucca. Very sturdy-subtle patina. Exc. shape. 6"W X 3.5"W X 2.5" H. Est. 85-150 **SOLD $115(95)**

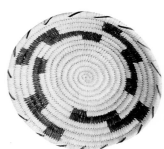

MOHAWK SWEET GRASS SEWING BASKET With LID Contemp.
Lined with dk. red velvet with matching color on the wide ash splints on bottom and rim. Exc. cond. 6" diam. X 3" H. Est. 60-95 **SOLD $35(94)**

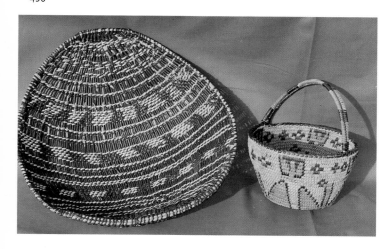

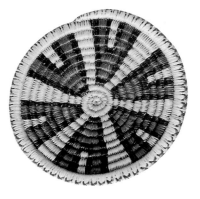

Left: MONO SEED BASKET
Redbud with split willow negative design elements. Very attractive utilitarian piece. Exc. cond. 12.5" L X 12" widest pt. Est. 150-250 **SOLD $175(94)**
Right: PAPAGO(?) FANCY COILED BASKET With HANDLE c.1920
Fine coil work with intricate bird and butterfly motifs overlap the bottom in natural brown, red, dk. brown and gold. Unique configuration. Rich patina. Slight break at handle attachment; otherwise perfect cond. 6.25" diam. X 4" H. + handle. Est. 150-300 **SOLD $125(94)**

2 PAPAGO SHALLOW BASKETS Contemp.
Very heavy coiling. Bear grass and devil's claw wrapped coils.
LEFT: 9" diam. has bold black design. 10" diam.
RIGHT: Rust and black dramatic motif with natural. Rust stitched rim. Exc. cond. Est. 125-225 both

168

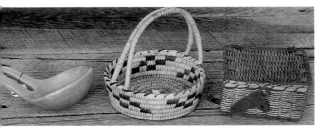

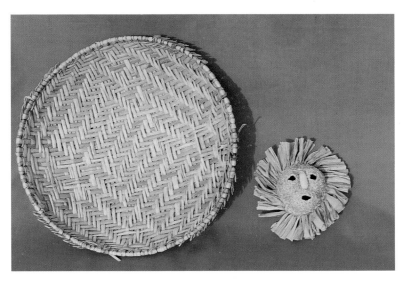

Left to Right: HOPI POTTERY LADLE c.1960
Buff color. *Signed "Frieda Poleahla"*. 8.25" X 4". Est. 62-95 **SOLD $70(95)**
SMALL PAPAGO BASKET With HANDLE c.1970
Devil's claw (black) on natural yucca. Double wrapped handle.
Sturdy construction. VG cond. 6" dia. 7"H. Est. 40-95
GREAT LAKES SWEET GRASS BASKET c.1930.
Red-stained ash splint with woven sweet grass. Slight fading on
outside. Red rayon ribbon on ring. 5" sq. 2.5" H.Est. 25-50
SOLD $25(95)

Left to Right: CHOCTAW DIAGONAL WEAVE BASKETRY TRAY
Natural cane. VG shape.16.5" X 15.5" X 3" deep. Est. 65-95
SOLD $55(94)
SENECA HARVEST MASKETTE Contemp.
From the Cattaraugus Indian Res. All twined corn husk. 5.5". Est.
50-75 **SOLD $70(94)**

Miniature Baskets

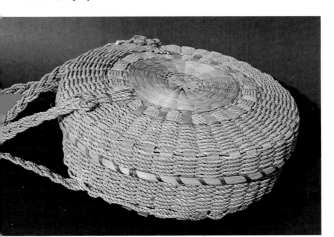

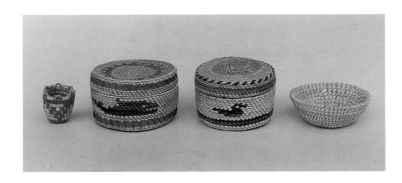

PENOBSCOT PLAITED SEWING BASKET With LID and HANDLE
c.1900
Faded colors look natural (bright inside interior). Fiber woven
with dyed ash splints and fiber braided handles. Good cond.
9.75" diam. Est. 50-125

Left to Right: KLICKITAT MINIATURE BASKET c.1930
Rare size. Very fine imbricated polychrome hard-coiled with
typical rim loops characteristic to the Klickitat. Red, rust and
lavender. Mint cond. 1.25" H X 1" diam. Est.60/150(96) **SOLD $37.50(91)**
NOOTKA MINIATURE LIDDED BASKETS c.1930
Cedar bark plaited bottoms. Round, twined with colored sea
motifs. Each is very slightly faded-nice patina. Exc. shape. Each
apx. 2.5" diam. X 1.5".
Purple whales with green and yellow circular design on lid.
Est.75/125 **SOLD $95(91)**
Purple seagulls with green and orange whirlwind design on-lid.
Est.75/125 **SOLD $45(91)**
WASHO MINIATURE BASKET c.1930
Unusual size. Finely coiled bowl. No designs. 2.5" W X 1" H.
Est. 50-95

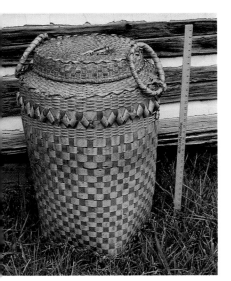

PASSAMAQUADDY LARGE HAMPER
c.1920-40
Includes 1948 letter of purchase and *Native
Peoples*, Spring 1995, magazine article on
the Neptune family of basket makers. Made
of natural ash with characteristic and
unique "curlicue" band at shoulder, using
twisted overlap strip plaiting technique.
Light brown patina. A few breaks on
"curlicue" band. 8" diameter handles.
Usable piece in VG cond. Top is 15"
diameter. 32" H and 19" W shoulder. Est.
175-350 **SOLD $125(96)**

Right: *See preceding photo and
description of similar examples.*
Left to Right: KLICKITAT MINIATURE
BASKET c.1920
Rare. Purple, orange and natural
imbrication. Base 1/2" diam-1.38" H
X1.25" rim W. Exc. cond. Est. 80-175
NOOTKA/MAKAH TINY LIDDED
BASKET Contemp. Deep colors
(unfaded) 2 man boat, whale and
seagull with circular motif on lid. Exc
cond. .88"H X 1.25"W Est. 60-95

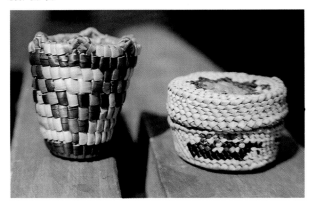

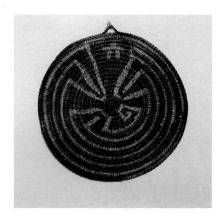

PAPAGO HORSEHAIR MINIATURE
PLAQUE Man-in-a-maze design. Exc.
cond. 2.75" diam. Est. 75-125

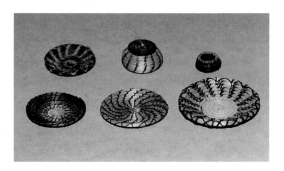

LOT OF 6 MINIATURE HORSEHAIR
BASKETS Contemp.
Lt. to dk. horsehair with black stitching.
Largest is 1.75" to a 1/2" bowl. Exc. cond.
Est. 100-200 **SOLD $150(96)**

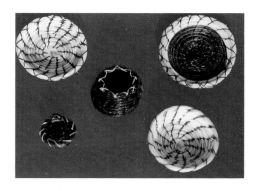

LOT OF 4 MINIATURE COILED HORSEHAIR
BASKETS Contemp.
2 natural coiled with black stitches. 1.25"
and 1.13" Black with white rim 1.38"
Bee-hive shaped black with 3/4" tight
fitting lid. 1" H. Exc. cond. Est. lot 75-
125 **SOLD $80(94)**

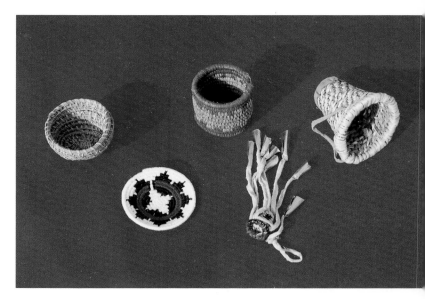

FIVE S.W. MINIATURE BASKETS Contemp:
TWO APACHE burden baskets: one is 2.75" L. and one is a thimble-size
with brain-tan dangles and tin cones, 4"total L.
NAVAJO wedding basket thread wrapped coils in white, burgundy and
black. 2" diam.
PINE NEEDLE coiled. 2" diam.
COILED CYLINDER in vegetable fiber. 1.5" H.
Est. 125-175 lot

VII. Pottery, Textiles and Jewelry

20th Century Pottery

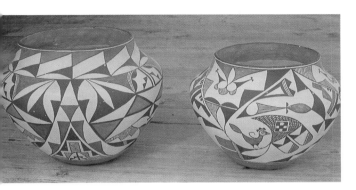

Left to Right: ACOMA LARGE POLYCHROME OLLA c.1960.
Exc. shape. Flares to 11" diam. X 9" H. Est. 350-500(96) **SOLD** $200(90)
ACOMA MEDIUM POLYCHROME OLLA c.1960.
Exc. shape. Flares to 10" diam. X 8" H. Est. 350-500(96) **SOLD** $250(90)

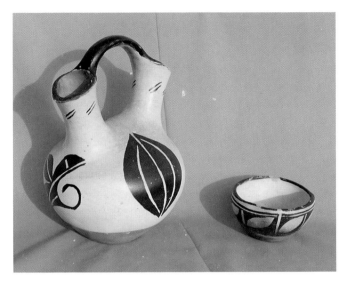

Left to Right: SANTO DOMINGO WEDDING VASE c.1915
Buff with black bold leaf patterns. Red slip interior and bottom 2" exterior. Slight damage on rim. 11.5" H. X 7" widest pt. Est.125-250
SANTO DOMINGO SMALL POLYCHROME BOWL c.1900
Buff over red with black negative/positive geometric design elements. 2 small chips on rim. 4.5" diam. X 2.75" H. Est. 75-150

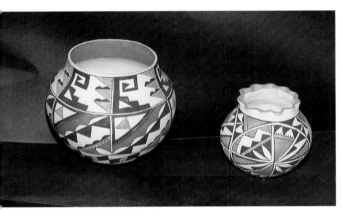

Left to Right: ACOMA PUEBLO POTTERY JAR 20th c.
Fine geometric polychrome motifs in orange,white and black. Inside rim glazed rust. Exc. shape. 8"W X 8.5"H. Est. 250-350
SOLD $150(93)
ACOMA SMALL POTTERY JAR With FLUTED RIM 20th c.
"Acoma NM" on bottom. Polychrome: orange, black on white. Exc. shape. 6"H. X 6" at widest part. Est.125-175 **SOLD** $100(93)

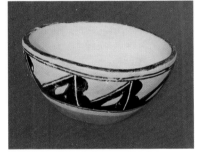

SANTO DOMINGO SIGNED BOWL c.1940
Cream over black with bold geometric pattern. Red slip lower 1.5". Heavy-weight piece (apx. 3/4" thick). Interesting patina. 8" diam. X 4.25". Est. 150-250 **SOLD** $106(97)

PUEBLO BOWL UNSIGNED 20th c.
Brown on cream. A few surface chips; otherwise, good cond. 6"H. X 7" W. Est. 175-250

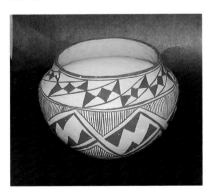

Left to Right: ACOMA POTTERY CANTEEN with polychrome design (1 side) c.1930
2 handles, 1/2" chip on bottom left, outside of design. 6" H X 5.75" W. Est. 75-150
JEMEZ PUEBLO POLYCHROME POTTERY JAR c.1960.
Scalloped-lip. A few superficial nicks; otherwise, good shape. 10" H X 6" diam. Est. 95-150

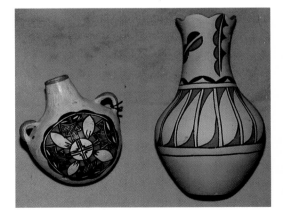

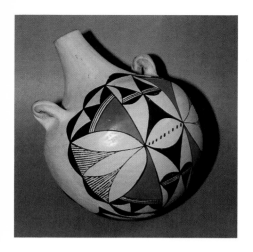

LARGE ACOMA POTTERY CANTEEN
c.1930
Polychrome with twisted handles. Exc. shape. 9". Est. 200-395

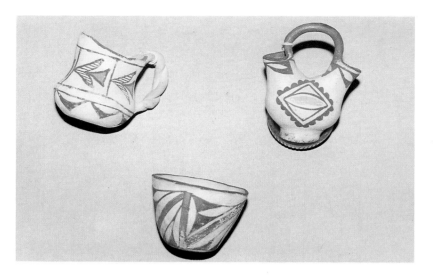

ACOMA SMALL POTS, c. 1910
Cream bkgrd. with terra-cotta and brown geometric designs:
PITCHER with braided handle, 3"
BOWL 2.5" H. Hair-line crack
WEDDING VASE 4" H. All show patina of age, no chips. Exc. shape. Lot of 3. Est. 75/150 **SOLD $75(91) lot**

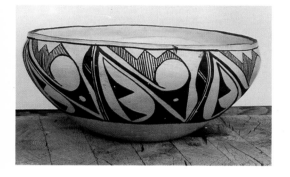

ACOMA BLACK ON WHITE BOWL
c.1940
"Acoma NM" on bottom. Geometric and curvilinear motifs. Exc. cond. 8.5" X 4"H. Est. 150-250 **SOLD $150(91)**

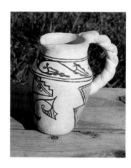

ZUNI POTTERY PITCHER c.1930
Rope style twisted handle. Black on white design. Good patina and cond. 6" H. Est. 50-125 **SOLD $55(95)**

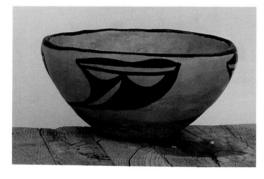

SANTO DOMINGO BLACK ON BUFF
BOWL c.1910
Typical curvilinear forms. Terra cotta bottom and lower portion. I very fine hair-line crack apx. 1/2"; otherwise, VG cond. Good patina and cond. 6"W X 3"H. Est. 125-175 **SOLD $100(91)**

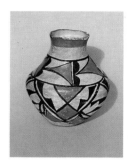

ACOMA POLYCHROME POTTERY c.1910
Bottom signed "Acoma pottery". Buff with white, orange and black geometric motifs. Some minor chips at rim and tiny flakes of glaze; otherwise, VG cond. Good patina. 5"H X 3.5" W. Est. 85-135 **SOLD $95(96)**

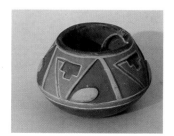

ACOMA POTTERY BOWL Contemp.
Relief geometric design (all dark areas in relief). Rust-color glaze over 2 shades lt. brown. Glazed bottom and rim. VG cond. 4"H. X 5.5 W. Est. 75-150

Left to Right: ZUNI SIGNED POTTERY JAR *Signed by "Adrian C. Zuni NM".*
Characteristic white chalky slip with dk. brown and red designs incl. deer with heart spirit lines. Central geometric band is concave relief. 5.75" H X 6.5" W. point. Exc. cond. Est. 125-225
HOPI POTTERY BOWL Orange slip field with black geometric design band and rim. White interior. Highly polished. A few very tiny nicks. 2.75" H X 3.75" W. point. Est. 80-150 **SOLD $75(94)**

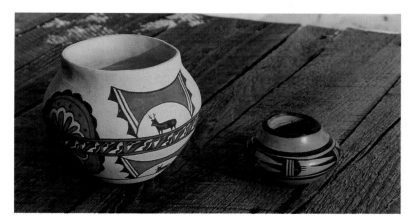

172

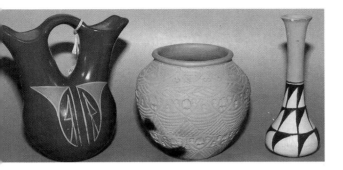

Left to Right: HOPI DOUBLE-NECKED TERRA COTTA VASE c.1935
Highly polished, thick and well-formed. Painted motif both sides in 2 shades of grey and tan. Exc. shape. 6.5" H. X 6" W. Est. 65/95 **SOLD $65(92)**
CHEROKEE IMPRESSED DESIGN POT c.1940
Signed "Maude Welch Cherokee, NC Indian Reservation". Stamped designs pressed into still-wet clay in old technique. Clay-colored with black and grey firing marks. 4.75"H. X 5" W. Est. 95/150 **SOLD $50(92)**
ACOMA BUD VASE c.1950
Signed "Acoma New Mexico". Painted with striking white and black geometric pattern. 6.25" H. X 2.25" W. Est.20/35

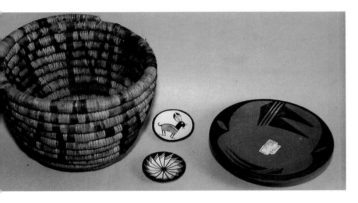

HOPI COILED BASKET c.1900
In 3 tones of brown. 1 minor break in wrapped fiber along rim, otherwise; good, sturdy shape. 5" H. X 7" W. Est. 125-175
Center: ACOMA MINIATURE MIMBRES-STYLE BOWLS c.1980
Black on white very well detailed and signed "Acoma (D.R.)NM". 2" diam.
Stylized Rabbit. Est.20-40
Geometric pattern. Est.2) **SOLD $15 each(92)**
Right: HOPI BLACK ON RED DISH c.1930
Heavy polished pottery. Attractive motif. Exc. cond. 5.75" diam. Est. 30/50 **SOLD $70(92)**

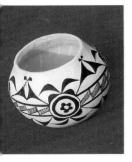

ACOMA SIGNED POTTERY BOWL
Signed "Dolores S. Sanchez Acoma N.M."
Very fine geometric with enclosed floral pattern. Brown on cream. 3.75" X 4.5" diam. Perfect cond. Est. 150-275

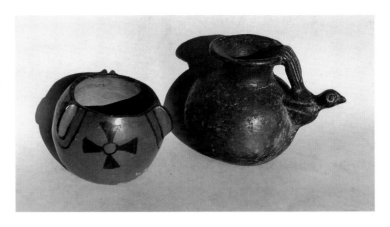

Left to Right MARICOPA BLACK OVER ORANGE GLAZED POT c.1940
Cross motif and 3 projections painted with black concentric lines. Cracked then glued. Black smudge marks on bottom. 3.5" H. X 4.5" at widest pt. Est. 45-75 **SOLD $45(94)**
BLACK WARE POT With BIRD HANDLE
Unknown provenance and age. Upright tail forms handle. Black smudge over red ware. Interesting texture. No re-construction. 5.5" H. X 4.5" W. +bird 7". Est. 60-150 **SOLD $70(94)**

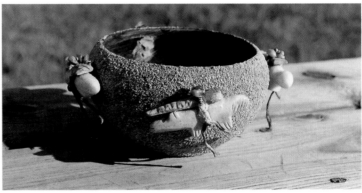

ZUNI FETISH BOWL Contemp.
Old-style. Covered with crushed turquoise. Interior lined with sacred blue cornmeal paste. 4 (2.5") animal fetishes with arrowheads and turq. and coral attached to exterior representing 4 directions. 5"W X 3" H.Est. 150-250 **SOLD $175(95)**

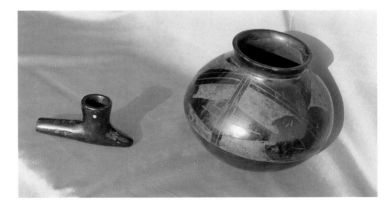

Left to Right: SANTA CLARA BLACK POTTERY PIPE with round turquoise inlay c.1930.
Remnants of tobacco on inside indicate heavy use but long ago as no odor remains. Good patina. 1/4" flake missing off back side of bowl rim. 5" L X 2.25" H. Est. 75-150
CASAS GRANDES REVIVAL BLACK-ON-BLACK POT Contemp.
Northern Mexico culture area. All-over geometric pattern. Exc. cond. 7"H. X 7" W. Est. 40-95 **SOLD $60(94)**

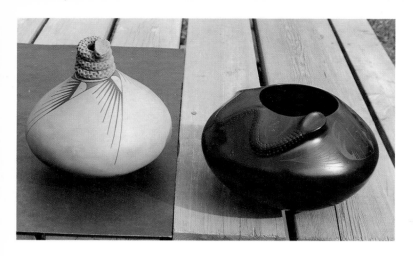

Left to Right: CASAS GRANDES REVIVAL OLLA Contemp.
Signed "Martta Meta". Sculptural coiled rattlesnake lip.
Polychrome black and red on buff. 8"H. X 7" W. Est. 110-175
SOLD $125(93)
CASAS GRANDES REVIVAL POTTERY BOWL Contemp.
Signed "Damien E. Quezada". Black on black designs plus
rattlesnake in relief 6"H. X 8.5". Est. 115-175 **SOLD $100(93)**

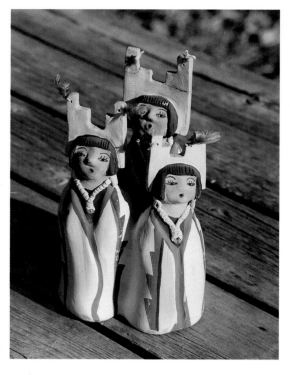

PUEBLO "3 SISTERS" POTTERY SCULPTURE Possibly Cochiti.
Bottom signed "E. Cajero bird image" and each figure named:
"Sunshine", "2 Basket", "Yucca Flower". Cream with turquoise-
colored headdresses and relief jewelry. Black and rust clothing
detail. Feather fluffs tied on top. Tallest headdress broken and
repaired. 10" H. Est. 145-195 **SOLD $145(95)**

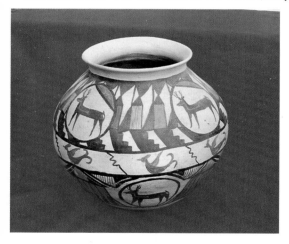

LARGE ZIA REVIVAL DEER and BIRD MOTIF
OLLA Contemp.
Cream bkgrd. with black spirit line deer and
rust-colored birds and geometric designs.
Large scale. Old-time designs. 14" H. X
14"W. Est. 500-650

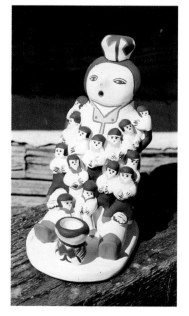

PUEBLO STORY TELLER FIGURINE
Contemp.
Signed "R. Chacho". White with black, terra
cotta and aqua glaze. 14 babies and 2 mini-
pots. Exc. cond. 7.5" H X 5.5" W. Est. 80/
125 **SOLD $50(91)**

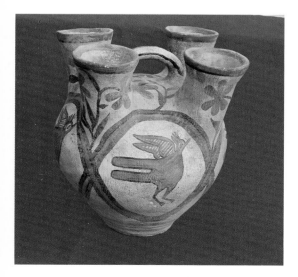

LARGE ZIA REVIVAL BIRD MOTIF POT
Contemp.
Interesting configuration top: 4 chimnies
with handle. Rust-colored birds and flowers
with black. Light patina adds to the old-
time look. 15" H. X 11.5"W. Est. 500-650

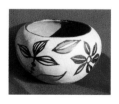

SANTO DOMINGO POLYCHROME BOWL
c.1920
Buff on red with black and red stylized bold
flower-leaf designs. 6" with pt X 4" H. Exc.
cond. Est. 95-150 **SOLD $90(94)**

General reference: Larry Frank
and Francis H. Harlow, *Historic Pot-
tery of the Pueblo Indians, 1600-1880,*
West Chester, Penna., Schiffer Pub-
lishing Ltd., 1990.

Pre-Historic Pottery

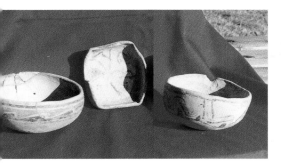

CASA GRANDE POLYCHROME BOWLS
A.D.1100-1500
Cream with faded red and brown designs.
LEFT TO RIGHT: Exterior red and black
border "wave" patterns. Round bowl. 5.5"
diam. 3" repair section.
RECTANGULAR top with round bottom.
Designs on both surfaces. 4.5" W. Large
chip missing. No reconstruction.
ROUND bowl. Loose zig-zag motif. Small
chip off rim. Original cond. 5.5" diam. Est.
115-195 **EACH SOLD $90 (94)**

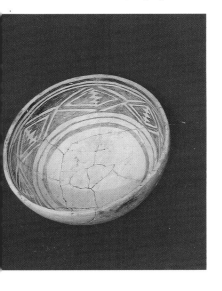

ANASAZI BOWL, PUEBLO III c.1100 A.D.
From Cortez, Colo. Reconstructed from
shards. All cream outside with lt. brown
geometric band. 7.25" X 3.25" H. Est. 220-
300 **SOLD $225(94)**

VERY LARGE EARLY HOHOKAM POTTERY
BOWL c.100 BC-1400 AD
*This old bowl has been passed down by
generations from an Indian trader's family on
the Yakima Res., Wash.* In remarkably good
cond. with no cracks or chips. Patina is
black interior (top surface) and patchy black
on buff underneath. No restorations. 18" W.
5"H. Exc. cond. Est. 800-1200 **SOLD
$950(93)**

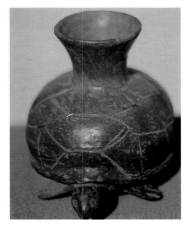

ZOOMORPHIC TURTLE EFFIGY POT
*Consignor says "Mound builder Ohio Valley
1200 A.D."* Full turtle including feet, tail,
head and incised shell with incised eyes,
mouth and toes. The flared bowl protrudes
from the middle of the shell. The rim has
been broken (barely visible). Color is dk.
brown to red-brown. Good patina and
polish. 7"L X 6" H. X 5"W. Est. 225-500
SOLD $250(94)

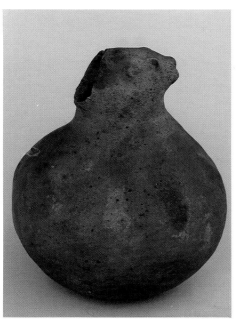

MOUND BUILDER ANIMAL EFFIGY BOTTLE
c.1300-1700
Middle Miss. Region. Gray to tan to dk. grey
patina. A few surface chips on lower
portion. Apx. 2" X 3" lower portion restored
and filled, exc. job, barely discernible. 7"H X
5.5" W. Est. 275/550 **SOLD $265(91)**

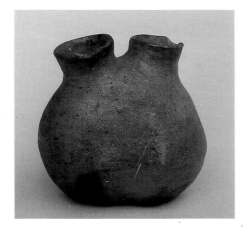

PUEBLO DOUBLE NECK KIVA POT c.1880
Unusual form. Terra-cotta with black kiln
marks. Iridescent glaze worn off in some
spots. Rim chip apx. 3/4". 5"H X 4.5"W X
3"D. Est. 95/175 **SOLD $75(91)**

PRE-HISTORIC SOUTH-WEST BOWL
Thick terra-cotta with gold flecks. Extensive
repair seems to be reconstructed from
shards. Color from red to grey to brown and
black marks on bottom. 9"W X 3.5"H.
Est.75/150 **SOLD $57.50(91)**

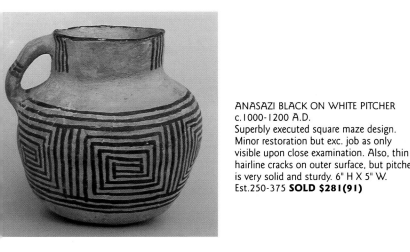

ANASAZI BLACK ON WHITE PITCHER
c.1000-1200 A.D.
Superbly executed square maze design.
Minor restoration but exc. job as only
visible upon close examination. Also, thin
hairline cracks on outer surface, but pitcher
is very solid and sturdy. 6" H X 5" W.
Est.250-375 **SOLD $281(91)**

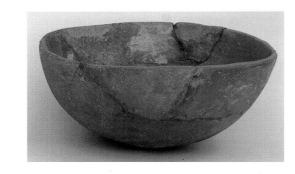

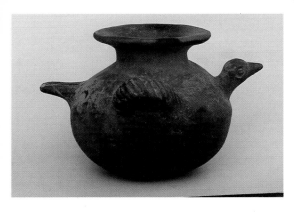

PRE-COLUMBIAN BIRD EFFIGY POT
Incised lines on 2 handles, tail and eyes. No
restoration. Interesting patina ranging from
blackened fire areas to encrusted brown and
red-brown terra cotta. Surface shows age.
7"W X 5"H. Est.95/250 **SOLD $120(91)**

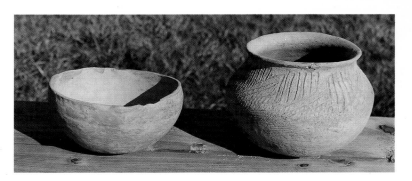

Left to Right: SW CLIFF DWELLER BOWL c.AD 600-1200
Plain buff unglazed. 3" H. X 7"W. Est. 95-135 **SOLD $90(95)**
CLIFF DWELLER UTILITARIAN POT
Same provenance. Incised buff unglazed lipped olla. Interesting
texture. One central crack- seems sturdy. 6" H. X 7" W. Est. 90-
150 **SOLD $100(95)**

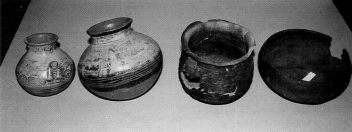

Left to Right: S.W. CASA GRANDE POLYCHROME POTTERY
Undetermined age.
Each has rounded bottom, terra cotta inner glaze and bottom 1/
3 terra cotta glaze. Interesting stripe and circle motifs in black
and rust over buff. Small protrusion 1 side. Nice polished and
worn patina of age. A few hair line cracks (1 side only.) 4"H X
4"W Est. 65-85 **SOLD $72(96)**
SIMILAR Buff with black. Top portion worn and polished. 1 tiny
hole. 5"H X 5.5" W. Est. 95-125 **SOLD $105(96)**
S.W. COOKING VESSELS FROM ARIZ. 1100 A.D. or earlier.
Corrugated pot reconstructed from large shards. All darkly
smudged from use. 5"H X 5" W. Est. 75-150 **SOLD $100(96)**
BOWL reconstructed from 2 shards. Black smudge; mica specks.
7"W X 3"H. Est. 75-150 **SOLD $100(96)**

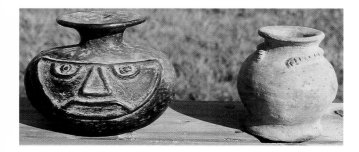

Left to Right: CASA GRANDE CLIFF DWELLERS POLYCHROME
OLLA c.AD 600-1200.
From SW Ariz. or Mexico. Rust and brown spiral motifs on buff.
Rubbed patina. 2 hair line reinforced cracks. 8" H. X 9" W. pt.
Est. 625-750 **SOLD $600(95)**
SMALL PRE-PUEBLO POT c. AD 600-1200
Dark grey unglazed with 2 holes either side of rim for hanging(?).
Good patina. 4" H. X 4.5" W. Est. 85-135

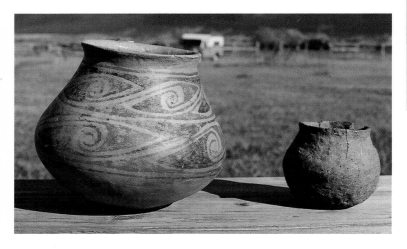

Left to Right: S.E. INDIAN? RELIEF FACE POT
Undetermined age and provenance. Looks old. Terra cotta with
blackened smudge patina. "Face" on both sides. 7"W X 5" W 5"
H. Est. 50-95 **SOLD $60(95)**
SAME, undetermined age and provenance. Looks old.
Small lipped buff unglazed. Rope relief design around neck.
Shows some black smudging nr. bottom. 5" H. X 4.5" H. Est.
50-75

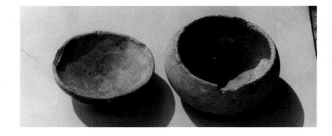

LOT OF 2 MISSOURI RIVER POTS, ARIKARA Pre-hist.
Found within radius of 60 mi. of Chamberlain, So.Dak. Both have
chipped rims and are in unrestored cond.
LEFT, shows fire smudge marks. Pink to grey patina. 3.25" X
1.25" deep.
RIGHT, terra cotta-pink to red with grey patina. Has shiny flecks
overall. 3.5" X 2.5"H. Est. 150-250 lot **SOLD $175(94) lot**

CADDO POTTERY JAR c. 1200 AD
From Clark Co., Ark. Incised and stamped
designs. Cracked and nicely repaired. Dk.
grey to brown patina. 4.25" H. X 4.5" top
diam. Est.95-150 **SOLD $140(93)**

Navajo Rugs and Other Weavings

Suggested reading: H.L. James, *Rugs and Posts*, West Chester, Penna., Schiffer Publishing, 1988.

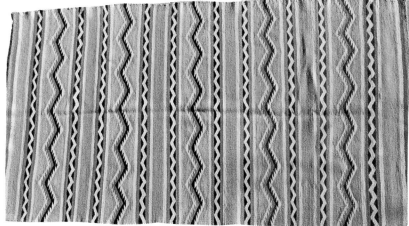

TRANSITIONAL NAVAJO RUG c.1890
All-over alternating stripe and geometric design. Muted shades of rose-red, grey, tan, dk. brown and cream. Exceptional design and cond. Soft texture. 39" X 69". Est. 900-1200 **SOLD $865(90)**

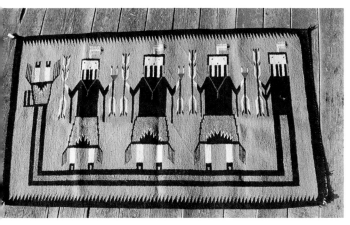

NAVAJO YEI RUG c.1940-60
*Probably from the Lukachukai area.** Exceptional very dense, tightly woven with hand-spun yarns: gold bkgrd. (varying shades) with black, nat. grey and white, red and turquoise accents. Has characteristic "Rainbow Goddess border." One end (bottom right in photo) tattered; otherwise exc. cond. 64"L X 39" W. Est. 440-800 **SOLD $650(97)**
* See *Rugs and Posts*, p.37.

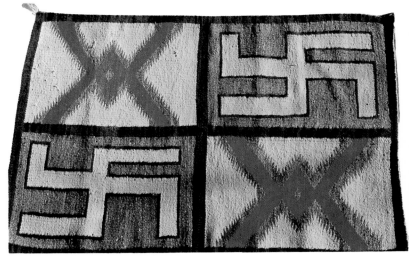

"SWASTIKA" PATTERN NAVAJO RUG c.1910
Four design fields; unusual pattern. Cream, lt. and dk. brown, red and grey. Perfect cond. 37" X 53". Est. 600-800 **SOLD $575(90)**

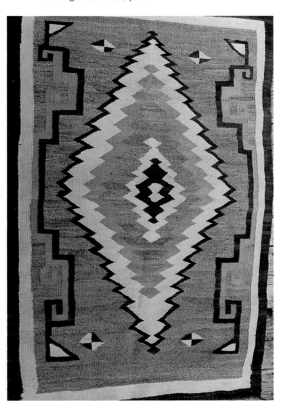

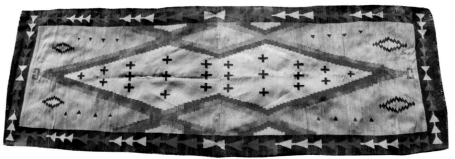

KLAGETOH NAVAJO RUG, GANADO AREA c.1906
Beautiful pattern in red, dk. brown, rust, white and grey. Edges are frayed all around. Red has slight bleed on 1 side only-a few very small holes. 11'8" X 4'2". Est.1800/2500 **SOLD $1200(91)**

NAVAJO RUG-EARTH COLORS c.1900
Dk.brown, cream, gold with grey field. Very fine weave. Exc. cond.
53" X 32". Est. 450-650 **SOLD 400(90)**

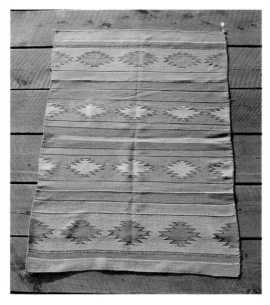

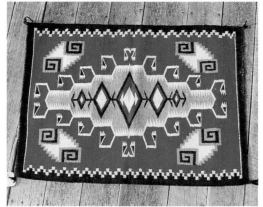

CLASSIC GANADO NAVAJO RUG
Tag reads "#57 Mae Johnson Ganado $1000.00". Characteristic deep red bkgrd. with complex geometric motifs: natural grey and white with mauve, rust and characteristic black border. 38"L X 30". Exc. cond. Est. 600-1000 **SOLD $650(97)**

CRYSTAL NAVAJO RUG c.1940
Classic vegetable dye stripe pattern with serrated diamonds. Shades of subdued gold, grey-brown and white. Exc. cond. 44.5" X 61". Est. 375-550 **SOLD $375(94)**

GANADO(?) NAVAJO RUG c.1920
Unusual bold diamond and rectangular patterns. In natural wool: lt. and med. grey and dk. brown. Analine dyed wool: red, orange and green (all with color variations). A few small stains. 34.5" X 50"L. Est. 750-950 **SOLD $550(94)**

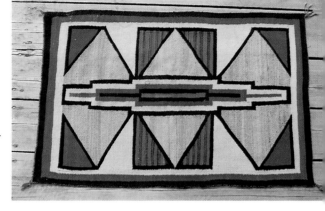

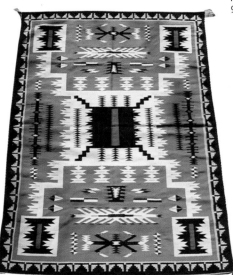

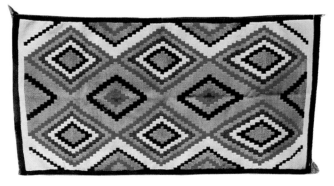

STYLIZED STORM PATTERN NAVAJO RUG
20th cent.
Four Corners area. Teec Nos Pos(?). Terra cotta field with black, white and rust. All vegetable dye. Very intricate pattern. Incredibly fine weave and pristine cond. 58" X 84". Est. 2500-4500 **SOLD $2760(94)**

ALL-OVER SERRATED DIAMOND PATTERN NAVAJO RUG
c.1940
Tight and fine weave. Clear rich colors: deep red, camel, black, grey, indigo and cream. Exc. cond. 32.75" X 60"L. Est. 1000-1500 **SOLD $1100(94)**

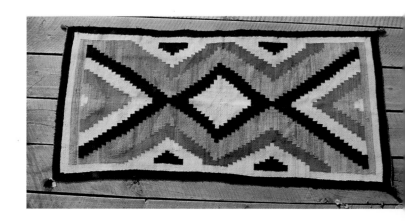

LARGE OUTLINE STYLE NAVAJO RUG
c.1930.
Heavy yarn-medium weave in serrated diamond pattern. All natural undyed wool: lt. brown (many color variations); dk. and med. brown and white. Exc. cond. Floor piece. 83" X 43". Est. 440-600 **SOLD $465(94)**

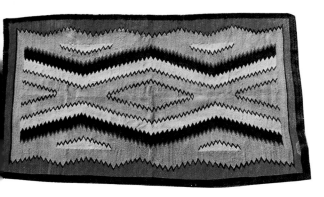

LARGE KLAGETOH NAVAJO RUG c.1915
Outline-style large concentric serrated
diamonds: rich red (many color variations),
natural brown, dk. brown and cream with
wide border. A few very minor stains. 42" X
72". Est. 375-800 **SOLD $400(94)**

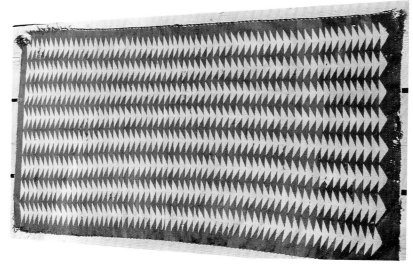

"FLYING DUCK" PATTERN NAVAJO RUG
c.1910
All-over triangular designs in yellow on dk.
brown bkgrd. 3 edges tattered-several small
repairable holes. 57" X 30". Est. 300-500
SOLD $325(93)

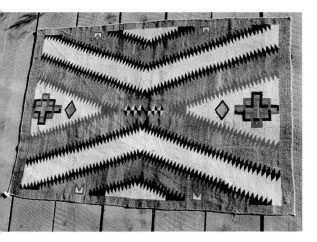

NAVAJO RUG c.1915
Soft heavy blanket. Natural grey/brown
bkgrd. with intricate serrated pattern in
natural dk. brown and red with cream. Very
subtle color graduations within brown/
grays. Exc. cond. 66"L X 48" W. Est. 350-
650 **SOLD $375(95)**

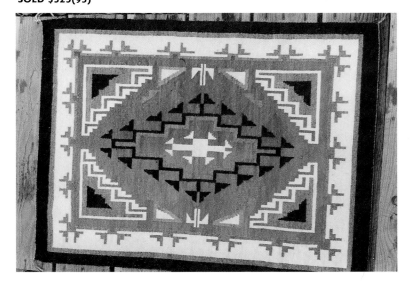

TWO GREY HILLS NAVAJO RUG c.1980
Classic central figure motif in all-natural white, brown, grey and
black. Fine weave. Exc. cond-all edges intact. 44" X 32.5"
Est.750-950 **SOLD $750(93)**

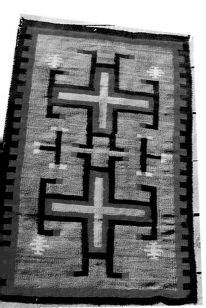

CLASSIC EARLY STORM PATTERN NAVAJO
RUG c.1910-20
Red Lakes Trading Post at Tonales, Ariz.
Earliest version with swastika designs; lt.
brown field with dk. brown border. Red,
cream, and Dk. brown filler designs. Exc.
cond. 58" X 38". Est.700-1200 **SOLD
$700(89)**

DOUBLE-CROSS MOTIF NAVAJO RUG
c.1915
Natural grey-brown bkgrd. with concentric
crosses (tan, red and natural dk. brown) and
white figures each corner. Border is dk.
brown and red. Heavy weave. VG cond.
65"L X 40" W. Est. 375-550 **SOLD
$435(95)**

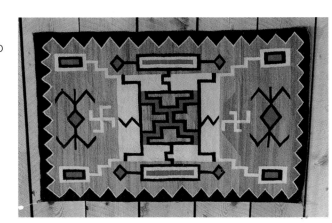

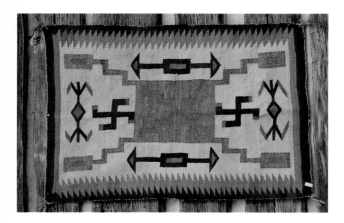

CLASSIC EARLY STORM PATTERN NAVAJO RUG c.1911-15
J.B. Moore's original style from Crystal Trading Post. (See James, Rugs and Posts). Hand-spun natural cream, tan, dk. brown, varied medium brown and dyed muted red. A few breaks only in overcast yarn binding. Clean and exc cond. 27"W X 40"L. Est. 375-650 **SOLD $375(96)**

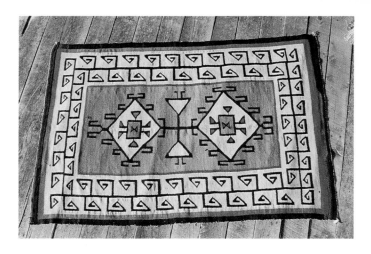

NAVAJO RUG-CRYSTAL(?) c.1910-20
Characteristic fret and hook patterns *(as intro. by early trader J.B. Moore of Crystal Trading Post).* Bordered with black and red. Central panel is lt. brown/grey bkgrd. with dk. brown/black bordered with cream and then red. Hand-spun and all natural except red. Very fine weave. A few small (1") holes; otherwise VG cond. 68" X 47". Est. 350-700 **SOLD $550(97)**

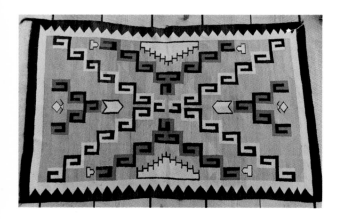

STORM PATTERN NAVAJO RUG c.1920
Geometric pattern in dk. brown, red and white on lt. brown field with dk. brown border. Exc. cond. 67.5" X 45". Est.600/950
SOLD $600(94)

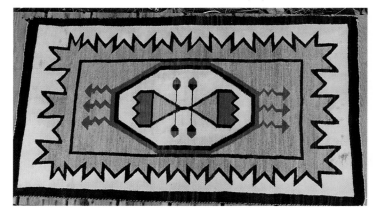

WESTERN RESERVATION STYLE NAVAJO RUG c.1910
Central motif in red "lightning" and stylized feathers with natural brown bkgrd. and white and black border design. Some dirt stains. Exc. cond. 57" X 34". Est.1000-1500 **SOLD $1000(93)**

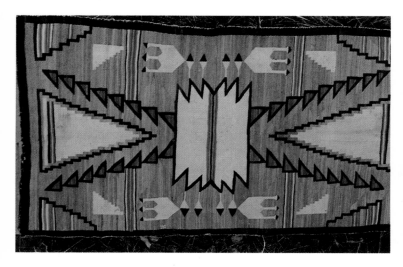

STORM PATTERN NAVAJO RUG c.1920
Western Reservation style, probably from Crystal Trading Post. Fine weave. Varying natural tan to brown bkgrd. with white, red, and dk. brown pattern. Floor piece in good cond except for dirt stains and 1 crudely repaired 2" tear on border and some worn yarn edging. 68.5" X 39". Est.1000-1500 **SOLD $1000(93)**

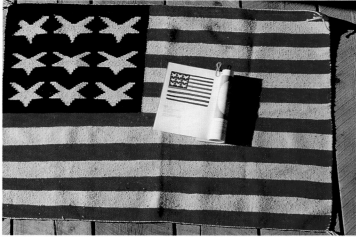

AMERICAN FLAG MOTIF NAVAJO RUG c.1960
This same rug pictured in *The American Indian/The American Flag,* Exhibition Catalog, Flint Inst of the Arts, 1975. p.94, #109. Red, white and indigo with 9 stars and 15 stripes. Hand spun wool. 35.25" X 49.5". Est.475-850 **SOLD $475(91)**

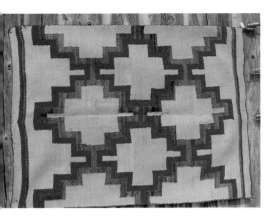

TRANSITIONAL NAVAJO RUG c.1900-10
Thick, soft hand-spun yarns in striking
large-scale pattern. Natural cream with
natural grey-brown and dyed red-orange.
Unfaded and clean. 2" tear nr. center and
nap worn through in a few nearby areas. 62"
X 54". Est. 375-600 **SOLD $400(96)**

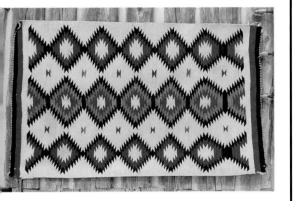

SERRATED DIAMOND PATTERN NAVAJO
RUG c.1920-40
Hand-spun yarns in natural dk. and medium
(varied tones) brown and dyed deep red.
Thick tight weave with unfaded bright
colors. 4" along outer edge-end frayed;
otherwise, exc. cond. 45" X 70" Est. 500-
700 **SOLD $550(96)**

SMALL NAVAJO RUG, "CHIEF" BLANKET
STYLE c.1920-40
Derived from very early style. Heavy, loose
hand-spun yarns in natural brown/grey and
cream with red. Central stripes are red and
tan with cream and brown on either side.
Very nice and soft;similar to saddle blanket
in weight. 54" X 47". Est. 300-500 **SOLD
$425(97)**

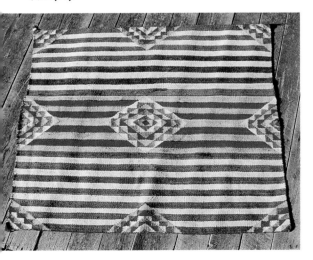

The following Chimayo weavings were made on Up-
per Rio Grande in New Mexico. Woven horizontally, not
vertically like Navajo rugs. See Dockstader, Frederick J. *Weav-
ing Arts of the North American Indian*, New York, Crowell,
1978:68.

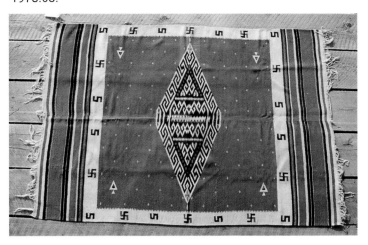

CHIMAYO RUG c.1940
Central diamond (complex fret pattern) on a blue-grey field.
White border with black swastika and "S" motifs. Striped ends
+ 8" white warp fringe. 6" diam. section on striped end has
several tiny holes;otherwise exc. cond. 54"W X 78.5"L. Est.
200-350

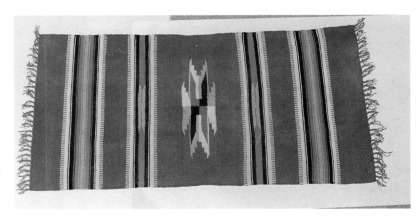

CHIMAYO WEAVING c.1920
Wool, commercial dyed yarn in stripes and geometric pattern.
Predominantly red, turquoise, black, cream and lt. gray. Several
tiny moth holes through 1 side only. 19"W X 39"L + 2" knotted
gray yarn fringe. Est. 50/75

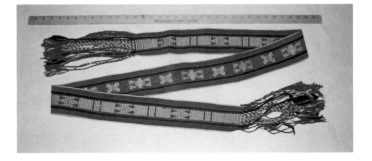

HOPI TRADITIONAL WOVEN SASH
Tightly woven wool yarn in typical red with dk. green stripes and
tan geometric figures. Exc. cond. 3.25'W X 74"L +11" fringe
each end. Est. 85-175 **SOLD $50(97)**

SILVER WORK

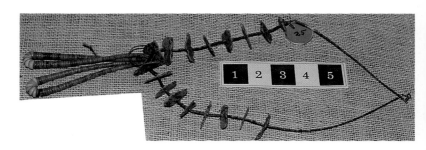

Suggested Reading: Larry Frank, *Indian Silver Jewelry of the Southwest 1868-1930*, West Chester, Penna., Schiffer Publishing Ltd., 1990.

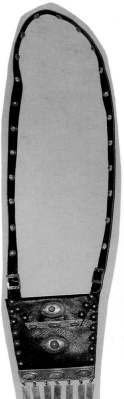

NAVAJO MEDICINE MAN STYLE POUCH
c.1940
With 8 turquoise stones and hand-stamped German silver-plated buckles, conchos and strips. 7 rectangular plated dangles. 7" H X 7" pouch. Hangs 33." Est.175/250 **SOLD $175(91)**

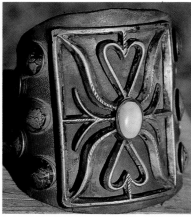

NAVAJO MAN'S KETOH (WRIST GUARD)
Sand cast silver with pale turquoise stone embellished each side with domed mercury dimes. Heavy leather with thong closure. Top: 4"L X 3". Opening: 3.25" X 2.25". Est. 250-495 **SOLD $325(94)**

NAVAJO TURQUOISE NUGGET NECKLACE With JOCLAS
Contemp.
Very fine olivella heishi strung with 1 to 1.5" flat turquoise with pr. of 10" joclas. Hangs 18" L. Est. 100-195 **SOLD $125(96)**

Left to Right: TURQUOISE NUGGET and HEISHI NECKLACE With JOCLAS
Classic Navajo piece. 1/2" to 1" flattish stones. Attached joclas are graduated turquoise discs .13" to .38" diam. Necklace is 30" + joclas 10". Est.175-250 **SOLD $125(93)**

PUEBLO (PROB. SANTO DOMINGO) ROLLED TURQUOISE NECKLACE c.1920
King Manassa Turq. Mine. Graduated discs .2" to .38" diam. 18" loop. Est. 110-160 **SOLD $70(93)**

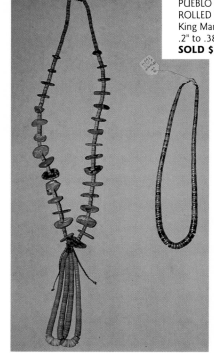

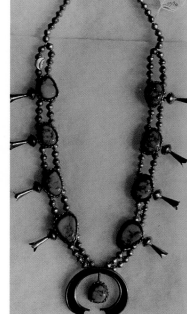

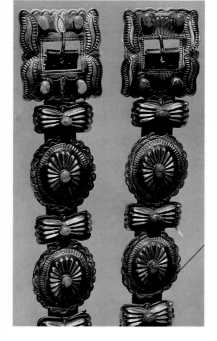

2 NAVAJO SILVER and HIDE CONCHA BELTS
Each has 5 scalloped rosette repousse conchas alt. with 6 butterfly repousse; fancy stamped and repousse rectangle buckle mounted on dk. brown leather. Each has slightly diff. designs; probably made by same craftsman. Each concha individually backed with leather. Light patina on both. 30"-40" waist.
LEFT TO RIGHT: BELT, each concha set with green chrysacolla stone and 4 on buckle. All stones intact. Est. 750-1000 **SOLD $750(94)**
BELT, each concha set with lt. blue turquoise stone-4 on buckle. All stones intact. Est. 750-1000 **SOLD $750(94)**

NAVAJO TURQUOISE and SILVER SQUASH BLOSSOM NECKLACE c.1940
Stamped "E C". Nine blue-green stones encircled with rolled rope work graduated sizes. Hand-made naja. Hangs 15.5" L. Est. 400-650 **SOLD $450(94)**

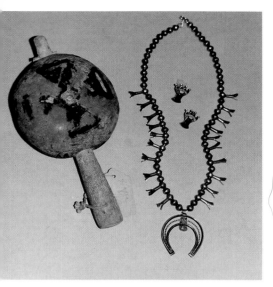

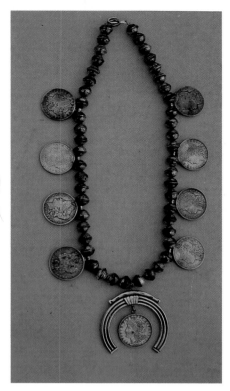

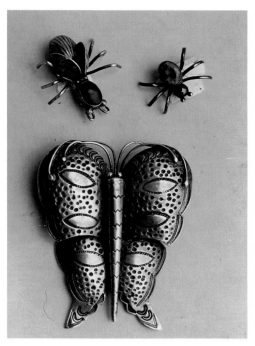

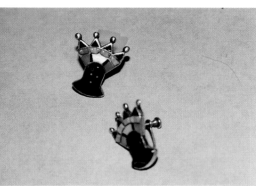

Left: OLD HOPI RATTLE 19th century painted gourd is well-worn redochre, black and remnants of pale green with worn wooden tapered handle and wooden peg. Good age patina. 9" L X 4.5" W. Est. 125-225 **SOLD $125(96)**
Above: ZUNI INLAY EARRINGS c.1940 Inside necklace and detail photo. Unusual Kachina mask motif in silver with jet, turquoise, mother-of-pearl and coral. Perfect cond. Screw-on. 1"L. Est. 60-95 **SOLD $50(96)**
Right: SILVER SQUASH BLOSSOM NECKLACE c.1930 Hand-soldered silver beads small turquoise stone center of naja. Hangs 12"L. Est. 250-350 **SOLD $3⊙(96)**

NINE SILVER DOLLAR NECKLACE
Contemp.
Dates on $ coins: 1891-1921. Strung with 48 beads made from domed mercury dimes. Hangs 16.5"L. Est. 325-500 **SOLD $375(94)**

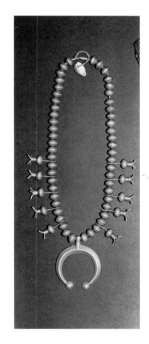

EARLY STYLE NAVAJO SQUASH BLOSSOM NECKLACE c. 1960
Made by Santa Fe silversmith Oscar Branson. Beads are hand-made from old dimes. Exquisitely made and strung on buckskin. Very heavy silver; abalone shell disc at tie. Cast naja 2.5" W. Hangs 15"L. Est. 500-900 **SOLD $700(97)**

Top to Bottom (left to right): NAVAJO SILVER BEE PIN c.1940
Set green turquoise head-stamped wings and body. Heavy silver wire legs and antennae gives 3-d effect. .75" H. X 1.5" X 1.5". Est. 75-150 **SOLD $75(95)**
NAVAJO SILVER SPIDER PIN c.1940
Deep blue turquoise body. Heavy wire legs. .75" X 1.13" X.38" H. Est. 50-95 **SOLD $50(95)**
NAVAJO SILVER BUTTERFLY PIN c. 1940
Original stamped work of art has separate cone-shaped body, silver wire antennae and curved stamped wings. 3"H. X 2.38". Est. 250-350 **SOLD $275(95)**

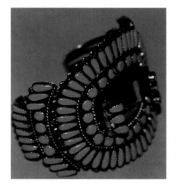

NAVAJO ZUNI-STYLE TURQUOISE CLUSTER WATCHBAND Contemp.
Turquoise stones all intact. Base appears to be German silver. Every stone perfect. 3" L X 2" deep X 2.5" W. Est. 125-225 **SOLD $125(95)**

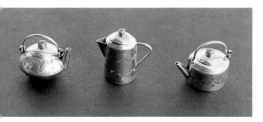

NAVAJO SILVER MINIATURE SET OF 3
Contemp.
Tiny stamped pieces each with tiny turquoise stone on top. 2 tea kettles and 1 coffee pot. 1" to 1.13" H. Est. 90-150 **SOLD $90(93) lot**

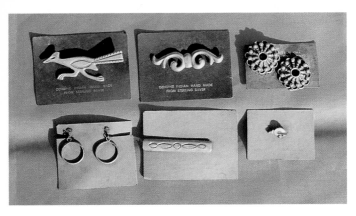

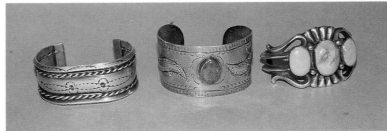

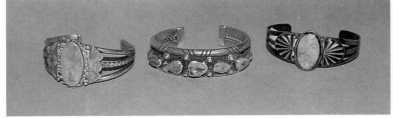

Left to Right (both photos): BRACELET, heavy stamped silver with twist and triangular wire. 1.13" W. 2.5" inner W. Est. 60-85
BRACELET, silver, 1.5"W with unique stamped and repousse leaf motifs-central single turquoise stone. 2.5" inner W. Est. 75-125 **SOLD $85(96)**
BRACELET, heavy sand-cast silver with 3 large turquoise stones. Beautiful piece. 1.75" W. 2.5" inner W. Est.130-175 **SOLD $155(96)**
BRACELET, c. 1930, Single oval turquoise with stylized stamped butterflies either side. Twist and plain wire. Est. 95-150 **SOLD $135(96)**
BRACELET, contemp. of unique heavy silver wire and twist with decoration. 5 irregular stones. .88" W. 2.38" inner W. Est. 175-250
BRACELET, c.1920 Single large turquoise with repousse either side and flat stamped silver band. Nice dark patina. 1.13" W. Est. 90-150 **SOLD $125(96)**

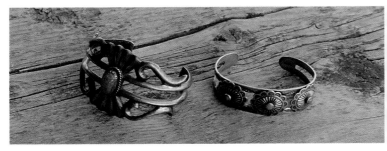

Left to Right: NAVAJO SILVER SAND CAST BRACELET c.1930 *Stamped "AJW" with arrow on the back.* Turquoise stone centered on top. Heavy silver. Good old patina. 2.5" L 1.88" With Est.150-250 **SOLD $150(93)**
NAVAJO STAMPED SILVER BRACELET c.1930 *Stamped "sterling" on back.* 3 stamped conchos set with small turquoise stones. 2.25"L X 1.75" W. Est. 100-175 **SOLD $125(93)**

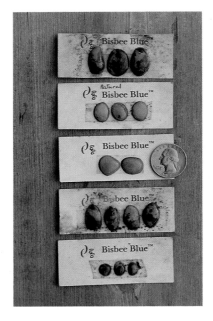

The following lots of South-west jewelry are OLD STOCK from a Montana trading post that closed in c.1950. Est. each lot. 40-100
TOP TO BOTTOM: cast silver roadrunner pin, .88" X 2.38"
cast silver pin .63" X 2.13"
silver and turquoise clip-on earrings 1" diam.
silver clip-on earrings .63" diam.
silver $ clip .38" X 2"
turq., coral and shell Shriner's hat/tie pin .5". **SOLD lot $40(94)**

Cast silver pendant 1.63" X 2.88"
silver and turq. pin 1.38" X 11/16"
silver pin .88" X 1.38"
silver and turq. $ clip .5" X 2.25"
cast silver pin 1.25" X 2". **SOLD lot $35(94)**

15 Bisbee turquoise cabochon stones. Largest is .75"L. **SOLD $46(94)**

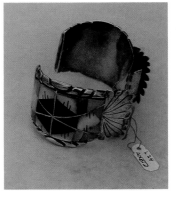

ZUNI INLAY MAN'S WATCHBAND
Contemp.
Signed "M. Spencer." Beautiful inlay pattern of yellow incised mussel shell, turquoise, jet and coral. Heavy sterling silver. 1.5" widest pt. Est.225-300 **SOLD $200(93)**

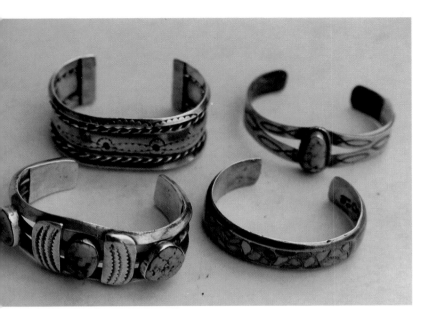

Top to Bottom (left to right): NAVAJO SILVER BRACELET
Double twisted silver wire on stamped piece. Inside 2.5" W. Est. 95-125
SILVER and TURQUOISE BRACELET c. 1930
Back stamped "A. EDSITTY" "STERLING". Flat stamped silver with single
turquoise. 2.5" inner W. Est. 100-175 **SOLD $125(95)**
NAVAJO 3 STONE SILVER BRACELET Heavy silver with 3 nice turquoise
and stamped leaf motif. Exc. shape, 2.63" inner W. Est. 200-300 **SOLD
$225(95)**
ZUNI TURQUOISE INLAY SILVER BRACELET
2.5" inner W. Est. 125-195

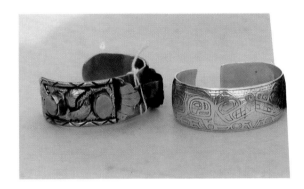

Left to Right: NAVAJO TURQUOISE and
SILVER WATCH BRACELET c.1940
4 stones with leaf motif. Heavy silver. Exc.
workmanship and patina. 2.5" inside W.
Est. 125-175 **SOLD $150(95)**
NW COAST SILVER HAND-MADE
BRACELET
Stylized bear motif. Domed shape. Signed
backwards S and "78" on back. 2.38"
inside W. Nice patina. Est. 250-350
SOLD $300(95)

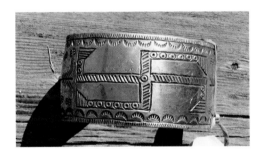

NAVAJO MAN'S SILVER BRACELET, c.
1880s
Rare. 1st phase stamped design, made
before turquoise became popular. Large
and heavy-weight. 1.63" W. Est. 200-400
SOLD $195(87)

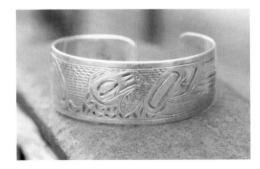

N.W. COAST SILVER HAND-MADE
BRACELET
*Signed "BK" on inside, a well-known NWC
artisan. Owner paid $300 for this 15 years
ago in a fine Denver gallery.* Stylized eagle
motif. Good patina. .43" W. Est. 300-400
SOLD $375(95)

VIII. Photo Essay "Is it Real...or is it an Artifake?"

Collecting and Identifying Replicas

In today's marketplace, the replica Indian artifact deserves your attention. Understanding this area of collecting is important regardless if you wish to own any replicas or not. Without knowledge of this phenomena you will, at some point in your collecting, undoubtedly become the owner of an artifake thinking that it is an authentic historic Indian made relic. It may even cost you a lot of money and will most surely be a disappointment to your collecting pleasures. This can all be eliminated if you take the time to learn about the types of replicas being made and the artists making them. Who knows, once you increase your knowledge, you may even find reasons to add a few replicas to your collection.

An Indian replica is the re-creation of an item to duplicate or resemble something Indians would have made and used in the past. When a replica receives additional efforts to make it appear as though it were actually made in the past it becomes an "Artifake." The value of such an item is not the same as the old original. For instance, the value of a fully beaded vest, in excellent condition, made in 1870 is higher than an exact replica or artifake made in 1990. The value of the replica is determined by the expertise of the maker, the rarity of construction materials, and the amount of construction time (hours, days or weeks).

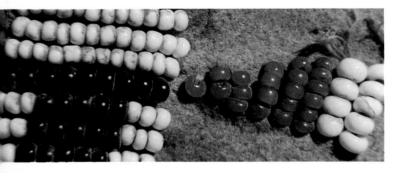

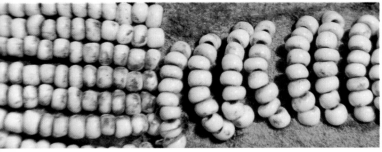

These photos show close-ups of pony beads that have been sinew-sewn to buckskin and aged to look old. The beads were painted with a water color solution. If you look carefully you can see dark water color lines on the buckskin next to some of the white beads. (Hide also has red ochre stains). The maker's brush slipped off the beads and left this stain. After the water color dries the excess is wiped off with a damp cloth. Look carefully and you will notice dark and light colored areas which result from how heavily the color was applied and how completely it was wiped off. Individual beads will often have a clean top surface with a ring of darkened stain that proceeds to the underside of the bead.

Some collectors would prefer that this process not be used to change an item's appearance. The fact is that some items are more attractive and sellable if they look old. Many collectors seem to equate dirt with wear and age. This, they feel, makes an item look like it was made by Indians long ago. On the other hand, let us suppose that a pair of moccasins, made in 1870, were purchased by the local Indian Agent and immediately stored in a trunk. This trunk has remained in the agents family for three generations. If all conditions, such as no light, no bugs, no dampness, no dust, etc. have remained stable the moccasins should look the same 100 years later. Some collectors will value these moccasins for their excellent condition while others would prefer a little dirt and wear (patina). The choice is up to the individual collector. The trick is to know which items have an original patina and which are replicas with an artificially applied patina. Experience and observation will help you learn to see the difference. The answer is, don't make a purchase unless an item satisfies you completely.

The importance of whether or not the replica was made by a person identifying themselves as an American Indian must be determined by the purchaser. Generally, this does not make a difference in the value of the finished item. Buyers seem to be more interested in the quality of the work and value finished items accordingly. Currently, most replicators are of non-Indian heritage. Most Indian artists are busy making contemporary items for the Indian and non-Indian markets. However, both Indian and non-Indian replicators are gaining a reputation for their skills and their ability and fame usually determine the monetary value of their replicas.

The lack of authentic old relics and the high prices they command are the reasons for the large number of replicators at work today. Suppose you would like to purchase a fine old Sioux beaded and quilled pipe bag; not only would you find few for sale, but the price would probably be over $2,000. A comparable expertly made replica would be available for under $1200. A more dramatic example would be a rare original shield too costly to purchase or in a museum. Why not a beautiful copy using authentic new materials: hand-made rawhide, brain-tan leather, saved list trade wool that looks wonderful over your fireplace but costs less than $300? (See Replica Shields in the companion volume and Old and New Comparisons later in this chapter.) Originals can be expensive, whereas replicas are more affordable. Also, original relics are sometimes rather fragile because the materials are old and they demand special care. The high cost, alone, can be a reason for special handling. However, replicas are fresh and durable. You can handle, wear and play with them. In fact, limited use usually makes them look even more authentic. Suppose you would like to have a beautiful war shirt you have seen displayed at the Smithsonian Institution. (See Lakota War Shirt in the Replica Section of the companion volume.) You can't buy it, but you can have a replica made. Suppose an old black and white photo you own shows a Crow warrior holding a beautiful beaded knife sheath. Not only does no one seem to know what happened to the original, but you probably couldn't own it if they did. For a lesser fee you can have a replica made. The reasons for having replicas made include many such examples.

Most replicators are good, honest, trustworthy folks who want your business and have no interest in selling you a replica as being

old and authentic. They want you to be pleased so that you will buy more. But, be careful, because there are replicators, dealers, collectors and sometimes questionable friends who will try to sell you an artifake as being genuine and authentic. Granted, it is possible they sometimes don't know, or aren't sure if it is genuine or not. Your best protection is education. Look, listen, study and learn to know the origin of what you are buying.

A **restoration** is an old item or some part thereof that has been restored to its original appearance. If there is not enough of the original piece present to indicate what it looked like originally, then you can not do an honest restoration. You can still use the part to make something else, but it will have to be labeled as a replica made with some old parts. Sometimes parts from several old pieces are combined to make a new piece. This would be a replica and not a restoration. It is interesting to note that Indians did this long ago. Look carefully in museums and collections and you will find many items made from one or more original pieces recombined to make something new. For instance, a strike-a-light pouch made from a little girl's fully beaded leggings or a knife case made from the beaded side of a saddle bag. Many things were recombined into something useful. If it was done long ago by Indians, we would call it an authentic relic. (See Old and New Comparisons later in this chapter.)

Sometimes the question is, How much of an item must be present before a restoration becomes a replica? For instance, if all you have is one rawhide moccasin sole and you use it to make a pair of beaded moccasins, this is not a restoration. This would be a replica because you had no insight into how the original moccasin looked just by viewing the rawhide sole. This moccasin would be a whole new creation. An example of a restoration would be a Sioux pipe bag with most of the porcupine quills eaten off the rawhide slats by carpet beatles; the replicator replaces the missing quills using good old colors and an authentic pattern. The *integrity* of the original pipe bag is still intact.

Ideally, restorations should be done so that the process can be reversed and the item returned to its original condition. This is the only kind of restoration that would be allowed in most large recognized museums.

Cleaning

The cleaning of artifacts is a restoration process that should only be undertaken by persons who have complete knowledge of the final outcome. For instance, the washing of white brain tanned buckskin in soap and water is irreversible. I once owned a beautifully quilled child's vest that some one cleaned with soap and water. What a shame to see the buckskin turned into a board-like stiffness that could never be returned to its beautiful soft condition.

Be careful, because items can be ruined and their value greatly or sometime completely lost if you cause any irreversible change in the material structure or stability of the object. Every item has its special patina or appearance that has been acquired through years of use or just natural aging. This can be a certain coloring, texture, smell, feeling to the touch or look. If the patina is good do not change it as you will most surely reduce the value.

DON'T DON'T DON'T do any of the following:

Wash Navajo rugs in soap and water. The colors will bleed together.

Wash white buckskin in soap and water. It will turn board stiff.

Use glue to repair damaged beadwork, quill work or baskets.

Restore painted colors with magic markers.

The best practice is to seek the advice of a reputable authority before doing anything that might change an artifact's visual appearance.

Authenticating Relics By Bead Colors

by Preston E. Miller

One of the first things to consider when authenticating the age of a beaded relic is the color of the beads. It is good to think about the color choices as though you were the Indian craft worker. 150 years ago, your life would have been centered around natural things. The colors you preferred would reflect those surroundings; they would probably be similar to the forests, mountains or deserts near which you lived. A good test is to think of the beadwork you are trying to authenticate as though it were hanging on a tree. Does it blend into the natural surroundings or would it blend in better with the colorful cereal boxes in your local grocery store? If it looks better in the natural surrounding, chances are good that it pre-dates 1900, and if it looks better in the grocery store it could be more recent.

It is interesting to theorize why color choice might be an important guide in helping the collector determine the age of a beaded object. There can only be two reasons: the Indians' preference or the availability of the beads. Certainly traders could not stock every bead color. We must assume they stocked the beads that were most in demand. But on the other hand, if bright oranges, pinks, yellows, reds and blues had been available in 1870, how do we know the Indian people would not have used them. They certainly are popular in modern times. It is interesting to note that, presently, bright orange is a very popular color among Indians and very unpopular among non-Indians. However, orange seldom shows up on pre-1900 artifacts. Was this because it was an unpopular color or because it was not available?

An assortment of **old** seed beads showing colors of white lined ruby red, greasy yellow, black and light blue.

Greasy yellow and greasy blue are good old colors that are often found on older pieces. Even though they have usually been available, Indians seem to have not used them much after 1915. Perhaps the brighter opaque yellows and blues became more popular. Presently there is a trend back to these colors, but they are still a good indication of a relic's age and authenticity.

Red bead types can be loosely dated as follows:
-a ruby red bead with white center dates before 1870,
-a rose-red with white center dates between 1870 and 1900,
-a bright red with white center dates from 1890 to 1920,
-a greasy opaque red dates from 1915 to 1940,

-transparent rose-red (various shades) dates from before 1870 to the present,

-and various shades of opaque reds date from 1920 to the present.

If these dates don't coincide with your beliefs, don't be too disappointed, as my data is based on my own personal observations. Because there is no accurate data to substantiate what years certain bead colors were produced, we can only make observations and estimates. There is no time limit between the year a bead is made and when it is used; Indians sometimes collect beads for many years before using them. Also they often tear an older used item apart and use the beads to make a new item. Some old beads are still being used today by Indians and replicators. So, these dates are only intended to give you an idea when certain colors of red appear to be most popular.

Beads are like dye lots of yarn, in that each time a color is made the shade will vary. Even though the factory assigns a number to a certain color the shade will usually vary slightly each time they are made. White and black are the only colors that stay the same. Blues show the most variation. Bead workers who haven't accumulated enough beads to finish a project will often find it difficult to match additional colors exactly. Many times you will find old fully-beaded items with the background color changing shades and sometimes sizes before it is finished. This is because the bead worker ran out of beads and the trading post couldn't supply the exact same color.

Look and learn, take photos, compare objects, ask questions and in time you should develop a sense of how to authenticate and date a relic by looking at the colors of the beads.

Trade Ornaments and Materials used on Indian Artifacts
Comparisons of Old vs. New

Brass Hawk Bells were attached to many old Indian items as decorative ornaments. They show up on Horse gear, dresses, pipe bags, war bonnets, dance bustles, medicine items, etc. As old and new bells are somewhat different they can often be a tell-tale indication of a relic's authenticity. Old hawk bells are made from two sheets of brass that have been domed and crimped together. The top is perforated to produce a tinkling sound and the underside has a hole into which a brass wire attachment loop is loosely inserted. Hawk bells come in many sizes with most being under 3/4" dia.

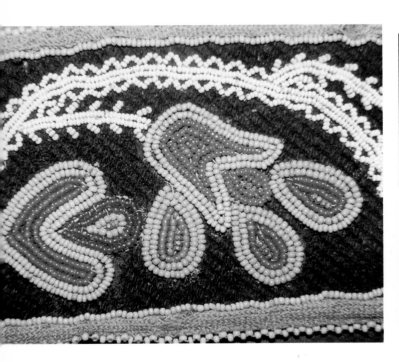

This is a section from an 1870s Ojibwa garter displaying the use of subtle old-time colors. Three different reds are visible. Transparent rose is used on the tear drop portion of the larger flower. The center of the large flower and two of the tear drop designs contain ruby red white center beads. The middle tear drop design uses rose-red white center beads. The center of each tear drop contains a row of gold metal faceted beads. Cheyenne pink is a popular old-time color. The white flower stems use an interesting style of barbs that identify this piece as Ojibwa.

LEFT TO RIGHT: the largest bell (aprox. 1.75" diam.) was dug up by G.B. Fenstermaker at the Daisy Site on the Fry property in Washington Boro, Pa. It dates before 1700 and is of Spanish manufacture according to Mr. Fenstermaker. It has an unusual attachment loop that is solidly attached and made from a strip of brass.
The second bell has a nice aged patina with brass wire loop. Notice the interesting raised ridge that circles the loop hole.
The remaining bells show a nice patina and still have buckskin thongs attached. Notice that one of the smaller bells still has some of it original red gilt finish near the crimped edge.

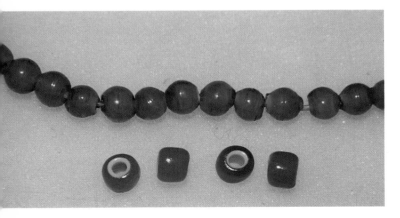

In this photo a string of old wire-wound white center red necklace beads is shown next to four new white center red beads (popularly known as a "Crow" bead). The old wire-wound beads were made one at a time by melting glass around a copper wire and slipping the finished bead off after the glass cooled. This type bead was already being traded to Indians prior to 1870;their use on a relic is a good indication that it is old and authentic. The four new beads, from France, were made from a long glass tube that was cut into small tubes and tumbled in sand to make the edges smooth. Because of this they retain a rather tube-like square shape. Notice these have white centers and that the colors are two different shades of red. This style bead is not as common on early relics and seems to have been most popular after 1900.

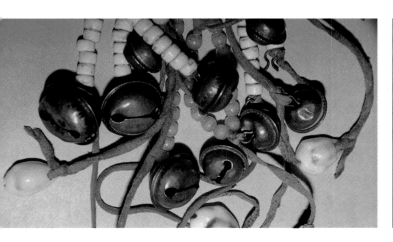

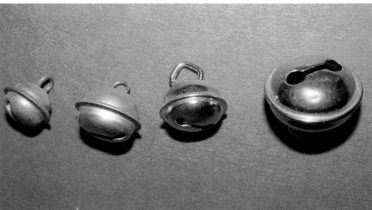

This photo shows an assortment of various sized hawk bells attached to the bottom of an old Flathead necklace. Notice the red and green gilding that is still visible near the crimped edge on some of these bells. Originally they were completely colored but most of the gilt plating has worn off. We do not know of any recently manufactured examples with color gilding. To identify old bells look for the crimping to be more rough looking, the loose wire loop, possible gilt coloring, and a nice even patina. Don't forget to look inside to see if the patina is evenly distributed. Also notice the old cowrey shells with hand filed holes on this necklace.

LEFT TO RIGHT: Here are four recently manufactured, and still shiny, hawk bells. Notice the smoothness of the crimped edge. On old bells the crimping will be less smooth. These bells have wire loops. On the first two, both ends of the loop are inserted into one hole. On the 3rd and 4th bells the wire loop is triangular shaped with each end stuck into its own individual hole. I have never seen an old bell with two holes for the wire loop or this triangular shaped wire. Remember an "artifaker" will antique these bells to look old and the patina will no longer shine. If you want to be able to recognize the difference try tarnishing one yourself. Just soak it in vinegar for a day or two and see what happens.
Keep looking and in time you will learn to recognize the difference between a natural old patina and an artificial modern patina.

Indians obtained brass tacks from traders as early as 1773. (See Hanson, Charles, *Museum of the Fur Trade Quarterly*, Vol. 18, #1 and #2, 1982:20). Tacks were also salvaged from worn out leather trunks that were made in abundance by Eastern trunk makers beginning in the 1700's. Indians used tacks to decorate gun stocks, quirts, knives and sheaths, war clubs, leather belts, mirror boards, etc.

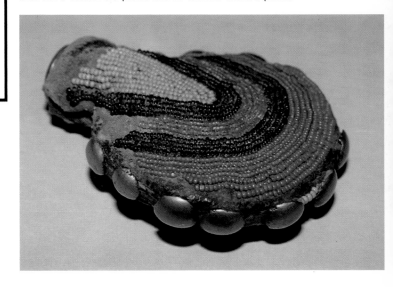

This is an old beaded musket cap holder with square shank tacks decorating the edge.

LEFT TO RIGHT: The first tack is new. It has a steel shank and a finished edge on the dome. Even though records indicate steel shank tacks were being made by 1870 they do not show up on many Indian made items until about 1900. Many collectors believe, falsely, that items decorated with steel shank tacks are "artifakes." The second tack is a very old example of a cast brass tack with a square brass shank. It was pulled from an old leather trunk. The square shank and the rough edge on the dome are proof to most collectors that a relic containing this type tack is old. These tacks are not being made today but old ones are being found and sometimes used to decorate replicas and artifakes. So, be careful!

Old bone hair pipe necklace strung with old hollow round brass beads.

Brass beads have been a popular Indian trade item for nearly 200 years. The old beads were manufactured by pressing the ends of a brass tube until it bulged into a round hollow bead. Solid brass beads were not made until after the invention of the metal lathe and probably didn't show up in the Indian trade until after the 1950s.

The four beads in the photo are hollow and were made since 1985. These new beads often have straighter sides and appear more square than the old beads.

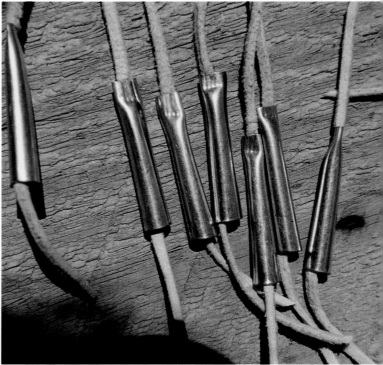

Tin cones, ranging from apx. 1/2" to 2", were made by Indians to ornament pouches, knife cases, dresses, moccasins, etc. Most often they were cut with shears or chisels from old tobacco tins, kettle tops, tin cans, etc. Because they were individually hand made, the tin cones found on old Indian items are usually crudely cut and bent.

LEFT TO RIGHT: These are new commercially manufactured cones which first became available about 1940. They are usually available in 3/4", 1", and 1-1/8" sizes. They are uniform in size and shape and the top hole is plenty big for stringing on leather thongs. The first one is made from brass, a metal that will seldom be seen among old cones. The 2nd is shiny tin (sometimes aluminum). The 2nd and 3rd cones show different degrees of surface patina that can be induced by soaking in vinegar. Other solutions and heat are sometimes used to create an old looking patina. Sometimes by looking inside a cone you can determine that the outer surface was artificially treated to make it look old. Also while looking inside the cone, you should look to see if the buckskin thong or thread has the same patina and cut edges as the outer visible portion. A new cut will be bright and clean without any aging or discoloration. But always remember a good artifaker will also think of this and probably take the time to apply some sort of patina, thus, making it difficult to detect whether or not the buckskin is really old.

LEFT TO RIGHT: The first old tin cone is 1-1/8" long with protruding black horse hair. The second is 1-3/8" long with protruding horse hair that has been dyed red. Notice that the 4th and 5th cones are attached to buckskin thongs and have red feather fluffs protruding. The two small cones on the left are 3/4" long. These and the larger cone, next to them, were found at the site of old Fort Bennett along the Missouri River in South Dakota.

These commercially made tin cones demonstrate the most obvious way to detect old from new. The tops have been crimped with a pliers to keep them from sliding off the buckskin thong; I have never seen this method of attachment used on a genuine artifact. This along with their uniform construction and size are certain proof that the tin cones were recently attached.

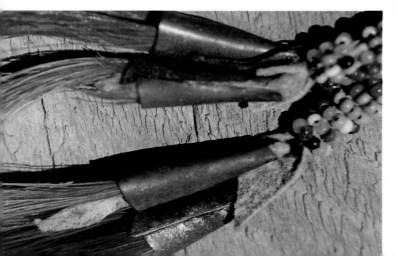

LEFT: These tin cones are attached to the bottom of an old Sioux beaded awl case with buckskin thongs and have dyed red horse hair protrusions. Notice the bottom edges do not come together perfectly. This is a good sign that they were hand-made; the evenly distributed patina is also a good indication of their authenticity.

This photo shows the same attachment procedure with a surface patina that has been created by soaking in a solution such as vinegar. If you look carefully, you can seen the spotty markings and uneven coloring of the patina. Most old patinas will be evenly distributed with (maybe) some rust spots here and there.

LEFT TO RIGHT: **Cowrie shells** were often used as ornamental attachments on dresses, vests, necklaces, pouches, etc. They were usually imported from the Pacific Islands and traded to Indian people without holes. By rubbing the sharp edge of a file or stone against the shell, a hole could be worn into the upper portion so a buckskin thong, sinew string or thread could be passed through. The old shells with holes, probably dating before 1920, were filed by Indians. After the invention of speed drills and small sharp bits, commercial companies began drilling round holes into the shells. Remember a round hole is an indication that the shells could be of recent manufacture. Notice that the 4th shell has a round drilled hole and is modern. The 1st two shells are of the bulbous/lumpy type called Yellow Money Cowries, which were the most popular style in the early American Indian trade. The smooth oval type. called Ring Top Cowries, could be an indication that your item is not very old. Anyone can file a hole into a cowrie shell. Try it sometime, it is quite easy. So be careful, because even a filed hole is not positive proof of authenticity. (See previous photo with old brass hawk bells, p. 189.)

(See previous photo with old brass hawk bells, p. 189.)

Sinew is made from the muscular tendons that are located in a deer back next to the tenderloins. It is peeled off, dried, and then broken down into strings that are wetted and twisted into thread. Sinew from elk, buffalo, moose, caribou and cow can also be made into sinew thread.

TOP TO BOTTOM: The small spool is Nymo brand (nylon) thread which is currently used by many Indian bead workers. (*NOTE: Nylon thread was not commercially available until after World War II.*) The large spool is imitation sinew which is made from a nylon material that has been heavily waxed. It looks like real sinew but will melt if heat is applied and does not have the feeling of stiffness that is a characteristic of real sinew. In the middle is a slab of genuine deer sinew with the mid-section broken down into individual strings. These are peeled off, one at a time, and twisted into individual threads as seen at the bottom of this photo. On many old items of Indian manufacture, sinew was used for beading, quilling and sewing. Sometimes commercial cotton thread and sinew will show up on the same piece with the beads being strung on the sinew and then sewn down with cotton thread.

This detail photo shows a slab and twisted threads of deer sinew.

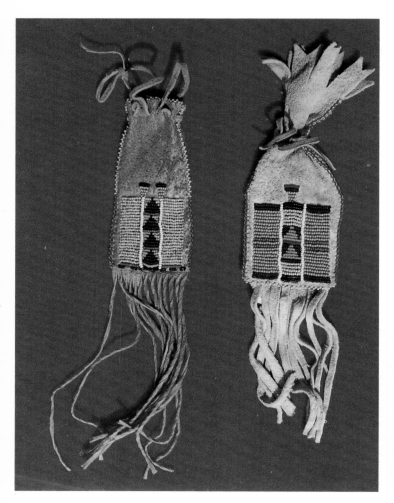

TRADE WOOL

The following photo essay on trade wool was first presented by Carolyn Corey at the 8th Annual Plains Indian Seminar, "Artifacts-Artifakes", Buffalo Bill Historic Center in Cody, Wyoming, in September of 1984. Swatches of old cloth in the author's collection are from the Milton Chandler Collection courtesy of Richard Pohrt.

"White Selvedge Trade Wool" or "Undyed Selvedge" or "SAVED* LIST"

Wool of this terminology is usually navy (indigo) or red, and is distinguished by the white (undyed) selvedge (edge or LIST) that made it the most popular and widely distributed trade cloth to North American Indians as early as 1700.

*"Saving" is the hand-done process of leaving the selvedge white. The term "saved list" is used in early fur trade ledgers, and I believe it to be the most accurate description.

Indigo (navy blue) **saved list** was the most common color and used for women's dresses, men's breech clouts, leggings, and blankets.(See examples in Chapter 1, Garments).

Red **saved list** cloth was highly prized for special medicine qualities as seen in the Bodmer paintings of Missouri R. tribes, c.1830s (See *People of the First Man*). They include: shield trims (see Replica Shields in the companion volume), ceremonial and warrior regalia, pipe bags, rattle covers, war bonnet trailers, medicine bundle wrappings, etc.

There were many variations in shades of scarlet. Bright scarlet was a very early color (popular for military uniforms) named "Stroudwater Red" for the vicinity in England where a superior wool and shade of red was achieved due to the water and high quality yarn. The variations included many shades of red, especially after the invention of synthetic dyes in 1862. The only new example in this photo is the striped selvedge trade cloth on the bottom row;this cloth was known as "Hudson's Bay stroud." The piece shown was purchased from Canada in 1976, the last year of its production (dyed by the author). Note the differences in the old selvedges and backs of selvedge (some have red bleed-through); also differences in texture, sizes of sawtooth edge, and degrees of yellowing. The yellowing from age also affects the red, making it a dull red-orange from age.

NOTE: new wool selvedge is **white**. The old cloth has turned yellow with age and exposure to light. Also, the texture, dye color and weave show significant differences:modern mills make wool with diagonal weave NOT the usual old-time (known as "plain") square weave. The new woolen goods are not coarse,but soft, as dictated by the fashion industry. The natural indigo actually darkens with exposure to light, so that even early cloth is rarely faded. (Not until 1897 was a synthetic indigo used). Modern navy is not so intense and deep nor as color fast as the old indigo.

Until we examined these Crow-style paint pouches closely, we thought they were old due to the use of old-stock beads and natural looking patinas. They are sewn with imitation sinew which was, of course, the give away! Very-well made pieces.

LEFT: Pale gr. blue, old rose white heart, gr. yellow, Crow pink, bottle green and white. Diff. design each side. Edge-beaded. Smoked brain-tan buckskin-looks genuinely old! 2"W X 10.5"L. Est. 95-175 **SOLD $125(97)**

RIGHT: Old-stock beads diff. design each side:Crow pink, lt. blue, t. rose, t. red, t. bottle green, mustard and periwinkle. Edge-beaded. Lightly red ochre. Old-time Indian herbal perfume (sweet pine, musk, etc.) inside. 2.38"W apx. 11" total L. Est. 110-185 **SOLD $135(97)**

DEFINITIONS OF MATERIALS USED FOR ARTIFACTS

HIDES: "Brain-tanned" or "Indian-tanned" buckskin refers to the original hand-worked and organic process of rendering a hide white, soft, supple, porous and easy to pierce with a needle for bead-work. *The saying goes that each deer has enough brains to tan his own hide!* Considerable time and effort are expended in scraping and stretching by hand. Smoking darkens and waterproofs it.

"**Commercial (comm.) hide tanning**" is a modern mechanical and chemical process which doesn't break down the grain (in comparison to brain-tanning) so that it is not porous or as supple or able to easily pierce with a needle; also, it smells like chemicals. Usually has a smooth and rough side. Color usually not like smoked but gold, etc. Costs much less than a brain-tanned hide.

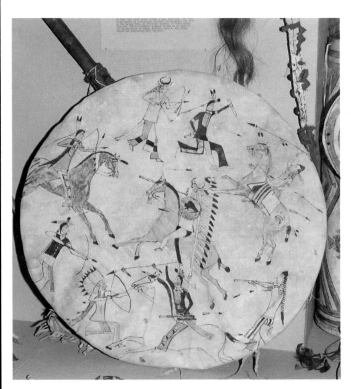

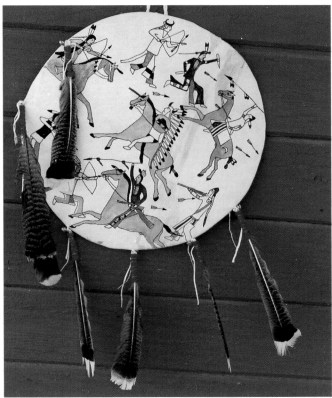

Bright green **saved list** was referred to as "grass green" in the 1828 American Fur Co. orders. Today, it is still sought after on the Crow Reservation to make a prestigious elk tooth dress. In contrast to the indigo dyed wool, green is very fugitive and fades dramatically with exposure to light, so that most 19th Century cloth is now a drab olive green, not the intense original Kelly green. See c.1875 example (upper right in the photo) which has not been exposed to light; shown next to a 19th Century Nez Perce breech clout fragment which has faded.(Far right is old hand-woven cloth dyed by the author).

Yellow also fades readily, although many shades were used from deep mustard to the lemon yellow (far left in photo) to pale yellow of the old Sioux legging (faded) binding. (NOTE: the white edge is barely discernible.) It was also used as trim on blankets, bonnet trailers, etc., but rarely seen made into whole garments.

Magenta and purple **saved list** were found on the Plateau, although infrequently.

Top to bottom: ORIGINAL SIOUX PICTOGRAPHIC SHIELD in a museum.

SIOUX-STYLE PICTOGRAPHIC SHIELD
Colorful painted buckskin cover with 7 tiger turkey feather attachments (red wool wrapped). Hand-pounded rawhide inner. 19" diameter. **SOLD $225(87)**

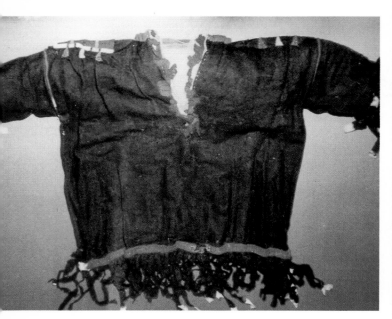

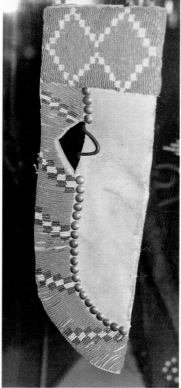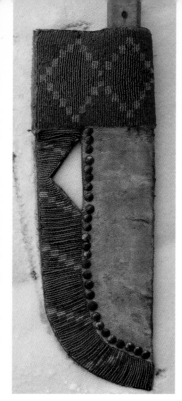

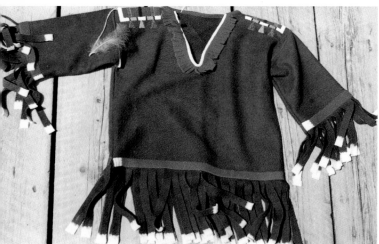

Left: ORIGINAL BLACKFOOT RAWHIDE KNIFE CASE
Original specimen is in a prominent Canadian Museum. It will remain behind glass, untouchable.
BLACKFOOT-STYLE RAWHIDE KNIFE CASE
with old brass square-shanked tacks, old-style seed beads and all sinew-sewn. This is an example of a replica which was made to look exactly like the original through careful selection of materials and expert aging techniques. The 2 gr. blue triangles with white lined rose bkgrd. are beaded on buckskin and fastened to the rawhide case. The diagonal stripes on the side are sewn directly to the rawhide (requiring an awl to make the holes.) *Author's collection* - can be handled, worn, bought and sold! Est. 350-600

Top: ORIGINAL CROW "HORSE STEALING" WAR SHIRT
This rare original shirt could be as early as 1850. Made from navy saved list trade wool. NOTE: white selvedges on bottom and sleeve fringes and trim in both red and navy wool.
See Wildschutt, William, "*Crow Indian Medicine Bundles*," New York, Heye Fdn. 1975: p. 60 and fig. 26. A similar shirt is pictured and discussed that is part of a medicine bundle.
Bottom: Copy CROW-STYLE "HORSE STEALING" WAR SHIRT c. 1850-style.
Exact replica of the old one. Navy saved list wool body trimmed with red saved list wool. Old color seed beaded epaulets. Single feather fluff on thong, just like the original. Patina-enhanced. 29"L X 20" W. Est. 325/450 **SOLD $250(91)**

CHEYENNE-STYLE PICTOGRAPHIC PISTOL HOLSTER
Fully-beaded and lazy- stitched. Buckskin over rawhide. Length 14" + 9" beaded wrapped thong. 4" buckskin fringe on side and flap. Expertly patinated. **SOLD $475(86)**
This original beautiful piece was designed and made by a contemporary replicator who made several similar to it; other replicators have copied his original design! Some of these pieces have been displayed at shows and prominent galleries identified as old and priced as high as $6500.

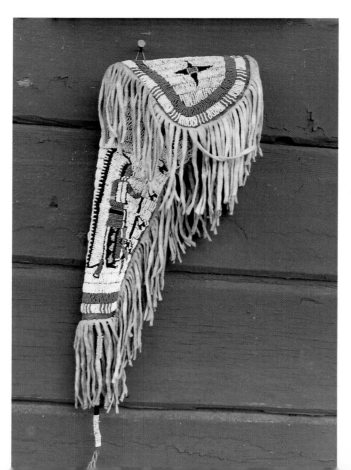

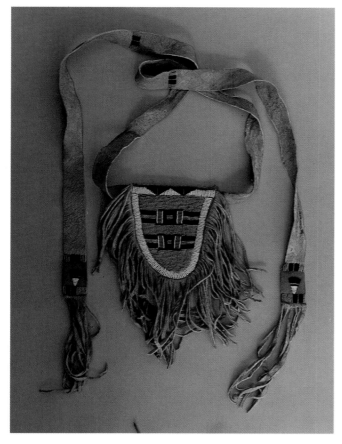

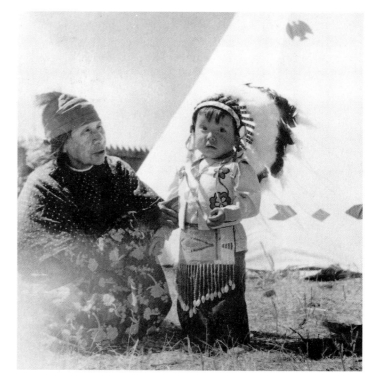

CROW-STYLE BELT and BEADED FLAP POUCH c.1860-STYLE
Flap panel **is re-cycled original moccasin toe piece**. It shows how an original old fragment can be used to make an entirely new object-which is very characteristic of many old Indian-made pieces. In this case, it was constructed by a contemporary replicator.
Lt. blue with gr. green, white center rose, dk. blue and gr. yellow outlined with white; buckskin fringes. Flap is 5" X 4.5" W + fringe. Buckskin belt sections are each 42" long incl. fringes. Expertly aged. Est.275-500 **SOLD $275(89)**

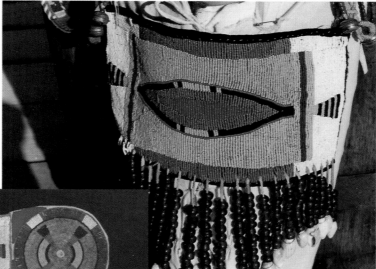

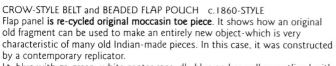

INTERMONTANE-STYLE BLANKET STRIP
Made with old-style bead colors including old rose white hearts. The rosettes have red wool inlay with twisted buckskin thongs at centers. 6" X 56"L. Est 1000-1500 **SOLD $1100(94)**
The rectangular panels are copied from the original c.1880 Crow or Nez Perce beading piece shown recycled (*above right*) used as a Flathead (Salish) child's apron & (*center right*) used later as a Flathead cradleboard bib. *The woman in the photo is Ellen Big Sam. See p. 142 for full view of the cradleboard and description of the provenance.*

195

The following are examples of new pieces copied from incomplete or damaged originals. The rare originals are left in **unrestored condition so as to not destroy the integrity of the piece.** An "**enhanced**" replica has been made to re-create the relic's original appearance, so that we can visually experience how it looked when new.

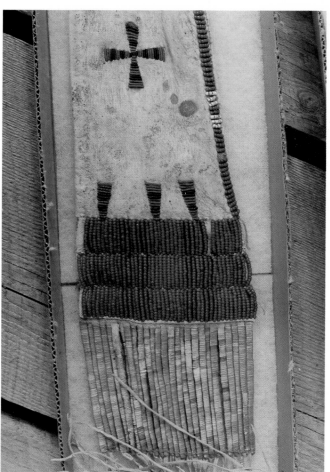

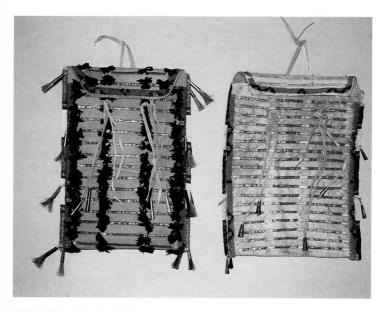

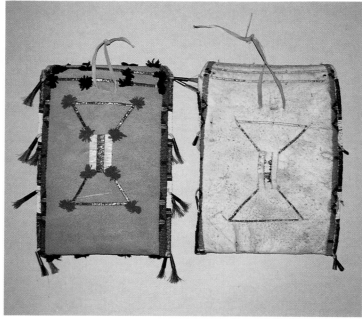

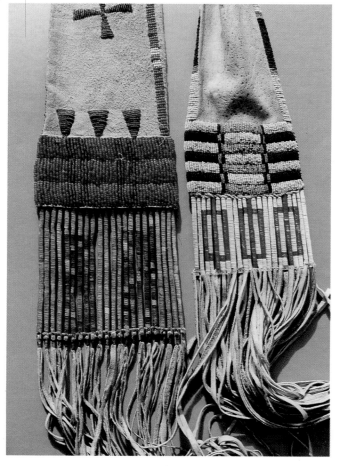

ORIGINAL SIOUX QUILLED MIRROR BAG and ENHANCED REPLICA.
Original is in a private collection and appears on the right in both photos. NOTE: Navy wool tufts on front and red wool tufts on back have been completely destroyed by insects on the original-only a tiny remnant of navy wool remained which the expert replicators were able to re-create in the copy. Also, the purple, yellow and red stylized spider web motif was half gone on the original. Front and flap are red and light blue single-line quilled. Borders on flap, back and front are gr.blue with cobalt, gold and red white-lined. Rolled edge beaded sides are amethyst, white, cobalt and rose white heart. Tin cones on sides have med. blue horsehair. Rawhide liners. Buckskin thong drops with tin cones. 10" L. X 7" W. Est. 350-600
REPLICA SOLD $375(96)